THE AHMANSON FOUNDATION

has endowed this imprint

to honor the memory of

FRANKLIN D. MURPHY

who for half a century

served arts and letters,

beauty and learning,

in equal measure by

shaping with a brilliant

devotion those institutions

upon which they rely.

The publisher gratefully acknowledges the generous contribution to this book provided by the Art Endowment Fund of the University of California Press Associates, which is supported by a major gift from the Ahmanson Foundation.

the not-so-still life

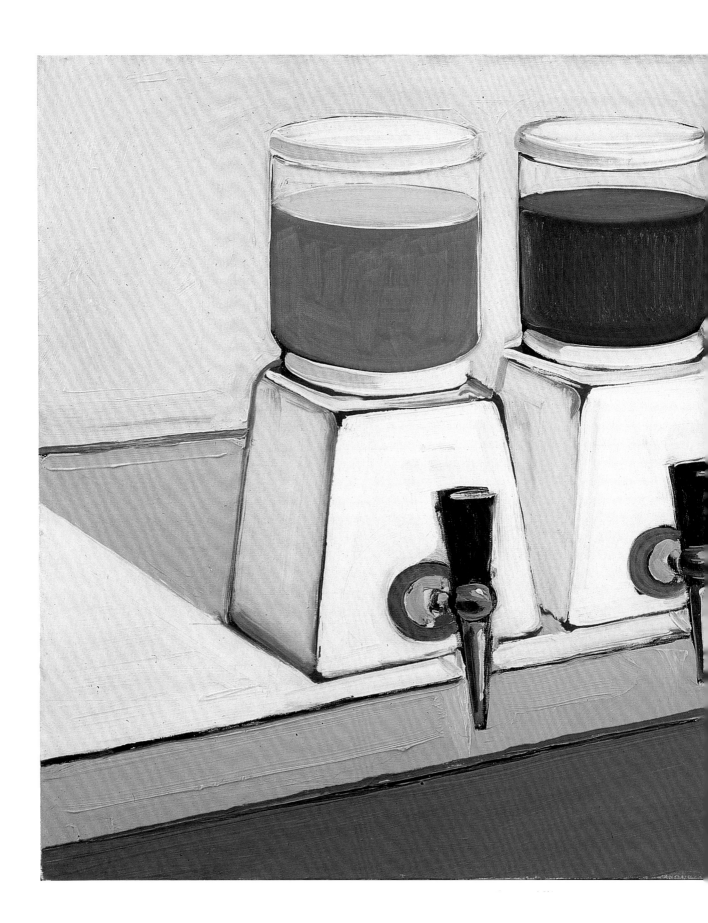

so-still life

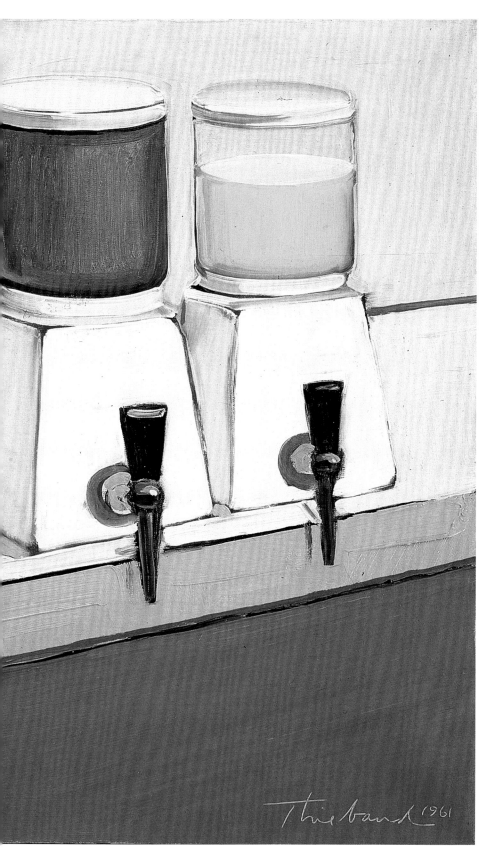

a century

of california

painting

and sculpture

susan landauer

william h. gerdts

patricia trenton

university of calif ndon san jose museum of art

This book serves as a catalogue

for an exhibition organized by the

San Jose Museum of Art

San Jose, California.

San Jose Museum of Art

November 22, 2003—February 15, 2004

Pasadena Museum of California Art

March 6—June 27, 2004

University of California Press
Berkeley and Los Angeles, California

University of California Press, Ltd.
London, England

San Jose Museum of Art
San Jose, California

© 2003 by the San Jose Museum of Art

FRONTISPIECE: Wayne Thiebaud, *Drink Syrups*
1961, oil on canvas, 24⅛ × 36 in.
Yale University Art Gallery,
the Twigg-Smith Collection,
gift of Thurston Twigg-Smith.
© Wayne Thiebaud/
Licensed by VAGA, New York.

LIBRARY OF CONGRESS CATALOGING-IN-PUBLICATION DATA

Landauer, Susan.
 The not-so-still life : a century of California painting and sculpture
/ Susan Landauer, William H. Gerdts, Patricia Trenton.
 p. cm. — (The Ahmanson-Murphy fine arts imprint)
An exhibition organized by the San Jose Museum of Art, San Jose, Calif.,
to be held at the Museum of Art, November 22, 2003–February 15, 2004.
Includes bibliographical references and index.
 ISBN 0-520-23937-7 (cloth : alk. paper) — ISBN 0-520-23938-5 (pbk. :
alk. paper)
 1. Still-life in art—Exhibitions. 2. Art, American—California—Exhibitions.
I. Gerdts, William H. II. Trenton, Patricia. III. San Jose Museum of Art.
IV. Title. V. Series.
 N8251.S3 L36 2003
 704.9'435'0979407479474—dc21
 2003002797

Manufactured in Canada

12 11 10 09 08 07 06 05 04 03
10 9 8 7 6 5 4 3 2 1

The paper used in this publication
meets the minimum requirements of
ANSI/NISO Z39.48-1992 (R 1997)
(*Permanence of Paper*).

donors

The San Jose Museum of Art gratefully acknowledges the following
sponsors of the exhibition and the accompanying catalogue for
The Not-So-Still Life: A Century of California Painting and Sculpture.

LEAD SPONSORSHIP IS PROVIDED BY

DEBORAH AND ANDY RAPPAPORT

SPONSORSHIP IS PROVIDED BY

THE MYRA REINHARD FAMILY FOUNDATION

WELLS FARGO

ADAPTEC

THE KENT AND RITA NORTON FOUNDATION

THE FOLLOWING INDIVIDUALS HAVE ALSO MADE
GENEROUS CONTRIBUTIONS IN SUPPORT OF THE PROJECT:

Joseph Ambrose and Michael Feddersen

Paul and Kathleen Bagley

Bente and Gerald E. Buck

Hal and Andrea Burroughs

Les and Zora Charles

Kelvin L. Davis

De Ru's Fine Arts

Edenhurst Gallery: Thomas Gianetto, Donald Merrill, and Daniel Nicodemo

Mr. and Mrs. Robert Ehrlich

Susan and Whitney Ganz

Mr. and Mrs. William L. Horton

Michael Johnson Fine Arts

William A. Karges Fine Art

Michael Kelley, Kelley Gallery

Tobey C. Moss Gallery

James and Janet Murphy

Jason Schoen

Mr. and Mrs. Thomas B. Stiles, II

Marcel Vinh and Daniel Hansman

Leslie and Nancy Waite

contents

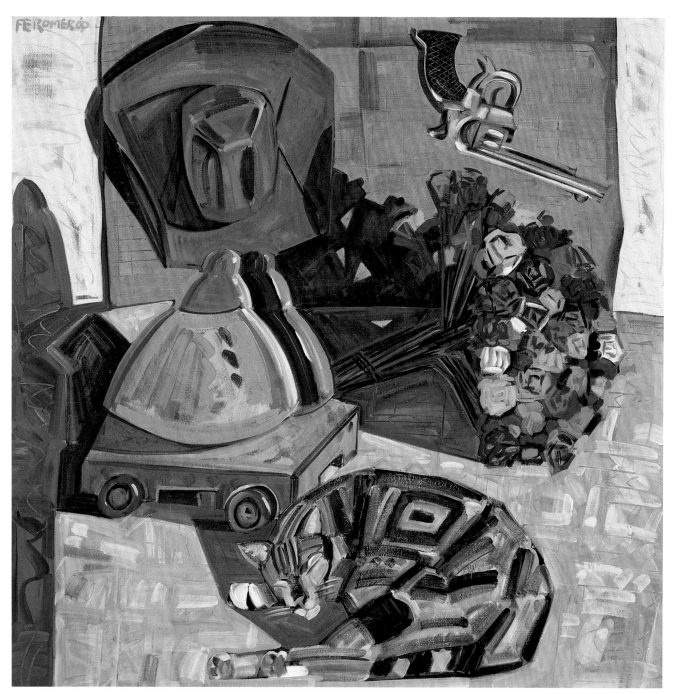

FRANK ROMERO
Scamp with Hat and Gun

1992, oil on canvas, 54 × 54 in. Courtesy of Robert Berman
Gallery. Photograph courtesy Douglas M. Parker Studio.

director's foreword

IT IS PARTICULARLY appropriate for the San Jose Museum of Art to mount *The Not-So-Still Life: A Century of California Painting and Sculpture*. Not only does the exhibition fulfill the Museum's commitment to the art of the West Coast, but it also achieves our goal of placing that art in a larger artistic and scholarly context. The exhibition and accompanying publication are groundbreaking. Although there have been many surveys of American still life, they have focused on the major cities in the East, neglecting the West Coast contribution. Janice Driesbach, former curator of the Crocker Art Museum, organized *Bountiful Harvest* in 1991, an admirable survey of nineteenth-century manifestations, but *The Not-So-Still Life* is the first extensive examination of the genre in twentieth-century California, a period of tremendous transformation and innovation.[1]

Artists' fascination with objects, and the challenges of depicting them, have been important themes in much of art history. The opportunity to view the still life work of California artists thus provides a unique lens for understanding not only the still life as a genre but also the passions and proclivities of the artists themselves. In addition, it provides an intriguing focus for a survey of California art over the past one hundred years.

During the past fifteen years there has been a remarkable revival of the still life, both as an art form and as an object of study. In an Internet search, the words "still life" yield more than a million sites. Like the connectivity—the associations—of a net search, the still life stimulates a similar process in our minds, establishing webs of shared experience and sparking unexpected associations that can change our perception of the world.

These associations are finally what make the still life significant and rescue the genre from being a mere celebration of material existence. For the best still life artists understand that although creaturely, aesthetic pleasure is important, in the end art, and the subjects it depicts, must give us knowledge of ourselves as well. As the late-nineteenth-century avant-garde poet and critic Guillaume Apollinaire put it,

> *I am not overly sentimental like those extravagant people who are overwhelmed by their own actions without knowing how to enjoy themselves. Our civilization is more subtle and exact than the objects they make use of. There's more to it than the easy life.*

We are deeply grateful to those who have made *The Not-So-Still Life: A Century of California Painting and Sculpture* possible. Among the many people who have assisted in this substantial undertaking we would like to thank above all our guest curators, Dr. Patricia Trenton and Dr. William Gerdts, two indefatigable scholars who worked with our chief curator, Dr. Susan Landauer, to make their conception of what was possible into a reality. We also owe a great debt to the private collectors, museums, and institutions who have generously agreed to share their art.

For their untiring dedication in conducting research we would like to thank Ann Armstrong, Hillary Helm, April Lynch, Bernadette Montez, Nora Nguyen, Mara Holt Skov, and, from our present Curatorial Department, Ann M. Wolfe and Lindsey Wylie. For their efforts in coordinating reproduction and copyright approvals, Anamarie Alongi, Chris Alexander, and Debbie McKeown deserve great thanks. Our appreciation is also extended to the entire staff at SJMA, who have contributed countless hours to the success of this publication and exhibition.

Many colleagues, friends, librarians, dealers, and acquaintances have given generously of their time and provided resources as well as constructive comments. These include Joseph Ambrose, Jr.; Tammie L. Bennett, Registrar, San Diego Historical Society; John and Gretchen Berggruen and the staff of the John Berggruen Gallery, San Francisco; Barbara Bishop, Archives of American Art, West Coast Division, San Marino; Jayne Blatchly, daughter of Helen and Otis Oldfield; art historian Nancy Boas, San Francisco; Rena Neuman Coen; Katherine B. Crum, Curator, Parrish Museum, Southampton, New York; Jeanne D'Andrea; David Dearinger, Chief Curator,

National Academy of Design, New York; James Delman; Marianne Doezema, Director, Mount Holyoke College Art Gallery, South Hadley, Massachusetts; Janice T. Driesbach, Director, Sheldon Memorial Art Gallery and Sculpture Garden, Lincoln, Nebraska; Ilene Susan Fort, Curator, American Art Department, Los Angeles County Museum of Art; Rebecca Frazer; Paule Anglim and Ed Gilbert, Gallery Paule Anglim, San Francisco; John Garzoli, Garzoli Gallery, San Rafael; Alfred Harrison, North Point Gallery, San Francisco; Tom Gianetto, Edenhurst Gallery, Los Angeles; art historian John Fitz Gibbon; Li-lan, artist and daughter of Yun Gee; Jeffrey Gunderson, Librarian, San Francisco Art Institute; Sydne Bernard, Tracy Freedman, and Michael Hackett, Hackett-Freedman Gallery, San Francisco; the late Mark Hoffman, Maxwell Galleries, San Francisco; Huntington Library, Art Library staff, San Marino; Barbara Janeff, San Francisco; Harvey Jones, Senior Curator, The Oakland Museum of California Art; Whitney Ganz, Joshua T. Hardy, and Patrick T. Kraft, William A. Karges Fine Art, Los Angeles and Carmel; Paul Karlstrom, former Director, Archives of American Art, West Coast Division, San Marino; Michael Kelley, Kelley Gallery, Pasadena; Marian Kovinick; Betty Krulik, Phillips Gallery, New York; Oscar and Trudie Lemer; Los Angeles County Museum of Art, Art Library staff; Los Angeles Public Library, Art Department staff; Kimberly Davis, Elizabeth East, Liz Fischbach, and Peter Goulds, L.A. Louver Gallery, Venice Beach; Marlys Mayfield; Dewitt C. McCall III, De Ru's Fine Arts, Laguna Beach and Bellflower; Stephen H. Meyer; Tobey Moss, Tobey C. Moss Gallery, Los Angeles; Walter Nelson-Rees; Elisabeth Peters, Montgomery Gallery, San Francisco; Amy Poster, Curator, Brooklyn Museum, New York; Ray Redfern, Redfern Gallery, Laguna Beach; Lisa Overduin and Shaun Regen, Regen Projects, Los Angeles; Randy and Michelle Sandler, Cincinnati Art Galleries, Cincinnati; Deborah Solon; George Stern, George Stern Fine Art, West Hollywood; Jean Stern, Director, Irvine Museum, Irvine; Louis Stern, Louis Stern Fine Art, West Hollywood; Linda Taubenreuther, In Words, Monrovia; Judith Throm, Chief of Reference Services, Archives of American Art, Washington, D.C.; Paula and Terry Trotter, Trotter Galleries, Carmel; Marcel Vinh and Daniel Hansman; Sarah Vure, Associate Curator, Orange County Museum of Art, Newport Beach; Shoshana Wayne, Shoshana Wayne Gallery, Santa Monica; Connie and Stephen Wirtz, Stephen Wirtz Gallery, San Francisco.

The Not-So-Still Life: A Century of California Painting and Sculpture will be seen in Southern California

thanks to the Pasadena Museum of California Art and to Director Wesley Jessup, who recognized the importance of the exhibition. We are delighted by their participation.

Finally, we would like to express our sincere gratitude to the University of California Press for co-publishing the catalogue. As always, Fine Arts Editor Deborah Kirshman and her staff were a joy to work with and produced a superb volume of the highest standards. Thanks to the Press's participation, the publication will be shared with readers worldwide.

Daniel T. Keegan
Oshman Executive Director
San Jose Museum of Art

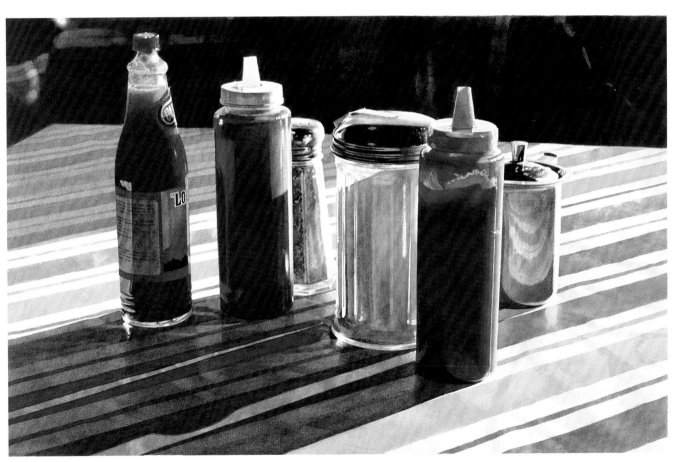

RALPH GOINGS
Café de Palma Still Life

1988, watercolor on paper,
15 × 23½ in. Collection of
Clare and Eugene Thaw.
Photographer: James Hart.

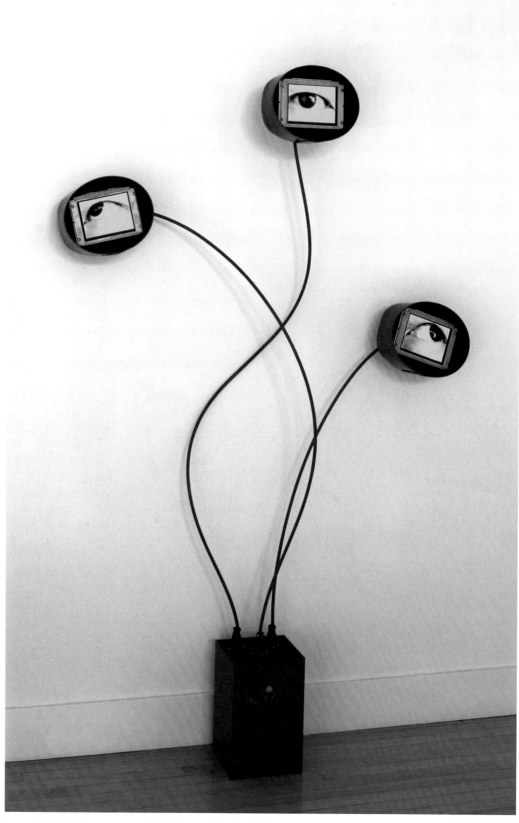

1 ALAN RATH 2001, video monitor installation, 74 × 49 × 11 in. Courtesy of the artist
 Eyeris and Cheryl Haines Gallery, San Francisco. Photographer: Alan Rath.

introduction

EVER SINCE GERTRUDE STEIN inaugurated the age of modern verse with the line "A rose is a rose is a rose," casual readers have interpreted it as a playful yet trenchant comment on traditional poetry's state of exhaustion.[1] Once a potent symbol of beauty and purity, the rose had diminished to a mere platitude, emblematic of the neutralizing effects of overexposure. Yet Stein was not interested in demonstrating vitiation—in fact, quite the opposite. As the artist George Herms relates, the true meaning of her poem emerges when listening to it read aloud and hearing the variations of the expressive inflections she gave to each iteration of the word "rose."[2] Stein's selection of such a trivial subject turns out to be very much akin to Cézanne's choice of apples for his still lifes. Cézanne attempted to breathe life into what might otherwise seem a hopelessly timeworn pretext, to paint endless variations on a theme and still make each canvas entirely fresh.[3] This challenge has long been among the ultimate ones for an artist and provides a clue to the remarkable staying power of the still life. To put one's imprint on tradition or, better yet, to transform convention has been a driving ambition of artists since Zeuxis supposedly deceived the birds with his flawlessly painted grapes. It is no accident that Picasso—whose career consisted of an unrelenting settling of scores with the Old Masters—was obsessed with the still life. Picasso aimed at transformation, not repetition. As he reportedly said, "Good artists copy; great artists steal."[4]

In recent years, with postmodernism's increasing eclectic engagement with the art of the past, artists are more involved than ever with deconventionalizing the conventional. Like other traditional genres such as landscape and portraiture, still life

has experienced both a dramatic resurgence and a radical transformation. The boundaries of still life, given a mighty push with European modernism, have now been stretched in every conceivable direction, often crossing into other categories. Still life is no longer still: it has moved not only off the table, but off the wall and into three dimensions. The contemporary genre no longer resembles the original Dutch *stilleven,* a term that came into use in the middle of the seventeenth century, nor does it conform to the French term *nature morte,* which appeared around a hundred years later. Where, then, are we to draw the line? With such an elastic and mutating form, how are we to define the genre?

The question is far from being settled, as still life has only recently reemerged as a respectable topic of scholarly examination. Despite its centrality to Cubism, arguably the most influential modernist movement of the twentieth century, the status of still life for many years remained inferior within the hierarchy of the genres. In the last several decades, however—beginning with William Gerdts's *American Still Life Painting* (1971)—a proliferation of critical studies and exhibitions devoted to still life has changed that perception. The revival of still life in postmodernist practice has precipitated a number of revisionist art-historical critiques, notably Norman Bryson's *Looking at the Overlooked* (1990), Anne W. Lowenthal's critical anthology *The Object as Subject* (1996), and Margit Rowell's *Objects of Desire* (2000), a survey of twentieth-century still life for the Museum of Modern Art.[5]

Most studies of twentieth-century still life have been quite inclusive, embracing readymades and Brillo boxes yet dodging the definition of parameters. Typically, the archetypal still life, based on Dutch prototypes, functions as a fulcrum around which everything deviant coalesces. This lack of rigor concerning definition parallels the tendency of contemporary scholars to characterize Pop Art in terms of Andy Warhol, and Abstract Expressionism as a bipolar construct built around the color fields of Mark Rothko and the gesture paintings of Willem de Kooning. Bryson takes a step in the right direction by explaining the elasticity of still life as a consequence of its evolution as a discourse, "not only within reception and criticism, but within the historical production of pictures."[6] But after that assertion, he falls back on archetypal notions of still life as depicting domestic objects, missing the rich diversity of the modern idiom as it has developed well beyond its traditional roots.[7]

Bryson's definition of still life essentially restates E. H. Gombrich's passing observations in a short essay published in 1959, "Tradition and Expression in Western Still Life," which is still among the most useful discussions of the genre to date. Gombrich attributes still life's coherence and flexibility to its existence as an artificial, even somewhat arbitrary, construct that, far from being God-given, functions as an evolving and competitive dialogue sustained from one artwork to the next. As such, it challenges precedent, in "the tradition of the *paragone,*" while at the same time perpetuating that tradition, for "without these elements of recognition and comparison, the discovery of the familiar in the unfamiliar, [the contemporary still life] would lose most of its meaning."[8]

This is not to say that the shifts and slumbers of still life in the past century are due to the mere hubris or modesty of successive generations of artists. While it is true that an artist can single-handedly alter the genre, as in the case of Picasso, who probably created the first sculptural still life (or at the very least, disseminated the idea), there are many reasons why still life has taken on the multiple forms it has. The present volume traces a range of forces and influences—historical, sociological, economic, psychological, biographical—that have shaped the genre, all the while keeping in mind Gombrich's relativist conception in maintaining parameters. As already mentioned, still life used to be painted; now it is almost as likely to be three-dimensional, sometimes consisting of found objects that might, for example, hang on the wall. Whereas still life in earlier times concentrated exclusively on intimate objects from the kitchen or the studio, the repertoire has expanded considerably to include everything from rolls of toilet paper to sledgehammers. No longer required to be a purveyor of allure and bounty, still life often now dispenses with the table, although even early in the century the outdoor floral arrangement was popular among traditional artists (fig. 2). One of the more remarkable traits of the twentieth-century still life is its tendency to take on the attributes of other genres, as in the still-life-as-portrait. But the most striking incarnation of the genre is the not-so-still life. In California, beginning with the Synchromist bouquets of Stanton Macdonald-Wright (see fig. 50) and culminating with the electronic sculpture of Alan Rath (see fig. 1), this metamorphosis is most fueled by what Gombrich identified as the challenge of precedent.

Precedent has always been critical in the study of California art, since most scholars (generally Eastern-based) have characterized the West's artistic development as a posterior phenomenon, following patterns established in the East. In truth, of

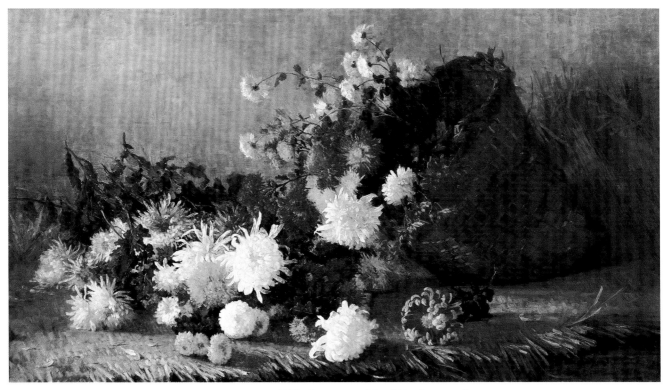

2 ALICE B. CHITTENDEN 1892, oil on canvas, 36 × 64 in. Courtesy of
 Chrysanthemums The Redfern Gallery, Laguna Beach, Calif.

course, the relationship is much more complex and reciprocal, parallel in many respects to that of the Hudson River School and European academies. What we find in California in the late nineteenth and early twentieth centuries is both a reliance on Eastern models and an attempt at independence—particularly in regard to subject matter, which concentrated on the grandeur of the Western landscape as well as the state's increasingly abundant agricultural riches. California's distinctive geography has had an enormous impact on the development of its art. With its perpetual sunshine and year-round outdoor painting conditions, the state became a mecca for plein air painters, and consequently, as William Gerdts discusses in his essay in this volume, plein air Impressionism reigned supreme among still life artists well into the 1920s, long after the movement had faded elsewhere.

When the modernist still life finally did arrive, as Patricia Trenton makes clear in her essay, its manifestations tended to be idiosyncratic. Knud Merrild initially followed fairly standard synthetic Cubist prototypes in his still lifes before turning to his

remarkable "flux" poured paintings of the early 1940s (see p. 216). Others, however—notably Yun Gee, the founder of San Francisco's Chinese Revolutionary Artists' Club in the late 1920s—developed a hybrid form of abstraction that melded Cubism, Orphism, Synchromism, and Futurism (see fig. 47). The reclusive Agnes Pelton created a mystical, highly personal strain of still life reflecting Southern California's propensity toward theosophy and other utopian cults (fig. 3). Certainly the most distinctive chapter in the story of early California modernism was the formation of the Postsurrealist group in 1934, the first surrealist movement in America with its own name and program. Differing from its European counterpart in its emphasis on the rational workings of the mind, Postsurrealism recast the terms of still life by enlisting objects formerly unknown to the genre (fig. 4).

After the Second World War, the dialogue with the East became more complicated. Essentially, the meteoric rise of the New York School as an international phenomenon so intensified California's marginal status that a reactionary, anti–East Coast

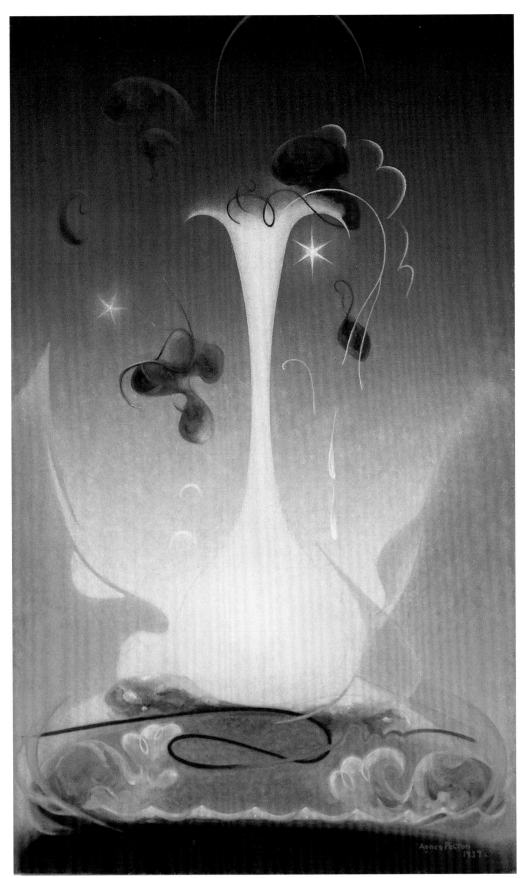

3 AGNES PELTON
Memory

1937, oil on canvas,
36¼ × 22 in. The Buck
Collection, Laguna
Beach, Calif. Photogra-
pher: Cristalen and
Associates.

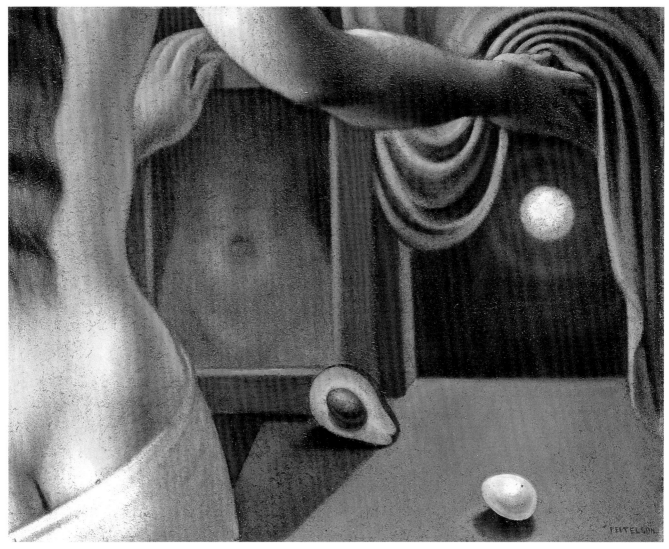

4 **LORSER FEITELSON** 1934, oil on celotex, 24 × 30 in. Collection of the San
 Genesis, First Version Francisco Museum of Modern Art, gift of Helen A. Klokke.

attitude began to influence artistic developments. For still life, this turns out to have been a blessing. The Bay Area Figuratives were the first to denounce Abstract Expressionism's vanguard rhetoric by turning to a backward-gazing approach that included still life among its subjects. Close on their heels were the Beat assemblage artists, whose hunger for potent content led them to produce passionate "object-poetry," refashioning in modern terms the proverbial still life obsession with death and desire. On the other temperamental extreme were the most reactionary of California artists: the Davis ceramic sculptors of the 1960s and 1970s. Robert Arneson, David Gilhooly, Richard Shaw, and Peter Vanden-

Berge celebrated their isolation from the mainstream with an antiserious, antislick variety of still life that often indulged in self-parody, notably in the case of their ludicrous vegetables spoofing the pride of the fertile Sacramento Valley (fig. 5). Although elements of the Pop aesthetic could be detected in their fondness for lowbrow subjects and techniques, the Davis artists deliberately rejected the antiseptic formalism of New York.

With the rise of postmodernist pluralism in the late 1970s, the trend-bucking regionalism of the sort the Davis artists practiced waned considerably. The homogenizing effects of the mass media and the increasing internationalism of recent years have

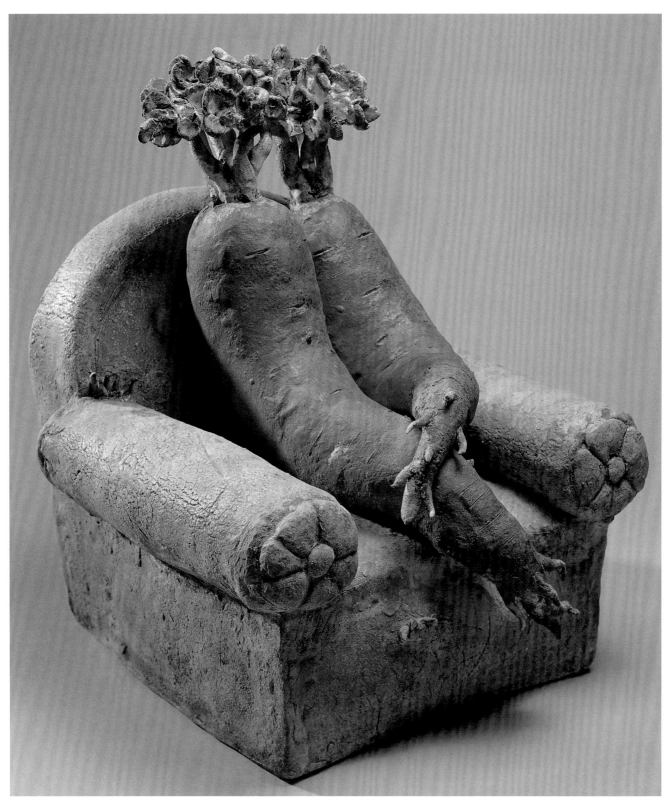

5 PETER VANDENBERGE
 Couple Watching Saturday Night Movie

1969, ceramic, 13 × 12 × 11 in. Collection of the San Jose Museum of Art, Museum purchase with funds from the Collections Committee. Douglas Sandberg Photography.

contributed to a blurring of regional differences. One remaining distinction, however, has continued to have far-reaching implications for California still life: the tendency to prioritize personal experience over critical theory. It is certainly true that the influence of poststructuralist thinking can be found in the recent work of artists such as Ken Goldberg, Mike Kelley, Maria Porges, and Kathryn Spence. With still life's fondness for deception, the genre naturally lends itself to inquiries into the nature of language and simulacra. Yet the West Coast's sense of distance from the constraints of the art market coupled with its increasing multicultural profile has diminished the importance of postmodernism's ideology of neutrality. California's liberation movements of the 1970s—notably the women's movement, Chicano and African American rights movements, and gay liberation—have left a lasting legacy. In the 1980s and 1990s, as the state became the most culturally diverse in the nation, identity politics have profoundly affected the subject of still life, giving greater credence to autobiographical exploration than to prevailing theory-based subversions of individual subjectivity.

The phenomenon of California still life is, in fact, ultimately a story of individuals. In answer to Wayne Thiebaud's witty reproach that "No one ever talks about West Coast mathematics, why should anyone speak of West Coast art?"[9] we would say that California has its own history and its own cast of characters. To assume that its product should be the same as it is elsewhere in the country—or worse, that it is merely derivative—is to deny the wealth of individual contributions California artists have made. Ultimately, scholars of American art will incorporate the innovations of West Coast artists into the larger national narrative. In the meantime, the present volume is a testimony to their imaginative interpretations of the allegedly sleepy genre of still life.

Susan Landauer
Katie and Drew Gibson Chief Curator
San Jose Museum of Art

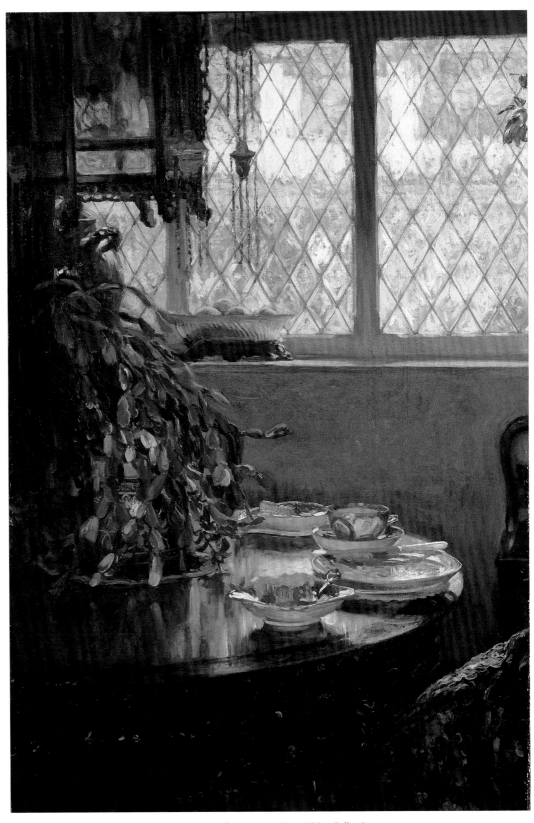

6 GUY ROSE c. 1910, oil on canvas, 35 × 23 in. Collection
From the Dining Room Window of Mr. and Mrs. Thomas B. Stiles II.

william h. gerdts

making arrangements

california still life

painting at the time

of the impressionists

STILL LIFE PAINTING in the United States began tentatively with the new nation. Elevated by Jean-Baptiste Chardin in France to a serious art form earlier in the eighteenth century, the genre in America was nourished by European artists working in this country and by Americans who studied abroad. By the mid-nineteenth century America's still life tradition, shaped by the accomplished Peale family in Philadelphia, had achieved a rich and varied imagery of fruits and flowers, rare or common objects, and trophies of the hunt in manufactured or natural settings. Yet for much of the century most painters and their patrons, mindful of the academic creed inherited from Europe, found still life less significant than other subjects for painting—less challenging to the artist and less inspiring to the viewer.[1]

In California, however, Bay Area artists began painting still lifes to considerable success, in response to the emerging cultural ambience that arose there following statehood.[2] These still lifes extolled the state's natural richness—Janice Driesbach, the foremost authority on California still life painting of the nineteenth century, has characterized them as a "Bountiful Harvest." This celebration of nature's bounty extended into the first three decades of the twentieth century, becoming especially prevalent in Southern California, where painters more often displayed the abundant flowers of the region than the yields of stream and vineyard emphasized by the earlier Bay Area artists.

Many of these Southern California painters adopted French Impressionist strategies, often infusing their still lifes with greater chromatic variety and warmer light, whether sunlight or studio lighting, than those of their northern predecessors.[3] This

chromatic focus generally separates Southern California still life painters from their northern contemporaries as well as from East Coast painters. It is significant that although Impressionism became a dominant aesthetic in the Northeast during the 1890s, it did not take hold in California until almost two decades later. A few examples of French Impressionism were on view in several loan exhibitions in San Francisco in the 1890s, and a number of California artists who had worked in Monet's home village of Giverny, France, exhibited with the San Francisco Art Association at that time. These paintings, however, provoked curiosity rather than emulation among Northern California artists, who followed Arthur Mathews, doyen of the art establishment there and the major teacher at the Mark Hopkins Institute of Art in San Francisco, in preferring Tonalism and the tenets of the Aesthetic Movement.[4] In Southern California, meanwhile, artistic creation followed a relatively traditional, even conservative course until the formation of the Painters' Club in Los Angeles in 1909; only at this point did the art world there begin to form a cohesive body.

Among the California Impressionists, however, still life was a minor theme. Indeed, it may come as a surprise to discover what artistic gifts painters such as Edgar Payne, Alson Clark, and other major California Impressionists brought to this relatively rare theme in their artistic production. Similarly, such major Northeastern Impressionist painters such as Childe Hassam and Edmund Tarbell produced still lifes only infrequently. Most of J. Alden Weir's still lifes—certainly his finest ones—were painted before he adopted Impressionist strategies. John Twachtman is known to have painted only two still lifes, and Mary Cassatt only one. Like their East Coast contemporaries, Southern California artists were particularly devoted to plein air painting. Yet an interesting distinction is that a number of Northeastern Impressionists, such as Hassam, Twachtman, and Willard Metcalf, created a body of close-up representations of garden flowers growing outdoors, whereas in California the preference was for vast fields of wildflowers, more landscape than still life.[5] Except for the bounteous flower paintings of Franz Bischoff, garden paintings per se are in fact less common in California than in many other regions of the United States.[6]

Only a few of the California painters discussed in what follows, such as Paul de Longpré, William Hubacek, and Nell Walker Warner, can be considered still life specialists. Even Alice Chittenden and Edith White were known in their own time for landscape as well as flower painting. (Since the seventeenth century women artists were traditionally associated with flower painting, in part because they were denied access to the study of the figure but also because physical hazards and social indecorousness made it inappropriate for them to work outdoors. By the early twentieth century these restrictions had disappeared and the gender balance had shifted; thus more than two-thirds of the flower painters presented here are male.)

Driesbach's definitive study of still life painting in nineteenth-century California centers on the work of the leading San Francisco specialist, Samuel Marsden Brookes.[7] Brookes was known especially for his renderings of salmon and fruit, particularly grapes, familiar commodities of the region and ones vital to its economy, though he was a master of a great variety of still life subjects, both nature-based and man-made. A number of leading landscape painters working in the Bay Area, such as Thomas Hill and Ferdinand Richardt, painted an occasional still life as well. Interest in the subject, together with the techniques to produce such work, was reinforced in 1887 when Danish-born Emil Carlsen, a superb still life specialist, came to direct and teach at the California School of Design. Carlsen, who remained in San Francisco for four years, brought to California a renewed appreciation for the work of the French master Chardin.[8]

In Southern California, still life was the domain largely of a husband-and-wife team, William and Alberta McCloskey. Their pictures of wrapped citrus are especially admired today (fig. 7), though both painters were equally involved with figure and portrait painting.[9] The peripatetic couple arrived in Los Angeles for the first time in mid-1884 for a year-and-a-half stay, having already lived and worked in Paris, New York, and Denver. In 1891 they visited San Francisco, where they stayed for a year, and at the end of 1893 they returned to Los Angeles, this time remaining for two years. San Francisco called them again at the end of 1897. After the couple separated the following year, Alberta remained in San Francisco until the time of the earthquake; she then returned to Los Angeles, where she died in 1911. William seems to have left San Francisco about the time the marriage broke up. Considerably later, in 1915 or 1916, he too returned to Los Angeles, though by then he was no longer painting still lifes.[10]

Although Carlsen left San Francisco in 1891 and Brookes died the following year, several other leading still life painters there continued to work in this specialty well into the twentieth century. The annual spring exhibition of the San Francisco Art

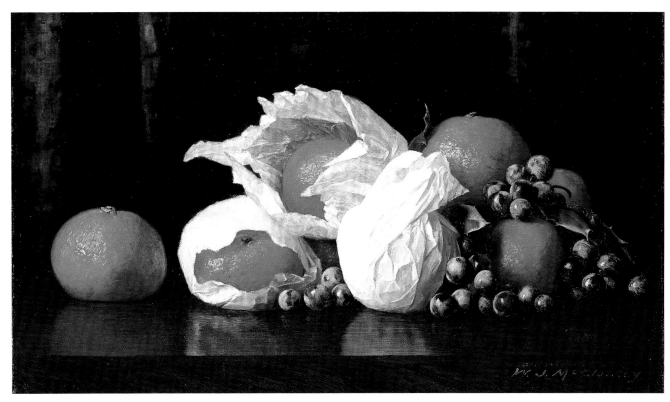

7 WILLIAM J. MCCLOSKEY 1912, oil on canvas, 10 × 17 in. Permanent Collection
Untitled (Still Life, Tangerines) of The Bowers Museum of Cultural Art, Santa Ana, Calif.

Association in 1900 featured a number of flower painters, all women, including Josephine Capwell, Mary Herrick Ross, and Lucia Mathews. During the next several decades Millie Burrall Wood and Charlotte Knudsen also showed florals, but the city's outstanding talent in this area was Alice B. Chittenden. Born in 1859, Chittenden grew up in San Francisco and studied at the California School of Design. She later taught at the school for over forty years, beginning in 1897.[11] Her *Chrysanthemums* of 1892 (fig. 2), reflecting the contemporary interest in things Asian (chrysanthemums and peonies figured strongly in still life and screen paintings as well as in fabric design), displays her celebrated exuberance.[12] In *Chrysanthemums* the airiness of the colorful flowers tumbling out of a rustic basket meshes with the outdoor setting, a contextual device for which Chittenden was especially known. She was, however, even more celebrated for her roses, such as those shown in figure 8, rhythmically composed on their arching stem and dramatically silhouetted against a dark background. Here, Chittenden displays the flowers in all stages of bloom, from scarcely

open buds to fully developed blossoms, reflecting their transience.[13] Equally acclaimed during her career were her paintings of California's wildflowers. In March 1918 some two hundred paintings depicting 271 varieties of flowers, produced over some thirty years, were exhibited at the Hamlin School in San Francisco and at the Art Gallery in Stanford.[14]

Although the vast majority of flower painters in the Bay Area were women, some of the most impressive floral pieces painted in the early years of the twentieth century were by Edwin Deakin. Deakin, an Englishman who settled in San Francisco by 1873, is best known for his three sets of depictions of the old missions as well as other architectural subjects.[15] In the 1880s and '90s, however, he produced a magnificent series of paintings of hanging grapes (begun, apparently, while he was staying in Denver and Salt Lake City in 1882).[16] While these paintings emulated the hanging-fruit pictures of his friend and colleague Brookes, with whom he shared a studio, Deakin gave special attention to their stonework backgrounds. When he moved from San Francisco to Berkeley in 1891 Deakin planted a rose

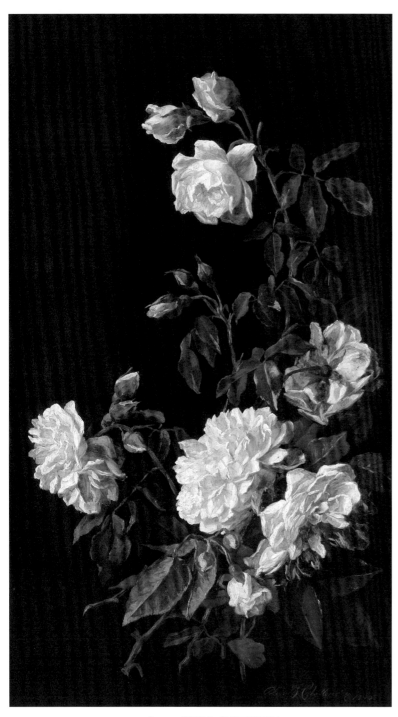

8 ALICE B. CHITTENDEN
Roses

1885, oil on panel, 24 × 14 in.
Courtesy of Garzoli Gallery,
San Rafael, Calif.

garden and turned to making lush paintings of his roses. One of these is *Homage to Flora* of 1903–4 (fig. 9), showing a profusion of many-colored roses cascading over stonework.[17] A similar, slightly later picture, *A Tribute to Santa Barbara*, combines his preferred themes—abundantly overflowing roses, a view of the Santa Barbara Mission, and stonework ledges—to which he added a Southwestern Native American pot and a sculptured image of Saint Barbara. Deakin exhibited one of his rose paintings in Berkeley, in 1907, in the Second Exhibition at the Studio Building.

William Hubacek was, along with Alice Chittenden, a well-known Bay Area still life specialist who straddled the late nineteenth and early twentieth centuries. Born in Chicago, he grew up in San Francisco and studied at the Mark Hopkins Institute of Art. After the 1906 earthquake and fire destroyed much of his work, he moved temporarily to San Bruno, then returned to San Francisco, and finally settled in San Bruno permanently in 1938. (The San Bruno Public Library has a significant collection of his work, donated by the artist's niece.)[18] In Hubacek's *Autumn's Bounty* of 1899 (fig. 10), dead game and vegetables intermingle with gleaming metal kitchen vessels, all painted in glowing variations of brown and other neutral tones, testifying to the influence of Emil Carlsen and, ultimately, the Chardin tradition.

Painters often took up still life at either the beginning or the conclusion of their careers—at the beginning because the subject matter was immobile, and at the end because the artists themselves were restricted in movement. Granville Redmond, a deaf-mute who explored the genre mainly as a young painter, was born in Philadelphia and moved to California with his family when he was very young. He attended the Berkeley Institution for the Deaf, Dumb, and Blind from 1879 to 1890, where he studied drawing and painting, then went on to the California School of Design and, in 1893, the Académie Julian in Paris. He became one of the most celebrated California landscape painters of the first three decades of the twentieth century, creating both beautifully lyrical Tonal scenes and popular vistas of fields of poppies and other wildflowers.[19]

Still lifes figured in Redmond's early career, although he abandoned the genre after the turn of the century. In his 1900 *Solace* (fig. 11), with its pipe, tobacco, and matches, Redmond applies Hubacek's neutral palette to the distinctly masculine smoking theme that had been popularized in the East more

9 EDWIN DEAKIN
 Homage to Flora

 1903–4, oil on canvas,
 36 × 30 in. Private
 collection.

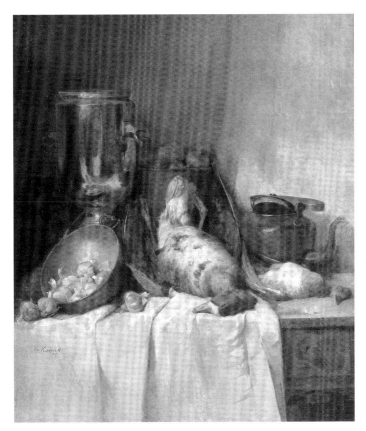

10 WILLIAM HUBACEK
 Autumn's Bounty

 1899, oil on canvas,
 45 × 38 in. Collection
 of Mr. and Mrs. Kevin
 J. McGuire. Photo-
 graph courtesy of
 Montgomery Gallery,
 San Francisco.

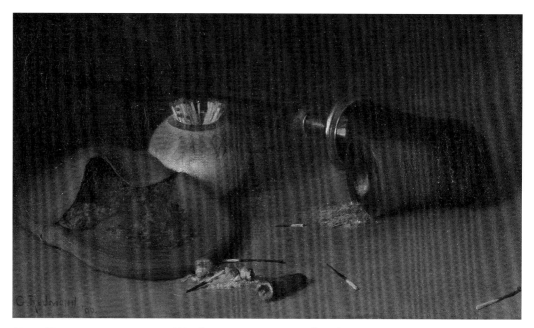

11 GRANVILLE REDMOND 1900, oil on canvas, 10 × 17 in. The Delman Collection, San Francisco.
Solace

than two decades earlier by William Michael Harnett.[20] *Solace* was shown in 1900 in the annual spring exhibition at the Mark Hopkins Institute of Art. Theophilus d'Estrella, Redmond's teacher at the Institution for the Deaf, Dumb, and Blind, wrote that the picture was "attracting general admiration from the throngs who visit the gallery, particularly those who are devotees of 'my Lady Nicotine.'"[21]

Unlike Redmond, many professional painters made occasional forays into the realm of still life painting throughout their careers. The choice of an alternative theme might be motivated by a patron's wishes, or by the challenge of proving an artist's versatility, or by a need for diversion—"holiday work." Plein air landscapists sometimes took up still life when weather conditions prohibited working outdoors, or in times of illness. Whatever the reason, the results of these forays are often fascinating, defining aesthetically and sometimes ideologically a very different strain of invention than is found in the artists' more typical work.

Italian-born Matteo Sandona studied in Verona, Paris, and New York before settling in San Francisco in 1901, where he became celebrated for his figure and portrait painting.[22] Sandona's *Still Life* of about 1910 depicts a colorful array of fruit, flowers, and tableware in a soft atmosphere. The artist used sim-

ilar Impressionist strategies in the exotic garments worn by some of his figural images, as in *In Her Kimono,* a picture that includes a colorful floral still life. *White Roses* (fig. 12) is a subtle, very poetic rendering of these tender blossoms. It bears comparison with the flower paintings of the French still life master Henri Fantin-Latour, as well as with those of Americans of the previous generation such as John La Farge and J. Alden Weir.

Anne Bremer was one of the leading women artists in San Francisco, her birthplace, in the early twentieth century. Associated more with a tempered Modernism than with traditional aesthetics, Bremer began her conversion to Modernism on seeing works by Cézanne and Matisse in the collection of her friend Harriet Levy.[23] After studying with Emil Carlsen at San Francisco's Art Students' League and at the Mark Hopkins Institute of Art, Bremer went to New York, where she saw contemporary French painting at Alfred Stieglitz's 291 Gallery, and then, in 1910 at age forty-two, traveled to Paris for two years of study with André L'Hôte. Bremer was primarily a painter of landscapes and stylized figures; it is here that her exploration of Modernist strategies was most apparent, and critics often termed her work "decorative."[24] She also painted still lifes fairly frequently, exhibiting them first in the 1905 Starr King Fraternity show in Oakland and thereafter at

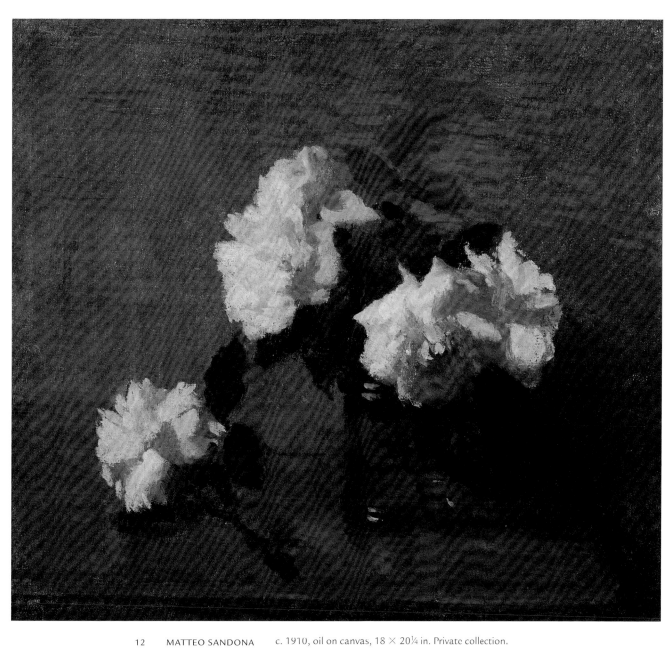

12 MATTEO SANDONA c. 1910, oil on canvas, 18 × 20¼ in. Private collection.
White Roses Courtesy of Edenhurst Gallery, Los Angeles.

the Sketch Club in San Francisco, an all-women's group of professional artists in which she was extremely active.[25] In addition, she showed still lifes in the Del Monte Hotel Art Gallery in Monterey in 1912 and with the California Art Club in Los Angeles in 1915, 1918, and 1920.

In the realm of still life, Bremer was especially known for colorful paintings of objets d'art. An example is *The Lacquer Screen* (fig. 13), which won a medal at the San Francisco Art Association's forty-second annual exhibition in the spring of 1918.[26] Such works, characterized by bold colors and formal simplicity, united two cultural preferences, the Aesthetic Movement and Chinese and Japanese art, for which there was growing appreciation. In *The Lacquer Screen* the central object, a large black porcelain vessel with polychrome figural decoration (possibly eighteenth-century Chinese or nineteenth-century Japanese), reveals a group of sixteen Lohans, Buddhist monks who had attained Nirvana; the green handles, in the form of bats, are an auspicious symbol. In Bremer's arrangement the large black vessel seems to swell within its confines, its opulence reiterated in the gold and lacquer screen, while the colors of the vase's sinuous figural decoration are repeated in the cloth beneath it and in the accompanying flowers.[27]

Bremer was a published poet as well as a painter. Her personal aesthetic is clear in the first stanza of her poem "Still Life":

Aubergine and yellow glazes,
Satsuma and rare old vases,
In the studio on the hilltop;
Silken curtains filter daylight,
Where the mellow shade falls softly
On a lacquered jar of rouge.[28]

Objets d'art still lifes, particularly those depicting Asian artifacts, had greater resonance in Northern than in Southern California, given the longer tradition of wealth and collecting in the North as well as its extensive ties with the Far East.

Like Bremer, Evelyn Almond Withrow was an exceptionally talented San Francisco woman who has fallen into relative obscurity.[29] Born in Santa Clara, Withrow studied in San Francisco before going to Munich in the early 1880s to become a devoted pupil of J. Frank Currier, a talented and radical painter in that city's American colony. After spending time in Italy, Paris, and London, Withrow returned to San Francisco in 1887, where she soon achieved acclaim for her figure and portrait painting.[30] Early in her career, especially during the

1890s, she made traditional floral paintings. Later, however, she created singular works such as *Soap Bubbles* (fig. 14), a painting that, through its virtuoso suggestion of weightlessness and elusive texture, form, and color, displays her ability to realize the most ephemeral of phenomena. The painting may be read as a metaphor of the transience of life, a traditional still life theme.[31] Because of her singular talent with this subject matter, Withrow came to be identified in San Francisco art circles as the "Bubble Lady."[32] This still life was exhibited about 1913 or 1914 in the Permanent Art Exhibition of the Work of the Women Artists of San Francisco, held at the Cap and Bells Club;[33] five or six years earlier she had shown *Still Life, Reflections of an Artist* with the Berkeley Art Association, and that same year she exhibited a pastel, *Prisms*, with the San Francisco Art Association.

Jules Pagès and Joseph Raphael, two of the most brilliant San Francisco painters of the early twentieth century, occasionally painted still lifes. Although both men spent much of their professional careers abroad, they exhibited frequently in their native state and found the greater part of their patronage in California—and both returned to California in their later years, after having gotten their start there. (Perhaps because of their expatriate status, their work, though respected by connoisseurs, has been largely ignored by scholars and omitted from surveys of California art.)

Pagès, the older of the two, studied at the California School of Design before seeking training in Paris in 1888 at the Académie Julian. He returned to San Francisco in 1890 to paint and work as an illustrator, dividing his time between Paris and his native city during the 1890s. In 1897 he won a gold medal at the Paris Salon for *A Corner of the Studio* (Bohemian Club, San Francisco), a painting exhibited yearly for the rest of the decade at the San Francisco Art Association. Pagès began teaching at the Académie Julian in 1902,[34] five years later becoming Rodolphe

13 **ANNE BREMER**
The Lacquer Screen

c. 1918, oil on canvas, 32 × 23½ in. Collection of Oakland Museum of California, bequest of Albert Bender. Photographer: M. Lee Fatherree.

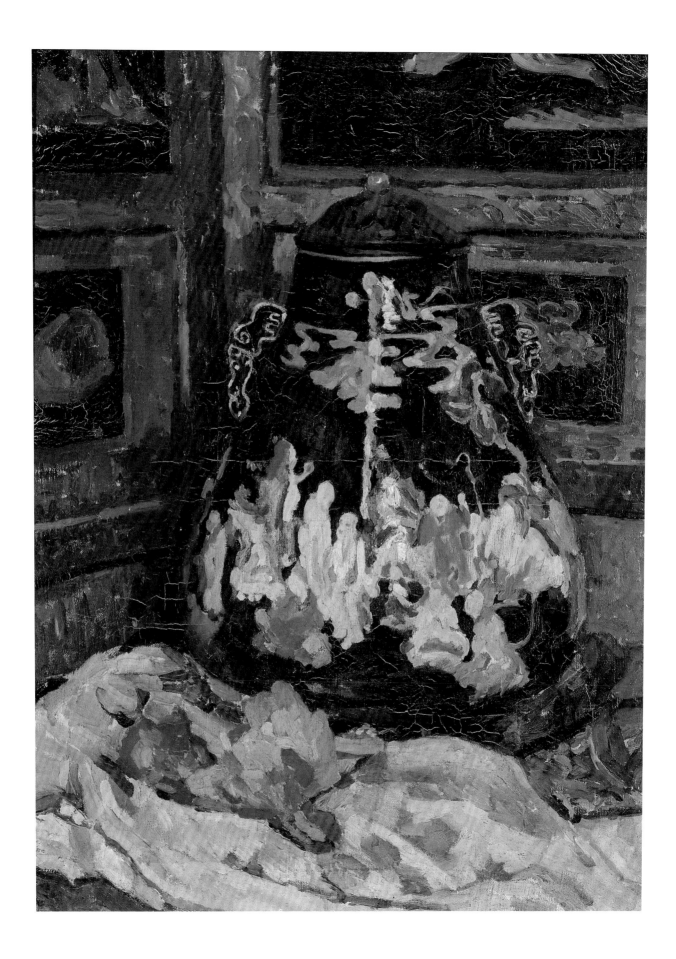

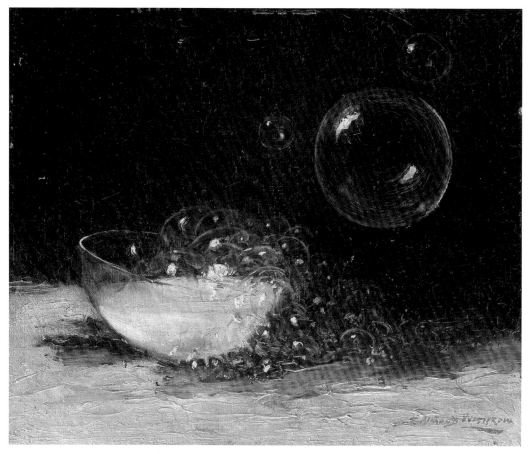

14 EVELYN ALMOND WITHROW 1913–14, oil on canvas, 10 × 12 in.
Soap Bubbles The Delman Collection, San Francisco.

Julian's partial heir to the academy. In 1910, at age forty-three, Pagès was made a Chevalier of the Legion of Honor, and for thirty-one more years he remained the most famous Californian artist in the French capital. During this time Pagès made numerous trips to San Francisco and Los Angeles. Gradually his aesthetic shifted from a brilliantly naturalist figural approach to one involving the high coloration and vivid brushwork of Impressionism, which he applied to scenes painted in Europe—Bruges, Toledo, and especially towns in Brittany—as well as to scenes of Chinatown and the streets of San Francisco.[35] While still life was incidental to Pagès's career, a work such as *Le Vase bleu* (fig. 15), highlighting the contrast between the fragile white flowers and the substantial form of their glistening blue container, demonstrates both his vivid handling of the medium, reminiscent of Manet, and his sensitivity to the subject.

An even more innovative artist was Joseph Raphael, who also studied in San Francisco before moving to Paris in 1903. The following year he joined the artists' colony in Laren, the Netherlands, where he created monumental dark canvases featuring local inhabitants. In 1912 he moved to Uccle, near Brussels, and at this point his aesthetic changed radically. He adopted Postimpressionist strategies of high coloration and large dabs of paint applied in a Pointillist manner, especially in paintings of gardens and fields of flowers, often painted on visits to Noordwijk in the Netherlands.[36] This radical departure from his earlier mode seems to have been inspired at least in part by the Dutch enthusiasm for the work of Vincent van Gogh during the decade of the 1900s.[37] Raphael returned to the Netherlands to live in 1929, remaining there, in Oegstgeest on the outskirts of Leiden, until the beginning of World War II, when he and his wife moved to San Francisco.

Throughout his time in Europe, however, Raphael remained very much a San Francisco artist, not

15 JULES PAGÈS n.d., oil on board, 14 × 10½ in. Private collection. Photograph
 Le Vase bleu courtesy of William A. Karges Fine Art, Los Angeles and Carmel, Calif.

because of his occasional return visits to the Bay Area but because his patronage came from there. His leading patron and a close friend was Albert Bender, Anne Bremer's cousin and a trailblazing collector of Modernist art.[38] Bender persuaded his friends, especially among the region's Jewish community, to acquire Raphael's works; he was also instrumental in obtaining representation for the artist during the 1910s at the Helgesen Gallery in San Francisco, then the city's most advanced outpost of Modernism.

Although still life was not a dominant theme in Raphael's oeuvre, he did produce a remarkable group of fruit and vegetable paintings. Most notable of these is *Apples* from about 1921–22 (fig. 16), one of the finest of all still lifes by a twentieth-century California artist. The blocky manipulation of colors to create structure recalls the work of Paul Cézanne, while the dynamic brushwork and tilted spatial planes are characteristic of the Expressionist direction Raphael's art took in the late teens and twenties.[39]

A Northern California artist attracted by the state's exotic flora is the Irish-born John O'Shea, an avid gardener who painted numerous floral images as well as flowering landscapes. In *Bird of Paradise* (fig. 17), painted in about 1931 on the Monterey Peninsula, O'Shea relies on strong, jagged shapes and bold tonal and color contrasts, the long green stalks and spiky orange blossoms standing out against the large, flat, elliptical leaves, the graceful, stylized swan vessel, and the stark geometric form of the glass tabletop, as well as the screen at the left with egrets, all of these motifs reflective of Art Deco. *Bird of Paradise* was exhibited in Carmel in 1931, leading one critic to write: "His still life oils . . . show O'Shea to be not only a colorist but a master of design."[40] His technique in this painting, Modernist rather than naturalist, is very different from the simplified, broad brushwork he later brought to his interpretation of the coastline near his home in Carmel.[41]

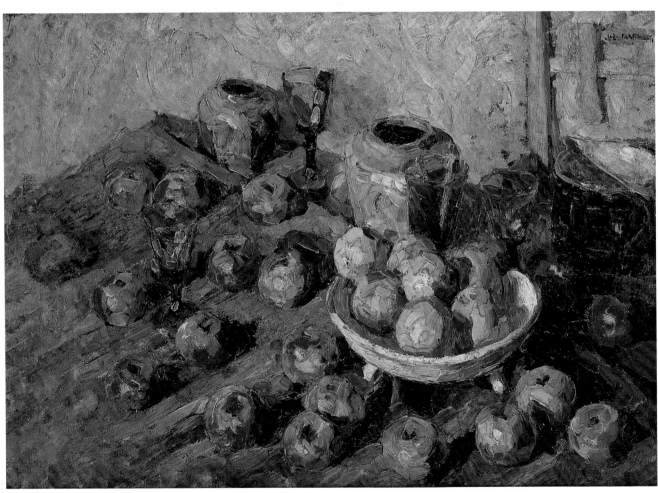

16 JOSEPH RAPHAEL 1921–22, oil on canvas, 27¾ × 38¾ in. Courtesy of
 Apples Garzoli Gallery, San Rafael, Calif.

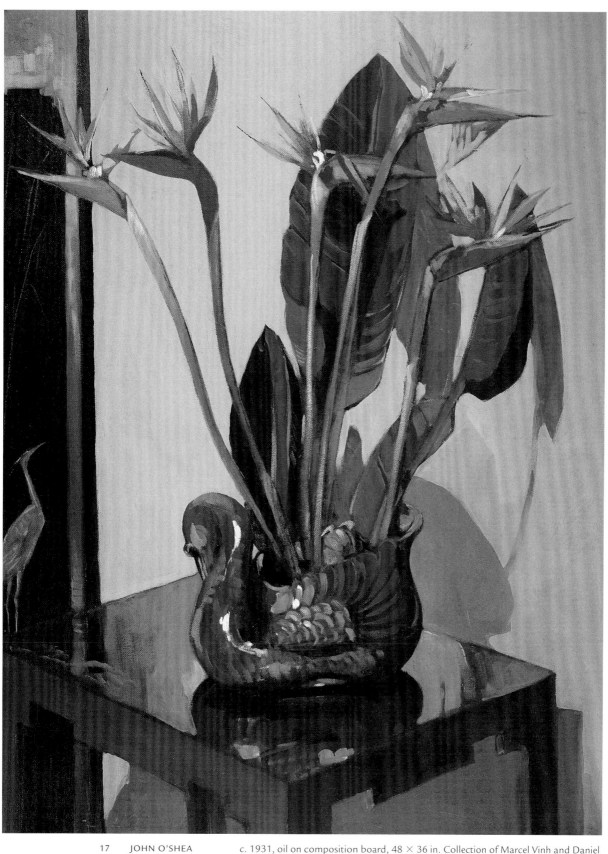

17 JOHN O'SHEA c. 1931, oil on composition board, 48 × 36 in. Collection of Marcel Vinh and Daniel
 Bird of Paradise Hansman. Photographer: Christopher Grandel/Adamson-Duvannes Galleries.

Still life painting in Southern California was very different in focus and appearance from that in the north. Not only was a dynamic cultural and artistic community longer in coming in the south, but the geography and climate of Southern California led to a greater focus on plein air painting and the more vigorous pursuit of artistic strategies associated with Impressionism. Not all still life painters of this period were Impressionists, however; indeed, the best known among them were not. Paul de Longpré, for example, the first artist from Southern California to establish a national—perhaps international—reputation, was a highly traditional painter of still lifes.[42] (He is also to my knowledge the only such specialist in the United States to have a street, De Longpré Avenue in Hollywood, named after him.) The son of a Creole mother from Martinique, de Longpré was born in Lyon, France, long a center for flower painting as an adjunct to the textile design industry. He studied in Paris, establishing himself first as a painter of fans and then gaining a reputation as a watercolorist. De Longpré exhibited at the Paris Salon beginning in 1876, and won a silver medal at the Paris International Exposition in 1889. A year later a bank failure led him to emigrate to New York, where he worked as both a window decorator and a painter, maintaining a summer home in New Jersey. In New York he gained critical acclaim for his annual shows at the American Art Galleries from 1895 to 1898 and for his book illustrations.[43] Between June 1893 and December 1897 the *Art Interchange* magazine used de Longpré's watercolors as examples for their "Instruction Department" column, and the Louis Prang Company in Boston issued chromolithographs after his watercolors.[44]

De Longpré moved to Los Angeles on March 19, 1899, seeking a suitable environment for painting flowers in abundance. The next year he held the first of what became annual exhibitions of flower pictures at the Blanchard Art Gallery in Los Angeles. Court records show that in April 1900 the artist purchased a site on Cahuenga Boulevard for ten dollars, where he built a palatial Mission-Moorish-style home. Needing a more extensive garden, in 1902 he persuaded Mrs. Daeida Wilcox Beveridge, the original developer of Hollywood, to accept three paintings, worth $3,000, in exchange for a three-acre parcel of land off Hollywood Boulevard at Cahuenga. De Longpré's house and the extensive garden he developed on the site became tourist attractions.[45] Although de Longpré painted plants native to the region, such as poppies and cacti, his main artistic focus was his garden's four

thousand rose bushes—hence his cognomen, "Le Roi des Fleurs."[46] De Longpré developed a unique style combining highly detailed botanical knowledge and an instinct for decorative design, as seen in *Rambling Roses* of 1908 (fig. 18). The pair of airborne bees were a common motif in his work, suggesting motion while providing a coloristic counterpoint to, in this case, the rich reds of the blossoms. The placement of blooming sprays of roses, often contained in vases or baskets, against a blank, neutral background helped to reinforce a compositional rhythm of natural growth. De Longpré was much admired in Los Angeles, although some critics, finding his work too detailed and somewhat mechanical, denigrated his "almost flawless technique."[47] His relatively early death in 1911, when he was fifty-six, deprived Los Angeles of its most celebrated painter.[48]

A counterpart to de Longpré and equally a master of the floral watercolor was Albert Valentien of San Diego, though his background and inspiration were quite different. Valentien was born in Cincinnati, where he studied art. In about 1900, recuperating from an illness in Germany, he began to paint the wildflowers of the Black Forest. On a visit to San Diego in 1903, intrigued by the abundance of California wildflowers, he began to record them and other local plants. His *Prickly Pear* (fig. 19) is one of 135 paintings that resulted from this visit, all of which were exhibited at the State Normal School in San Diego. Back in Cincinnati, Valentien became director of the famed Rockwood Pottery, where he remained until 1905. In April 1908 he settled permanently in San Diego, establishing the Valentien Pottery Company in 1911 and continuing to produce art pottery until 1913. In December 1908 he exhibited his flower watercolors at the Blanchard Art Gallery in Los Angeles.[49] That year he also started to devote his time to a phenomenal commission from Ellen Browning Scripps to paint 1,100 watercolor "portraits" of California wildflowers, a project that occupied the next decade of his life, combining both accomplished technique and design with careful botanical recording.[50] Valentien also painted lovely, more formal still lifes.

The wildflowers of California attracted many landscape masters of the early twentieth century, though almost always on a broad scale as artists such as Granville Redmond, John Gamble, William Wendt, William Jackson, and Theodore Wores attempted to capture the magnificent carpets of poppies, lupines, and other springtime flowers of the California countryside. The wildflower theme occurred in literature as well, taken up by writers such as Emma Homan

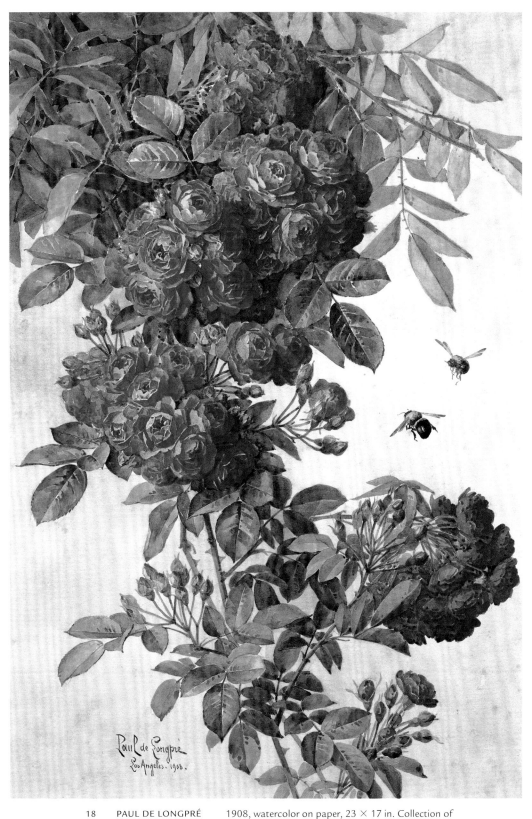

18 PAUL DE LONGPRÉ 1908, watercolor on paper, 23 × 17 in. Collection of
Rambling Roses Dr. and Mrs. Randal J. Williams. Photograph courtesy
 of Spanierman Gallery, LLC, New York.

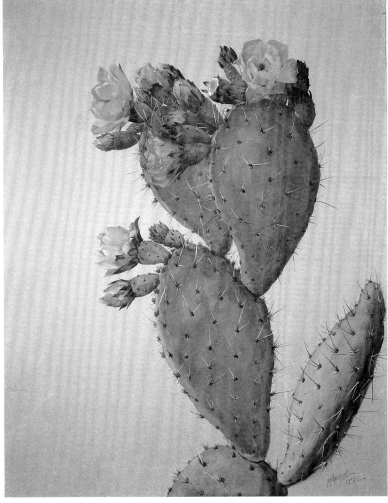

19 ALBERT VALENTIEN
Prickly Pear

1903, watercolor and gouache on
paper, 20 × 12½ in. Collection of the
Lodge at Torrey Pines, La Jolla, Calif.

Thayer, Volney Rattan, Elisabeth Hallowell Saunders,
and Mary Elizabeth Parsons, whose publications were
sometimes beautifully illustrated.[51]

Edith White, San Diego's leading painter of tra-
ditional still lifes, also specialized in flowers.
White studied in San Francisco but established her
first studio in Los Angeles in 1882, moving to
Pasadena a decade later. That year, 1892, her
White Roses was shown in New York at the autumn
exhibition of the National Academy of Design. In
1897 White joined the Theosophical Society, and
five years later she moved to Lomaland, the Soci-
ety's international headquarters at Point Loma, at
the entrance to San Diego Bay, where she became
the principal art instructor at the Raja Yoga Acad-
emy.[52] Throughout her career White especially
enjoyed painting roses, both blooming in gardens
and formally arranged. *Pink Roses* of 1899 (fig. 20)
is typical of her work; in it a sumptuous display of
blossoms, ranging from bud to full maturity, pours
out of a vase, their fragility emphasized by the fallen
flowers and stray petals lying on the tabletop.[53]

Several of San Diego's leading artists painted
only an occasional still life, but these are often of
exceptional quality and interest. *Still Life with Lob-
ster* by Charles Fries (fig. 21) is an unusual work,
not only for this landscape specialist but in Califor-
nia still life painting generally.[54] It is very specifi-
cally a "kitchen piece" in which Fries suggests the
preparation of a meal, with a radish salad to
accompany a lobster soon to be boiled in the very
functional pot. The setting—the rough plank floor,
plastered wall, and scarred, broken wood around
the door—is the antithesis of an elegant dining
environment, and Fries clearly revels in the variety
of shapes and, especially, textures: the smooth,
shiny carapace of the lobster contrasts strikingly
with the soft, leafy lettuce and the dullness of the
unpolished cooking pot.[55] In the 1880s, the East
Coast artist William Michael Harnett had painted a
number of small still lifes featuring lobster, but
Fries's painting, except for its vivid colorism, is far
more in the tradition of Emil Carlsen.

Hungarian-born Maurice Braun studied in New
York before settling in San Diego in 1909. Like
White, he became involved with the Theosophical
Society at Point Loma, and was given a downtown
studio in the Isis Theatre (owned by the society) by
Katherine Tingley, founder of the Point Loma head-
quarters. The city's leading representative of the
Impressionist movement, he was the only San Diego
painter of the early twentieth century to achieve a
national reputation. During the 1920s Braun also
spent part of each year in the East and Southwest,

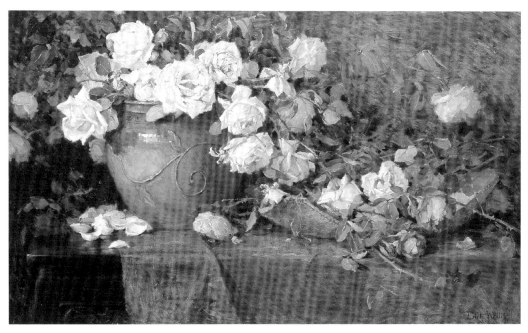

20 EDITH WHITE
 Pink Roses

1899, oil on canvas, 24 × 39¾ in. Mount Holyoke
College Art Museum, South Hadley, Massachusetts,
gift of Susan Tolman Mills (class of 1845), 1899.

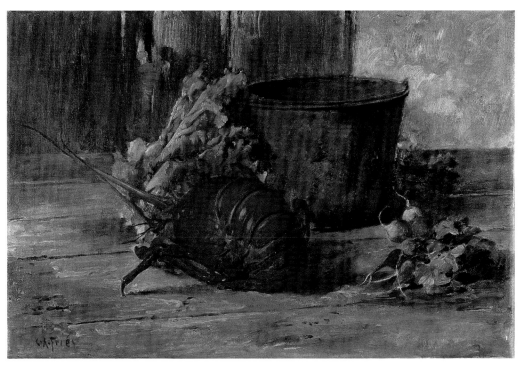

21 CHARLES FRIES
 Still Life with Lobster

1905, oil on canvas, 16 × 24 in. Collection of the
San Diego Historical Society, gift of Lawrence
Laughlin, 1981. Photographer: Nick Juran.

for several years being associated with the Old Lyme art colony in Connecticut.[56]

Braun's primary focus was landscape painting, and he turned to still life only as a very occasional diversion, mainly in the 1930s. Some of these still lifes include Oriental objets d'art, while others feature flowers from his garden.[57] His mastery of the theme is demonstrated in the undated *Anemones and Daffodils* (fig. 22), in which bright flowers contrast with the dark green of the glass vase, all set against a cool neutral tabletop and background. The critic John Fabian Kienitz wrote about Braun's still lifes: "Absolute composure rules. . . . It is impossible for him to look at what was small or large in nature, or among man's things, without translating what he saw into lucid harmonious arrangement. Here, as elsewhere in his art, delicate relations of line, form, and color are simply signs of even more exquisite fineness which he knew to be basic in nature."[58]

Braun was also active among the artists at Laguna Beach, the foremost art colony in the West, made up principally of painters who celebrated the California landscape—its massive mountain scenery, its lush valleys, its woods, its fields of golden poppies, and its sparkling coastline. The still life was an infrequent subject among these artists, and those they did undertake tended to be formal floral pictures, small and intimate—loving reproductions of fragile blossoms, antithetical to the vast spaces depicted in their landscapes, and very unlike the lush arrangements of flowers painted by artists such as Chittenden and Deakin in San Francisco or White in San Diego. Apparently the impetus to paint the flower in nature was satisfied by capturing expansive fields of wildflowers in plein air.[59]

Edgar Payne, for instance, a Chicagoan who first visited Laguna Beach in 1909 and settled there in 1918, was celebrated especially for his spectacular views of the Sierra Nevada and his panoramic vistas of the Southwestern desert. He is known to have painted only two still lifes, *Sunflowers* and *Flowers (Ranunculus)* (fig. 23), yet in each he captures beautifully the special characteristics of his subject.[60] In *Sunflowers,* the massive flowers are matched by their solid round vase, all in shades of yellow and brown, against a yellow background; in *Flowers,* more fragile blooms of contrasting colors, with reds predominating, are arranged against a mauve background. Payne's vivacious handling of paint is almost Manet-like, quite different from the brushwork in the still lifes painted by his wife, Elsie Palmer Payne, whose engagement with this theme may have encouraged her husband to experiment in still life as well.

Though these two paintings are undated, their stylistic breadth suggests that they are relatively late, from the 1930s.[61]

Equally rare are still lifes by Alson Clark, who became a resident of Pasadena on New Year's Day 1920. Clark was one of the best known of the California Impressionists for his figural works and especially for his landscapes. He painted in Claude Monet's Giverny and elsewhere in France, as well as in Chicago, Mexico, Quebec, Charleston, and Panama; in Southern California he painted at La Jolla and Mission Beach, outside of San Diego, and in Laguna Beach.[62] The brilliant chromaticism of his floral *Still Life* (fig. 24), contrasting oranges and purples, yellows and blues, suggests a conscious application of prevailing color theory.

German-born Karl Yens, likewise known for landscapes and figural work, was also involved with the art colony at Laguna Beach, where he moved in 1918.[63] Yens's large *Nature's Charm* of about 1920 (fig. 25) shares the painterly values of Payne's two flower paintings, although Yens places the roses more dramatically against a dark background. Although *Nature's Charm* is undated, it resembles a 1916 description of Yens's *Young Roses:* "heavy pink blooms with one white Cherokee in the center, all in a brown earthenware jug."[64]

Southern California artists explored the depiction of objets d'art as well. *The Green Jar* (fig. 26) by Dana Bartlett, a major figure of the California plein air school following his arrival in Los Angeles in 1915, presents a fascinating juxtaposition of two- and three-dimensional forms. In it, the solidity of the vase contrasts with the outlines of the birds and branches on the painted Japanese screen, the two motifs connected by the whiplike stem of the brilliantly colored lotus plant.[65] The painting, from 1934, reflects both the increasingly decorative nature of Bartlett's art and his interest in Asian motifs. Like Anne Bremer's black porcelain vessel in *The Lacquer Screen,* the malachite green jar may be eighteenth-century Chinese or, more likely, nineteenth-century Chinese or Japanese export ware, which used traditional forms.[66] Writing of Bartlett's "subtle still life arrangements," Homer W. Evans noted: "Oriental embroideries, jade carvings, Ming Jars, bronze and ivory figures—none of these paintings were large, but each is a jewel, representing in the majority of instances an extraordinary degree of imagination, intensive application, time and detail."[67]

Franz Bischoff, the one painter among the Southern California Impressionists who painted still lifes extensively, also painted the most exuberant bouquets. Bischoff was born in northern Bohemia, in

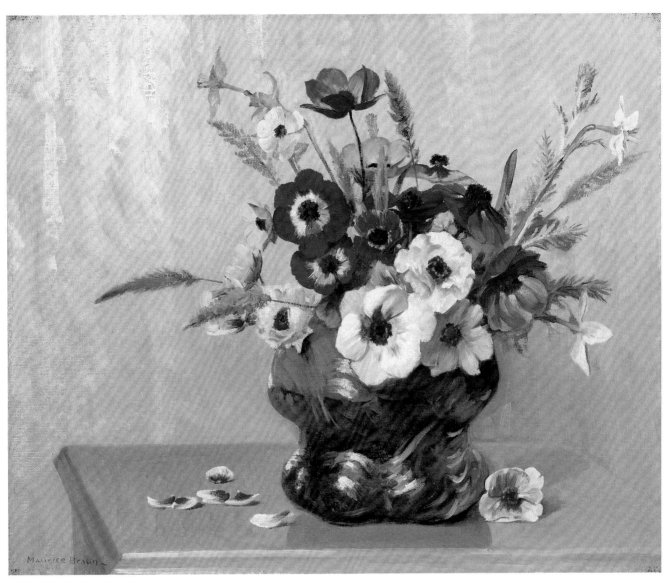

22 MAURICE BRAUN
 Anemones and Daffodils

 n.d., oil on canvas, 20 × 24 in.
 Courtesy of De Ru's Fine Arts,
 Laguna Beach, Calif. Christopher
 Bliss Photography.

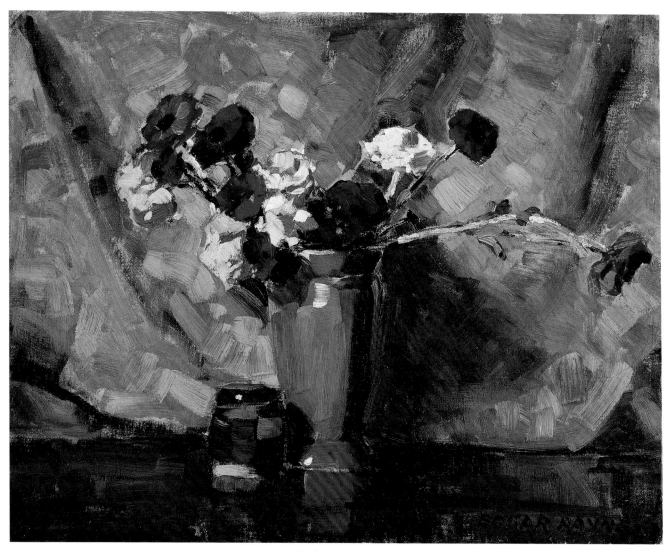

23 EDGAR PAYNE n.d., oil on canvas, 16 × 20 in. Private collection.
 Flowers (Ranunculus) Courtesy of De Ru's Fine Arts, Laguna Beach,
 Calif. Photographer: Brian Forrest.

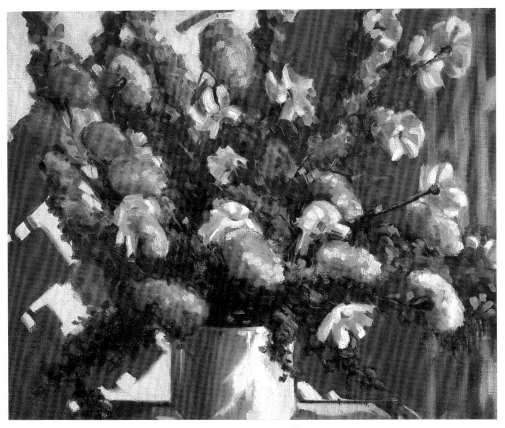

24 ALSON SKINNER CLARK
Still Life

n.d., oil on canvas, 15 × 18 in.
Courtesy of The Redfern
Gallery, Laguna Beach, Calif.
Christopher Bliss Photography.

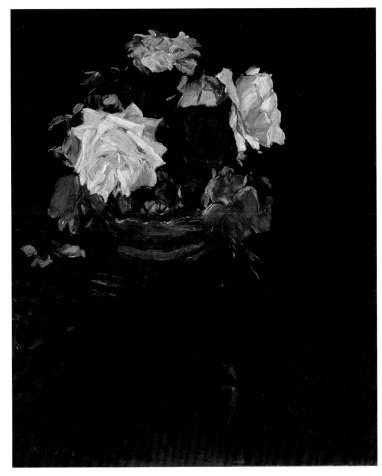

25 KARL YENS
Nature's Charm

c. 1920, oil on canvas, 36 × 30 in.
Courtesy of De Ru's Fine Arts,
Laguna Beach, Calif.

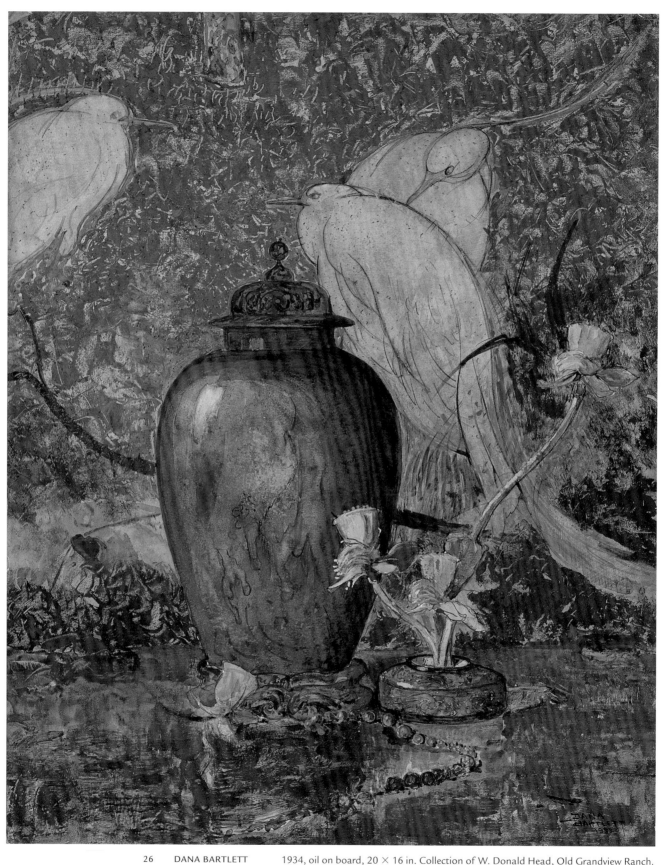

26 DANA BARTLETT
The Green Jar

1934, oil on board, 20 × 16 in. Collection of W. Donald Head, Old Grandview Ranch.
Photograph courtesy of William A. Karges Fine Art, Los Angeles and Carmel, Calif.

what was then the Austro-Hungarian Empire, and immigrated to this country in 1885. Settling first in New York, he moved to Detroit in 1892 and three years later to nearby Dearborn. There he gained great renown as a china painter, specializing in floral design, and became president of the local Keramic Club. After visiting California in 1900, he settled in Los Angeles in 1906, building a studio-home in South Pasadena's Arroyo Seco in 1908.[68] At that point he began to paint the surrounding landscape, and at this time he may have turned from watercolor to oil still lifes—many of which were painted outdoors in his own garden—as well.[69] As he noted in 1912, "I never have to go very far away from home for my inspiration to paint. I have more material for pictures than I can paint in a lifetime."[70] Bischoff was elected to the Painters' Club in Los Angeles in 1909, showing with them that year and then with its successor, the California Art Club, in its annual exhibitions beginning in 1911. He exhibited both landscapes and still lifes with these groups, heralding his double artistic identity. As heir to de Longpré, he was acknowledged as "King of the Rose Painters."[71] Still life paintings were unusual in these exhibitions, where Bischoff was joined principally by the little-known Susie Dando, a painter of flowers in watercolor,[72] and occasionally by San Francisco's Anne Bremer.

Will South, a scholar of California Impressionism, notes that Bischoff learned from his fellow Californians and was "attracted to the sensual qualities he observed in local painting."[73] He also observes that the decorative vision of both Bischoff's still lifes and his landscapes stem from his craft-oriented training. Bischoff studied ceramics in Vienna, and his first job in the United States was as a decorator of china; he also taught china decoration after moving to Detroit, establishing the Franz A. Bischoff Art Studio there. This work (which he continued for a time in California) involved painting floral designs on blank porcelain forms—vases, plates, platters, serving dishes, decorative plaques, and tiles—imported from Limoges.[74] His ceramics especially featured roses, as in *Porcelain Plate with Roses* and *Porcelain Vase with Roses*, although he celebrated other flowers as well, as seen beautifully in *Porcelain Vase with California Poppies* (fig. 27), a product of his Pasadena years.[75] The designs on his ceramics, though exuberant, are carefully delineated in comparison to the vivacious, painterly treatment he employed in his landscapes and still lifes. It seems likely that Bischoff gave up china painting sometime after turning to easel work, perhaps by 1915.[76]

In his still lifes—*White and Pink Maman Cochet-Roses* (fig. 28) being one excellent example—as in his ceramics, Bischoff especially favored the rose, a specialty no doubt encouraged by the extensive rose gardens of Pasadena and the annual Rose Bowl Parade. However, long before he settled in California, he was identified with the painting of roses. One writer observed in 1892, while the artist was still living in Michigan, that "roses are Mr. Bischoff's forte." Another, referring to the painted tiles the artist was sending to the 1893 Columbian Exposition in Chicago, noted that "these tiles are decorated with roses, painted from nature as only Prof. Bischoff can paint roses."[77] In his *Spider Mums* (fig. 29) Bischoff showed another preference; the chrysanthemum, with its long petals and loose structure, was an ideal flower for his expressive brushwork. The highly colored, patterned background of this work also demonstrates his enthusiasm for the decorative.

Joseph Henry Sharp and Nell Walker Warner are two other Southern California painters of the early twentieth century who created lush, exuberant bouquets, as opposed to more intimate arrangements. Sharp's inclusion here may be surprising, for his considerable fame comes from his depictions of Native Americans, in Montana and especially in New Mexico, and his regional identification is almost always with either his home base of Cincinnati or Taos, where he first visited in 1893. Sharp, however, attracted the patronage of Phoebe Hearst, who purchased eighty of his works for the University of California at Berkeley in 1901–2. After a visit in 1898 to Pasadena, where his sister and some of his wife's family lived, he began vacationing there regularly, and in 1910 he acquired a home and a permanent winter studio there.[78] In Pasadena, Sharp painted still lifes of the flowers in his studio garden, lush, lovely arrangements such as *Peonies* (fig. 30). With the exception of works that include Native American artifacts, however, it does not seem possible to distinguish the still lifes painted in Pasadena from those he created in Taos (and even then, some of those artifacts may include Taos acquisitions he kept in his home in Pasadena).[79] Peonies and zinnias were the flowers he most favored for his still lifes, followed by dahlias and irises; almost all of these pictures date from the very late 1920s through the 1930s and '40s.

Nell Walker Warner, another floral specialist, was a later counterpart in the Los Angeles region to Edith White in San Diego and Alice Chittenden in the Bay Area. Like them, Warner occasionally painted landscapes, both in California and on visits to the New England coast. Born in Nebraska, Warner settled in Southern California in the 1910s, living in Glendale, La Crescenta, and La Cañada, and began to

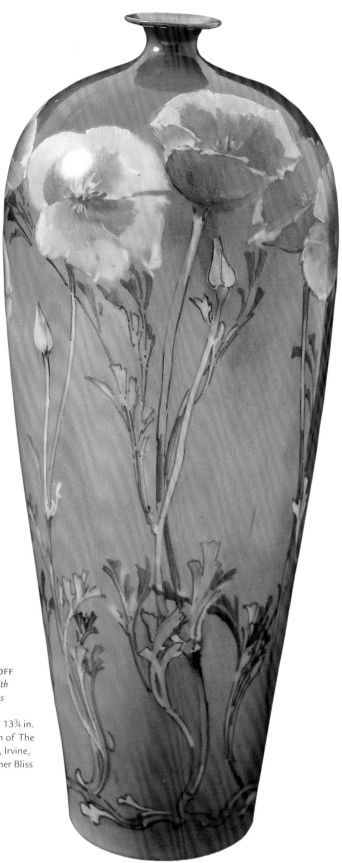

27 FRANZ BISCHOFF
Porcelain Vase with
California Poppies

n.d., porcelain, 13¾ in.
high. Collection of The
Irvine Museum, Irvine,
Calif. Christopher Bliss
Photography.

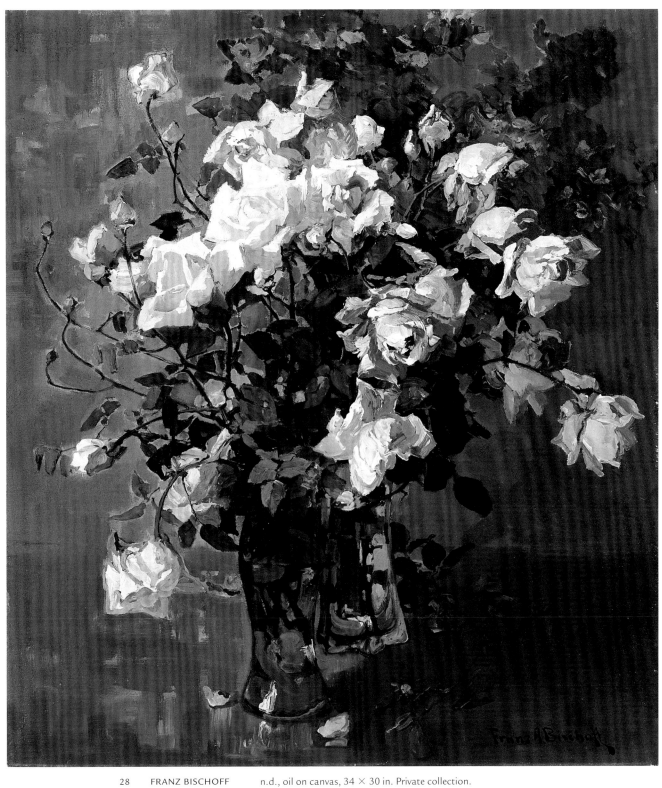

28 FRANZ BISCHOFF n.d., oil on canvas, 34 × 30 in. Private collection.
White and Pink Maman Photograph courtesy of William A. Karges Fine Art,
Cochet-Roses Los Angeles and Carmel, Calif.

29 FRANZ BISCHOFF
Spider Mums

n.d., oil on canvas,
28 × 24 in. Collec-
tion of Mr. and Mrs.
Thomas B. Stiles II.
Photograph courtesy
of The Redfern
Gallery, Laguna
Beach, Calif.

exhibit with the California Art Club in the mid-1920s. She was president of the Women Painters of the West and remained in the region until 1950, when she moved to Carmel.[80] A much-acclaimed artist, Warner specialized in exuberant bouquets such as *Alstromeria* (fig. 31), with vividly colored flowers overflowing their containers and reflected on highly polished tabletops. One reviewer for the *Christian Science Monitor* in 1936 declared that "California flowers allow Nell Walker Warner to continue a work that has acclaimed her America's foremost painter of flowers." Antony Anderson, a former art critic for the *Los Angeles Times,* wrote in the *South Coast News* that "Nell Walker Warner is positively one of the ablest painters of flower studies America has produced."[81] Warner was also active as a teacher of flower painting and still life and published a book on the subject, *How Nell Walker Warner Paints in Oils.*[82]

Most of the still lifes considered so far have been up-close impressions, primarily of flowers—and in the case of de Longpré and Valentien, still-growing flowers—but also of edibles and inanimate objects, usually on tabletops. A number of painters painted the occasional "environmental" still life as well, concentrating on objects within an indoor setting. These paintings are more autobiographical, reflecting the artists' lifestyles. Guy Rose, a native of San Gabriel and California's most celebrated Impressionist, painted *From the Dining Room Window* (see fig. 6), his only recorded mature still life, about two decades after his student days in San Francisco and Paris in the late 1880s. Dating from about 1910, it was painted in the old stone cottage Rose had purchased in Giverny, France, in 1904.[83] In it he concentrates on gleaming dinnerware, contrasted with a richly blooming Christmas cactus on a polished tabletop; a chair is pushed to one side, and a silver basket of fruit rests on the window ledge; human presence is suggested by the unfinished meal. Not only is the still life arrangement opulent, but the

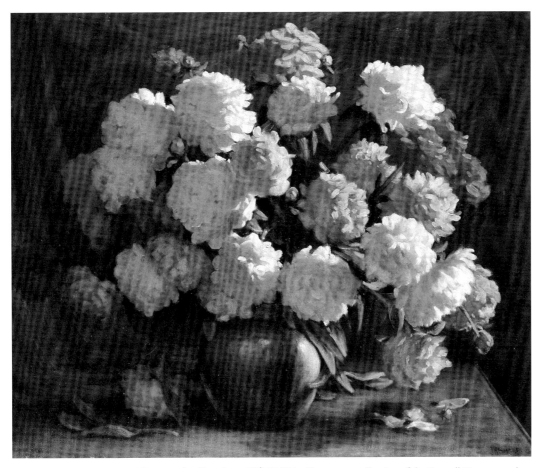

30 JOSEPH HENRY SHARP n.d., oil on linen, 30¼ × 36 in. Permanent collection of the Roswell Museum and
 Peonies Art Center, gift of Elizabeth A. Malone Estate, 1987.005.0001. Photographer:
 Richard Faller.

whole interior, with its hanging lamp and diamond window panes, suggests a sophisticated and elegant lifestyle, especially as seen against the village architecture discernible through the window.[84] The environmental still life was hardly limited to California painters. Artists throughout the nation represented their lifestyles and themselves through their choice and juxtaposition of inanimate forms. Charles Sheeler, in paintings such as *American Interior* (1934), is only one of the celebrated artists who worked with such imagery.

Untitled (fig. 32) by John Hubbard Rich presents a similar situation: on a patterned rug, a plant rests on a shining table; again a chair is pushed aside, and the curvilinear table, seen against an outdoor landscape, is framed by an open white door on the left and a painting in shadow on the right. Differences from Rose's painting abound, too. Although the furniture suggests tradition—the table is Chippendale or, more probably, Chippendale revival—

it is very American and domestic; there are no exotic elements here. An even greater difference is in the arrangement. Whereas Rose's scene suggests the recent departure of one or more individuals enjoying a meal at the table, Rich's is artificial, the table squarely in the way of anyone entering the room.

Boston-born Rich made a brief visit to Pasadena late in 1907, then moved to Los Angeles in 1914, where, together with William Cahill, another California painter, he established the School for Illustration and Painting.[85] Rich was primarily a figure painter, known especially for his images of lovely young women in flowered garments or surrounded by floral accoutrements.[86] In addition, Rich painted and exhibited a number of interior scenes, with and without figures, a heritage of his study in Boston with Edmund Tarbell at the School of the Museum of Fine Arts.

A very different approach to the autobiographical still life can be found in *Highlights* (fig. 33), painted in

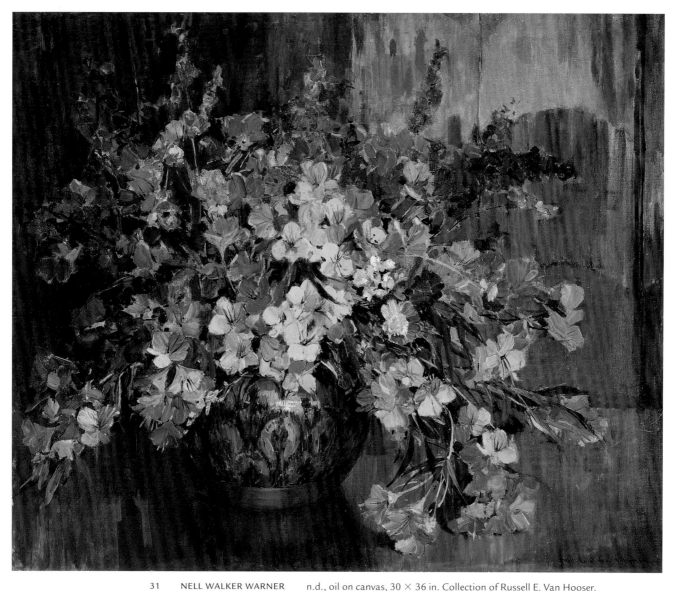

31 NELL WALKER WARNER n.d., oil on canvas, 30 × 36 in. Collection of Russell E. Van Hooser.
 Alstromeria Photograph courtesy of De Ru's Fine Arts, Laguna Beach, Calif.

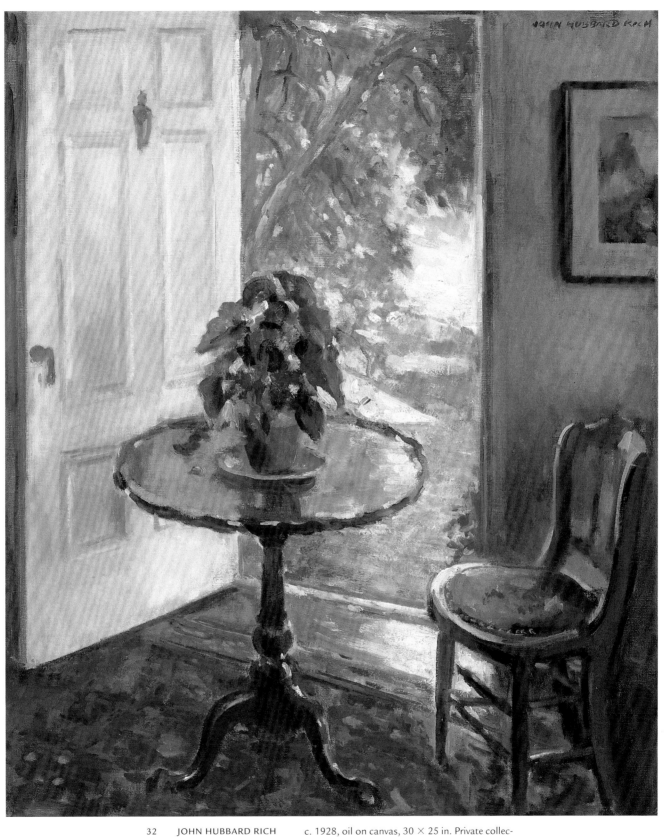

32 JOHN HUBBARD RICH c. 1928, oil on canvas, 30 × 25 in. Private collec-
 Untitled tion. Courtesy of Kelley Gallery, Pasadena, Calif.,
 and Maureen Murphy Fine Art, Montecito, Calif.

about 1925 by Joseph Kleitsch. This picture, in its size and complex composition, is one of the most ambitious still lifes by any of the California Impressionists.[87] From the Banat region of Hungary (now part of Romania), Kleitsch came to the United States in 1901 or 1902 and lived in Cincinnati, Denver, Hutchinson, Kansas, Mexico City, and Chicago before moving to Laguna Beach in 1920. Mainly a figure and landscape painter, Kleitsch was one of the most important painters in the Laguna Beach art colony, where he established the Kleitsch Academy.[88]

Kleitsch's outdoor work displays the enchantment with California light that he shared with his Laguna Beach colleagues. His indoor work, however, both figural and still life, utilizes strong tonal contrasts and intense colors, with sharp diagonal movement back into space. As Will South observes, this treatment "is far more Baroque in sensibility than Impressionist, calling to mind the Dutch, Flemish, and Spanish still-life traditions."[89]

These qualities certainly characterize not only *Highlights* but also Kleitsch's dramatic *Oriental Still Life (Yellow Cloisonné and Amber Beads)* of 1925 (fig. 34), one of several still lifes shown in a one-man exhibition at the Stendahl-Hatfield Galleries in Los Angeles in February of that year.[90] Praise of these works was glowing. Antony Anderson wrote: "Ah those still lives [*sic*]! You will pounce upon four or five in the gallery that are simply overwhelming in their virtuosity."[91] Disparate in size—*Oriental Still Life* is roughly half as large as *Highlights*—these two pictures also display quite different, somewhat gender-complementary sensibilities. *Highlights,* with its violin, accordion, disassembled flute, and sheet music, reflects the artist's musical interests (Kleitsch played all three instruments),[92] while his personal and artistic identity are conveyed by the books, palette, canvases, and mask as well as by the pitcher, wine glass, and bowl of apples on the table, which suggest an evening of conviviality.[93] (Apples figure as a prop in several of Kleitsch's figure paintings, and a picture titled *The Apples* was included in his solo show held at the Stendahl Art Galleries in May 1928.) In *Oriental Still Life,* by contrast, the blue scarflike textile, the dark blue bottle, the amber beads, and the yellow bowl (perhaps a cosmetic box or a cache-pot for the beads) suggest a woman's intimate world.

Even more career referential is *My Worktable* of 1917 by Armin Hansen (fig. 35). Hansen was a leading painter on the Monterey Peninsula, where a thriving art community had developed after the San Francisco earthquake and fire of 1906. The community was sustained in part by an art gallery established in 1907 in Monterey's Hotel Del Monte that sponsored high-profile exhibitions. Many of the major artists on the peninsula specialized in landscapes of the dune country, the cypress groves, and especially the area's rugged coastline and sea. Hansen, however, born and trained in San Francisco, was unique in emphasizing the activities of the local fishermen and mariners, in both oil paintings and etchings. He spent four years as a crewmember on a number of vessels before returning to San Francisco in 1912, when he was twenty-six. The following year he began to paint in Monterey.[94] Although Hansen only occasionally painted still lifes, his were some of the finest examples in the genre on the peninsula from the early twentieth century.

In still lifes such as *My Worktable* and the sensitive tabletop arrangement *After Lunch* of about 1915 (fig. 36), Hansen relied on softer, more broken brushwork and the more harmonious chromatics of traditional Impressionism. Thematically and formally, the two still lifes both complement and contrast with each other. In *My Worktable,* which documents the artist's professional environment, Hansen vigorously applies intense colors, while in the refined *After Lunch,* featuring a large table covered with white linen and tilted to display elegant china, silver candlesticks, a vivid bouquet, and a bottle of wine, he employs a finer touch and a richer, more varied chromatic scale.

After Lunch evokes a human presence, much like Guy Rose's *From the Dining Room Window* and *Sunday Breakfast* by George Brandriff (fig. 37). Brandriff, who abandoned dentistry in 1928, late in his working career, to become a full-time artist, lived and taught painting in Laguna Beach. He is known primarily for his harbor scenes, painted both at Newport Beach and abroad.[95] Many of his still lifes, such as *Sunday Breakfast,* are more or less traditional—intimate views into his private world. Here, the single set of flatware and glass of juice suggest a solitary breakfast, presumably for the painter himself. The newspaper at the center of the composition, opened to the comics (perhaps the "Red Ryder" series of the *Los Angeles Times*), reinforces the Sunday identification. The painting is self-referential in several ways beyond the single place setting. Brandriff had served briefly as a newspaper editor and cartoonist, so his choice of reading material adds a personal and gently humorous note to the scene. And the fact that the room's occupant is a painter can be deduced from the stacked frames at the far left.

Brandriff is especially noted, however, for still lifes he began to paint in 1931 depicting toys and dolls, such as his vividly colored *Ebb-Flow* of 1934 (fig. 38). Brandriff termed these paintings "allegories."[96] This

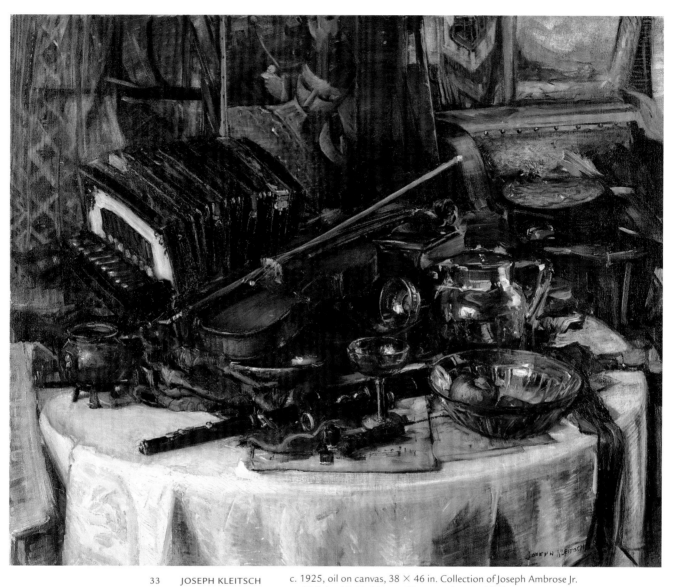

33 JOSEPH KLEITSCH c. 1925, oil on canvas, 38 × 46 in. Collection of Joseph Ambrose Jr.
Highlights and Michael D. Feddersen. Photographer: Budd Cherry.

34 JOSEPH KLEITSCH
 Oriental Still Life (Yellow Cloisonné and Amber Beads)
1925, oil on canvas, 16 × 20 in. Collection
of Lenoir M. Jossey. Photograph courtesy of
The Redfern Gallery, Laguna Beach, Calif.

subject matter, which defines a small but distinguished subcategory of California still life painting, was explored by very few Eastern artists of this period, one exception being Marsden Hartley's *Doll, Glass, and Fruit* of 1912.[97] Brandriff's toy-and-doll images were based on newspaper reports of events that troubled the artist and are fraught with reflections of religion, marriage, chance, war, economics, the depression, and artistic achievement.[98] *Ebb-Flow,* for example, at first glance looks like an unremarkable collection of dolls of various sizes; a closer look, however, reveals its political overtones. Two vividly colored, triumphant Russian peasants stand on a map of North America, toward which a ship is sailing; at their feet lie a toppled monochromatic statuette of "Napoleon" and a marching soldier, face down. The book at the left, *Europe Since 1815,* refers to the defeat of the French by the European Alliance in that year.[99] The painting implies the artist's sympathy with the Russian triumph over Napoleon and the appeal of contemporary Russian Communism to the American working classes, an issue implicit in another Brandriff

toy still life, *Holiday* (1931–32). The political implications of these works gained further emphasis from their frames, which were collaged with newspaper headlines and articles; the frame for *Ebb-Flow,* for instance, incorporated headlines about Russian-American interaction: "Russia Raps American Views," "A.F. L. Against Russian Trading," "Alien Film Folk Plan Quick Exit," "U.S.C. and Stanford Debate on Russia," "Court Studies Red Appeals," "New Alien Drive Round-Up Near," and "Soviet Orders New Grain Tax."[100] While Brandriff stated that he chose this approach to still life "to dispel the popular notion that artist's [sic] have no brains," the propagandistic slant of *Ebb-Flow* was recognized by critics.[101]

Toy still lifes by other California painters were more straightforward in intent.[102] One such work, *Protection* of about 1928 (fig. 39), may be the only still life by Paul Grimm, an artist best known for landscapes of the desert, often backed by the towering San Jacinto Mountains, painted after he settled in Palm Springs in 1932.[103] In this painting, in which the beautifully coiffed and gowned doll,

35 ARMIN HANSEN 1917, oil on canvas, 30¼ × 36 in. Private collection.
My Worktable

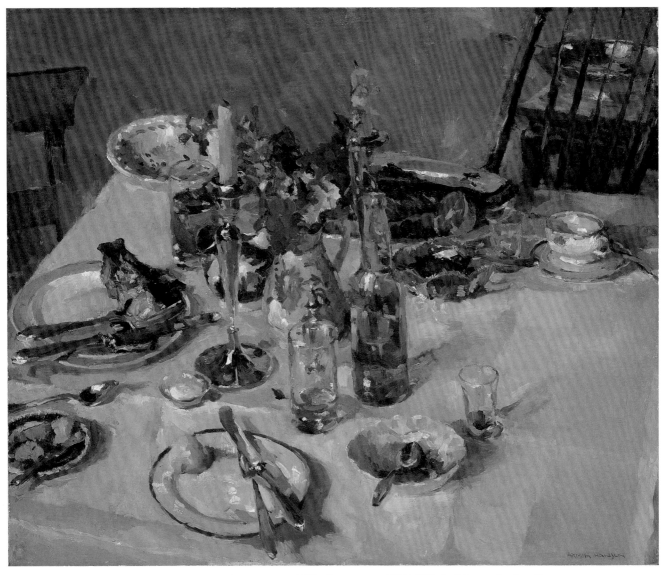

36 ARMIN HANSEN c. 1915, oil on canvas, 24¼ × 30³⁄₁₆ in. Private collection. Courtesy
After Lunch of George Stern Fine Arts, Los Angeles. Photographer: Q. Siebenthal.

37 GEORGE BRANDRIFF c. 1935, oil on canvas, 24 × 30 in. The Buck Collection,
Sunday Breakfast Laguna Beach, Calif. Christopher Bliss Photography.

38 GEORGE BRANDRIFF
Ebb-Flow

1934, oil on canvas-
board, 14 × 18 in.
LAM/OCMA, Art
Collection Trust, gift
of the estate of
Frances Conden
Brandriff Brooks in
memory of Frances C.
Brandriff Brooks and
George K. Brandriff.

39 PAUL GRIMM
Protection

c. 1928, oil on can-
vas, 25 × 30 in. Col-
lection of the Misses
Carrie and Hannah
Stern. Photograph
courtesy of George
Stern Fine Arts, Los
Angeles.

leaning against ornamented pillows on a sofa, seems to be protecting the two stuffed dogs, the artist has imposed an intriguing spatial conundrum: Is the furniture miniaturized as if for a doll's house, or are the doll, animals, and sofa almost life size? The second interpretation seems more likely, given the interior setting and the painting on the rear wall. Before he moved to Palm Springs, Grimm lived in Hollywood for twelve years, supporting himself with design and advertising work as well as by painting backdrops for movie studios. The theatricality of this painting may reflect his occupations at the time.

Toys Resting of about 1917 by Meta Cressey (fig. 40) is one of the most elaborate and joyous of the toy still lifes. The full panoply of the colorful pleasures of childhood—not only toys, figural and equine, but also a jack-in-the-box and a coloring book — are complemented by the flowering red plant and the vividly patterned draperies. The whole scene is bathed in sunlight, fresh air almost palpably streaming through the open windows. The painting truly celebrates family life.

Meta and her husband, Herbert "Bert" Cressey, were both artists. They met while attending Robert Henri's summer painting class in Spain in 1911 and married in 1913, settling in Los Angeles the following year. Both became active exhibitors with the California Art Club. The art critic Arthur Millier praised their paintings, saying they displayed "color, dash, a thorough knowledge of their color scales and a delightful spirit of play made manifest in work."[104] Meta showed paintings of her garden especially, as well as the occasional still life. Family wealth negated the necessity for the Cresseys to sell their work extensively, but the Depression forced them to give up their Compton ranch and their Hollywood residence. With the loss of the Hollywood house and garden, Meta gave up painting in about 1936.[105]

Toys Resting was first shown in 1918, in the second and final exhibition of the Los Angeles Modern Art Society, the earliest of a series of organizations intended to infuse a more progressive spirit into the local art scene.[106] Among the paintings Meta Cressey exhibited in the society's first exhibition at the Brack Gallery was her *Japanese Doll*. The society members, including the Cresseys, were not only rejecting the purely mimetic art of their more conservative contemporaries but also reacting against the dominant Impressionist mode exemplified in the annual exhibitions of the Los Angeles-based California Art Club.[107] Indeed, excepting the work of the slightly later Oakland-based Society of Six, Southern California took the lead in developing a Modernist viewpoint in the late 1910s. It was a relatively "conservative modernism," however, for the work of these artists was a far cry from European Modernism or from the Fauve, Cubist, Futurist, and other contemporary explorations of some Northeastern painters.[108] Instead they generally looked to the manipulation of formal elements of line, shape, and color, following the work of Postimpressionists such as Cézanne, Gauguin, van Gogh, and perhaps Matisse. They were also less singularly devoted to outdoor painting, spending more time in their studios. As a consequence, still life began to receive more emphasis. As Antony Anderson, reviewing the society's first show, wrote: "The moderns, in love with actuality, do not disdain still life; in fact, they paint it very often."[109]

In 1919, after the Los Angeles Modern Art Society expired, a new association, the California Progressive Group, was formed. It held only one exhibition of sixteen paintings at the Lafayette Tea Room that July. Two of the featured artists, another husband-and-wife pair, Edouard and Luvena B. Vysekal, remained in the forefront of more progressive tendencies during the following decade. The Vysekals belonged to the Group of Eight, who exhibited together in 1921 and 1922 and again in 1927 and 1928. The figure, landscape, and still life imagery of these artists includes bold distortion and simplification of form, as seen in Luvena Vysekal's *Still Life with California Poppies* of about 1920 (fig. 41). Here, botanical accuracy gives way to decorative expression; the segmented curves of the white, vermilion, and golden poppies contrast with the geometric pattern of the cloth, woven using the same colors, that covers the upended table.

The Vysekals had come to California in 1914, and both Luvena, a figure and still life specialist, and Edouard, who turned from figure painting to urban landscape, came under the influence of Stanton Macdonald-Wright soon after he returned to California in the fall of 1918. Macdonald-Wright became the major exponent of Modernism in the region, leading the most progressive organization formed in Los Angeles in the 1920s, the Modern Art Workers.[110] The Vysekals participated in the group's exhibitions in 1925 and 1926.[111]

The Modern Art Workers espoused no single aesthetic; rather, the group's aim was to bring together the most creative and experimental artists of the region.[112] Its vice president, Mabel Alvarez, exemplifies this outlook. First, from 1915, a pupil of William Cahill and John Hubbard Rich, and then, beginning in 1920, one of Macdonald-Wright's most devoted students, she also belonged to the

40 META CRESSEY c. 1917, oil on canvas, 40 × 36 in. Collection of Mr.
Toys Resting and Mrs. Robert Cressey. Photographer: Q. Siebenthal.

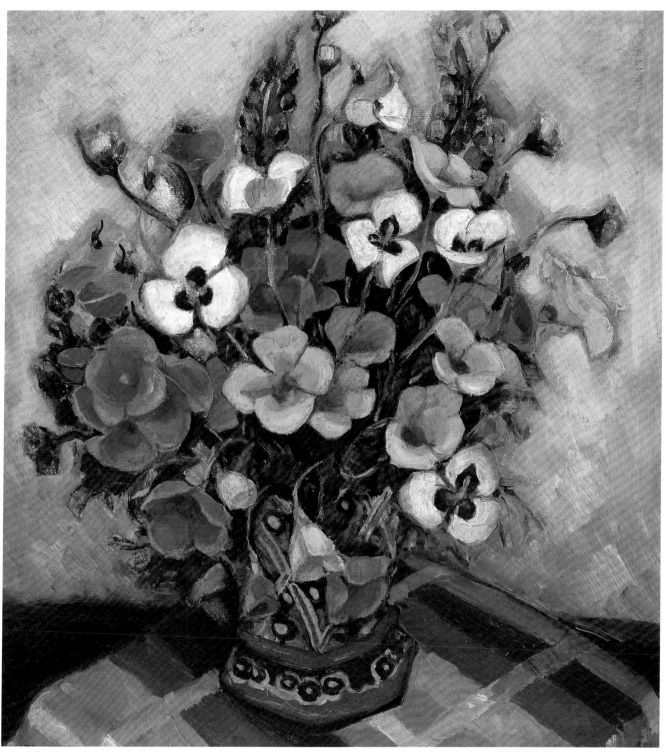

41 LUVENA B. VYSEKAL c. 1920, oil on canvas, 20 × 18 in. Collection
 Still Life with California Poppies of Jean Stern. Christopher Bliss Photography.

Group of Eight, exhibiting with them both before and after the brief existence of the Modern Art Workers.[113] Although Alvarez was known principally as a figure painter, especially for her highly symbolic "dreamscapes," as she called them, she was probably the Modernist most involved in still life. She showed flower paintings fairly regularly with the California Art Club, with titles such as *Flower Music* and *Flower Worship,* and in a three-artist show she shared with Loren Barton and Paul Lauritz at Los Angeles's Museum of History, Science, and Art in November 1920 her still lifes outnumbered her figure paintings.[114] Alvarez's flower pictures range from ones like the somewhat muted and painterly *Narcissus and Ranunculus* (fig. 42), probably painted earlier in her career, to brightly colored, stylized images of magnolias,

camellias, and other flowers, which likely date to her association with Macdonald-Wright in the 1920s.[115] While some of the zinnias, dahlias, begonias, and magnolias she painted were purchased at a local flower shop, she also depicted the spring flowers she planted in her garden.

In an unpublished document titled "Notes on Art," Alvarez transcribed Macdonald-Wright's 1920–25 lectures. In one of them her teacher stated: "The sculptor works with only one element—form, just as a musician worthy of the name works with only one element, sound. Hence the painter of today who would create masterworks must proceed only with that element which is inherent to his art—color."[116] Alvarez apparently took this pronouncement to heart, especially in her still lifes. As one critic wrote in 1935, "She belongs

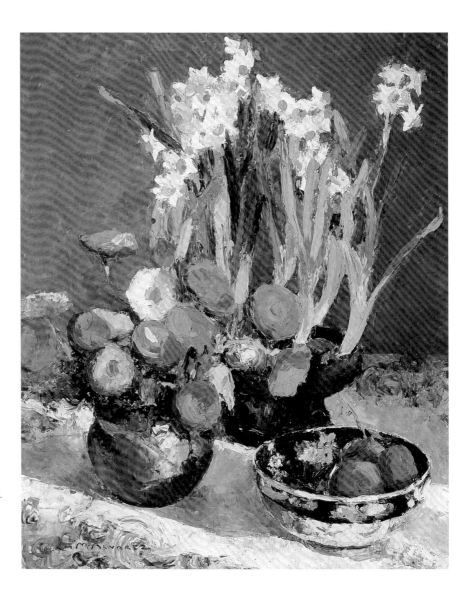

42 MABEL ALVAREZ
Narcissus and Ranunculus

c. 1929, oil on canvas, 24 × 20 in. The Russak Collection. © Glenn Bassett, Estate of Mabel Alvarez.

in that company of still life searchers to whom the oil medium owes many of its triumphs. . . . Her special province is substantial color, hence her most appealing works are fruit and flower pictures, things of rich, pulpy substance and sensuous surface which lend themselves to the full brush. . . . For the plastered walls of our Southland homes her flower and fruit canvases seem the perfect pictures. They are full bodied, glowing with color yet restrained by fine taste."[117]

Donna Schuster was another California progressive in the Group of Eight. Like her colleague John Hubbard Rich, she had been a student of Edmund Tarbell's at the Boston Museum's School of Fine Arts. She went on to study with the great Impressionist painter and teacher William Merritt Chase, first during a summer in Belgium in 1912 and then again in Carmel in 1914 (Chase's last class). During 1914 and 1915 she painted a series of celebrated watercolors of the Panama-Pacific International Exposition in San Francisco, and in 1915 she settled in Los Angeles.[118] Schuster's artistic dynamic is peculiar, her works falling into two more or less equal categories: archetypal Impressionist scenes of figures in suburban environments on the one hand, and forceful, simplified figurative and landscape imagery on the other. Some analysts argue that this second mode, which includes nature studies of gardens and lily ponds, reflects the coloristic impact of Macdonald-Wright, with whom she reportedly studied in about 1928 and by whom she had been influenced earlier.[119] Yet Schuster apparently undertook this experimental work before 1928, painting in both modes simultaneously. Like her garden studies, Schuster's occasional still lifes—such as *Morning Radiance* (fig. 43), its chromatic contrasts enlivened by the brilliant sunlight streaming through the window—are in a bold, decorative mode. Here she contrasts a still life of fruit with a floral arrangement and a multicolored parrot, while the still-growing garden flowers form a kind of tapestried background as they press against the long, vertical windowpanes. This undated picture was probably painted between 1921 and 1924.[120]

Still another member of the Group of Eight produced a body of still life of very individual and high quality.[121] California native Clarence Keiser Hinkle began his art studies at the Mark Hopkins Institute in San Francisco, exhibiting his first still lifes as early as 1905—such as *Still Life from Chinatown*, which was shown at the Starr King Fraternity show in Oakland that year. He then went east to study at the Art Students' League in New York with William Merritt Chase and at the Pennsylvania Academy of the Fine Arts in Philadelphia. There he won a Cresson Scholarship to Paris, where he was greatly influenced by both the Impressionists and the Pointillists. Hinkle returned to San Francisco in 1912 and five years later settled in Los Angeles, where he became a noted teacher of art. He built a studio at Arch Beach in the city of Laguna Beach in 1924, and in 1935 he moved to Santa Barbara. Hinkle painted both figural subjects and landscapes, at first in the Impressionist style, though he became especially celebrated for his more expressionistic, modernist coastal views painted at Laguna in the 1920s.[122]

Hinkle's expressive brushwork, strong tonal and coloristic contrasts, and Cézannesque structural handling characterize his mature still lifes, as exemplified by *Still Life* from about 1930 (fig. 44).[123] A number of Hinkle's still lifes, this one included, focus on a corner of a room, almost surely in his Arch Beach studio, and they imply an impending human presence. Here, for example, a tray is set for a simple repast: a piece of fruit to be peeled and segmented with the knife lying on the dish, a drink to be poured from the pitcher into the blue glass, a napkin to be unfurled.[124] This is no mimetic reproduction but a carefully calculated arrangement; the curves of the chair railing, the fruit, the leaves, and the pitcher are balanced against the strong diagonals of table, tray, and venetian blind slats. The blinds form an abstract pattern, shutting out the view. This background appears again in *Outdoor Still Life*, a similar but more casual arrangement that features the same blue-patterned jug, which is also depicted in his *Pomegranates*.[125]

Although relatively few important California artists of the first three decades of the twentieth century specialized in still life painting, many of them produced very beautiful, sometimes quite powerful, and occasionally very original works in this genre. The impulse toward still life increased in the 1920s as more formalist strategies began to be explored, often in the studio. The work of these "conservative progressives" paved the way for more truly Modernist experimentation within the still life genre in the decades to come.

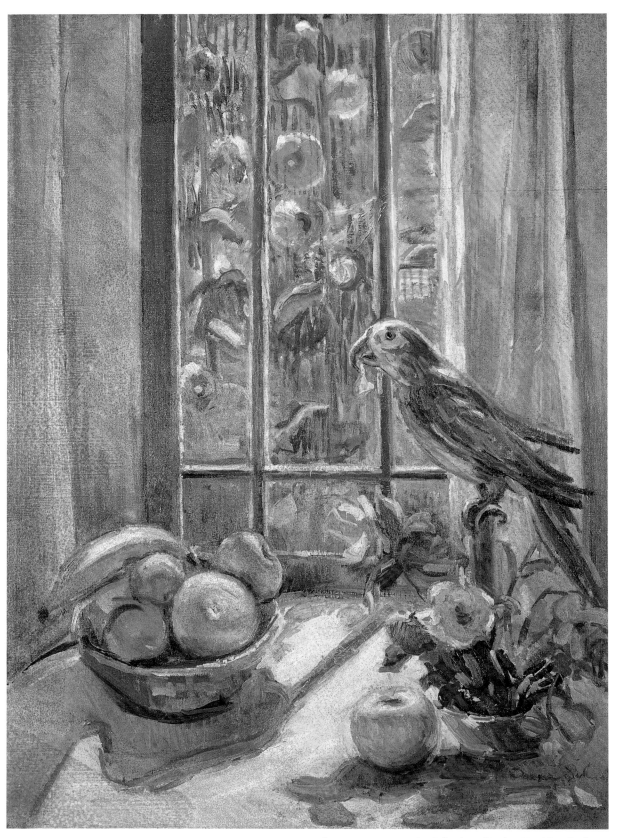

43 DONNA SCHUSTER c. 1921–24, oil on canvas, 36 × 28 in. Collection of Paul and Kathleen Bagley.
Morning Radiance

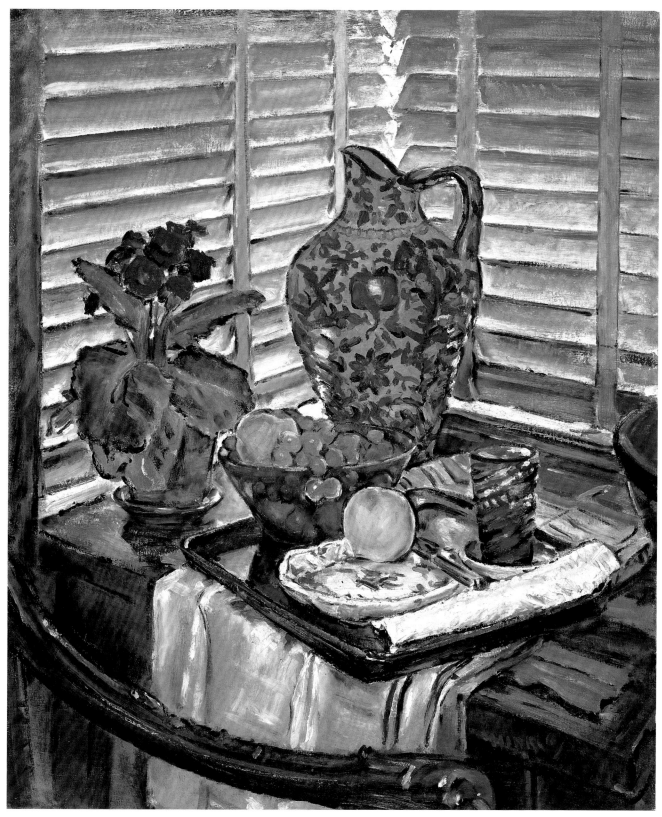

44 CLARENCE KEISER HINKLE c. 1930, oil on canvas, 36 × 30 in. Collection of Marcel Vinh and
Still Life Daniel Hansman. Photograph courtesy George Stern Fine Arts,
Los Angeles. Photographer: Casey Brown.

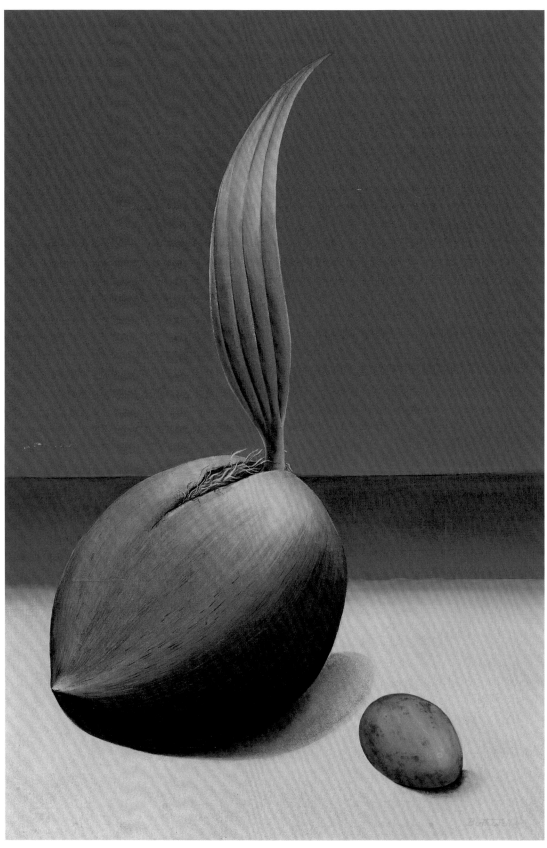

45 DORR BOTHWELL 1940, oil on canvas, 20 × 14 in. Collection of John A. Meyer.
Growth in Silence

patricia trenton

before the

world moved in

early modernist

still life in california,

1920–1950

AS CALIFORNIA ARTISTS began to embrace new ways of seeing in the late 1910s, still life seemed an ideal vehicle for the formal innovation and unconventional subjects that came to characterize modernism. This neglected, often unpretentious genre had the advantage of being less ideological than religious or history painting, and its boundaries could easily be stretched, as Cézanne had clearly demonstrated.

Adapting some of the stylistic modes of European modernism—Fauvism, Cubism, and Futurism as well as variants of Symbolism and Surrealism, Geometric and Biomorphic Abstraction—a few bold California artists experimented with new pictorial languages. Their experiments expanded the definition of American still life beyond realistic depictions of arranged objects to avant-garde formulations. During the first half of the twentieth century their imagery became more abstract, more subjective, and at times laden with symbolic meaning. In Southern California's "artistic desert" innovation took hold earlier than in the north, which remained more conservative until the late 1940s.[1]

Traditionally, a mastery of still life skills had been required before an artist was ready to work in the more complex, more elevated genres of religious or history painting.[2] San Francisco artist and teacher Otis Oldfield carried on this tradition, insisting that his beginning students in drawing and painting produce conventional still life studies. At the same time Oldfield, who had been exposed to Cézanne and European modernist movements during his years of study in France from 1911 to 1924, made his students aware of the tenets of modernism.

In the mid-1920s Oldfield developed his Color Zone theory to teach his students the "simultaneous contrast of color and the rapport of contrasted objects."[3] Inspired by the trends he had observed in Paris, including Cubism, Synchromism, Orphism, and Futurism, Oldfield demonstrated his theory with handmade blocks in many shapes and colors (fig. 46).[4] Using his method, students then composed paintings by laying distinct strokes or planes of pure color directly on the canvas in methodically constructed zones based on a "nucleus key tone." The goal was to retain the freshness and strength of unmixed color without concern for details of form.[5] But Parisian experiments with color as the primary element of painting had led to abstraction, whereas Oldfield's students' paintings, like his own, were representational, not abstract. Oldfield idolized Cézanne, and his still lifes of apples or oranges embody this reverence.

One of Oldfield's students was the talented young Chinese American Yun Gee, whose still lifes of 1926 and 1927 reflect the importance of color and rhythmic flow of forms. Yun Gee's *Skull* of 1926 (fig. 47), a small oil on paper, is a mimetically correct portrait of an actual skull from an archaeological dig—an untreated skull that was not cleaned, bleached, or wired together, its jaw still askew.[6] A photograph from the Oldfield Estate shows a still life setup with the same skull (see fig. 46).

Although *Skull* suggests the influence of Stanton Macdonald-Wright's Synchromist work, Yun Gee could not have seen Wright's work until 1927, when it was first exhibited at the California Palace of the Legion of Honor. And it is unlikely that he studied Wright's 1924 *Treatise on Color*, because his English skills at that time were limited.[7] The only plausible explanation for Gee's treatment of form lies in Oldfield's Color Zone theory. Yun Gee's remarkable creativity allowed him to take Oldfield's teaching method one step further to a high level of personal expression.

Yun Gee's small, semiabstract still life compositions are closely related to Synchromism and Orphism with their energetic surface of irregular arcing planes, shapes, and triangular facets. *Skull*, art historian Joyce Brodsky observes, "unites object and color into a dynamic vortex of rhythmic intensity that almost anticipates Picasso's skull studies of the 1940s. . . . This is no decorative synchromy but an evocation of radiant force . . . that bears comparison with the work of American painters like Arthur Dove or Georgia O'Keeffe."[8] While a student at the California School of Fine Arts, Gee established the Chinese Revolutionary Artists' Club in San

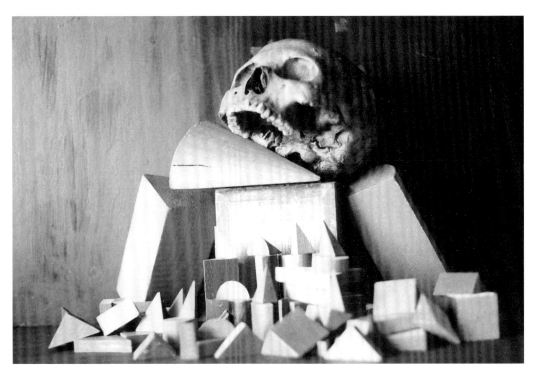

46 OTIS OLDFIELD © 2003 Estate of Otis Oldfield/Jayne Blatchly Trust,
 Skull and Color Blocks San Francisco/Artists Rights Society (ARS), New York.

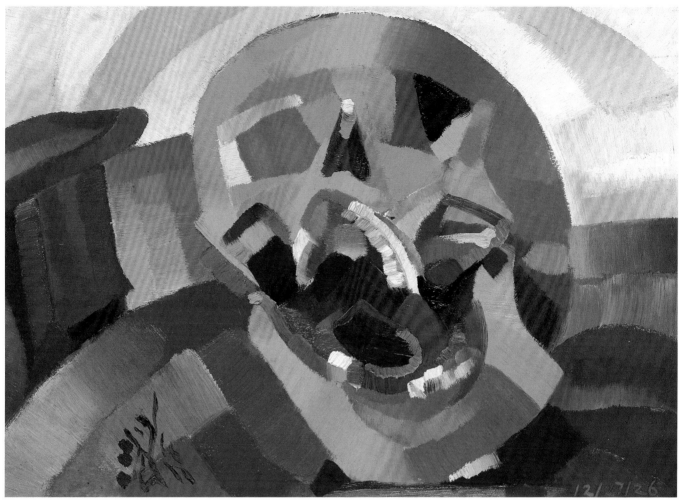

47 YUN GEE 1926, oil on paperboard mounted on wood, 11¼ × 15½ in. Collection of the Hirshhorn
 Skull Museum and Sculpture Garden, Smithsonian Institution, Washington, D.C., gift of Joseph
 H. Hirshhorn. Photographer: Lee Stalsworth.

Francisco's Chinatown, where he taught classes in advanced forms of Western art to other Chinese immigrants (fig. 48). The term "Revolutionary" has led several scholars to suggest that the club had a radical political agenda rather than a strictly cultural one.[9] Although San Francisco's restrictive conditions for Chinese immigrants could have motivated a political agenda, the club was in fact formed to create an awareness of current trends in art. Its aim, said Yun Gee, was "not to cultivate merely an art of compromise, nor a safe, middle-of-the-road art, but to create an art that is vital and alive that will contribute to the development of Chinese painting technique."[10]

Throughout the 1920s and early 1930s most San Francisco artists continued to embrace Impression-ism, Postimpressionism, and academic realism. The dominance of conservative styles was reflected in submissions to the San Francisco Art Association annuals, which typically featured just a sprinkling of modern works. The more progressive artists exhibited their work at small boutique galleries, such as the Paul Elder Gallery, Galerie Beaux Arts, and East West Gallery of Fine Arts. Private collections of modern art were occasionally shown in San Francisco during this period, but there was no bona fide venue for exhibiting modern art until the San Francisco Museum of Art (now the San Francisco Museum of Modern Art) was founded in 1935. In 1926, a group of younger progressive San Francisco artists, including Yun Gee, organized the cooperative Modern Gallery in the heart of the studio quarter on

48 Yun Gee and the Chinese
 Revolutionary Artists' Club

 1926. © 2003 Estate of Otis
 Oldfield/Jayne Blatchly Trust,
 San Francisco/Artists Rights
 Society (ARS), New York.

Montgomery Street. Although it enjoyed the support and encouragement of established modernists Gottardo Piazzoni, Ray Boynton, Ralph Stackpole, Lucien Labaudt, and Otis Oldfield, the overarching exhibition schedule proved too difficult to maintain, and the gallery was closed in January 1928.[11]

While San Franciscans were slow to accept the European modernist aesthetic, something radically different was taking place in the East Bay. In 1917, six open-minded plein air painters—William Clapp, Bernard von Eichman, Louis Siegriest, Selden Gile, August Gay, and Maurice Logan—banded together to form the Society of Six, a group that lasted almost fifteen years. They first exhibited together in 1923 at the Oakland Art Gallery, of which Clapp was curator and director for over thirty years, from 1918 to 1949. The gallery, today the Oakland Museum, became a "progressive oasis" for modern art in Northern California.[12]

In the early 1920s the work of the Society of Six began to take on a more Fauvist character, inspired by exhibitions of Impressionist and Postimpression-

ist paintings at San Francisco's Civic Auditorium in 1923 and the Inaugural Exposition of French Art at the Palace of the Legion of Honor in 1924–25. Selden Gile was among the group's artists whose work moved from Impressionism into a more intense world of color. In his still life *The Red Tablecloth* of 1927 (fig. 49), Gile also uses Cubist-inspired simultaneous points of view. Tilting the table with its striking red cloth forward, he forces the viewer to look down onto its surface and then to the scene directly outside the window, where the high horizon line carries the eye across a plane of water up to mountains. The picture recalls similar scenes as well as the stylistic approach found in Matisse's Fauvist work. In 1977 the art critic Arthur Bloomfield called Gile's work "a vital link between the brightly chiseled work of Matisse and the blocky, quasi-abstract canvases of the Bay Area's Figurative Painters of the 50s" such as David Park and Richard Diebenkorn.[13]

Unlike the close-knit art community of San Francisco, the Southern California art scene was

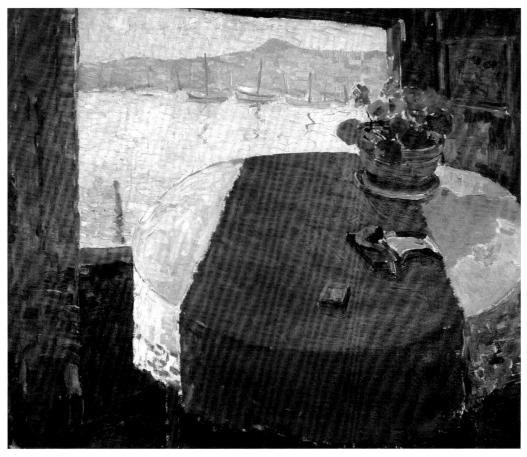

49 SELDEN GILE 1927, oil on canvas, 30 × 36 in. Private collection.
 The Red Tablecloth

characterized by openness and cultural isolation from competition—conditions that brought Stanton Macdonald-Wright back to Los Angeles in the fall of 1918.[14] As art students in Paris, he and painter Morgan Russell had explored a style they called Synchromism, which focused on the interaction and perception of colors. Inspired by Cézanne and the fascinations of Asian art, Macdonald-Wright tested and probed his new theory through the creation of still lifes that moved restlessly between abstraction and realism. Disgruntled by the indifference of the New York establishment to Synchromism, he sought acceptance of his ideas in California, where he became an eloquent spokesman for and critic on modernism.

Returning to Los Angeles at the onset of an economic boom, Macdonald-Wright quickly launched a number of teaching, lecturing, publishing, and promotional projects designed to promote European modernism and galvanize the Southern California art community. Among his most significant activities was the organization of exhibitions, notably the "American Modernists" show at the Los Angeles Museum of History, Science, and Art in 1920. Mounted with the aid of photographer Alfred Stieglitz, the exhibition exposed local viewers to works by a range of leading modern painters working in the United States, including Charles Demuth, Preston Dickinson, Arthur Dove, Marsden Hartley, John Marin, Henry Lee McFee, Man Ray, Charles Sheeler, and Macdonald-Wright—the sole Californian. After the show, reviews of modernist exhibitions became a regular feature in the Los Angeles press, and the public and the local art community were forced to react to them.

Nonetheless, Macdonald-Wright's success in promoting the avant-garde was limited. Eventually he began painting in a more traditional manner that retained mere vestiges of Synchromist color, fragmentation, and rhythm. *Untitled (Vase of Flowers)* (fig. 50), from about 1924–25, reflects his move away from pure Synchromism and abstraction. His

50 STANTON MACDONALD-WRIGHT
Untitled (Vase of Flowers)

1924–25, oil on canvas, 23 × 17 in. LAM/OCMA, Art Collection Trust, Museum purchase with funds provided through prior gift of Lois Outerbridge. Photograph courtesy of George Stern Fine Arts, Los Angeles.

other still lifes of the mid-1920s show the same blend of traditionally Western formal qualities with traces of Synchromism and quasi-Asian subject matter and line.

Macdonald-Wright's strongest influence was on a group of progressive artists, collectors, and enthusiasts, in large part through lectures and painting demonstrations at the Art Students League of Los Angeles and the Chouinard Art Institute in the 1920s, attended by students such as Mabel Alvarez and Edouard Vysekal. He inspired Donna Schuster to paint in a bolder manner and to focus on distorted forms and more intense colors, as her *Russet Pears and Gourds* (fig. 51) shows. By employing a formalism derived from Cézanne, she moved from Impressionism to Postimpressionism.

Most Southern California artists in the 1920s, like their counterparts in San Francisco, were either traditionalists or still influenced by Impressionism. The growth of modernism here in that decade was limited to a small circle that included Helena Dunlap, Ben Berlin, E. Roscoe Shrader, Peter Krasnow, Knud Merrild, Henrietta Shore, and Belle Baranceanu as well as Macdonald-Wright students Mabel Alvarez, Edouard Vysekal, and Nick Brigante.

Influenced by instructor Rex Slinkard at the Art Students League, Brigante's early interest in Chinese watercolors and philosophy had evolved into a more contemporary, abstract aesthetic. Although Brigante shared Macdonald-Wright's interest in Asian philosophy and art, he never fully embraced his teacher's extreme modernist aesthetic and technical color theories.

Attuned to European modern art movements, Brigante had exhibited in a 1923 show by a local modernist-focused collaborative, the Group of Independents. His work is notable for its highly personalized approach to the watercolor medium, in which luminosity, brilliance, and transparent depth are achieved through expert handling. His work of the 1920s and 1930s further reflects the influence of Cubist simplification of form and overlapping planes. The effect in *Prohibition Era* of 1932 (fig. 52) is created by layering transparent, cubistic facets of luminous color—a technique that gives these paintings spontaneity despite their precisely organized structure.

In the 1932 *American Mercury,* H. L. Mencken lampooned the government's policy prohibiting the sale of alcohol—a farce that spawned speakeasies and bootleggers across the nation—in "What Is Going On in the World," an article that describes the war between the "wets and the drys" and its effect on the 1932 presidential election.[15] Brigante

makes his own political statement in *Prohibition Era,* depicting some easily obtainable choices: bourbon, brandy, and grapes for making wine. Checkered tablecloths were ubiquitous in many speakeasies and private clubs of the Prohibition Era.

Canadian-born Henrietta Shore, an influential figure in progressive Los Angeles art circles since 1913, helped plan independent exhibitions beyond the conservative juried annuals of the California Art Club (in which she also exhibited). Shore established a local reputation for a colorful, expressionistic style, recalling the work of one of her teachers at the New York School of Art, Robert Henri of the Ash Can School, but in brighter tonalities influenced by California light. Always open to new opportunities and fresh stimuli, Shore returned to New York in 1920—undoubtedly prompted by the "American Modernists" exhibition. In search of a new idiom, she began producing radical, semiabstract still lifes with natural undertones, using line and shape to create rhythmic effects. While contour line figured in Shore's art even before her return to New York, the art historian Roger Aikin suggests that Shore was perhaps influenced by several radical modernists working there, including Georgia O'Keeffe, who had been transforming flowers and shells into monumental abstractions since 1915; Arthur Dove, who began to abstract plant forms even earlier; and the enthusiasts of Precisionism, a new art of hard edges and lines practiced by Charles Demuth and Charles Sheeler.[16]

In 1923 Shore and O'Keeffe exhibited back-to-back in New York, Shore at the Ehrich Gallery and O'Keeffe at the progressive Anderson Galleries. The titles of Shore's semiabstractions suggest organic themes, basic life forces, or cosmic landscapes. The two shows were reviewed together by critics who had only negative things to say about both the artists and their work. This criticism revealed gender bias in the stereotypical notion of a uniquely feminine sensibility: the paintings reflected "smothered passion" and "dark destiny or original sin."[17] Critics saw projections of feminine sexuality in the work rather than the ambitious metaphysical themes both artists intended to express.

Shore returned to Los Angeles in July 1923 with an established East Coast reputation and was well received by artists, critics, and friends. An introduction to photographer Edward Weston there on February 14, 1927, marked the start of a lifetime friendship, exchange of ideas, and mutual admiration. Taken with Shore's drawings of rocks and shells from her personal collection, Weston was inspired to photograph these objects. The resulting

51 DONNA SCHUSTER c. 1930, oil on canvas, 28 × 30 in. Collection of James
 Russet Pears and Gourds and Janet Murphy. Christopher Bliss Photography.

52 NICHOLAS BRIGANTE
Prohibition Era

1932, watercolor on paper,
20 × 15 in. Private collection.
Photograph courtesy of Tobey
C. Moss Gallery, Los Angeles.
McClaine Photography.

photographs marked a turning point in his career and in the history of photography as well.[18] Weston coveted Shore's *Cactus* of about 1926–27 (fig. 53), the sturdy shape of the monumental plant echoing the painter's heavyset physique and its prickly skin seeming to represent her personality.[19]

Weston's glowing account of a trip he had made to Mexico in 1926 inspired Shore to travel there with her studio mate, artist Helena Dunlap, in August 1927. A temporary breach between the two women in Mexico City gave Shore the freedom to pursue her art alone. In a letter to Weston dated October 15, 1927, she exulted, "To-day I worked on a drawing—

in paint,—which is as good as any I have done. You know those wonderful white flowers like great bells—I think they call them Floripronteos [*sic*]. Well, I found the most marvellous black gourd—the most elemental thing in shape and form—from this strange gourd the flowers are eagerly soaring—as eagerly as ever a sea gull flew against the sky." *Floripondios* (fig. 54) shows the change in Shore's style after her sojourn in New York.[20] In this painting, as in her other nature studies of the period, organic shapes have been simplified, flattened, and made more decorative and stylized by rhythmic, expressive contour lines.

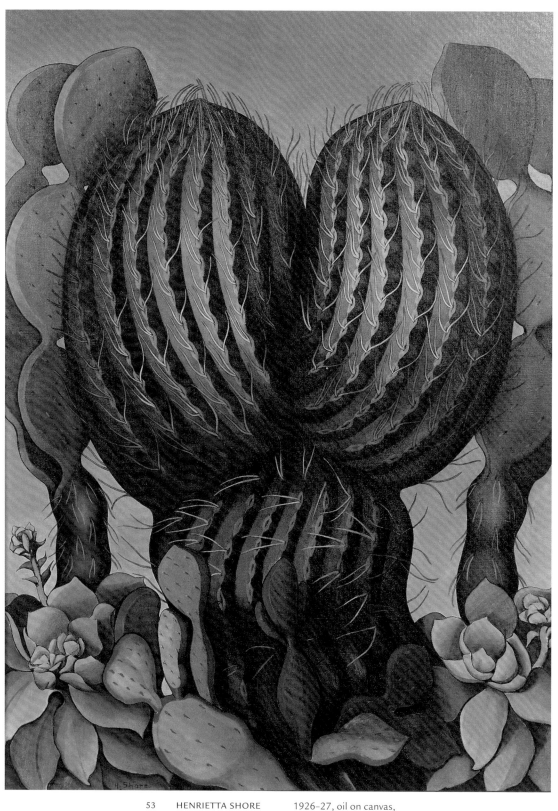

53 HENRIETTA SHORE 1926–27, oil on canvas,
Cactus 38 × 28 in. Private collection.

Weston and Shore's close friendship and creative collaboration continued after both moved to Carmel in the 1930s. Weston observed that Shore's art had become more closely identified with nature, incorporating its underlying rhythms and forces and free of nonessentials. "Shore now realizes a fusion of her own ego with a deep universality. . . . When she paints a flower she IS that flower, when she draws a rock she IS that rock."[21] In *Gloxinia by the Sea* of about 1930 (fig. 55), a budding and flowering plant, symbol of femininity, is placed against the void of an empty sky or sea. The image makes one wonder whether Shore felt isolated because of her sexual preference for women.[22]

Belle Baranceanu, an early member of the modernist movement in San Diego, is known primarily as a figurative and landscape painter. During a visit to Los Angeles in 1927–28, Chicago-born Baranceanu found the quaint boxlike houses, shrubbery, and winding roads in the Hollywood Hills above Los Angeles more appealing than the urban milieu. Many of her late 1920s paintings feature a dizzying, elevated perspective that suggests the congestion and growth of the Southern California suburbs.

Baranceanu's few but intriguing still lifes—notably *Still Life with Blue Saucer* of 1928–29 (fig. 56), with its multiple perspectives, overlapping volumetric shapes, flattened planes, angular contours, and objects in disarray—reflect the turmoil she was experiencing over her relationship with her teacher, Anthony Angarola, and her resentment of her father's efforts to block their marriage. Cultural historian

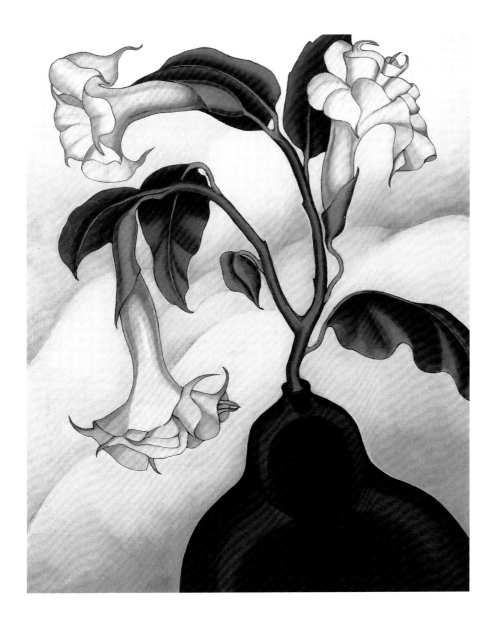

54 HENRIETTA SHORE
Floripondios

1927, oil on canvas, 24 × 20⅛ in. The Buck Collection, Laguna Beach, Calif. Christopher Bliss Photography.

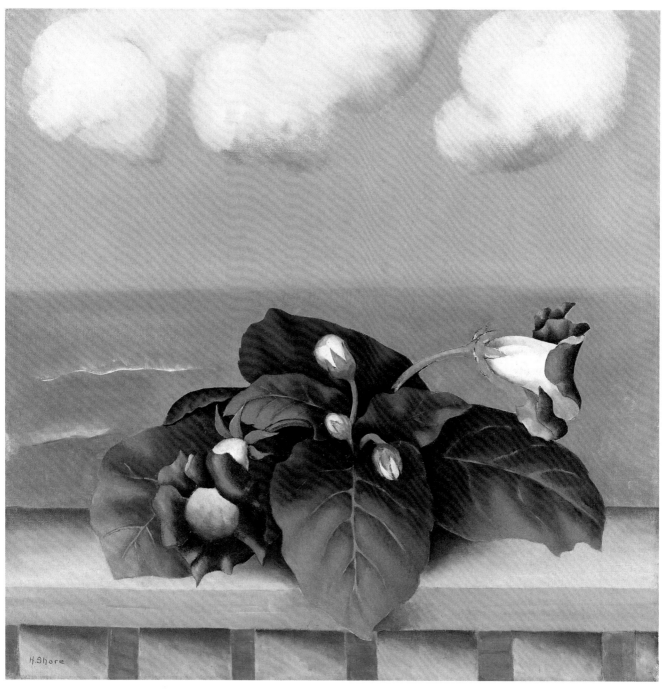

55 HENRIETTA SHORE c. 1930, oil on canvas, 26 × 26 in. Private collection. Photograph
Gloxinia by the Sea courtesy William A. Karges Fine Art, Los Angeles and Carmel, Calif.

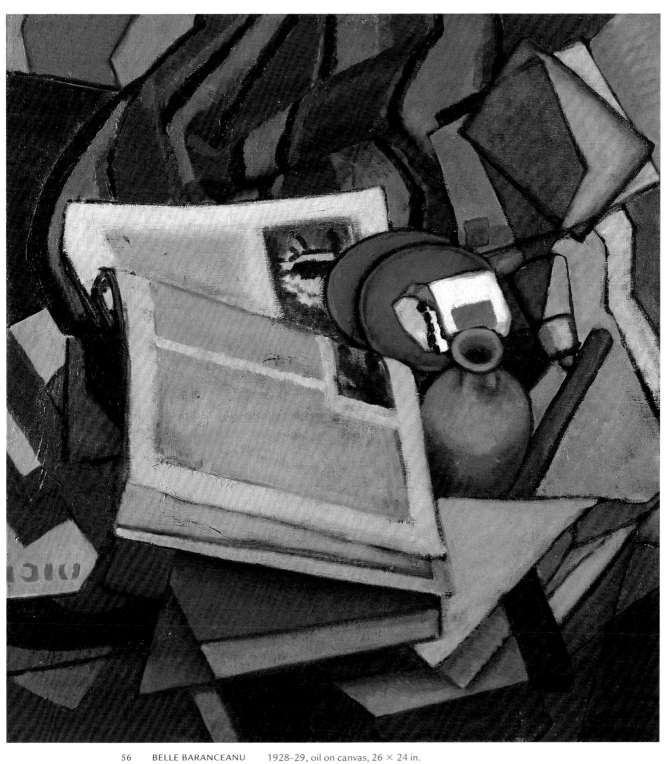

56 BELLE BARANCEANU 1928–29, oil on canvas, 26 × 24 in.
Still Life with Blue Saucer Collection of Bram and Sandra Dijkstra.

Bram Dijkstra observes that despite her ease with abstract forms, Baranceanu's "love for essential shapes of nature made her turn away from complete abstraction."[23]

With the stock market crash in 1929, California's economic boom abruptly ended. The severe downturn in the economy cut across all employment sectors, including the arts. With some reluctance, many artists turned for relief to the Roosevelt administration's New Deal projects, producing easel paintings for public exhibitions sponsored by the various federal art projects and accepting commissions to decorate public spaces with murals and sculpture. Since the federal government discouraged abstraction in public places, the subjects of these works were predominantly scenes of contemporary American life or events in American history. As a result, the advances of the 1920s toward a modern aesthetic were set aside. Still life, one of modernism's key genres, was relegated to a secondary position.

In January 1934 several figures in the Bay Area known in part for their modernist still lifes received commissions from the Public Works of Art Project to decorate the interior walls of San Francisco's landmark Coit Memorial Tower. One of these artists, Rinaldo Cuneo, a native San Franciscan of Italian heritage, had been in the vanguard of modernism in the Bay Area. Critic Louise Taber wrote in *The Wasp*, "No matter where one may find his canvases, one is bound to pause, for they hold something distinctive, and . . . unfailingly have strength. The work is modern in style, but not modern in a craze for originality or an ugliness that attracts by repelling."[24]

Although Cuneo was predominantly a landscapist, he painted a number of still lifes. *Candle, Garlic, and Apples* of about 1934 (fig. 57) shows the influence of Cézanne and Cubism in its simultaneous perspectives and tilted tabletop. The artist uses drapery to establish space and depth and to create the illusion that the viewer is looking across and down at the table. Like Cézanne, Cuneo uses color to create his simplified, abstracted forms. *San Francisco Chronicle* critic Alfred Frankenstein said that Cuneo "could do more with an apple and a white cloth than anyone in the painting business after Cézanne."[25] With its smooth finish and invisible brushwork, this painting also anticipates the Neo-Realist work of the 1990s.

Parisian-born Jane Berlandina also worked on Coit Tower—a building designed by her architect husband, Henry Howard. Educated at L'Ecole Nationale des Arts Décoratifs after World War I, Berlandina studied privately with Raoul Dufy, whose influence is apparent in the "cursive shorthand of little strokes" that suggest rather than describe her subjects.[26] The decorative vein and delicate touch of her teacher are seen in her untitled floral *Still Life* of 1935 (fig. 58). Writing in the *Argonaut*, artist Glenn Wessels characterized Berlandina paintings such as this one as being "in the true lyric spirit. Their drawing is a bold and flexible arabesque, which goes its own way and lives its own life. There is an almost acrobatic dexterity reminiscent of her master Dufy, and a straightforward expression familiar in Matisse."[27]

During the same period, Japanese-born Miki Hayakawa's Cézanne-inspired landscapes, portraits, and still lifes were widely exhibited in the Bay Area. In a still life of about 1935, *Open Window* (View of Coit Tower) (fig. 59), she captured a distant view of Coit Tower from her window; the image is deliberately constructed to draw the viewer's eye up and beyond the flower arrangement in the foreground to the tower on Telegraph Hill. Hayakawa became an artist over the strenuous objections of her father and left home to pursue her art education. She won scholarships to the California College of Arts and Crafts in Oakland and later to the California School of Fine Arts (now San Francisco Art Institute), supporting herself with odd jobs. Hayakawa was actively involved in the art community, not only as a frequent exhibitor but also as a member of the San Francisco Art Association and the San Francisco Society of Women Artists.[28] In 1942 Hayakawa became a victim of war hysteria. She was separated from her family and sent to the Santa Fe War Relocation Center, and later released on her own recognizance. Hayakawa remained in Santa Fe for the rest of her life, where she was warmly accepted into the local artist community.

In the 1930s, many American intellectuals as well as artists, yearning for simpler lifestyles, were attracted to the art and culture of neighboring Mexico. Muralist Alfredo Ramos Martínez, in his homeland a painter of nostalgic scenes of a native paradise, gained immediate popularity among California collectors following his arrival in Los Angeles in 1929. There, some of his paintings took on an expressive vigor as he explored new concepts and assimilated some of the structural methods of the avant-garde.

Martínez produced a significant number of still lifes whose motifs were defined by restrained ornamental line over backgrounds of Cubist planes. *Alcatraces (Calla Lilies)* of about 1930 (fig. 60) is an example of this style. The tightly constructed vertical arrangement of calla lilies against the vivid, faceted background takes on the formal attitude seen in his figural works as well. Flowers were a

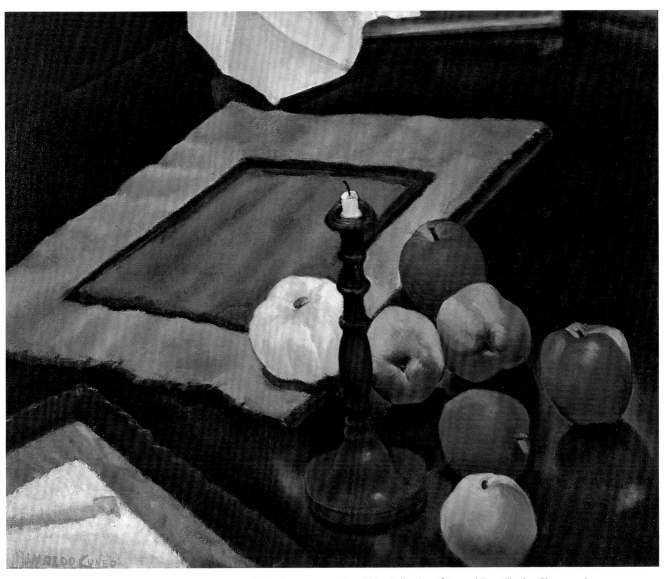

57 RINALDO CUNEO c. 1934, oil on canvas, 30 × 36 in. Collection of Les and Zora Charles. Photograph
 Candle, Garlic, and Apples courtesy of William A. Karges Fine Art, Los Angeles and Carmel, Calif.

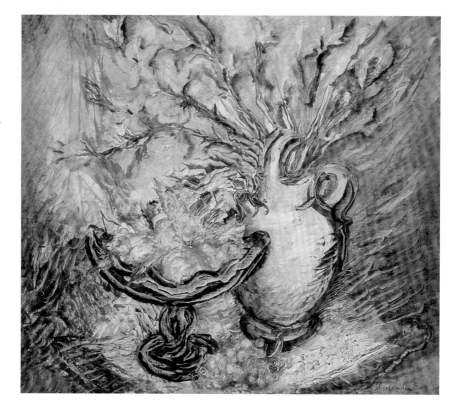

58 JANE BERLANDINA
Still Life

1935, oil on canvas,
30 × 34 in. Collec-
tion of Oakland
Museum of Califor-
nia, gift of Dr. and
Mrs. James Meier.
Photographer:
M. Lee Fatherree.

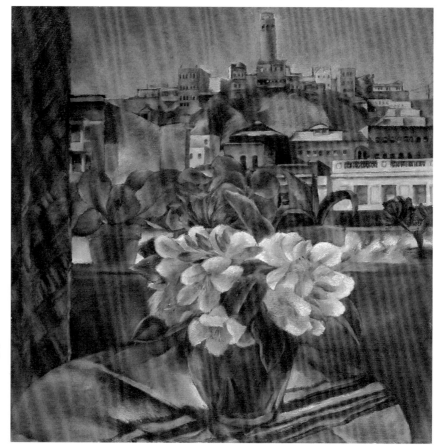

59 MIKI HAYAKAWA
Open Window
(View of Coit Tower)

c. 1935, oil on canvas,
28 × 28 in. Collection
of Bram and Sandra
Dijkstra.

central motif in both his still lifes and his nostalgic indigenous pastorales.

A different perspective on still life is seen in the work of Danish artist Ejnar Hansen, who moved to Pasadena in 1925. Educated at the Royal Academy of Fine Arts in Copenhagen, Hansen was a member of Denmark's Secessionist group De Tretten (The Thirteen), which endorsed modernist art and was aware of avant-garde developments in Germany and France. Initially, Hansen's art was expressionistic, moody, and tonally dark. After moving to Southern California, his palette changed completely and his work became richer in color and texture. Hansen painted many still lifes in a realist vein that incorporated modern tenets. *Artist Table* of 1934 (fig. 61), an intimate view of Hansen's studio, offers an insight into the artist's method. At this time, he was interested in depicting structural forms through modeling and in achieving depth through the diagonal placement of rectangular forms. In this Cézannesque composition the prominently placed T-square directs the viewer's eye into the picture.

Despite the partial eclipse of modernism in the 1930s, not all California modernists completely abandoned their personal aesthetics. The depression turned some artists inward to explore psychological and metaphysical phenomena. Southern California modernists such as Henrietta Shore, Ben Berlin, and Knud Merrild had worked in a subjective mode in the 1920s, but the most compelling manifestation of this direction in California was Postsurrealism. Conceived by artists Lorser Feitelson and his wife and former student, Helen Lundeberg, Postsurrealism was a response to European Surrealism. It shared Surrealism's interest in the metaphysical but rejected the arbitrary nature of its dreamlike, irrational images, focusing instead on structure, order, and rationality.[29] By applying the principle of association, seemingly random arrangements of unrelated objects were brought together in ways that suggest meaning through their juxtaposition.

The Postsurrealist movement was officially launched in November 1934 when a loose association of artists with similar aims banded together to exhibit their work at Hollywood's Centaur Gallery. In addition to Feitelson and Lundeberg, the group eventually included Grace Clements, Philip Guston, Reuben Kadish, Harold Lehman, Lucien Labaudt, Knud Merrild, Helen Klokke, and Etienne Ret. A show at the Stanley Rose Bookshop on Hollywood Boulevard followed, in May 1935, and the group made their Northern California debut later that year at the San Francisco Museum of Art. This exhibition traveled to the Brooklyn Museum in

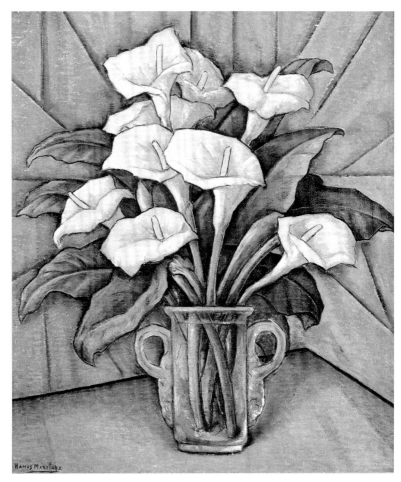

60 **ALFREDO RAMOS MARTÍNEZ**
Alcatraces (Calla Lilies)

c. 1930, oil on canvas, 32¼ × 27¾ in. Collection of Mimi Rogers. Photograph courtesy of Louis Stern Fine Arts, Los Angeles.

April 1936, predating by several months the Museum of Modern Art's landmark 1936 exhibition "Fantastic Art, Dada, Surrealism" and substantially affecting the New York avant-garde.[30]

Feitelson and Lundeberg's manifesto on the new movement, which they called "Subjective Classicism" or "New Classicism," was issued in 1934. Although this new movement was soon termed Postsurrealism,[31] it was primarily a personal and self-referential art, and the pair believed its symbols were universal. Art historian Mitchell Douglas Kahan points out that Feitelson and Lundeberg reflected the "general American tendency" to create

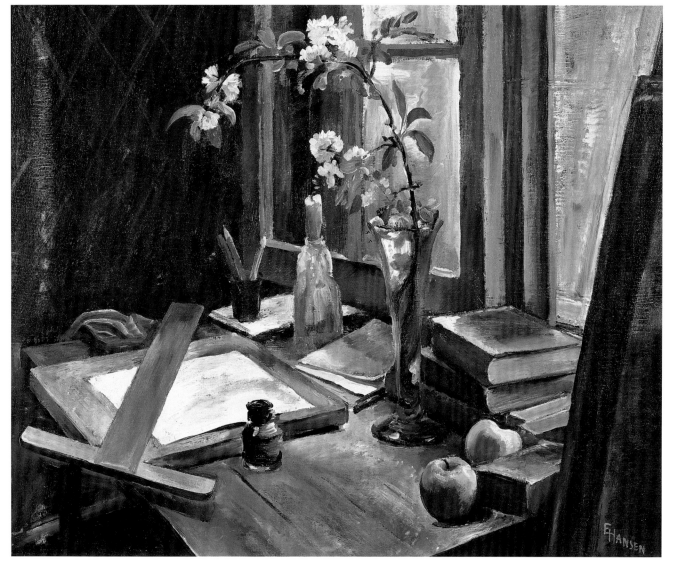

61 EJNAR HANSEN 1934, oil on canvas, 25 × 30 in. Collection of Robert
 Artist Table and Susan Ehrlich. Christopher Bliss Photography.

meaning and structure, "even as they moved away from objectivity."[32]

Feitelson had been attracted to Southern California by its unstructured environment in 1927. He described the Los Angeles area as an "artistic desert" that was "beautiful" and "so easy-going."[33] Despite his active schedule as a teacher, lecturer, gallery owner, and director of Southern California's Federal Art Project mural division, he nonetheless found time to develop his Postsurrealist imagery.[34]

Feitelson had been exposed to the world of art by his father, who had an extensive library of art books and periodicals. Museums, galleries, and a coterie of artists fueled the young man's interest in art. First-hand contact with American modernism in New York in the 1910s and European modernism in Paris in the 1920s gave him the professional sophistication he later drew from in teaching a younger generation of painters at Pasadena's Stickney Memorial School of Art. Philip Guston recalls that Feitelson introduced him to the Renaissance masters and took him with other students to the important modern art collection of Walter and Louise Arensberg in their Hillside Avenue home in Hollywood.[35]

In the late 1920s Feitelson began exploring what he called the "dynamics of directional suggestion"

in his Neoclassical "Peasant Series," which treated themes of a timeless and universal nature. Using the gaze of a painting's subject to direct the sequence in which a viewer perceives the objects in his compositions, the artist controls perception of the picture's content. For example, a face looking in a certain direction exerts a psychological thrust "totally distinct from the value of that face as a formal element." This psychological device, adapted from Italian High Renaissance painting, was a key factor in the development of Postsurrealism.[36]

For Feitelson, the goal of Postsurrealism was to create a unity of form and content through associative sequences that sparked a process of interaction by which the viewer experienced the picture intellectually, emotionally, and aesthetically. His overriding theme was the cycle of life. In his still life tableau *Genesis, First Version* of 1934 (see fig. 4), the viewer is led by a precise arrangement of individual forms—the sun, egg, avocado, and female torso—to contemplate the interrelationships between cosmic, plant, animal, and human sources of life and to perceive human fertility as one of several connected life processes. In *Genesis #2* of the same year (fig. 62), Feitelson again focuses on female fecundity, but the system of symbols is more enigmatic and complex. Feitelson said his goal here was to "stimulate a deep emotional response through the use of forms, the arrangements of which are comprehended intellectually." Art historian Diane Moran offers an interpretation of the picture's meaning:

Egg shell, conch, and melon are overtly female sexual forms. The meaning of the pendent light bulb remains somewhat ambiguous until the viewer's eye travels . . . through the cosmic illumination in the darkened sky to a traditional image of the Annunciatory Virgin, shown at the moment of miraculous conception. . . . On the right, the eye encounters the diagrammatic line rendering of a female figure which echoes in silhouette the Annunciate Virgin. . . . In the diagrammatic rendering, the breast of the conceptualized mother grows successively fuller to nourish the nursing child, presented as one of a set of masks symbolizing stages of life from birth to death. The process of life . . . is suggested by the telescope which penetrates the eyes of the masks and focuses on the cosmos.[37]

Genesis and the cycle of life were also primary themes in the work of Helen Lundeberg. While a self-referential element dominates all of her paintings, the gaze of her subjects, like those of Feitelson, directs attention to the psychological relationships in her pictures. *The Mountain*, a proto-Postsurrealist painting of 1933, exemplifies this tendency.[38]

Subjectivity, mystery, and classical order played key roles in many of Lundeberg's paintings. At first glance, *The Red Planet* of 1934 (fig. 63) looks like a simple yet somehow mysterious interior still life of a table and books. On careful observation, other relationships begin to emerge, aided by visual clues that help solve the mystery. One of the books is titled "Mars," revealing the identity of the title's planet. An image of a comet, painted to resemble a photographic plate, alludes to the presence of a cosmic space. The elliptical tabletop, rather than a simple flat surface supporting a red marble, is a metaphor for the path of the red planet's orbit. Moran observes that the doorknob becomes "the source of a cosmic light which casts long shadows from the table legs and stacked books. . . . What was first perceived as a solid door magically becomes infinite space, enigmatic in its evocation of multiple levels of reality."[39]

Most artists associated with the Postsurrealist movement represented different aesthetic orientations. Parisian-born Lucien Labaudt, an early San Francisco modernist influenced by the French Cubist André L'Hôte, made his reputation as a couturier, painter, color theorist, and teacher. He and Feitelson met in 1929, and ensuing discussion between the two probably centered on Feitelson's ideas for a new art form.

Labaudt was introduced to Surrealism in 1934, when San Francisco art dealer Howard Putzel curated a show of works by Miró at the East West Gallery. (He later arranged one-man exhibitions for Dali and Max Ernst at the Paul Elder Gallery in 1934.)[40] Imaginative and creative, Labaudt was clearly influenced by what he saw and began to construct figurative still life images that one writer, anticipating the assemblages of the Beats, described as a "poetry of objects."[41]

In 1935 Labaudt created the signature paintings that made his work the Northern California counterpart of Postsurrealism. He brought his own idiomatic pictorial language to the movement, one of romantic allusion and chimerical fantasy that grew out of his penchant for fashion and stage design. Art historian Jeffrey Wechsler describes Labaudt's imagery as "assiduously compiled arrays of objects heaped together in such a manner as to build up a human form—a kind of figurative still life."[42]

Labaudt's *Shampoo at Moss Beach* of 1935 (fig. 64) was first shown in the landmark Surrealist

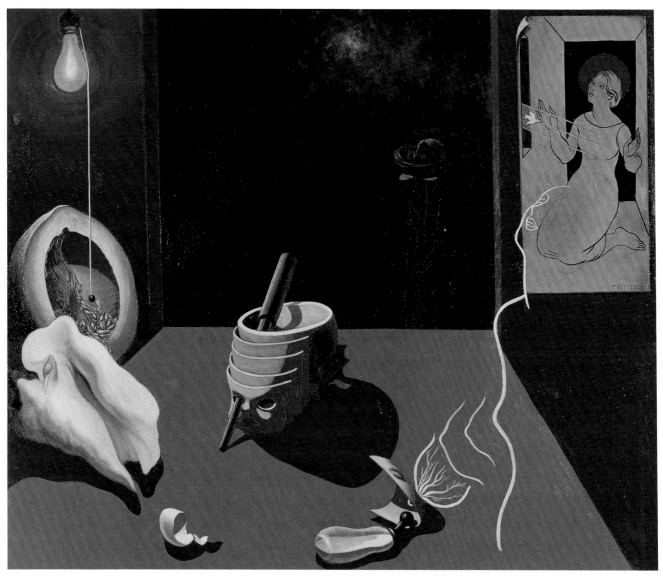

62 LORSER FEITELSON
Genesis #2

1934, oil on Masonite, 40 × 48 in.
Smithsonian American Art Museum,
Museum purchase. Photograph
courtesy of Tobey C. Moss Gallery,
Los Angeles.

63 HELEN LUNDEBERG
The Red Planet

1934, oil on celotex, 30 × 24 in.
Collection of Roselyne Chroman
Swig. Photograph courtesy of
Tobey C. Moss Gallery, Los Angeles.

exhibitions at the San Francisco Museum of Art and the Brooklyn Museum during 1935 and 1936.[43] In this and similar paintings Labaudt builds up a humanoid form with assorted objects; here a fringed shawl turns a bent masculine leg into a horse's head, and jar lids serve as breasts. Wechsler calls the work a figurative still life in which the objects "clambering about each other" eventually resolve into a seated figure.[44] Arguably, Labaudt, who was preoccupied with the mutations of objects, composed his figures in a manner similar to those of Surrealist André Masson.[45]

The fusion of visual reality with the metaphysical in *Shampoo at Moss Beach* also recalls Giorgio de Chirico's ensembles of still life elements, architectural forms, and fragments from antiquity. The

theme of Labaudt's disjunctive composition is established by the prominently placed plaster cast of Venus de Milo and the multiple images alluding to womanhood, femininity, sensuality, vanity (the transience of female beauty), and love. A small still life on a radio table holds cosmetics for a woman's personal adornment. Beyond the draped curtain in the distance are two pairs of "dream lovers." One couple walks toward the palace of playing cards; the other moves away over the clouds. The cards seem to imply chance—fortune in love—or the transient nature of cities; the skeletonlike wooden armature may suggest mortality, the cycle of life and death—themes similar to those of Feitelson and Lundeberg.

Introspection also characterizes the paintings of Agnes Pelton, who moved from the East Coast to the small desert community of Cathedral City, near Palm Springs, in 1932. There for the next fifteen years she painted her abstract, mystical visions— filling her still lifes with assemblages of objects that reflect her fascination with deep reflection, dreams, and spirituality. Like the abstractions of Arthur Dove and Georgia O'Keeffe, Pelton's mystical canvases evolved from a nature-oriented art with non-sacred associations.

Pelton kept a diary that reveals her familiarity with religious and philosophical literature, the sciences, and metaphysical writings on the stars and the universe. In the habit of painting outdoors in the soft light of early morning before sunrise or at twilight, Pelton recorded in forms and colors the reflections a poet might capture in lines of verse.

In *Even Song* of 1934 (fig. 65), Pelton's luminescent blues and yellows melt into deeper hues, and her joyous flowing lines suggest the ethereal stuff of dreams. Water flows from the womblike vase, symbolizing birth, as the planet Venus glows above.[46] Pelton wrote an "introduction" to this painting in "Even Song," a poem in her diary of 1934:

> *The evening stars glow softly down*
> *Above a flowing urn*
> *Days overflow that disappears*
> *Within the sunsets turning*
> *A tear, a pearl*
> *A flower white*
> *A memory, upon the night*
> *Within the urn*
> *The fires are banked,*
> *Conserved and glowing*
> *While underground the deep streams flow*
> *Endlessly renewing.*[47]

64 LUCIEN LABAUDT
Shampoo at Moss Beach

1935, oil on board, 60¾ × 48½ in. Collection of the City and County of San Francisco, gift of Marcelle Labaudt. Douglas Sandberg Photography.

65 AGNES PELTON
Even Song

1934, oil on canvas,
36 × 22 in. Collection
of Margaret and
Leighanne Stainer and
Chauncey Bateman.
Douglas Sandberg
Photography.

In *Memory* of 1937 (see fig. 3), flowerlike forms and graceful lines emerge from a frosted white vase above flowing waters to convey the same cosmic imagery. Pelton said that abstract paintings "should be a new experience in seeing without reference to what has been familiar in the past. They communicate to us through color, as music does through sound. These paintings are seldom presentations of forms in Nature—except in a symbolic sense; they are impressions of inner visual experiences."[48]

With the onset of war in Europe in September 1939, the U.S. economy began to recover rapidly. California's defense industries soon expanded employment opportunities for many migrant workers, bringing several million people to the West Coast. Declaration of war by the United States in December 1941 sparked patriotic fervor throughout the country. As New Deal programs were phased out, many artists shifted their energies and sympathies to supporting the war effort by expressing their reactions to the sources and results of the conflict. Two Surrealist works from 1940 by painter Dorr Bothwell record her sense of impending doom at the rise of Nazism. In the first, *Invasion* (fig. 66), a hybrid still life that borders on landscape, Bothwell tests the boundaries of the genre with a stilled jack-knifed march of red hands casting extended shadows that reach out to grasp minuscule, terrified figures.[49] It is a graphic recollection of her gripping experience during a visit to Berlin in November 1930, when she encountered "a group of twelve brown-shirted men" walking down a street. While some people backed away, others shouted "Sieg heil!" The next day, revisiting a bookstore, she found broken windows "and *Jude* written all over the store front."[50]

In Bothwell's *Isolationist* (fig. 67), the searchlight beam of the distant lighthouse and the large ear in the middle ground refer to vigilance and protection, while the armadillo with its thick horny armor, facing away from the beam and the ear, is undoubtedly a reference to American isolationism before the country entered the war. The deep space, architectural framing, and shadow pattern suggest the metaphysical paintings of de Chirico. Although Bothwell rejected the Surrealist designation, both *Invasion* and *Isolationist* approach orthodox Surrealism.

Bothwell painted another Surrealist work, *Growth in Silence* (see fig. 45), in 1940, drawing on two earlier years of contemplation spent on a remote island in Samoa. The painting's epigrammatic symbols— the monumental coconut with its cleavage, sprouting a phallic shoot—may suggest generative power and represent the artist's sexual awakening. The sexual imagery was possibly unconscious, since none of her work contains nudity or explicit sexual content. Bothwell's friend Marlys Mayfield noted that Dorr struggled with sexual repression, and much later the artist told Mayfield that one of her paintings—perhaps *Growth in Silence*—showed her overcoming "the bondage of the biological."[51]

Another still life that makes a forceful political statement about the war is Sueo Serisawa's *Nine O'Clock News* of 1939 (fig. 68). Serisawa, a Los Angeles painter and a Japanese American, uses symbols to comment on the events that started the European war: the invasion of Poland by the Germans and the deaths of thousands.[52] *Long Beach News* headlines, partly obliterated, report the horror of the event, and the clock points to nine, the hour the news of the invasion was broadcast. The image of Christ carrying the cross refers to Catholicism, the dominant religion in Poland. The three apples represent the Axis powers, Germany, Italy, and Japan.

On Sunday, December 7, 1941, as Japanese planes dropped bombs on Pearl Harbor, Serisawa was being honored by the Los Angeles County Museum as its artist-of-the-month with an exhibition of his paintings. In 1950 *Los Angeles Times* critic Arthur Millier recalled that the artist was the subject of his lead review that day. Just two months after Pearl Harbor, in February 1942, everyone of Japanese ancestry on the Pacific Coast faced the threat of mass evacuation and forced internment. Serisawa and his wife decided to move inland and left immediately for Denver. After living briefly in Colorado Springs and Chicago, they settled in New York City. In 1947 they returned to Southern California, where Serisawa resumed his career.

With the rapid rise of Fascism in Europe in the 1930s and its repressive practices, a significant number of distinguished émigrés came to America, including painters, sculptors, musicians, and filmmakers. Most of them settled in the large cities, especially New York, Chicago, Los Angeles, and in San Francisco's Bay Area. San Francisco Museum of Art director Grace McCann Morley organized several important exhibitions of experimental contemporary art by noted émigré painters "to keep San Francisco 'close to the growing edge of creative art.'"[53] These shows and the national annuals at the California Palace of the Legion of Honor kept San Francisco on the vanguard of contemporary art and helped it evolve from a regional to a national center.

Another vital art center during this period was Mills College, under chairman and artist William Gaw. Gaw also taught classes in drawing and still

66 **DORR BOTHWELL**
Invasion

1940, oil on Masonite, 24 × 20 in.
Archives of American Art, Smith-
sonian Institution, Washington,
D.C. Reproduced with permission
of the Estate of Dorr Bothwell.
Photographer: John Sullivan, Hun-
tington Library, San Marino, Calif.

67 **DORR BOTHWELL**
Isolationist

1940, oil on canvas, 40 × 30 in.
Archives of American Art, Smith-
sonian Institution, Washington,
D.C. Reproduced with permission
of the Estate of Dorr Bothwell.
Photographer: John Sullivan, Hun-
tington Library, San Marino, Calif.

68 SUEO SERISAWA, 1939, oil on canvas, 30 × 40 in. McClelland Collection.
 Nine O'Clock News

life painting at the California School of Fine Arts in San Francisco from the late 1930s through the war years. As chairman of Mills's art department in 1940 he was largely responsible for bringing distinguished East Coast American artists and well-known European émigrés—among them Yasuo Kuniyoshi, Reginald Marsh, Fernand Léger, and Max Beckmann—as guest instructors during summer sessions. Gaw with his colleague at Mills Alfred Neumeyer pioneered experimental modernist art programs.[54]

In his own work, Gaw experimented with a variety of styles, including Impressionism, Cubism, and Surrealism. His still lifes of lush, vibrant fruits and vegetables and sculptural drapery paid special homage to Cézanne. An example of his Cubist explorations is *Arrangement* of 1947 (fig. 69), a still life before an open window in the pastel colors of Matisse's late work. The painting resembles some of Picasso's collages in its overlapping forms and skewed perspective; it also recalls Picasso's use of the skull as a metaphor for the horrors of war and the transience of life.

Like Gaw, Helen Clark Oldfield turned to Cubism late in her career, in the late 1930s and early 1940s. An artist and teacher who had always been in the shadow of her famous husband, Otis Oldfield, she began to shift from Regionalism, or "Oldfieldism," in the late 1930s to experiment with the ideas of Gris, Braque, and Picasso. *Brown Bowl* of 1937 (fig. 70), with its tilted perspective and overlapping forms, recalls the structure of Juan Gris's *La guitare sur la table*. Here, Helen Oldfield employs everyday kitchen objects—a Mexican pottery herb grinder, a pestle with glazed handle, and a triangular bottle of salad dressing—in a composition reminiscent of the "theme" still life setups her husband arranged for his studio classes.[55]

As the appeal of conservative art began to wane in the 1940s and the trend toward modernism accelerated, a rebellion that surfaced against the new styles affected still life painting as well as other genres. Recognizing the loss of support for their work, Southern California conservatives fought back in 1940 with the formation of the Los Angeles branch of the Society for Sanity in Art. The group,

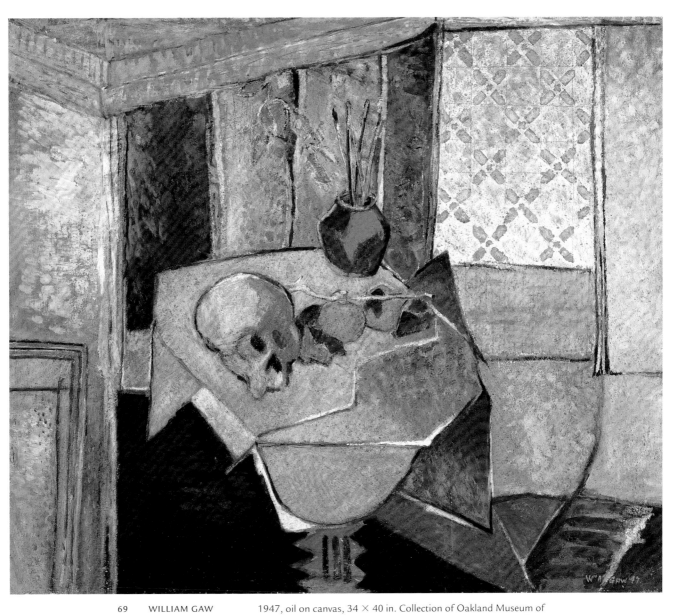

69 WILLIAM GAW 1947, oil on canvas, 34 × 40 in. Collection of Oakland Museum of
 Arrangement California, gift of anonymous donor. Photographer: M. Lee Fatherree.

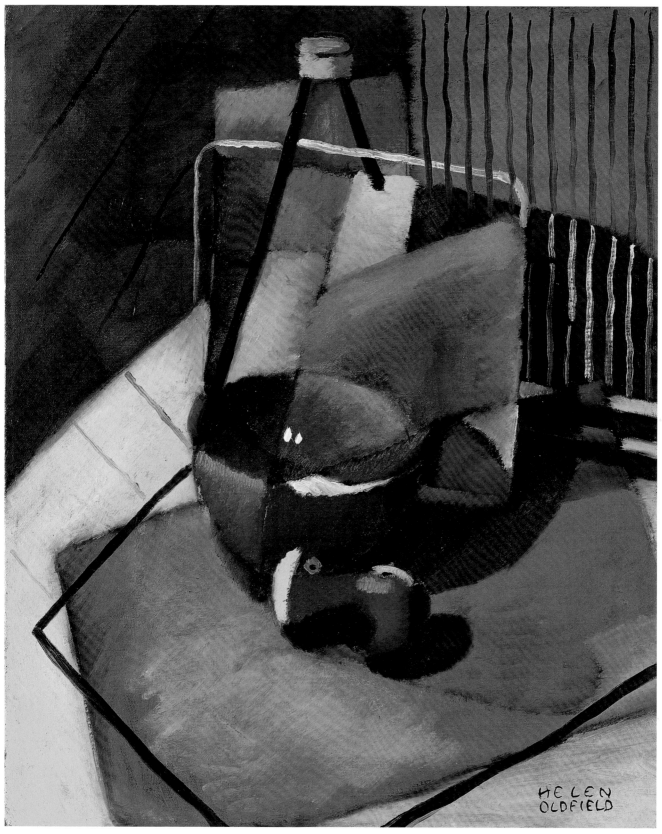

70 HELEN CLARK OLDFIELD 1937, oil on canvas, 22 × 18 in. © 2003 Estate of Helen Oldfield/Jayne
 Brown Bowl Blatchly Trust, San Francisco/Artists Rights Society (ARS), New York.
 Photographer: Sue Tallon.

spearheaded by Edgar Payne, included a number of conservative women painters.

Payne's former wife, Elsie Palmer Payne, was not among them. After separating from her domineering husband in 1932, she emerged from his shadow and regained her self-esteem as she received recognition for her painting, teaching, and civic work. Her paintings of the 1940s, though still realistic, were bolder than her earlier decorative, stylized work. Payne's preference for bold pattern, strong color, and expressive line can be seen in *Patio Forms* of 1944 (fig. 71), a striking picture with a rich variety of textures and strong tonal contrasts. A terracotta vase holds gnarled driftwood, and a cactus overgrows its clay pot in an unruly spread across a tabletop. The painting's eerie surreality and dark, brooding tone may express Payne's emotional response to the gloom of wartime.

After the armistice, with millions of GIs returning to civilian life and demand for housing, automobiles, and scarce household goods booming, the postwar economy surged. Government-sponsored programs—the GI education bill, housing subsidies, and others—contributed to the euphoria of victory and optimism for the future. In the late 1940s and early 1950s, painting in California underwent a radical change with the emergence of Abstract Expressionism. Even still life painters who adhered to Formalist Realism—a style based on Cézanne's principles of order, volumetric form, and structure—did not wholly escape the influence of abstraction in their treatment of space and organization. Indeed, many thought of themselves as modernists. Some also reclaimed the symbolic, allegorical, and narrative content shunned by many of their modernist contemporaries, anticipating the Neorealists of the 1980s and 1990s.

Henry Lee McFee, a major proponent of Formalist Realism, came to Southern California from the East Coast in the mid-1940s.[56] Primarily a still life painter, he was obsessed with Cézanne. McFee tilted horizontal surfaces to distort the picture plane, borrowed Cézanne's treatment of draperies, and used color to convey a sense of volume, playing shapes off each other. A close brush with death in the mid-1940s resulted in a number of still lifes imbued with deep symbolic meaning. Traditional symbols of mortality are found in his *Skull* and *Cow Pelvis*, both painted in 1946. In several other paintings of this period, McFee used the striking symbolism of a broken pot to connote death. In *Broken Pot with Blue Vase* of 1949 (fig. 72), the fractured pot, chipped bowl, spiky plant, dark coloration,

and drapery allude to the artist's awareness of his own mortality.

McFee's work was essentially traditional, although he was clearly influenced by abstraction. Reviewing a 1950 exhibition at the Rehn Gallery in New York City, *New York Times* critic Howard Devree noted that despite "the essentially traditional if not actually academic realism of his textures, the stiffness of fabrics and the solidity of colors—the generally objective decorative effect—McFee's work has not wholly escaped the influence of abstraction as his organization and treatment of spaces . . . give evidence."[57]

McFee attracted a large following of artists throughout the country. One of these was Edna Reindel, who was influenced by his Cézannesque compositions of the 1930s. In 1939 Reindel moved to Hollywood from the East Coast; her California work also relies strongly on modernist ordering, giving her meticulous realism a surreal edge.[58] A complement to Brigante's *Prohibition Era* (see fig. 52), Reindel's *December 5, 1933* (fig. 73) displays the joyous celebration of the repeal of Prohibition.

Among McFee's students at Scripps College, where he taught until his death in 1953, inspiring a generation of Southern California artists, was teacher and still life painter Robert Bentley Schaad. In 1962 Schaad produced a primer for the "serious young art student," *The Realm of Contemporary Still Life Painting,* illustrated with his compositional and technical solutions and those of fellow Southern California artists. The use of drapery as a compositional element, for example, is described thus: "Drapery may at times become an intricate and labyrinthine structure that in its involvement enhances other more starkly simple sections and forms. Or functioning in a comparatively quiet area in rich, broad forms and planes of color it may serve as a foil or a change of pace for the more complex areas or forms."[59]

In his own work, Schaad was concerned with the same interrelationships of objects and structural and design principles that preoccupied McFee and other Formalist Realists. In *Harvest* from 1949–50 (fig. 74), a rather staged, surreal conception of a bountiful harvest, he uses draped cloth as both sculptural form and backdrop for the large, elongated orange squash, the central image.

Another Realist artist of this period, Frank J. Gavencky, anticipates the 1970s work of Photorealist painters like Richard Estes on the East Coast and Robert Bechtle in Northern California. *Hat Market* of about 1944 (fig. 75), a superb example of his meticulous photographic realism, is viewed from an oblique angle to take advantage of the overflowing display of decorated straw hats and baskets.

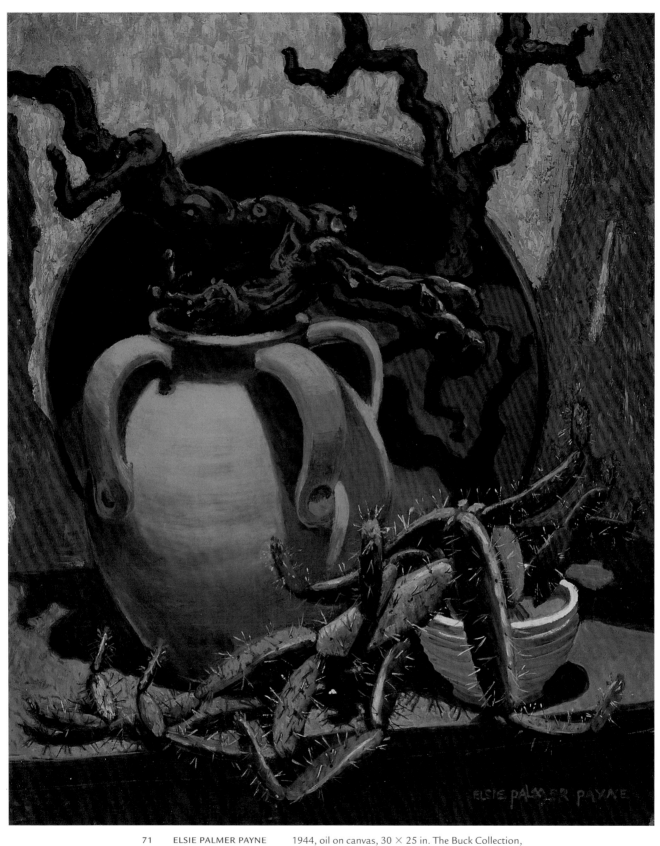

71 ELSIE PALMER PAYNE 1944, oil on canvas, 30 × 25 in. The Buck Collection,
Patio Forms Laguna Beach, Calif. Christopher Bliss Photography.

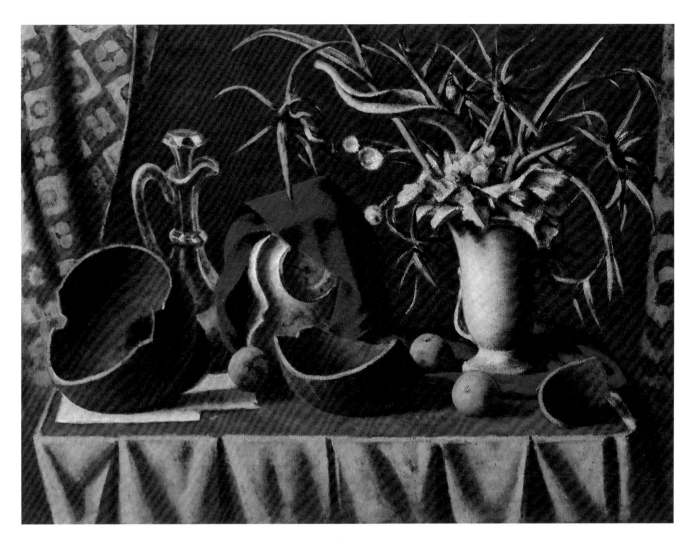

72 HENRY LEE MCFEE
Broken Pot with Blue Vase

1949, oil on canvas, 30 × 40 in.
The Buck Collection, Laguna
Beach, Calif. Photographer:
Cristalen and Associates.

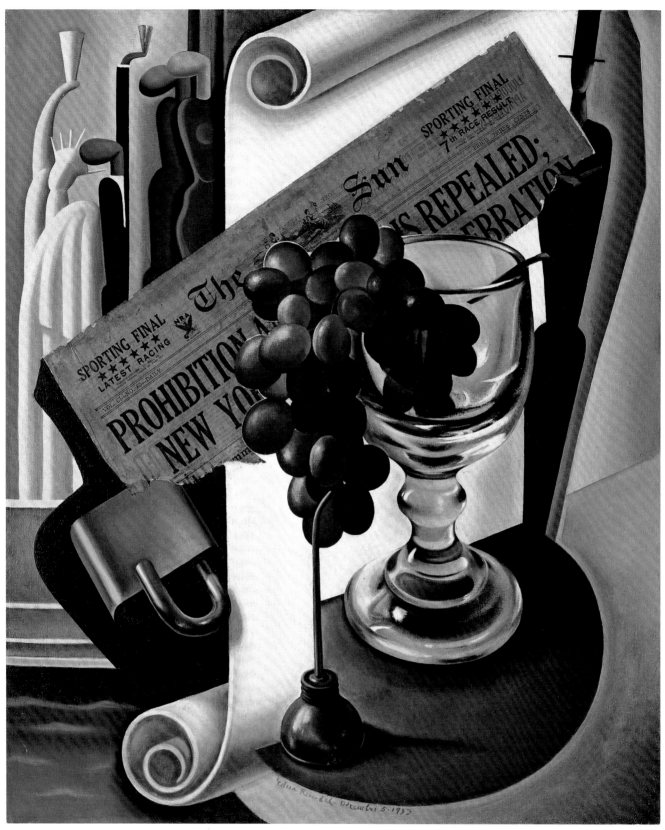

73 EDNA K. INDEL 1933, oil on canvas, 24 × 20 in. Collection of Mr. Jason
December 5, 1933 Schoen, Miami, Fla. Photographer: Jason Schoen.

74 ROBERT BENTLEY SCHAAD
Harvest

1949–50, oil on canvas, 36 × 30 in.
The Buck Collection, Laguna Beach,
Calif. Photographer: Cristalen and
Associates.

Gavencky's peripatetic nature brought him to California often during the 1930s, and he finally settled in Ramona, near San Diego, in the late 1940s. Living near the Mexican border, he frequently traveled to nearby Mexican cities to find fresh and colorful subjects like this one.

While many California painters of representational or illusionistic still lifes were attempting to reconcile realism with abstraction during the 1940s, others, like Hans Burkhardt, Jules Engel, and John McLaughlin, explored biomorphic and nonobjective geometric abstraction.

Before he moved to California from New York in 1937, Burkhardt had shared a studio for more then ten years with the nonobjective painter Arshile Gorky. Under Gorky's tutelage, Burkhardt developed an understanding of European abstraction from Cézanne to Miró and adopted Gorky's biomorphic abstract forms for his own work. Like many first-generation Abstract Expressionists, Burkhardt was heavily influenced by Surrealism, especially its concern with "unpremeditated painting."[60] *Abstraction* of 1942 (fig. 76) is typical of his paintings from those years, a still life that owes more to Surrealism than to Cubism. Floating biomorphic shapes are suspended around angular forms in a shallow, airless space. At this time, Burkhardt's work had diverged from Gorky's in its imagery, color, and densely painted surfaces. Income from his commercial ventures had freed Burkhardt to pursue his art outside New York's avant-garde mainstream.

During the 1930s and 1940s another influence was cross-pollinating the world of still life painting: Hollywood filmmaking. Jules Engel, a self-taught painter, printmaker, and filmmaker, came to the United States from Budapest as a teenager in 1931 and began to paint in a hard-edge geometrical style while in high school in Evanston, Illinois.[61] In 1937 he moved to Los Angeles and app.enticed at the Walt Disney Studios, where he was assigned to

75 FRANK J. GAVENCKY c. 1944, oil on panel, 24 × 36 in. Private collection.
 Hat Market Photograph courtesy of Michael Johnson Fine Arts, Fallbrook, Calif.

76 HANS BURKHARDT
Abstraction

1942, oil on canvas,
32 × 42 in. Courtesy
of Jack Rutberg Fine
Arts, Inc., Los Ange-
les. © Hans G. &
Thordis W. Burkhardt
Foundation.

choreograph Tchaikovsky's *Nutcracker Suite* for the animated film *Fantasia*.

Unhappy with the restrictive creative environment at Disney, Engel spent the war years at the Hal Roach Studios making educational films for the Air Force Motion Picture Unit. After the war he became a designer and then art director for the newly established United Productions of America. There he and the other talented artists altered the image of commercial animated filmmaking by adapting the artistic concepts of contemporary artists as varied as Dufy, Duchamp, Matisse, Kandinsky, and Klee. Engel's personal philosophy embraced what he called "experimental animation—art in motion": "I have concentrated, with particular emphasis, upon the development of a visually inspired, dynamic language, demonstrating that pure graphic choreography is capable of non-verbal truth. I have chosen to convey ideas and feelings through movements, visually formed by lines, squares, spots, circles and varieties of color."[62]

From 1946 to 1949 Engel created a series of hard-edge geometric still lifes with architectonic elements. Paintings like *The Vase* of 1947 (fig. 77) seem to relate to the visual language of his films at that time, which dealt with movement, space, and color. Engel's intention was to bring to his films "the simplicity, the directness, the flat aspect of the painting, and the color taste."[63]

Like Engel, John McLaughlin was self-taught. From the beginning he avoided representational art, launching his career as a nonobjective painter. "I wasn't going to make any pictures of trees or skies or anything like that," the artist said. "Nothing the matter with them at all, but that wasn't for me. Time was wasting."[64] McLaughlin spent the first half of his life involved with Asian art and the Far East, for some of that time running an art dealership in Boston, where he sold Japanese prints. A student of Asian languages, he was proficient enough to be enlisted as a military translator and linguistic specialist in the Intelligence Corps on the Asian front. Assigned to army bases across California, he and his wife succumbed to the state's charm and temperate climate. In 1946, when he was forty-eight, they bought a house at Dana Point near Laguna Beach and McLaughlin devoted himself fully to painting.

Because of his late career start, McLaughlin felt an urgency to develop and express his ideas about art and nature. To understand the principles of modern art he turned first to Cézanne, moving on to Picasso and the Cubists, then to Mondrian and Malevich. The work of the last two painters showed him the value of basic shapes and negative space. Eventually this exploration led him to the still life abstractions in which he reconciled his deep interest in Eastern aesthetics with the Western abstract tradition.[65]

77 JULES ENGEL
The Vase

1947, gouache on paper,
19¼ × 14 in. Collection of
Oaktree Capital Manage-
ment, Los Angeles. Courtesy
of Tobey C. Moss Gallery,
Los Angeles. Photographer:
Tobey C. Moss. © Jules Engel.

From the beginning of McLaughlin's full-time painting career he "avoided symbolism and hieratic arrangements, and fairly well skirted any referential imagery and emphasized clear cut shape and value relationships," but he admits to having "fiddl[ed] around" with conventional watercolor still lifes in the late 1930s.[66] Critic Fidel Danieli finds that the works of the 1940s and early 1950s "reflect the absorption of a variety of post-Cubist sources, the free floating spatial effects of Suprematism without the diagonal, the hard edge graphics of the Bauhaus, the sparse reduction of colors and horizontal-vertical limitations of Mondrian's Neo-Plasticism, . . . even a trace of Nicholson in the use of curved forms, shared contours, transparency of overlaps, and a delicately textured touch to surface manipulation."[67] *Untitled (Abstract)* of about 1947 (fig. 78) reflects some of these early sources, in particular the use of the "void," or negative space, to encourage visual and philosophical openness and to urge each viewer to bring a personal understanding to the work. The abstract arrangement of curvilinear and rectangular shapes suggests a still life, with the red rectangle serving as a base plane or table.[68]

As McLaughlin's work of the 1940s demonstrates, once still life painting was released from its traditional bondage by Cézanne, artists were able to expand, transform, and even reinvent this pliable genre. Like their East Coast counterparts, California artists experimented with still life throughout the early 1940s, manipulating forms and stretching boundaries, bringing to still life their own idiomatic styles and ideas. With the rise of Abstract Expressionism after World War II, still life lost its appeal, but only for a time. Today, renewed by later generations of California artists, it flourishes once again as a revitalized genre.

78 JOHN MCLAUGHLIN c. 1947, oil on Masonite, 24 × 28 in. The Buck Collection,
 Untitled (Abstract) Laguna Beach, Calif. Christopher Bliss Photography.

79 RICHARD SHAW 1980, porcelain with glaze transfer, 14 × 9 × 8½ in. Collection of the San Jose Museum of Art,
 Martha's House of Cards Museum purchase with funds from the Collections Committee. Douglas Sandberg Photography.

susan landauer

the not-so-still life

a survey of the genre in california, 1950–2000

WHEN ART CRITIC HILTON KRAMER visited the Poindexter Gallery in 1963, he was deeply impressed by the nerve of Richard Diebenkorn's *Knife in a Glass* of that same year (fig. 80), a tiny still life hanging amid a welter of larger figurative canvases in the artist's New York solo show. "One hardly knows," he pondered in his review, "whether to embrace its audacity—it is certainly a very beautiful painting—or shudder at such naked esthetic atavism."[1] Kramer's appraisal can only be understood within the context of the extreme degradation still life had suffered since midcentury. It is not that the genre had run dry, dissipating itself into dull familiarity. On the contrary, as Patricia Trenton's essay in this volume attests, from the 1920s into the 1940s modernists in California as elsewhere had freed the genre from its staid reputation and transformed it almost beyond recognition. Dada and Surrealism had opened the Pandora's box of still life iconography—its precincts were now host to every subject imaginable, from fur-lined cups to armadillos (see fig. 67). Apples no longer sat in quiet clusters on a table but, following Magritte's lead, might fill an entire room. The thematic scope of still life now encompassed a vast range, from psychosexual auto-probings to philosophical musings about the universe.

Yet in spite of the multiplying options that would seem to point to a promising future for still life, the Second World War rendered it an anachronism. The rise of Abstract Expressionism, which aimed to transcend the physical world through emotive intangibles of color and form, reduced representation of any kind to a lowly status. The politically fraught modern art controversy of the late

80 RICHARD DIEBENKORN 1963, oil on panel, 14¾ × 10⅞ in. Collection of Nancy and Roger
 Knife in a Glass Boas. Reproduced courtesy of the Diebenkorn Estate. Photographer:
 M. Lee Fatherree.

1940s was crucial in ultimately demonizing "realism," which became a catch-all category for any art with even the most vaguely recognizable imagery.[2]

To some extent, realism is still paying penance for the attack Truman and Congressman George Dondero launched in 1947 on modernist artists, accusing them of anti-Americanism. Cheered on by legions of traditional realists, and most infamously by the arch-conservative Society for Sanity in Art, the campaign backfired, however: instead of growing discouraged, modernists became more abstract with each new accusation. Ultimately, it became clear to politicians and the advertising industry that the brash new movement the fracas had helped to spawn—Abstract Expressionism—could in fact serve as the ultimate embodiment of egalitarian virtue and American brawn.

As the poorest stepchild of realism, still life seemed incapable of anything but the stalest triviality, reduced to early classroom exercises in shading It had lost the enormous prestige it had gained earlier in the modernist era with the innovations of Cézanne, Matisse, and Picasso. Still life would have to wait for Pop Art's aggressively vanguard approach to the common object to bring it out from the extreme margins, and longer still, for the postmodernists of the 1980s and 1990s, to recover its rich possibilities for plumbing psychological depths and philosophical ideas.

The major exception to this national moratorium on still life can be found in the painting of a small number of artists working in Northern California during the 1950s who came to be known as the Bay Area Figuratives. The leaders of this group—David Park, Elmer Bischoff, and Richard Diebenkorn—had each embraced Abstract Expressionism before deciding that, as Diebenkorn put it, the movement was becoming little more than "a book of rules."[3] They were especially troubled by certain artists' exalted claims of originality and metaphysical inspiration, which they viewed as empty rhetoric.[4] The Bay Area Figuratives rejected the notion of avant-gardism altogether, believing that, as Park famously said, "concepts of progress in painting are rather foolish."[5] Instead of catering to the art market's insatiable demand for the shocking and the new, the Bay Area Figuratives sought an art that would be approachable and self-effacing. Their initial aim, as Bischoff stated, was to find an expression that was "more humble, more down to earth, more every day, more accessible" than the monumental abstractions of the New York School, which dominated the pages of art magazines during the 1950s.[6]

Given their credo of accessibility and respect for artistic tradition, it made sense that most of the Bay Area Figuratives gravitated toward still life, drawing on their most familiar surroundings for subject matter. Park was the first to strike out in a figurative direction, and some of his initial efforts included a series of still lifes whose homey subjects offered a clear defiance of Abstract Expressionism's lofty aspirations. *Table with Fruit* of 1951–52 (fig. 81) might depict the artist's own dining room. There is no pretense of profundity in this traditional home repast, which has the intimacy of a late-nineteenth-century Bonnard or a Vuillard. Yet unlike the French Intimistes' pyrotechnics of color and form, *Table with Fruit* attempts no stylistic virtuosity. Park pulls together his composition through idiosyncratic means—an echoing of stripes in the fabric of the man's shirt, the plain plank floor, the glistening ribbed glasses on the table. At the same time, Park's exaggerated foreshortening and perspective read like cartoony caricature, reminiscent of Grant Wood or Thomas Hart Benton. As Bischoff observed, when Park first began painting figuratively, he took "perverse pleasure" in going out on a limb with the corniness of his subjects.[7]

Bischoff's first figurative works, by comparison, partake of a straightforward naturalism, with none of Park's propensity toward playful caricature. Nonetheless, he clearly shared Park's desire to return to the bedrock of perceptual reality as a kind of reclamation of art's lost innocence. Bischoff's still lifes, few in number and mostly confined to his sketchbooks, concentrate on direct notation of scenes of everyday life. In *Pink Table* (1954), the tilted tabletop is laden with artifacts of domesticity: a coffee pot, a vase of flowers, and a rag doll. Similarly, *Untitled (Table with Baby Bottle)* from about 1953–54 (fig. 82) presents a kitchen table cluttered with dishes and a baby bottle. As he described his intention, Bischoff was choosing subjects that evoked a response within himself. In effect he was saying, "Here is something that exists out in the world that I think is worth dealing with . . . that I have a certain love for, possibly . . . as opposed to inventing a brand new language."[8]

By the mid-1950s both Park and Bischoff had considerably softened their reactionary attitudes toward Abstract Expressionism and begun reincorporating aspects of gesture painting into their vocabularies. Although their close associate, figurative painter Theophilus Brown, has stated emphatically, "I don't think gesture painting played a great part in any of our work,"[9] there can be little doubt that the Bay Area Figuratives absorbed many stylistic innovations of the New York gesture painters. Park's still

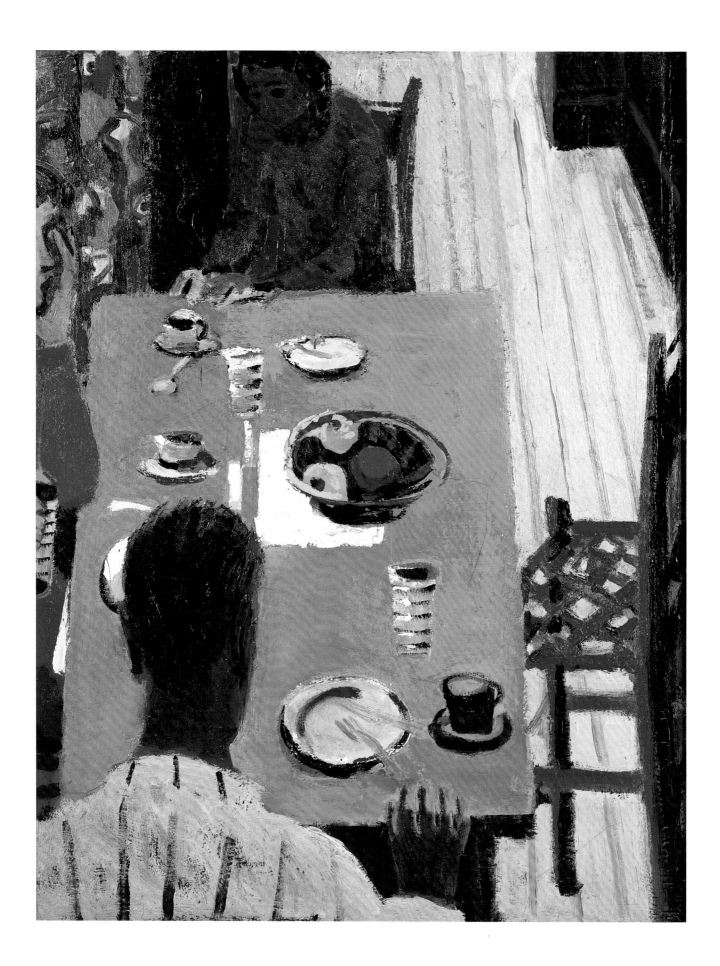

lifes, while continuing to focus on only the humblest of subjects, now showed an obvious pleasure in spontaneous handling of paint. The juicy impasto of *Brush and Comb* from 1956 (fig. 83), for example, gives the work an almost sculptural presence, with upward-thrusting incisions giving tangible life to the bristles of the brush.

Diebenkorn, the last of the trio to make the shift from abstraction, may well have encouraged Park and Bischoff to loosen their brushwork, since he had turned to the figure in 1955 without substantially altering his earlier Abstract Expressionist approach. Regardless of subject matter, techniques such as dripping, kneading, and incising remained mainstays of his work. Diebenkorn's thematic range followed that of Park and Bischoff, with a focus on his immediate environment. While acknowledging a personal attachment to the objects he painted, Diebenkorn's primary concern in his still lifes is the working out of formal problems. On first glance his subjects appear to be scattered in haphazard fashion. In *Bottles* of 1960 (fig. 84), one might almost miss the ink container behind the wine carafe. Yet the same curious vertical alignment of contiguous and overlapping forms appears in *Still Life with Letter* of 1961 (fig. 85), where the open sketchbook lies edge to edge with a match striker, a letter, and two coffee cups. Clearly, Diebenkorn did not paint his objects the way he encountered them in his studio, but organized them into complex compositions that were offbeat and unlikely, even while hinting at the classicizing geometry of his later elegant "Ocean Park" paintings.

82 ELMER BISCHOFF
Untitled (Table with Baby Bottle)

c. 1953–54, ink on paper,
11 × 8½ in. Collection of
Gregory Bischoff. Photographer: M. Lee Fatherree.

81 DAVID PARK
Table with Fruit

1951–52, oil on canvas,
46 × 35¾ in. Collection
of Bebe and Crosby
Kemper. Photographer:
Dan Wayne.

83 DAVID PARK
 Brush and Comb

 1956, oil on canvas, 13⅞ × 17 in.
 Collection of John and Gretchen
 Berggruen. Douglas Sandberg
 Photography.

84 RICHARD DIEBENKORN
 Bottles

 1960, oil on canvas, 34 × 26 in.
 Norton Simon Museum, Pasa-
 dena, Calif.; gift of the artist,
 1961. Reproduced courtesy of
 the Diebenkorn Estate.

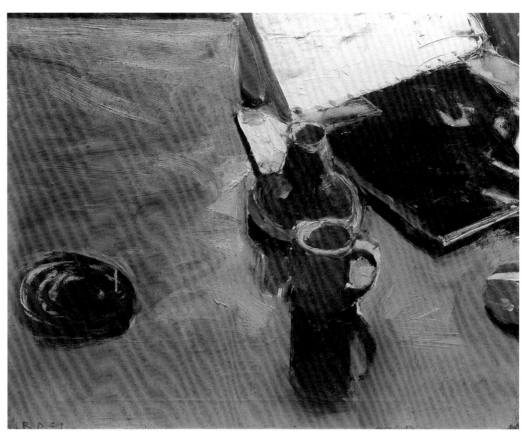

85 RICHARD DIEBENKORN 1961, oil on canvas, 20 × 25 in. Collection of the City and County of San Fran-
 Still Life with Letter cisco, purchased by the San Francisco Arts Commission for the San Francisco
 Hall of Justice. Reproduced courtesy of the Diebenkorn Estate. Photographer:
 Rudy Bender.

Paul Wonner seems to have taken Diebenkorn's cue in his "Dutch" still lifes of the 1980s and 1990s, which feature meticulously painted objects often stacked in neat vertiginous piles (see fig. 131). These still lifes would earn for Wonner a reputation as one of California's premiere realists, but during the 1950s and early 1960s he enjoyed a distinguished career as a member of the Bay Area Figuratives. Wonner began painting figuratively around the time he graduated from Berkeley in 1953. He met Bischoff, Park, and Diebenkorn two years later, joining them for weekly drawing sessions. The next year he moved to the agricultural town of Davis, where his work took on the brilliant light of the Sacramento Valley. *Still Life with Artichoke* from about 1962 (fig. 86) is typical of Wonner's work of this period, with its Diebenkorn-esque wedgelike shapes, "pistachio" colors (Wonner's own phrase), and melting, buttery brushwork suggestive of a radiant noonday sun.[10]

Joan Brown, a student of Bischoff's and Diebenkorn's and a second-generation Bay Area Figurative,

achieved an extraordinary fusion of Abstract Expressionism and figuration in the canvases she produced during the late 1950s. She credits Bischoff with her "diaristic" approach to still life, concentrating on simple objects she found around her home—shoes, dog toys: whatever happened to capture her eye. Despite Brown's quotidian subject matter, the canvases of the late 1950s are frequently so abstract that they are difficult to decipher without the aid of titles. *Thanksgiving Turkey* of 1959 (fig. 87), for instance, shows Brown's ability to transform everyday subjects into marvels of abstraction. Here she has surpassed Park in the thickness of her surfaces, using palette knives and even spatulas to layer on slabs of oily pigment. Trussed and stuffed, the splayed bird of *Thanksgiving Turkey* recalls the hanging fowls of Chaim Soutine, but without the brutality of the Russian expressionist; Brown's painting clearly revels in a joyful manipulation of paint.

Brown's best-known still lifes are the colorful impastos she painted around the time of her marriage

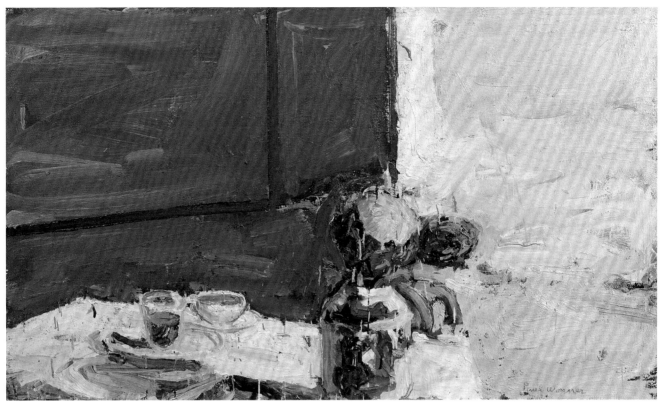

86 PAUL WONNER
 Still Life with Artichoke

 1962, oil on canvas, 27⅞ × 47¼ in.
 Collection of the San Francisco
 Museum of Modern Art, gift of
 Roland Petersen. Photographer:
 Ben Blackwell.

87 JOAN BROWN
 Thanksgiving Turkey

 1959, oil on canvas, 47⅞ × 47⅞ in.
 Collection of The Museum of Modern
 Art, New York. Larry Aldrich Foundation
 Fund. Photograph © 2002 The Museum
 of Modern Art, New York.

to sculptor Manuel Neri in the early 1960s. Perhaps her association with Neri encouraged her to develop her earlier sculptural inclinations to an extreme, with massive build-ups of paint sometimes measuring as much as three to four inches. The environmental walk-in space of Brown's still life *Noel at the Table with a Large Bowl of Fruit* of 1963 (fig. 88) shows Brown at her most ambitious. Here, the colors are lush and abundant: vivid pinks and reds contrast with lemony yellows and greens, all lassoed together with a shot of electric blue that draws the eye directly to a heaping cornucopia of fruit. Brown's one-year-old son Noel sits behind the central mélange, spoon clutched in hand as if to scoop up the apples, pears, grapes, lemons, and oranges toppling over each other in a riot of color.

While the Bay Area Figuratives were turning out their colorful canvases with their painterly textures, a movement of a very different temperament emerged representing another of the resolutely antimainstream chapters in California art: variously known as "Beat" or "Funk" assemblage sculpture.[11] Part of a loose community of poets, musicians, filmmakers, and photographers of the so-called Beat generation, these artists—spearheaded by Bruce Conner in Northern California and Edward Kienholz in the south—coexisted with the Bay Area Figuratives, even showing together in the same galleries.[12] Yet despite this peaceable kingdom, their aims were entirely different. Far from seeking the plain and down-to-earth, these artists sought drama and exotica, magic, mysticism, and fantasy—and as a consequence, their subjects were emotionally provocative. Moreover, whereas the Bay Area Figurative painters assiduously kept their distance from politics, the assemblage artists engaged in a full-blown critique of consensus values, attacking the bland conformist culture that profited from a terrifying Cold War arms race. They seemed, rather, to answer Norman Mailer's call "to divorce oneself from society, to exist without roots, to set out on that uncharted journey into the rebellious imperatives of the self."[13]

It might seem odd that these sculptors, with their intensely nonconformist outlook, were drawn to still life, which avant-garde artists in America had long since spurned. True to their Dada and Surrealist predecessors, however, the Californians' approach to the genre was anything but conventional. Early in the century Picasso had made the discovery that the still life artist was first and foremost an assembler of objects; hence the final step—that of simulation—could be eliminated. After inventing the collage still life, beginning with his *Still Life with Chair Caning*

(1911–12), Picasso made the logical leap into three dimensions; his first recorded assemblages, *Guitar* and *Mandolin,* were made the following year out of scraps of wood and other found materials.[14] But it was Duchamp, as Robert Motherwell observed, who became the "asp in the basket of fruit," overturning previous conceptions of object assemblages with his "readymades"—composed of cast-off items that no one would have bothered with until they were presented as art.[15] The assemblagists of the 1950s picked up where Duchamp left off. Their choice of discarded materials—the "rattier the better," said Joan Brown—compelled East Coast critics to later call them "Neo-Dadaists."[16] Yet their sensibility differed from Duchamp's in important respects. While Duchamp's approach was essentially cerebral, cool, and deadpan, even when full of teasing conundrums, the Beat assemblage artists tended to work intuitively, often drawing from a core of intensely personal experience. Their aim was to achieve what George Herms called an "alchemical transformation": taking the dross of everyday existence and transforming it into "object-poetry."[17] This object-poetry might shimmer with wondrous associations or create a sense of horror and dread, but in any case it would be "associationally alive."[18] And unlike their East Coast contemporary Jasper Johns, also routinely classified as a Neo-Dadaist, the Californians never attempted to neutralize or dehumanize their subject matter. On the contrary, their use of dingy, cast-off materials gave their assemblages an aura of mystery, romance, and, occasionally, nostalgia.

Bruce Conner's sculpture of the 1950s and 1960s epitomizes the overheated sensibility of these artists. His best work mingles his colleagues' attraction to mystery and nostalgia with a taste for gothic horror uniquely his own. *THE LAST SUPPER* from 1961 (fig. 89) exemplifies Conner's peculiar ability to unnerve and revolt the viewer through grotesque innuendo. The title suggests a table laden with food, yet there is nothing vaguely edible on the blackened surface. Rather, Conner has served up a monstrous feast of unnamable objects. These objects, which are buried beneath a skin of wax, are not so much composed—as in a traditional still life—as *de*composed beyond recognition. The suggestion is one of decaying flesh barely able to contain the rotting organs within. Conner has recast the familiar memento mori in this deeply disturbing work. *THE LAST SUPPER* may not represent a morality tale, yet death and rebirth are unmistakably the artist's subjects. In fact, the piece ultimately perished and found new life within a decade of its creation when the artist disassembled

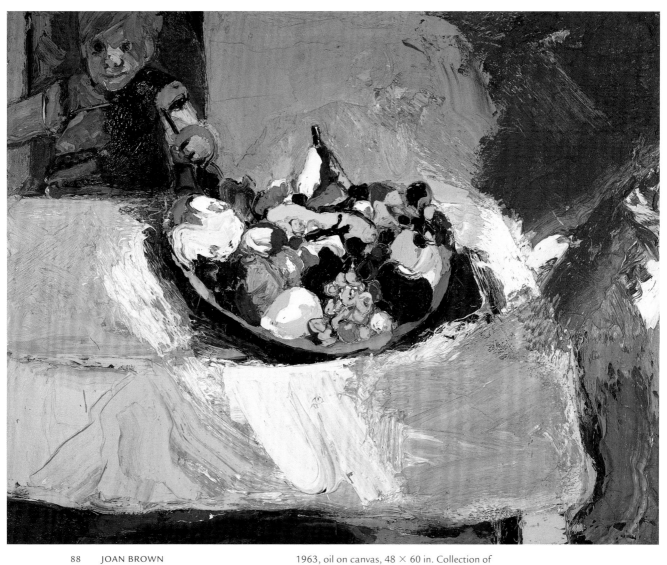

88 JOAN BROWN
Noel at the Table with a Large Bowl of Fruit

1963, oil on canvas, 48 × 60 in. Collection of
John Modell. Photographer: Ben Blackwell.

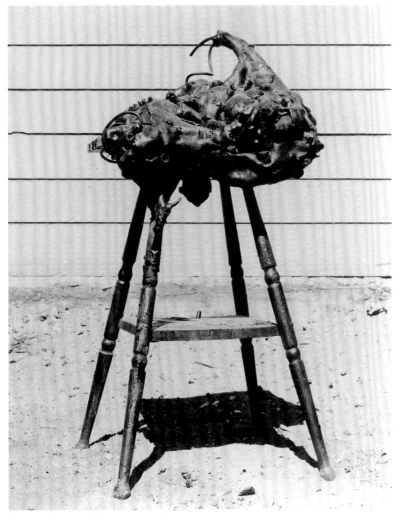

89 **BRUCE CONNER** 1961, mixed media, 38 in. high, no longer extant.
THE LAST SUPPER Collection of Bruce Conner. Photographer: Erni
Burden and Bruce Conner. © Bruce Conner.

it and, in his own words, "returned it to the world as original matter."[19]

It might be said that nearly all of Conner's assemblages engage in a dialogue with the memento mori tradition insofar as the majority deal with death and decay, often blended with themes of fertility and fetishized sexuality. *BLACK DAHLIA* from 1959 (fig. 90) brings together all of these aspects to chilling effect. Conner credits the American nineteenth-century still life painter William Harnett as an unlikely inspiration for this assemblage, although the matter-of-fact wall tackings of Harnett could not be further removed from this grisly creation.[20] *BLACK DAHLIA* is named after one of the most brutal and bizarre unsolved murders in the history of Los Angeles, the slaying of Elizabeth Short, a beautiful twenty-two-year-old aspiring actress who was found cut in half with a butcher knife in a vacant lot near Hollywood in 1947.[21] Conner has captured the horror and the fascination of the story, which fifty-five years later still commands an active website and five books in print.[22] The piece consists of a nylon stocking (with its intimations of forbidden eroticism) containing a photograph of a nude woman seen from the rear. Like a supernatural Plains Indian medicine bundle, the stocking is filled with mysterious objects: bits of broken glass, tobacco, costume jewelry, and an ostrich plume, which, as Rebecca Solnit has evocatively written, "slithers up one side like a centipede."[23] Yet there is also the suggestion of a crucifixion—Conner has driven nails along the upper edge of the stocking and straight through the center of the photograph. Elizabeth Short is depicted as a martyr: the emblems of feminine vulgarity no doubt allude to the media's slandering of her as a cheap, promiscuous drifter—slander that was recognized as false when it was discovered that she had a genital defect rendering her incapable of intercourse. Short was society's ultimate victim, and Conner's *BLACK DAHLIA* condemns the brutality and demented sexuality of a culture that could commit such horrific acts while remaining intensely captivated by them.

Edward Kienholz, like Conner, was also concerned with psychic and social malignancies, including the exploitation of women as sex objects. He once remarked that "all my work is about death and dying," although in some cases death might take the form of psychological anesthesia, as in works such as *John Doe* (1959), where a paint-streaked mannequin is lopped in half.[24] Kienholz is best known for his theatrical environmental tableaux of the 1960s, such as *Roxys* (1961–62), a recreation of a Nevada brothel; *The Illegal Operation* (1962), a critique of the antiabortion law; and a series of

works that portray institutional brutalities, notably the unforgettable *State Hospital* (1966).[25] While these large-scale installations sometimes contain intriguing still lifes, the works as a whole fall outside the still life tradition because of the dominance of the figure.[26] Kienholz nonetheless produced a number of assemblage sculptures in which the dialogue with still life is central. In *The U.S. Duck, or Home from the Summit* from 1960 (fig. 91), the depiction of a dead fowl is conventional enough, but Kienholz has parlayed it into a charged political statement. Eisenhower's attempt at easing Cold War tensions in the Big Four Conference had seriously backfired, and the piece thus alludes to his status as a lame duck. It consists of a sad-looking stuffed duck, its feathers seemingly tarred rather than painted the colors of the American flag and head crushed into the corner of a coffinlike box.[27] Another work, *The Future as an Afterthought* of 1962 (fig. 92), shows Kienholz to have been ahead of his time in his concern for global overpopulation. In it he presents a bundle of multiracial dolls strapped helplessly together on a tabletop. Bicycle pedals attached to the piece suggest that the wheels of disaster have been set in motion and can only result in death and destruction.[28]

If Conner and Kienholz portrayed the forces of darkness and evil in society, George Herms concentrated on the ideals of lightness and love. Along with Wallace Berman, Robert "Baza" Alexander, and other Beat poet-artists who divided their time between Los Angeles and San Francisco, Herms belongs to the gentle mystical strain of the movement, whose philosophy Berman encapsulated in 1959 with his famous inscription on the wall of the Venice West Expresso [an intentional misspelling] Café: "Art is Love is God." Like Conner and Kienholz, Herms assembled his sculptures from aged, cast-off materials, but he did not select objects for their suggestions of squalor and abuse. Rather, he was interested in their generative, life-giving potential, calling his

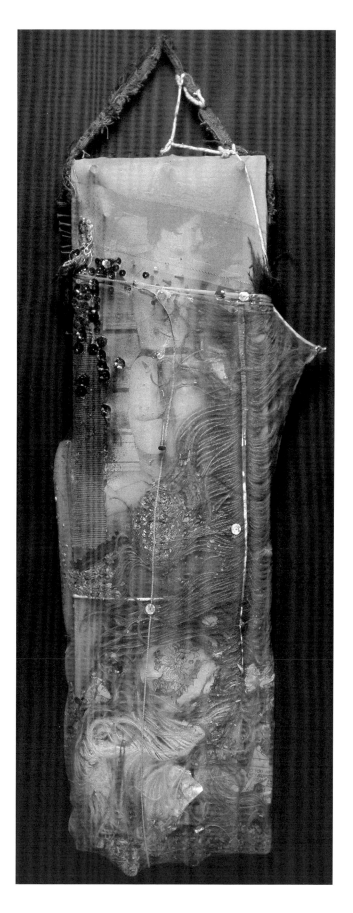

90 BRUCE CONNER
BLACK DAHLIA

1959, mixed media,
26¾ × 10¾ × 2¾ in.
Collection of Walter
Hopps. Photographer:
George Hixson.

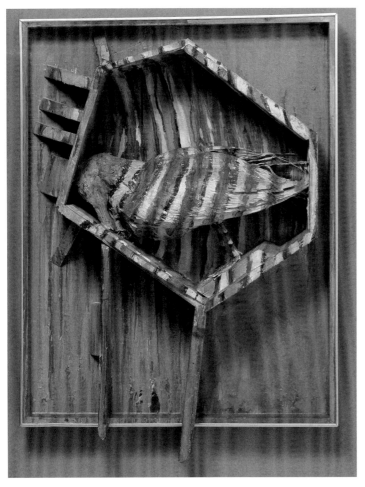

91 EDWARD KIENHOLZ
The U.S. Duck, or Home from the Summit

1960, mixed media, 26⅞ × 21¼ ×
6 in. Los Angeles County Museum of
Art, Michael and Dorothy Blankfort
Bequest. © Edward Kienholz and
Nancy Reddin Kienholz. Photograph
© 2002 Museum Associates/LACMA.

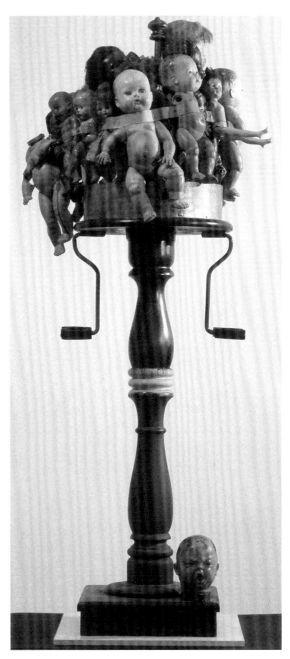

92 EDWARD KIENHOLZ
The Future as an Afterthought

1962, mixed media, 54 × 21
× 18 in. Onnasch Collection.
© Edward Kienholz and Nancy
Reddin Kienholz.

assemblages "furniture for the soul."[29] Herms's work epitomizes the "negentropic" side of the Beat impulse, which, according to poet Jack Foley, wanted "to wrest not only order but permanence out of its frequently all-too-mortal materials." Herms's aim, Foley suggested (quoting Michael McClure), was "to create objects that had bypassed entropy and become beautiful and alive."[30] By rescuing the everyday from oblivion and staving off the destructive passage of time, Herms thus added a new dimension to the memento mori.

The Librarian of 1960 (fig. 93) shows Herms in his most elegiac mode. The artist recalls that on one of his sunrise trips to play his flute on the Larkspur dump he found a treasure-trove of rotting books.[31] Arranging them into a simple cruciform, Herms created a tribute to the town librarian—the

first of the "celebration series" of assemblage portraits that he would continue to produce for the next forty years.[32] Over the following decade the piece took on a life of its own, shedding and accruing attributes. Initially conceiving of it as a pun on the Libra zodiac sign, Herms attached "loving cups" to each of its outstretched arms. One has since disappeared. After teenage boys stole the original central photograph of a nude female swimmer, Herms attached a photograph of a black woman. Taking his cue from the black/white dichotomy that recurred throughout the piece, Herms scratched the woman's eyes out white, to complement a book titled *Thinking White*. In this final incarnation, now preserved for viewers at the Norton Simon Museum in Pasadena, the piece can be understood—among other possible interpretations—

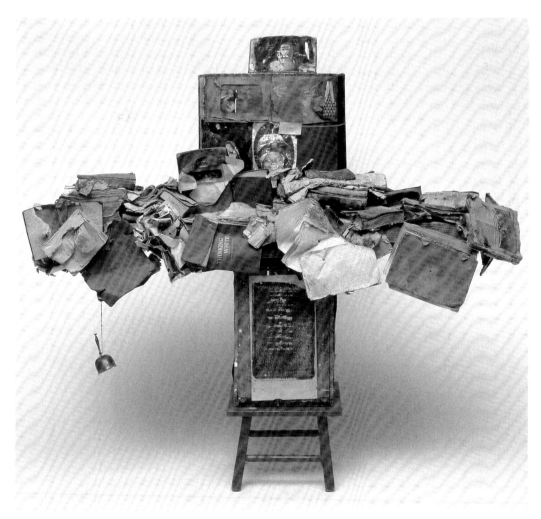

93 GEORGE HERMS 1960, mixed media, 57 × 63 × 21 in. Norton Simon
 The Librarian Museum, Pasadena, Calif. Gift of Molly Barnes, 1969.

as expressing the ideal of a culturally and ethnically balanced world.

Herms has been called a "master of the visual metaphor," yet it was crucial for him to keep his assemblages open to interpretation.[33] As he said, "I don't want to limit the meaning of my work. Even titles can be fascistic."[34] This attitude might seem strangely antiliterary for an artist whose associates were primarily writers and who wrote and published poetry on his own hand press.[35] Yet Herms's philosophy—as well as that of most other Beat-era writers—can be likened to the Symbolist writers' point of view, which held that clusters of metaphors should intimate but never state ideas directly. The Beats agreed with the Symbolists' notion described by Edmund Wilson that "every feeling or sensation we have, every moment of consciousness, is different from every other" and therefore impossible to render through ordinary symbols.[36] More important, they believed that to explain too much not only destroys art's fundamental mystery but also, as Mallarmé said, "deprives the mind of the delicious joy of believing that it is creating."[37]

Renewal of meaning is the true subject of Herms's *Secret Archives* of 1974 (fig. 94).[38] For this work, Herms salvaged an industrial shelving unit with twenty-nine compartments, filling them with objects ranging from the bust of an Egyptian pharaoh to a broken electric toaster still holding its last pieces of burnt toast. Some of the objects take a moment to recognize—a clock filled with hairballs, a cut-up old globe, and a squat, round lamp that has the appearance of a flying saucer. Other objects are unidentifiable, even to the artist. Nonetheless, Herms has imposed order on his creation, "archiving" each object in its own compartment. Paradoxically, this gridlike structure only strengthens the power of the objects to defy categorization. Pigeonholed or not, collectively they remain in a state of unending reverberation of associations. Thus, the chairs that hold the shelves should not be understood as bookends, but as facilitators of a perpetual dialogue.

Not all of the Beat-era artists in California worked in the medium of assemblage sculpture. Jess, who achieved renown for his large-scale, obsessively detailed collages, began his artistic career painting highly idiosyncratic interpretations of the traditional genres, still life among them. Of all of the visual artists in his circle, Jess was quite possibly the most romantic, mining a relentlessly nostalgic lode of sources in Victorian culture, including long-neglected fairy tales and sentimental novels. Some of Jess's early works reflect his training as a chemist, but in these his glance is decidedly backward. *Trinity's*

Trine of 1964 (fig. 95), for example, has the look of a nineteenth-century scientific workroom, with laboratory instruments that might as easily be used for alchemy as for practical science.

The frank romanticism and idealism of the Beats stood miles apart from the attitudes of younger artists such as William Wiley, whose junk assemblages have often been annexed into the Beat quarters under the rubric "Funk art." Yet Wiley's *Thank You Hide* (fig. 96), constructed in 1970–71, expresses none of the outraged social protest or cultural utopianism of the Beat sculptors. This assemblage is hip and glib, playfully turning the still life genre on its head with its outlandish, nonsensical juxtapositions. Composed of a large swatch of stretched cowhide emblazoned with the words "thank you" and "nomad is an island," the piece presents an assortment of objects—a rusted spike, an arrowhead, an iguana skin (from his son's collection), a shelf holding Nietzsche's *Beyond Good and Evil*, a series of bottles containing mysterious items such as "fresh bait." The ensemble, with its tongue-in-cheek allusions to the Wild West and its use of punning words, led the critic Hilton Kramer to dub Wiley's style "Dude Ranch Dada."[39]

The flippant humor of Wiley is best understood within a sea change in attitudes toward art-making that began in the late 1950s and early 1960s—a shift that had far-reaching implications for a major revival of the still life in American art. Wiley's refusal to take seriously the Abstract Expressionist generation's "heavy moral trip" was becoming the collective wisdom of a whole new generation of artists in New York. Nearly a decade after the Bay Area Figuratives had concluded that Abstract Expressionism was hardening into aesthetic dogma, artists like Jasper Johns and Robert Rauschenberg began disputing the movement's emotional excesses and inflated spiritual claims by similarly turning to common, everyday objects for subject matter. The debate in New York, however, became far more antagonistic than in the Bay Area, resulting in art that was reactionary in the extreme. Pop Art, of course, represented the ultimate chapter in this polemic, brutally undermining the high-art aspirations of Abstract Expressionism by elevating the "kitsch" of mass culture. Painters such as Andy Warhol, Roy Lichtenstein, James Rosenquist, and Tom Wesselmann intentionally countered values of uniqueness and aesthetic intelligence by concentrating on the most anonymous and neutral subjects they could find: commercially produced objects culled from supermarkets, advertising, and the popular media.

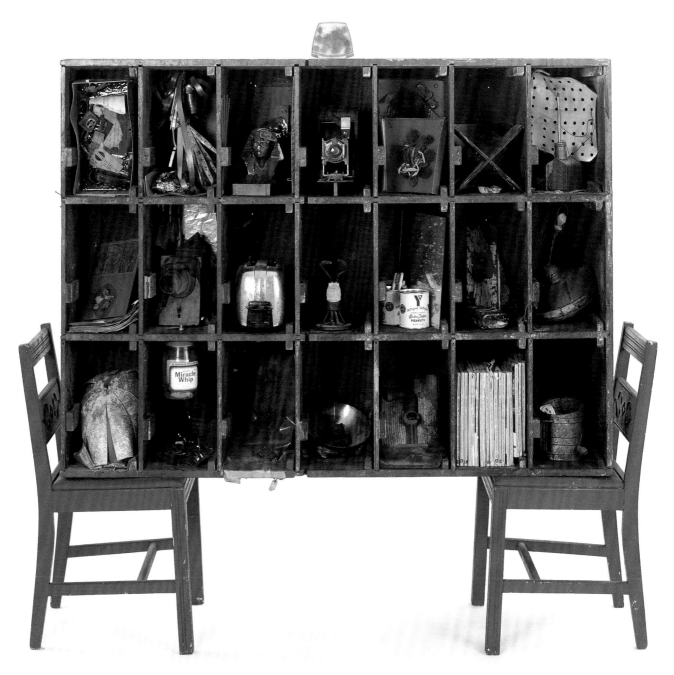

94 GEORGE HERMS 1974, mixed media, 57 × 63 × 21 in. Private collection.
Secret Archives Photograph courtesy L.A. Louver Gallery, Venice, Calif.

95 JESS
Trinity's Trine

1964, oil on canvas over wood, 45⅞ × 48⅛ in. The
Museum of Modern Art, New York, purchased with
the aid of funds from the National Endowment for
the Arts and an anonymous donor. Photograph
© 2002 The Museum of Modern Art, New York.

Pop Art, also known as "object painting" and
"common object art" when it first appeared in the
early 1960s, opened up entirely new vistas for still
life in California, with American consumer culture
providing hitherto unexplored subject matter rang-
ing from gumball machines to electric frying pans.
However, the vast majority of California artists
eschewed the neutralizing strategies of New York
artists. It is difficult to find in their work the tech-
niques of advertising art and mass printing that so
dramatically depersonalized and drained significant
meaning from the work of artists like Warhol and
Lichtenstein. Many Bay Area artists in particular not
only rejected Pop Art's slick surfaces and appropria-
tion of commercial imagery, but also found ways of

emphasizing what was personal and idiosyncratic in
their work. The result was not really Pop Art in the
pure sense, but rather a playful embrace of lowbrow
content and technique that reveled in defying
accepted taste.[40]

The major center for Pop-inspired still life in a
variety of eccentric forms was the University of Cal-
ifornia at Davis, where two of Northern California's
leading artists of the Pop persuasion—Robert Arne-
son and Wayne Thiebaud—began teaching in the
early 1960s. Although Thiebaud rejected the "Pop"
label, preferring to think of himself as "a humble
practitioner" of the traditional genres, his still lifes
fit clearly within the Pop Art aesthetic because of
their concentration on the artifacts of popular cul-
ture—slot machines, yoyos, lipsticks, soda fountain
syrups (see title page), and above all his signature
cakes and pies.[41]

Pies, Pies, Pies of 1961 (fig. 97) exemplifies Thie-
baud's infatuation with the banal though plea-
surable objects of consumer culture, depicting a
dessert that is pure Americana (other Thiebaud
favorites include ice cream cones, sundaes, and
banana splits). With its antihierarchical arrange-
ment of pie slices of equal size in gridlike rows, the
painting employs the compositional technique
Warhol made famous in his "multiples." Yet if
Thiebaud's serial images suggest production lines
and supermarket shelves, they never do so with
the aim of vitiation, hoping to become monoto-
nous through repetition. Rather, the sheer plethora
intensifies the sensuality of his canvases. This is in
part because Thiebaud did not emulate the flat
and simplified vocabulary of commercial illustra-
tion, in the manner of Warhol. Even though he
had begun as an advertising artist, the individual
stroke of the artist's hand remained essential to
Thiebaud's work—so much so that his style has
been characterized as forging a bridge between
Pop Art and Bay Area Figuration.[42] Like Bischoff,
Diebenkorn, and Park, whom he admired, Thiebaud
did not generally paint from life but relied on his
remarkable visual and tactile memory. In fact,
some of Thiebaud's most successful paintings fea-
ture creamy impastos with "bas-relief modeling"
that mimics with marvelous vivacity the confec-
tionery textures of his desserts, as in figure 98.[43]
Perhaps the most remarked-upon aspect of his
technique is what he called "the quality of glare"
produced by orange-rimmed blue shadows cast
against brightly lit white grounds.[44]

Thiebaud developed a style so uniquely his own
that it was not easily given to successful emulation—

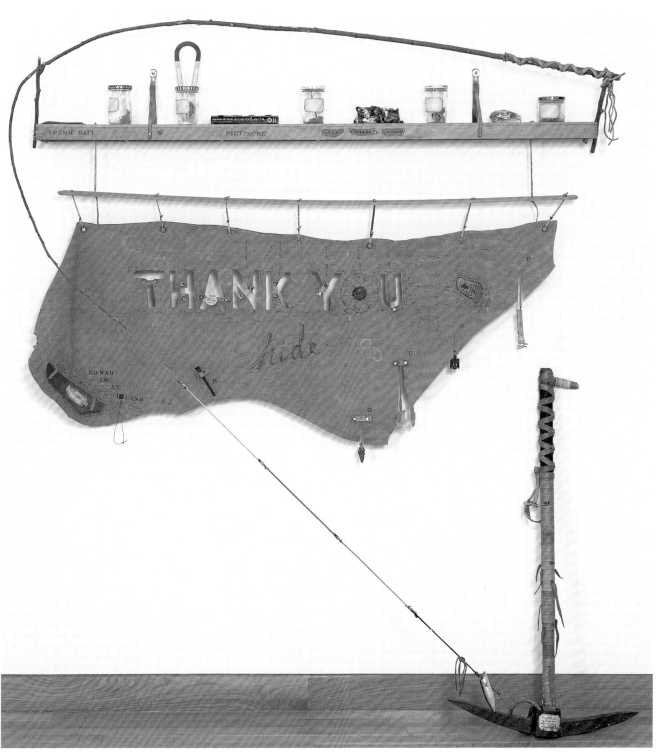

96 WILLIAM T. WILEY
Thank You Hide

1970–71, mixed media, 74 × 160½ in. Nathan Emory Coffin Collection of the Des Moines Art Center, 1977.9. Purchased with funds from the Coffin Fine Arts Trust. Photographer: Michael Tropea, Chicago, Ill.

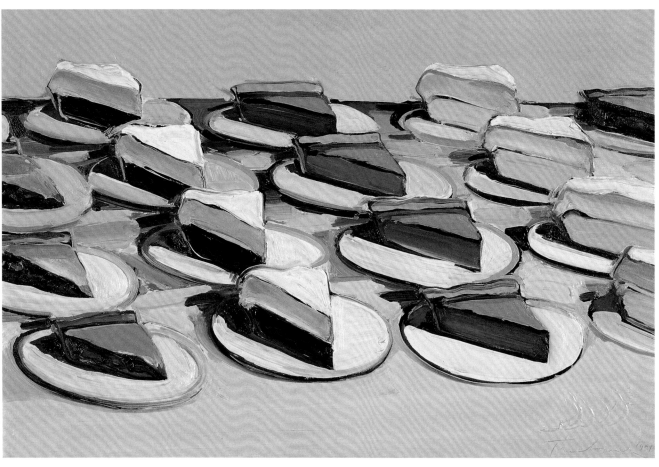

97 WAYNE THIEBAUD 1961, oil on canvas, 20 × 30 in. Crocker Art Museum, Sacramento, Calif. Gift of
 Pies, Pies, Pies Philip L. Ehlert in memory of Dorothy Evelyn Ehlert. © Wayne Thiebaud/Licensed
 by VAGA, New York. Photograph © 1961 Paul LeBaron Thiebaud.

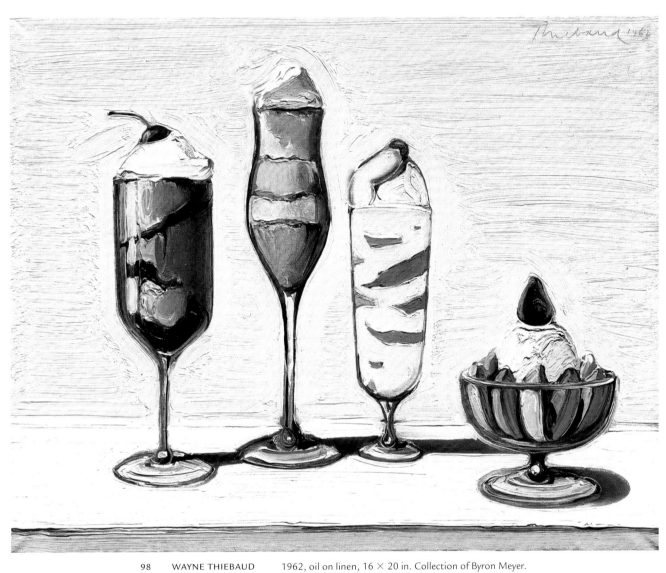

98 WAYNE THIEBAUD 1962, oil on linen, 16 × 20 in. Collection of Byron Meyer.
Confections © Wayne Thiebaud/Licensed by VAGA, New York.

though he has often been copied and parodied, for instance by Robert Colescott in his painting *Artistry and Reality (Happy Birthday)* (fig. 99).[45] The painting of Raimonds Staprans stands as one notable exception. Staprans, though he appears to have found inspiration in Thiebaud's work, was never associated with Davis or Thiebaud himself. A Latvian by birth, he studied in the early 1950s at Berkeley, where the faculty's nucleus had trained with Hans Hofmann, and almost from the start gravitated toward still life as a primary theme.[46] He never went in for Pop Americana, but by the 1960s he embraced the unassuming subjects that were fashionable at the time, including

ordinary edibles and the studio ephemera popularized by Johns—jars of paint brushes, bottles of paint-clouded water, and gesso cans: subjects that continue to occupy him today. Staprans's frequent prismatic palette, specifically his delineation of edges with complementary hues, bears a striking resemblance to Thiebaud's signature style. Yet on the whole, his sensibility is more restrained, closer in temperament to Richard Diebenkorn, an artist he acknowledges as an important influence. Staprans can be whimsical at times, as in *Way Too Many Unruly Oranges* of 1998 (fig. 100), but he never would have characterized himself, as Thiebaud did, as a "painting

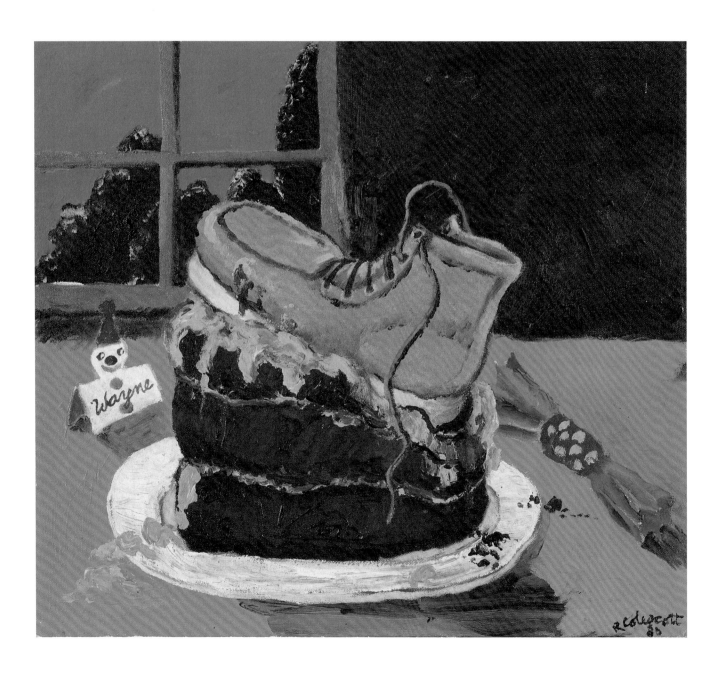

100 RAIMONDS STAPRANS
Way Too Many Unruly Oranges

1998, oil on canvas, 48 × 43 in.
Collection of Barbara and Ken
Oshman. Douglas Sandberg
Photography.

99 ROBERT COLESCOTT
*Artistry and Reality
(Happy Birthday)*

1980, acrylic on canvas,
16 × 18 in. Collection
of Jane and John Fitz
Gibbon. Photographer:
Stuart Allen.

cartoonist."[47] In paintings such as *The Two Gesso Cans* from about 2000 (fig. 101) there is a stately elegance in the delicate gradation of slate-blue tones and the architectonic structure, which, in a variation of Hofmann's push-pull dictum, vibrates faintly through a subtle slippage of register.

Although both Thiebaud and Arneson achieved national acclaim, Arneson was the most influential artist to come out of Davis in the 1960s. It was Arneson who, together with Peter Voulkos, revolutionized the medium of ceramics, elevating it from a traditional craft to the realm of fine arts. But Arneson and his circle, unlike Voulkos, fully embraced Pop Art's love of kitsch by replacing respectable stoneware with cheap low-fire white clay colored with garish hobby-shop glazes. They also celebrated popular culture in their emphasis on humor, which even today enjoys little respectability due to its association with illustration and cartooning.[48] By combining comedy and clay—breaking two high-art taboos at once—the Davis ceramists thus created a "double-whammy," according to Arneson's student Richard Shaw.[49] Yet while they shared an appreciation for the debased and vulgar, the Davis group deliberately asserted their independence from New York trends, finding affinity only with Claes Oldenburg—although the Davis sculpture was goofier, gawkier, and sillier than Oldenburg's colossal droopy teddy bears and towering clothespins. As Thomas Albright noted, the stance of the Davis artists constituted a reactionary "anti-Formalist 'personalism,'" celebrating above all individual eccentricity.[50]

Arneson's first ceramic works at Davis epitomize the difference between East and West Coast sensibilities. *Six Pack* of 1964 (fig. 102), for example, takes its inspiration from Warhol's well-known *Green Coca-Cola Bottles* of 1962 (fig. 103), but unlike Warhol's deadpan repetition of trademark imagery, Arneson renders "6-Up" bottles in an intentionally antislick manner that one critic praised for its "expert crudity."[51] *Typewriter* (fig. 104), made the following year, might have taken its cue from Oldenburg's vinyl sculpture of the same subject, but it is closer in spirit to the paradoxical Surrealist *objet poétique*, with its conflation of woman and office machine, substituting typewriter keys with fiery red fingernails.[52]

Arneson's later object sculpture became increasingly autobiographical. The monumental *Smorgi-Bob, the Cook* of 1971 (fig. 105) inaugurated a series of eighteen self-portraits that were completed over the next two years. It is unusual in that it is as much

101 RAIMONDS STAPRANS
The Two Gesso Cans

c. 2000, oil on canvas, 63 × 51 in. Collection of the San Jose Museum of Art. Gift of Raimonds Staprans. Douglas Sandberg Photography.

103 ANDY WARHOL
Green Coca-Cola Bottles

1962, oil on canvas, 82¼ × 57 in. Whitney Museum of American Art, New York, purchased with funds from the Friends of the Whitney Museum of American Art. © 2003 Andy Warhol Foundation for the Visual Arts/ARS, New York. Photograph © 1998 Whitney Museum of American Art, New York. Photographer: Geoffrey Clements.

102 ROBERT ARNESON
Six Pack

1964, glazed ceramic, 10 × 9¼ × 6½ in. Collection of di Rosa Preserve, Napa, Calif. © Estate of Robert Arneson/Licensed by VAGA, New York. Photographer: Stefan Kirkeby.

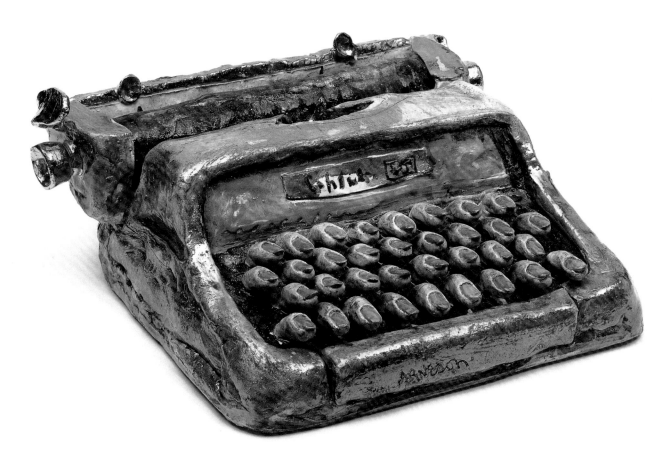

104 ROBERT ARNESON
Typewriter

1965, ceramic, 6⅛ × 11⅜ × 12½ in. University of California, Berkeley Art Museum. Gift of the artist. © Estate of Robert Arneson/Licensed by VAGA, New York. Photographer: Ben Blackwell.

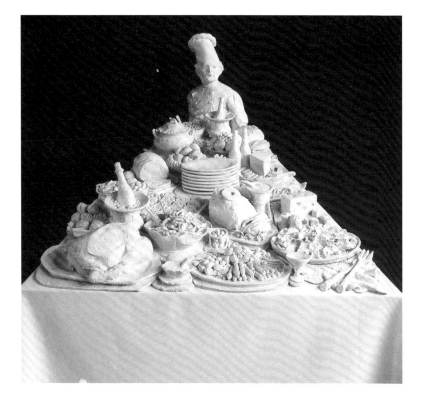

105 ROBERT ARNESON
Smorgi-Bob, the Cook

1971, white earthenware with glaze, vinyl tablecloth, and wood table, 73 × 66 × 53 in. San Francisco Museum of Modern Art; purchase. © Estate of Robert Arneson/Licensed by VAGA, New York. Photographer: Phillip Galgiani.

a portrait as a still life—not in the tradition of the "object-portrait" that George Herms revived, but in a manner all Arneson's own. Arneson had just completed a series of "Dirty Dishes"—finished and unfinished meals on plates, some of which spoofed the work of Thiebaud.[53] He then expanded this idea into a full tableau with a buffet table laden smorgasbord-style, every inch supporting plates piled high with ham, turkey, salads, rolls, fruit, cheeses, and various finger foods. With a depth of less than five feet, the sculpture is a tour de force of three-dimensional illusionism, using extreme foreshortening to create the appearance of deep spatial recession. After he had finished the work, Arneson realized "that if I added another element in the back I could have a perfect triangle, so I included myself as a chef, honoring myself as a ceramist, a man of baked goods."[54]

David Gilhooly, one of the earliest students in the Davis ceramics department, also tackled the ceramic still life with a raucous sense of humor that vied with Arneson's. Gilhooly credits Thiebaud and Oldenburg as the primary inspirations for his first sculptural consumer edibles, beginning in the mid-1960s with outsized fur-covered Snickers Bars and fudge-

sicles. These ultimately gave way in the early 1970s to an enormous variety of clay foodstuffs that derived their humor chiefly from their interaction with what had become Gilhooly's consuming obsession: frogs. Indeed, not only had the amphibious creature become Gilhooly's alter ego, but it now populated a parallel universe of Gilhooly's invention that cast frog counterparts to everyone from important historical personages (Mao-Tse Toad) to movie stars (Boris Frogloff). According to Gilhooly's "Frogdom" creation myth, the deity FrogOsiris "evolved into a Compost God who grew brilliantly glazed ceramic vegetables, which were eventually marketed on a stand operated by a creature named Frog Fred."[55]

Thus came about the first of Gilhooly's roadside stands, where frogs frolicked freely with turnips and tomatoes (fig. 106).[56] As the artist recalled, "There were lots of plump vegetables around in the barrows and baskets, and some especially plump frogs seemed to be making love to them."[57] Although Gilhooly was not likely to have concerned himself with historical precedent, his produce stands were in effect still lifes in the Rabelaisian tradition of the butcher stalls and fish stands of mid-sixteenth-century Dutch painters such as Pieter Aertsen and

106 David Gilhooly with Frog and Vegetable Stand Photograph courtesy of David Gilhooly.
 in Nathan Phillips Square, Toronto, 1972.

Joachim Beuckelaer.[58] Yet they were also firmly of their time, kin to Oldenburg's celebrated *Store* (1961–63), a recreation of a Lower East Side retail outlet filled with garishly enameled objects. Gilhooly's produce stands might well be categorized as still life Happenings—the ultimate "not-so-still life"—in that all of the objects were, as in the case of a real roadside operation, infinitely replaceable and for sale, with price tags often as low as the genuine item.

In fact, it seems that Gilhooly's love of comic narrative precluded a stationary status to any of his still lifes. His frogs cavort in bowls of Oreo cookies and splash about in oyster stew. Typical of Gilhooly's work is *Never on a Sundae* (1974), part of what the artist described as "an elite line of frog food that would appeal to people in love." In this piece, Gilhooly depicts a honeymooning pair of frogs consummating their marriage on a mound of whipped cream.[59] His hamburgers and dagwood sandwiches generally contain wriggling frogs among their fixings or, as in *The Leaning Tower of Dagwood* of 1984 (fig. 107), are so tall they sway precipitously to one side.

Unlike most of his fictional works, Gilhooly's "FrogFry" series (fig. 108), which spanned the years 1974–95, has a true story behind it. As the artist explains, in 1974, when he was teaching at York University, the new chairman of the department, "a New York reactionary," threatened to fire him for working in a medium that he found unacceptable as fine art. Gilhooly's response was to produce his first ceramic sculpture of a frying pan sizzling with eggs, ham, and of course, frogs—a piece that apparently impressed the faculty sufficiently to save his teaching position.[60]

Gilhooly's fellow student from his Davis days, Peter VandenBerge, also developed a humorous line of not-so-still lifes, but in his case the dramatis personae were root vegetables. Two versions exist for the origins of VandenBerge's vegetables. One holds that he was encouraged by the very setting of the University of California, Davis, an agricultural school in the fertile Sacramento Valley. The ceramics classes were held in a small corner of the TB-9 building, headquarters of the sprawling Food Sciences Department and its infamous lab—which, like some kind of mad scientist's workshop, reportedly produced thousands of cans of experimental produce, including such fantastic hybrids as "aspara-tomatoes" and "tangi-kiwis."[61] Another explanation comes from VandenBerge himself, who was teaching at San Francisco State in the late 1960s and spending a good deal of time with Gilhooly, then teaching at San Jose State:

One time we went by the Farmer's Market and I was struck by the forms. First I did root vegetables: carrots, turnips, radishes, beets. . . . Then I gave them a setting, because humor is particularly important. I did a sculpture of a carnivorous carrot lady in a house with a tile roof and you could see into the house from all different angles. She had bones lying on the floor and things like that. In those days in San Francisco vegetarianism was popular.[62]

In the late 1960s VandenBerge produced a series of erotic vegetables such as "trysting turnips" and "bathing-beauty broccoli" before settling on the carrot as his primary subject.[63] By the time VandenBerge's ceramic sculptures premiered at the Candy Store gallery in Folsom, California, in 1968, he had developed a wide array of provocative guises for them. The Candy Store exhibition reportedly included carrots lolling about in bed, luxuriating in a bubble bath, and playing tennis.[64] One of the earliest of these works, *Couple Watching Saturday Night Movie* of 1969 (see fig. 5), depicts two carrots entwined in an overstuffed chair. Close inspection indicates that the couple and even their chair are sprouting roots. Apparently, they have been snuggling in front of their television for so long that they have become a root version of the "couch potato."[65] Another work of 1975, *Carrot Mother and Child* (fig. 109), demonstrates VandenBerge's capacity for irreverent satire worthy of Gilhooly. Here a carrot mother tenderly holds her tiny infant between her more than ample breasts. The cruciform shape of the piece makes the biblical reference unmistakable, yet Immaculate Conception is out of the question. As VandenBerge has explained, the seam that runs vertically along the mother's lower belly indicates that a Caesarean section has been performed.[66]

Humor in Richard Shaw's still lifes also comes from absurdist incongruity, the comic spark that occurs when two disparate things come together unexpectedly. Shaw studied ceramics with Ron Nagle, James Melchert, and Robert Hudson at the San Francisco Art Institute before enrolling in the master's program at Davis with Arneson in 1966. His first works were hand-sculpted objects made from earthenware decorated with absurdly inappropriate hand-painted scenes. In 1971, diverging from his Davis colleagues' predilection for the gloppy surfaces of low-fire clay, he began to work in cast porcelain, a fine-grained, high-fired ceramic. After experimenting with underglazing and photo silkscreen, Shaw hit upon the remarkable trompe l'oeil technique for which he is best known. This

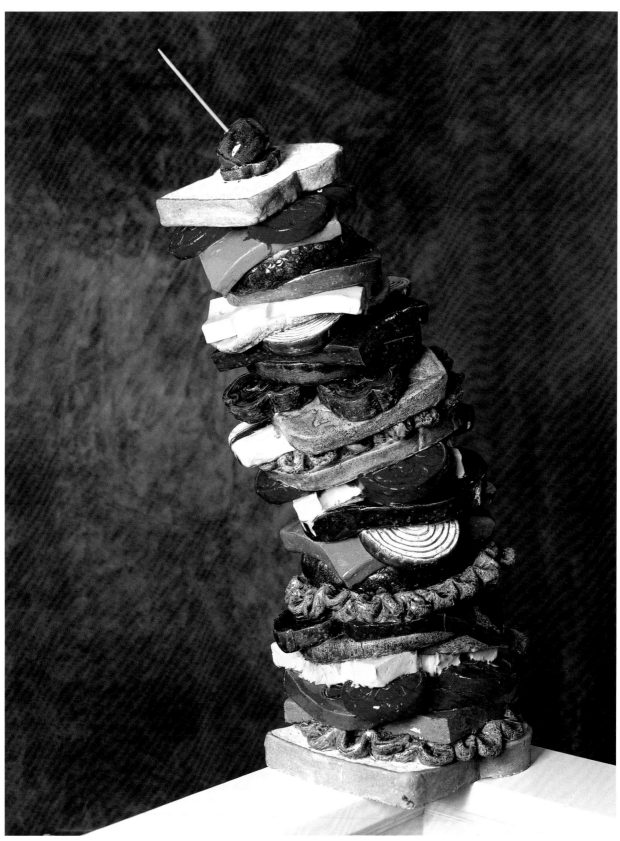

107 DAVID GILHOOLY 1984, ceramic, 38 × 12 × 19 in. Collection of Katie
The Leaning Tower of Dagwood and Drew Gibson. Douglas Sandberg Photography.

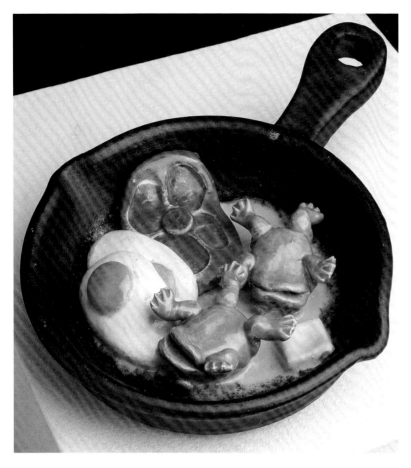

108 DAVID GILHOOLY
Mini-Fry (with eggs and ham)

1991, ceramic, 2 × 10⅝
× 7½ in. Collection of
Bebe and Crosby Kemper.
Photographer: Dan Wayne.

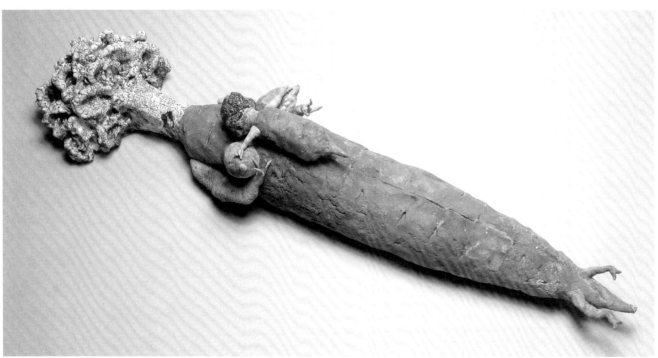

109 PETER VANDENBERGE
Carrot Mother and Child

1975, ceramic, 33¼ × 9 × 6 in. Collection of the San Jose
Museum of Art, museum purchase with funds from the
Collections Committee. Douglas Sandberg Photography.

method enabled him to achieve photographic likeness of just about any object that struck his fancy—generally "found" common objects collected from his studio, taken from friends, or culled from antique shops and flea markets. Shaw's use of playing cards, stacks of books, and letters makes conscious reference to the nineteenth-century American masters of the trompe l'oeil still life William Harnett and John F. Peto. *Martha's House of Cards* of 1980 (see fig. 79) exemplifies one of Shaw's most successful works in this genre: a life-sized house of cards propped precariously on a stack of books, all rendered with astonishing fidelity, down to a child's pencil scrawl on the volumes' pages.

In the late 1970s Shaw decided he wanted to animate his stacks of objects—to "make walking figures as anthropomorphized still lifes," as he later put it.[67] These whimsical stick figures are cast from everything from soup cans to coffeepots. Loosely held together with porcelain limbs simulating pencils, deer antlers, and tree branches, they are mostly funny for the arbitrariness of their assembly. Some, however, like *Little French Girl* from 1996 (fig. 110), are truly witty. At first this piece suggests a spindly pumpkin-headed figure, perhaps an allusion to Frank Baum's lovable character in *The Land of Oz*.[68] Closer examination reveals a structure composed of hamburgers and hot dogs. But the piece becomes ludicrous when one discovers that its inspiration is Constantin Brancusi's elegant sculpture of the same name at the Solomon R. Guggenheim Museum (fig. 111). The only other reference to the figure's French identity is the melting wedge of brie beneath her right foot.

The development of the Pop Art still life in Los Angeles underlines the striking regional distinctions between north and south in the 1960s. New York Pop Art came early to Southern California and was extremely well received.[69] The movement made its West Coast debut in 1962 when Irving Blum showed Warhol's Campbell Soup cans at the Ferus Gallery in Los Angeles—the artist's first solo exhibition on either coast. Later that year, curator Walter Hopps organized what was probably the first group museum exhibition in the country for Pop Art at the Pasadena Art Museum, "The New Painting of Common Objects," a show that featured New York and Los Angeles artists side by side.[70] Yet as art historian Anne Ayres observed in her landmark study of the subject, iconic Pop Art never caught on in Southern California. Pop was always infused with Neo-Dada (especially that of Johns) and vague currents of Surrealism, producing a blend she called "Impure Pop."[71] If "pure" Pop is taken to mean the

nearly unmodified appropriation of commercial subjects and mechanical techniques from mass culture—best exemplified by Warhol and Lichtenstein—then it never was practiced in Southern California for the simple reason that Los Angeles artists never relinquished personal inflection. Nonetheless, their approach is quite different from that of their Northern California counterparts, with none of the zany antiformalism common in Davis. Fantasy and humor can be found, but it is always subtle, much more akin to the East Coast spirit of detached irony.

Of all the Los Angeles artists, Ed Ruscha comes closest to the cool stance that was essential to the Pop style of New York. (In fact, Ruscha met Warhol and Rosenquist on a trip to New York in 1961 before the movement was named.)[72] Ruscha's crisp, unmodulated surfaces and use of readymade advertising imagery were executed with flawless lettering and design. Yet Ruscha's paintings generally involve personal invention and parody rather than deadpan appropriation. In early responses to Pop such as *Actual Size* of 1962 (fig. 112), Ruscha selected a subject that is truly low-brow: Spam, the processed ham spread that in the 1950s came to be emblematic of plebeian taste. As the title suggests, he has borrowed a convention from advertising, representing the product as life size, so that viewers can appreciate it in all its glory. But far from rendering the food as an advertiser might, by appealing to the consumer's appetite, Ruscha shows the can plunging downward, spewing a trail of fire like a plane about to crash. In this context, the oversized letters across the top of the painting spelling "Spam" assume new meaning. The word's rhyme with "blam" deftly parodies the bellicose comic book language beloved by Lichtenstein.[73]

Ruscha's playful subversion of art world convention can be seen in his still lifes of the late 1960s, which are rarely still. In 1968 he began a series of paintings of marbles in various guises and activities. Marbles, unless placed decoratively in a bowl, are inherently on the move, and in Ruscha's case they can be destructive. In *Marble Shatters Drinking Glass* of 1968 (fig. 113) Ruscha impetuously shows us the result of a marble's collision with a solitary glass. The subject here is not the child's game, but rather the nature of painting and illusion. In Ruscha's inimitable style, the glass and the marble are rendered with almost tangible clarity, while their spatial relationships are ambiguous. The objects float against a russet-colored field with a smooth-as-airbrush gradation from dark to light—paradoxically calling to mind both a Tanguy-style landscape and

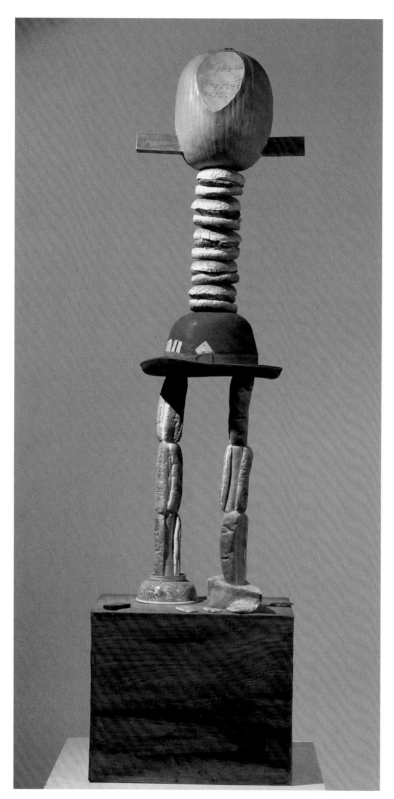

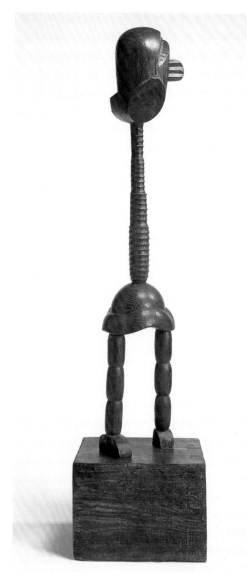

111　CONSTANTIN BRANCUSI
Little French Girl

c. 1914–1918, oak, 60 × 13 × 14⅝ in. Solomon R. Guggenheim Museum, New York. Gift, Estate of Katherine S. Dreier, 1953. © 2003 Artists Rights Society (ARS), New York/ADAGP, Paris. Photographer: David Heald; © The Solomon R. Guggenheim Foundation, New York.

110　RICHARD SHAW
Little French Girl

1996, porcelain with glaze transfer, 61 × 17¼ × 12 in. Collection of the San Jose Museum of Art, museum purchase with the support of Drew and Katie Gibson, the Oshman Family Foundation, and the Lipman Family Foundation in honor of Wendy Kirst. Photographer: schoppleinstudio.com.

112 ED RUSCHA
Actual Size

1962, oil on canvas, 72 × 67 in. Los Angeles County Museum
of Art, anonymous gift through the Contemporary Art Council.
Photograph © 2002 Museum Associates/LACMA. © Ed Ruscha.

113 ED RUSCHA 1968, oil on canvas, 20 × 24 in. Collection of Mr. and Mrs.
 Marble Shatters Drinking Glass Ahmet Ertegün. Photographer: Adam Reich. © Ed Ruscha.

the kind of monochromatic Color Field painting popular in New York. In *Bouncing Marbles, Bouncing Apple, Bouncing Olive* (fig. 114), painted a year later, we find the objects once again distributed against a void. Here too the painting begs the question of the literal versus the depicted shape: although the title tells us the objects are bouncing, in reality they are merely placed at varying heights in a field of color. By placing the marbles at the extreme edges, Ruscha may also have been satirizing Morris Louis, who throughout the 1960s was highly praised by critics such as Michael Fried and Clement Greenberg for his "radical" concept of opening up a central field in his abstractions.[74]

Ruscha's colleague Joe Goode also developed an innovative approach to still life informed by the strains of Neo-Dada, Pop, and Color Field painting emanating from New York—but with hardly a hint of Ruscha's satire. From the beginning it was evident that these two artists, boyhood friends from Okla-

homa City and fellow students at the Chouinard Art Institute in Los Angeles, would follow the lead of their differing temperaments: Ruscha the clever punster and Goode the quiet lyricist. In 1961 Goode took inspiration from Johns's cast-bronze ale cans, exploring the possibilities of the common object with deliberately plain, closely observed pencil drawings and lithographs of such ordinary household subjects as screwdrivers, jackknifes, telephones, and loaves of bread. That same year he began painting the "Milk Bottle" series that brought him national attention. Each of the thirteen works in the series includes a real but hand-painted glass bottle standing on the floor in front of a single or two-part color canvas. Occasionally, the bottle is accompanied by a "ghost" image on the canvas.

The "Milk Bottles" have provoked a broad range of conflicting interpretations. They have led critics to variously characterize Goode as, on the one hand, a sophisticated rhetorician along the lines of

114 ED RUSCHA
Bouncing Marbles, Bouncing Apple, Bouncing Olive

1969, oil on canvas, 60 × 55 in. Collection of The Nelson-Atkins Museum of Art, Kansas City, Missouri; gift of Norman and Elaine Polsky, Fixtures Furniture, Kansas City, F86-50/3. Photographer: Jamison Miller. © Ed Ruscha.

Frank Stella and, on the other, a modern-day Harnett, sharing, in art critic Philip Leider's words, "that peculiar attraction to the common art object which seems to be ingrained in the very fiber of American life."[75] The truth lies somewhere in between. Although Goode studied with minimalist artist Robert Irwin at Chouinard and was well versed in the formalist issues of the day, his concerns were never, as was true of New Yorkers such as Stella, hermetically sealed within an art-about-art dialogue. Like most West Coast artists, Goode retained a belief in the expressive possibilities of form and color, long after they had become relics of a discarded ideology in the East.[76] As Goode has often taken pains to make clear, the "Milk Bottle" paintings, like all of his subsequent work, are meant to evoke a range of emotional responses. For the artist, they are deeply personal, and they lack any trace of irony: *One Year Old* (1961) refers to the age of his young daughter; *Happy Birthday* (1962; fig. 115), with its expanse of party pink, evokes feelings of innocence and nostalgia; another, *One for Monk* (1962), is an homage to the bebop musician. In most cases there is some autobiographical reference, but the artist has said that his most successful paintings are the ones that "make the viewers feel something personal about themselves. . . . I try to keep the subject as universal as possible, simple and conventional."[77]

Vija Celmins's work of the 1960s is routinely annexed into the precincts of Pop, but she, like Goode, began with an interest in household objects before the New York movement endowed such subjects with art world cachet. In the early 1960s, while still an art student at the University of California at Los Angeles, Celmins found herself drawn to the Italian modernist still life painter Giorgio Morandi, admiring his simple renderings of bottles and jars, especially those painted in delicate grisaille tones. Morandi's ability to produce an atmosphere that is at once chaste and almost unaccountably strange became a lifelong goal for Celmins.

Beginning with basic studio set-ups of crockery and plates of food, Celmins soon started painting household electric appliances such as lamps and television sets. *Eggs* of 1964 (fig. 116), while depicting a subject with an ancient history, has an inescapable "Pop" feel due to the electric frying pan (then quite modern) as well as its frontal, flat presentation against an empty ground. *Heater* (fig. 117), by contrast, while painted the same year, bears the hallmarks of Celmins's mature work. Here the influence of Morandi is apparent, though completely transformed. Celmins has taken on the Ital-

ian's simplification of form and close tonal range, but her grays have an expressive value that transcends their visual interest. Subconsciously calling to mind cinder and ash, these grays heighten the heater's sinister fiery glow. What might seem a straightforward painting of an innocuous appliance thus projects a menace as subtle as a barely registered aftertaste. In fact, Celmins was developing an interest in Surrealism's subliminal expression. In the late 1960s her admiration for Magritte led her to produce an homage in the form of a six-and-a-half-foot tortoise-shell comb.[78] Celmins also crafted a remarkable set of outsized "Pink Pearl" erasers made of acrylic-coated balsa wood, each nineteen inches long (fig. 118). Typical of Celmins, they combine beauty and austerity, with soft pinks and grays that are seductive yet restrained by the uninflected transcription of so banal a subject.

If Celmins's still lifes imbued the familiar with a quality of the unfamiliar, Martha Alf performed a similar artistic alchemy on mundane subjects. In the case of Alf, however, the aim was never to produce disquiet or disjuncture, but rather to aestheticize the unaesthetic, to turn the most forgettable objects into visions of enchantment. Alf, like Celmins, came of age in Los Angeles at a time when Pop and Color Field painting were ascendant, and both strains appear to varying degrees in her work. Also like Celmins, Alf began her career painting conventional still lifes. Her first paintings while pursuing master of arts degree at San Diego State University in the early 1960s—meticulously executed vases of flowers and clusters of vessels—applied the techniques of the seventeenth-century Spanish still

115 JOE GOODE
Happy Birthday

1962, oil on canvas and oil on glass milk bottle, 67⅛ × 67 × 3 in. San Francisco Museum of Modern Art, gift of The Gerald Junior Foundation. Photographer: Ben Blackwell. © Joe Goode.

116 VIJA CELMINS
Eggs

1964, oil on canvas, 24¼ × 35¼ in. Collection of the Museum of Contemporary Art, San Diego, Calif., museum purchase with funds from George Wick and Ansley I. Graham Trust, Los Angeles, in memory of Hope Wick. Photographer: Philipp Scholz Rittermann.

117　VIJA CELMINS
Heater

1964, oil on canvas, 47⁷⁄₁₆ × 48 in. Whitney Museum of American Art, New York, purchased with funds from the Contemporary Painting and Sculpture Committee.

118 VIJA CELMINS
 Eraser

1967, acrylic on balsa wood, 6⅝ × 20 × 3⅛ in. Collection of the Orange County Museum of Art, gift of Avco Financial Services, Newport Beach, Calif. Christopher Bliss Photography.

life painters Juan Sánchez Cotán and Francisco de Zurbarán, whose *bodegones* (shelf pictures) she admired for their spare simplicity of design. On trips to New York and through close study of the few examples in Southern California collections, Alf taught herself illusionistic painting techniques of the Old Masters, becoming increasingly drawn to those artists who used "no edges"—Leonardo, Rembrandt, and Vermeer.[79] By the late 1960s, when she enrolled for an M.F.A. at the University of California at Los Angeles, Alf had acquired a fairly sophisticated understanding of how to render light and shadow through the Renaissance devices of grisaille, glazing, chiaroscuro, and sfumato.

In Los Angeles, Alf would combine all of these methods to produce a kind of painting that was at once traditional and profoundly unconventional, brilliantly fulfilling the Pop aspiration of turning quotidian waste products into high art. Within a short time of moving back to Los Angeles and taking classes with Richard Diebenkorn, who had begun his stately "Ocean Park" abstractions, Alf took a formalist turn in her approach to her art. After a brief stint in nonobjective painting she returned to the still life theme, selecting objects that had no specific connotations—a ceramic insulator, a fire-hose nozzle, and a series of deodorant caps. These then led to the work

that would occupy her for the next five years: a series of canvases depicting rolls of toilet paper, known as the "Cylinder Paintings." In the inherently soft and almost fleshy texture of tissue paper Alf found the perfect vehicle for her accumulated knowledge of the craft of painting, particularly the smoky gradations she had studied in the sfumato and chiaroscuro of Leonardo. In 1971 she painted three rolls in *Kleenex Boutique* (fig. 119), shortly followed by four cylinders in *Zee-4-Pack* (1974). By 1973 she was isolating and centering a single roll against a "horizon" line. Paintings such as *Violet, Yellow, and Green* (1974), *Lavender and Black* (1974), and *Red and Black #2* (1975; fig. 120) are no longer designated by titles referring to their status as bathroom commodities, but only by their colors. It seems Alf had outgrown her cheeky Pop-inspired delight in choosing so base a subject as toilet paper. In fact, these works are first and foremost studies of color and light—not in the strictly formalist sense, but in the tradition of Rothko: they create an extrasensory "chord of feeling." In the artist's words, the "Cylinder Paintings" (as can be said of all of her still lifes, including the pears of more recent years) were intended to serve as a "contemplative formal equivalent to mystical experiences."[80] Still, as former *Los Angeles Times* critic William Wilson observed with no small hint of irony, to bring

119 MARTHA ALF 1971, oil on canvas, 16 × 28 in. Collection of Richard and
 Kleenex Boutique Gittelle Gold. Photographer: © Douglas M. Parker Studio.

about such a transformation is quite a feat: "Martha Alf may be the only artist who ever made a roll of toilet paper look metaphysical."[81]

A survey of Pop-inspired still life would be deficient without acknowledging David Hockney. Yet although he has been called the "British Andy Warhol," Hockney makes perhaps the least comfortable fit of all of the artists examined thus far. Hockney's Pop credentials stem from his association with the London Pop movement that, in the late 1950s, preceded developments in New York, and from his unabashed celebration of the glitz and glamor of Los Angeles, the ultimate "pop metropolis." Nonetheless, almost from the first, Hockney rejected the formalism of movements in American art during the 1960s, finding them devoid of significant content. His own inclinations were too personal and autobiographical. Perhaps it was Hockney's outsider status as both a gay and a foreigner—along with the freedom that he found in his adopted home of Los Angeles—that gave him permission to think and work so fully outside the parameters of the American avant-garde.

In the first group of still lifes Hockney produced in America shortly after his arrival in 1964, we find him coming to terms with the formalist position, first making a nod of recognition, then disputing its fundamental tenets. By his own account, Hockney began *A Realistic Still Life*, followed by *A More Realistic Still Life* and *A Less Realistic Still Life* (fig. 121), all from 1965, with the New York abstract artist Kenneth Noland in mind.[82] Like Noland, he used stained acrylic paint on raw cotton duck to achieve smooth, self-effacing surfaces. In these and related works, including *Blue Interior and Two Still Lifes* (fig. 122), also from 1965, the stained rivulets that form a framing border may also allude to the stained *Unfurleds* of Morris Louis. But taken together, these paintings challenge rather than pay tribute to the extreme formalism of post-painterly abstraction. In *Blue Interior,* the much ballyhooed staining technique is reduced to empty decoration—no more than a framing device. Most important, as art historian Marco Livingstone has pointed out, the paintings take issue with Cézanne, the founding father of formalism. The inclusion of cones, cylinders, and spheres makes

120 MARTHA ALF
Red and Black #2

1975, oil on canvas, 39 × 50 in. Collection of the Orange County Museum of Art, museum purchase with additional funds provided by the National Endowment for the Arts, a federal agency. Photographer: Gene Ogami.

obvious allusion to Cézanne's famous remark about distilling visual reality to these three components—a view that Hockney disputed in his autobiography:

The thing Cézanne says, about the figure being just a cone, a cylinder and a sphere: well, it isn't. His remark meant something at the time, but we know a figure is really more than that, and more will be read into it. . . . You cannot escape sentimental—in the best sense of the term—feelings and associations from the figure, from the picture, it's inescapable. Because Cézanne's remark is famous—it was thought of as a key attitude in modern art—you've got to face it and answer it. My answer is, of course, that the remark is not true.[83]

This is just what Hockney did in his still lifes of the mid-1960s. As Livingstone points out, in its "less realistic" version "the result is a virtually abstract picture that teeters dangerously close to vacuity in its presentation of slender formal devices outside their customary formal context."[84] As if to make his point unmistakable, Hockney's *Portrait Surrounded by Artistic Devices*, also of 1965, takes the cylinders of his still lifes and presents them as a useless pile obstructing the real subject of the painting, a subject that personally mattered to the artist: his father.

By the end of the year, Hockney had staked his claim to freedom from the constraints of formalism and avant-garde imperatives of any kind. His series of prints entitled *Hollywood Collection* (1965) shifted with unapologetic abandon from abstraction to the most traditional interpretations of the conventional genres—landscape, portraiture, and still life—demonstrating that for him, these were merely options to be chosen at whim. Hockney's subsequent still lifes show a stylistic range from abstraction to tight realism, although most seem to partake of a Matissian hedonism, reveling in vivid color and bravura brushwork. *Breakfast at Malibu, Wednesday* (fig. 123) and *Breakfast at Malibu, Sunday*, both from 1989, are nearly operatic in the drama of the ocean, particularly in contrast to the calm and dignified table settings for tea. In fact, these pictures of his newly purchased Malibu cottage were painted not long after he had completed his stage sets for the Los Angeles Music Center Opera's production of Wagner's *Tristan and Isolde*, which were accompanied by a number of related paintings executed with bold color and rapid paint handling. At the other extreme, since the late 1980s Hockney has produced a series of quiet flower paintings like *Bridlington Violets* from 1989 (fig. 124), an openly sentimental tribute to a friend who died of AIDS.[85]

121 DAVID HOCKNEY
A Less Realistic Still Life

1965, acrylic on canvas, 48 × 48 in.
Private collection. Photographer:
Adam Reich. © David Hockney.

122 DAVID HOCKNEY
Blue Interior and Two Still Lifes

1965, acrylic on canvas, 57 × 56¾ in. Virginia Museum of Fine Arts, Richmond. Gift of Sydney and Frances Lewis. Photographer: Katherine Wetzel. © Virginia Museum of Fine Arts. © David Hockney.

123 DAVID HOCKNEY
Breakfast at Malibu, Wednesday

1989, oil on canvas, 24 × 36 in.
Private collection. Photograph
courtesy of L.A. Louver Gallery,
Venice, Calif. © David Hockney.

124 DAVID HOCKNEY
Bridlington Violets

1989, oil on canvas, 14 ×
18 in. Private collection.
© David Hockney.

Hockney's embrace of still life, particularly the traditional variant he practiced, steeped in sentiment and sensuality, made him a true maverick in the 1970s. Aside from the Davis antiformalists and a few scattered eccentrics in the Bay Area, most California artists, especially in Los Angeles, fell into step with the rest of the country in their pursuit of new art practices that allowed little room for still life. The years from roughly 1968 to 1981 have been called the "pluralist era," and it is true that a confusing number of overlapping approaches jostled for attention.[86] Artists could choose among minimalism, pattern painting, systemic abstraction, fiber art, light art, earth art, process art, conceptual art, performance art, installation art, video, and many varieties of political art, generally focusing on liberation, identity, and environmental themes. Yet in spite of this multiplicity, the period was not as free as many art historians have assumed, and its "postmodernism" was nascent at best.[87] In hindsight it is becoming apparent that the 1970s suffered from a kind of schizophrenia, driven by two mutually exclusive impulses. Artists were either constrained by a fanatical formalism that narrowly focused their attention on materials and original manners of deployment to the exclusion of meaningful content; or, if they chose to address content, they gave precedence to the work's message (usually political), eschewing aesthetic concerns. Taken as a whole, the period was overbearingly austere, even puritanical.

There are always exceptions to art-historical generalities, and one of these exceptions is Eduardo Carrillo, whose extremely personal still lifes belong in a category all their own. From the start Carrillo was an intuitive painter, having studied with Stanton Macdonald-Wright and William Brice at UCLA in the early 1960s. While Pop, Op, and formalist abstraction were at their height, he looked instead toward Spain and his Mexican heritage for inspiration. After an extended trip to Madrid, where he saw paintings by de Chirico, Bosch, El Greco, and Velázquez, he returned with a style that reflected the Baroque rhythms and flickering light of the Spanish masters and a propensity toward fantastic imagery with Magic Realist overtones. Along with a handful of rebels from UCLA—Roberto Chavez, Charles Garabedian, Joan Maffei, and Lance Richbourg— Carrillo exhibited at the Ceeje Gallery, an offbeat alternative space in Los Angeles that countered the increasingly slick formalism of the Ferus Gallery with a commitment to narrative art.[88]

While Carrillo painted a broad range of themes, from epic murals of Mexican history and mythology to self-portraits of penetrating depth, he returned to still life again and again throughout his career. Many of his paintings show an almost child-like delight in the manipulation of the shapes, colors, and textures of the sensory world. Often small in scale, these still lifes commemorate objects of personal significance. Others, such as *Testament of the Holy Spirit* of 1971 (fig. 125), incorporate symbols of Mexican culture. In this painting, Carrillo has transformed the Formica table in his suburban Sacramento home into an image of spiritual awakening. The coiled snake, a pre-Columbian symbol of divinity, combined with the magical play of reflected light streaming from the windows, signals the presence of the holy in this most mundane of settings.

Carrillo was clearly following his own muse in the 1970s, a time when most still life in California flourished in the restricted area of formalist realism and its subset, photo-realism, also known as superrealism. The latter tendency, sometimes called "post-Pop," seems to have grown out of Pop Art's reliance upon the prefabricated images of magazine reproductions and photographs. Most photo-realists, like Robert Bechtle and his East Coast counterparts Richard Estes and Malcolm Morley, concentrated not on still life but on urban or suburban scenes to give their work the stamp of modernity.[89] These artists professed indifference to the significance of their subject matter and its social and psychological implications, focusing primarily on matters of color, light, space, shape, and composition. But if the orientation of these realists was optical, their sensibility was rarely sensual, emphasizing instead synthetic, sometimes antiseptic, materials and surfaces.

Ralph Goings, generally regarded as a senior member of the original photo-realist group in California, was unusual in making still life central to his work.[90] His earliest photo-realist paintings in the mid-1960s concentrated on pickup trucks and other vehicles, but he soon moved on to interior views of suburban supermarkets and fast food chains. Goings's still lifes of condiments found in Burger King and McDonald's in the early 1970s are classic examples of the photo-realist style: cool, meticulous, and unrelentingly prosaic.[91] Later paintings of café and diner table settings—often larger-than-life assemblies of mustard and ketchup bottles, creamers, and napkin dispensers—are more complex as they emphasize the play of reflected light while maintaining a smooth and detached finish (fig. 126 and p. xi). As the artist has said, "My intention was always to remove myself from the work so that there was no intermediary between the viewer and the subject of the picture."[92]

125 EDUARDO CARRILLO 1971, oil on Masonite, 47½ × 60 in. Collection of the Crocker
 Testament of the Holy Spirit Art Museum, Sacramento, Calif., gift of Maude T. Pook Fund.

Like Goings, Jack Mendenhall denies both the human presence and the human touch. Mendenhall's still lifes are generally adjuncts to his domestic interiors, often smartly contemporary, up-to-the-minute apartments. The objects in these apartments all look factory minted and straight out of the box. One can almost smell the new carpet and fresh paint. Indeed, it seems as if no one has ever lived in his dwellings or handled their contents. In the case of *Sofa with Flowers* from 1976 (fig. 127), this turns out to be true: although the satin sofa, sparkling crystal, and extravagant floral arrangement appear to belong to a plush living room, they are in fact a fictitious arrangement in a storefront window. The overriding feeling, as in all of Mendenhall's work, is one of gleaming artificiality.

A related quality of immaculate, airless precision can be found in the formalist-realist still lifes of Charles Griffin Farr. Unlike Mendenhall, Farr did not rely on photographs or reproductions, yet his works achieve an equally eerie impersonality. A generation older than Mendenhall with roots in traditional formalist abstraction, Farr was considered an artist of the most conservative stripe when he declared in the late 1940s, during the height of Abstract Expressionism, that he was no longer "interested in working freely."[93] For decades he then worked in obscurity, perfecting his spare style and concentrating almost exclusively on the still life. His subjects were always traditional—flowers, especially irises and calla lilies, and tables tilted parallel to the picture plane offering sliced melons and bowls of apricots and plums. Although his work changed little after the late 1950s, it was only in the 1970s that Farr was recognized as an artist worthy of critical attention. Paintings such as *Watermelon and Knife* of 1971 (fig. 128) give an impression of frozen timelessness that have caused commentators to describe his work as "otherworldly" and "funereal."

126 RALPH GOINGS 1976, oil on canvas, 24 × 34 in. Collection of Louis K.
 River Valley Still Life Meisel Gallery, New York. Photographer: Steven Lopez.

127 JACK MENDENHALL 1976, oil on canvas, 38½ × 54½ in. Collection of Oakland Museum of California,
 Sofa with Flowers Museum Donors Acquisition Fund and the National Endowment for the Arts.

Indeed, Farr once said of his calla lilies paintings that it "doesn't matter at all when people say that they look like they should be on a casket."[94] Although their paths were entirely separate, Farr's work has much of the same quality of cool yet seductive restraint that one finds in Celmins.

Restraint is also the defining characteristic of Gordon Cook, perhaps California's finest still life painter of the formalist-realist persuasion in the 1970s. A printmaker by training, Cook did not begin painting seriously until the late 1960s after he married Joan Brown and discovered the work of Morandi. His initial efforts on canvas were mostly Morandi inspired domestic objects: simply arranged cups, jars, and kitchen utensils. In the early 1970s he began painting the food delicacies he purchased in shops while walking the streets near his studio in North Beach, San Francisco's traditional Italian neighborhood: stuffed mushrooms, blood pudding, cotta salami, marinated peppers, olive loaf. Despite the exotic and indulgent nature of these subjects, Cook's paintings projected a quiet modesty and austerity that matched the artist's own self-effacing personality. *One Lb. Garbanzos* of 1976 (fig. 129) is typical of these intimate, small-scale works. Cook has painted the plain brown paper bag filled with dried beans with painstaking fidelity, rendering

every buckle, pucker, and crease of its surface, even the merchant's hand-written 59-cent notation on the wrapper. As with many of his paintings of this period, the palette is limited and subdued, reflecting the influence of Morandi. And as in Morandi's work, the objects are placed against a monochromatic field. There is also something of the Metaphysical Italian tradition in the strong cast shadow. But instead of a sense of mystery, the tone is one of prosaic pleasure in the simple purity of craftsmanship.

Cook, like most artists of the 1970s, used the still life primarily as a scaffold for plastic exploration. Although the boundaries of modernism were surely being tested during that decade, the rich associative potential of the object—and the enormous expressive possibilities of clusters of objects—was held back by a reflexive late-modernist antagonism to the art of the past. Still life could be fully explored only when artists realized that, as Kirk Varnedoe puts it, "the radically new is often the conventional reconfigured."[95] The artists of the 1980s and 1990s discovered that still life could be infinitely reshuffled, deconstructed, and reordered to suit the needs of the moment, whether as an instrument of parody, passion, or cool reflection. With its archaic pedigree, the genre easily lent itself to subversion and witty simulacra, yet it could also

128 CHARLES GRIFFIN FARR 1971, oil on canvas, 17 × 27⅜ in. Collection of Charles
Watermelon and Knife and Glenna Campbell. Douglas Sandberg Photography.

provide a powerful means of philosophical, psy-
chological, and social inquiry.

Murmurs of the genre's revival could be heard at
the end of the 1970s, but it was only in the 1980s
that still life came roaring back into American art,
making its mark on every conceivable medium,
from site-specific installation to new forms of elec-
tronic art. Initially, however, or at least most con-
spicuously, the genre made its comeback with the
rising tide of realism in the early 1980s. The first
exhibition to signal its return was the Allan Frumkin
Gallery's "The Big Still Life" of 1979 in New York,
which set off a flurry of critical reviews conjecturing
the revival of the genre and realism more gener-
ally.[96] This seminal exhibition was followed in the
early 1980s by a series of museum and gallery sur-
veys of still life throughout the country and the re-
printing of Charles Sterling's 1950s classic, *Still Life*

Painting from Antiquity to the Present Time, in 1981.[97]
As early as 1982, critic Janice Oresman could write
that "the acceleration of interest in realism during
the past ten years has re-established still life as an
important subject among artists working in many
different styles and media."[98]

Among the pioneers of the still life revival was
Paul Wonner, whose *Dutch Still Life with Cats and
Love Letters* (1979) was one of the most talked-
about paintings in the Frumkin show.[99] Wonner
had been painting still lifes since the 1950s (see
fig. 86), but only after 1976, when he switched to
acrylics, did he abandon his painterly Bay Area
Figurative manner to concentrate on the whimsical
still lifes for which he is best known (fig. 130).
Paintings such as *Dutch Still Life with Stacked Objects
and Telephone* of 1983 (fig. 131) show his delight
in bending seventeenth-century Dutch traditions

129 GORDON COOK 1976, oil on canvas, 15¾ × 18¾ in. Collection of Oakland Museum of
 One Lb. Garbanzos California, gift of the Collectors Gallery and the National Endowment
 for the Arts. Photographer: M. Lee Fatherree.

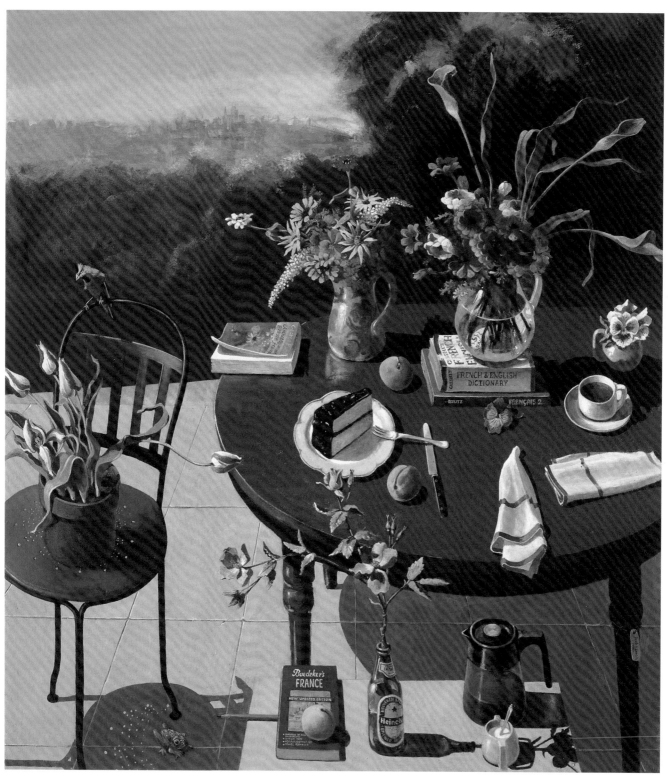

130 PAUL WONNER
*Garden Table with Flowers
and French Books*

1996, acrylic on canvas, 54 × 48 in. Private collection. Photograph
courtesy of John Berggruen Gallery, San Francisco.

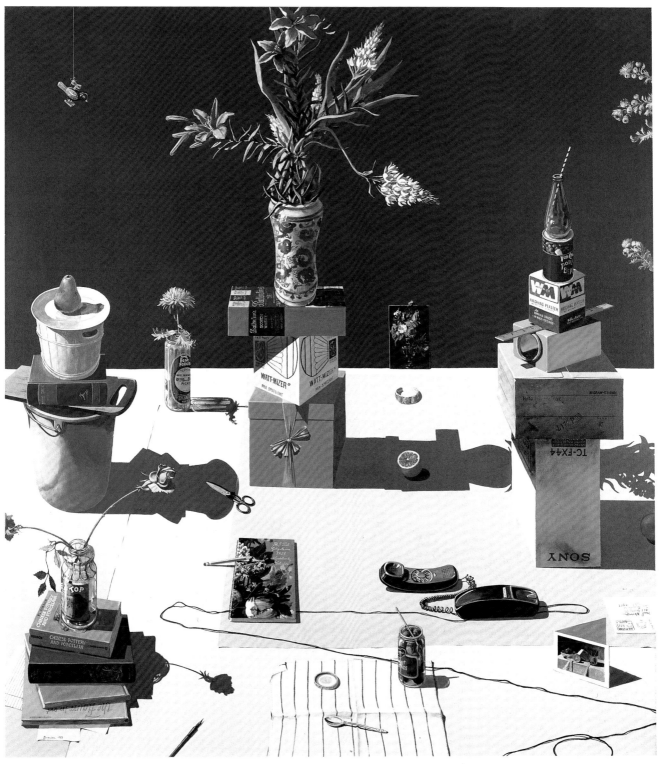

131 PAUL WONNER
*Dutch Still Life with Stacked
Objects and Telephone*

1983, oil on canvas, 71 × 64 in. Private collection.
Photograph courtesy Babcock Galleries, New York.

toward his own idiosyncratic ends. Wonner has borrowed not only the crisp literal style, which renders every detail with equal clarity and intensity, but he has parodied the Golden Age's love of material inventory. Wonner presents us with an array of the artist's own personal effects heaped in multitiered stacks to exaggerate the impression of plenty. But rather than the opulent spread of culinary indulgences and finery typical of Dutch *pronk* banquet tables, we find a quirky selection: a telephone with its receiver off of the hook, a pickle jar holding a single chrysanthemum, a soda bottle with a striped straw, and a jar of Del Monte gherkins. The centerpiece that might provide the expected opulence— an arrangement of tiger lilies in a Sung Dynasty blue-and-white vase—is rendered absurd by its position atop a precarious stack of boxes. There are also allusions to art-historical sources, including a postcard and calendar bearing reproductions of Dutch Golden Age still life paintings.

A reshuffling of hallowed tradition is also characteristic of David Ligare, who was influential in reestablishing realism in painting in the 1980s. Unlike Wonner, Ligare has never felt the need to qualify his embrace of tradition through irony or parody. Not only has he borrowed the stylistic techniques of Poussin and David, but he has adopted whole aspects of Neoclassical ideology, notably his conviction in art's capacity to shed philosophical and epistemological insight. "When I began making unapologetically Classical paintings in the late 1970s," he explains, "one thing became clear; that it was possible to make choices within the Classical canon that reflected not just aesthetic but moral or ethical decisions."[100]

Ligare spent a decade painting Arcadian landscapes populated with mythical personages before turning to still life as one of his primary themes. The format he established in the late 1980s has remained virtually unchanged. He selects a small group of objects and places them on shallow, stagelike shelf against a backdrop of sea and sky— Ligare's California version of the Renaissance technique of *repoussoir*. *Still Life with Grape Juice and Sandwiches (Xenia)* of 1994 (fig. 132) is typical of these eclectic still lifes. In this painting, Ligare combines classical Greek, Christian, and thoroughly contemporary iconography with the linear precision of Neoclassicism. The pitcher of grape juice next to slices of bread connotes the Eucharist, yet the juxtaposition also alludes to the ancient Greek practice of offering *xenia*, gifts of food to guests and strangers. This latter reference calls forth yet another layer of meaning when one learns

that grape juice and sandwiches are common fare at the community shelter for the homeless in Salinas, California, where Ligare has volunteered his time for many years.[101]

F. Scott Hess has earned a place alongside Ligare in his pioneering efforts to gain respectability for realism in the 1980s. As a student at the University of Wisconsin in the late 1970s, Hess found himself virtually alone in his interest in narrative art and the illusionist devices of the Old Masters. Frustrated with his instructors' lack of expertise in classical technique, he left Wisconsin on graduation and enrolled at the Academy of Fine Arts in Vienna under the tutelage of the quasi-Surrealist painter Rudolf Hausner. In the six years he spent in Austria and traveling throughout Europe, Hess steeped himself in the traditions of Bellini and Vermeer, as well as the work of the Viennese expressionists Egon Schiele and Oskar Kokoschka. When he returned to the United States, settling in Los Angeles in 1984, Hess brought with him a fanciful, often erotically charged style of realism that sparkled with jewel-like color.

In the years since, joined by a loose fraternity of Los Angeles-based realists self-named "The Bastards" (a playful reference to their so-called illegitimate style), Hess has refined his extraordinary skills in narrative realism.[102] Although the core of his work has been in the figurative vein, notably his dreamlike cycle "Hours of the Day" (1994–2000), he has also produced a number of remarkable still lifes. Among the most ambitious are the ten paintings of his "Hotel Vide" cycle (2001), which diverges from his typically dark mood with its tongue-in-cheek subject matter. Each canvas represents a freeze frame in an Agatha Christie–style murder mystery, filled with love intrigues, betrayal, and a host of flamboyant characters. We never see the protagonists; only the contents of their individual hotel rooms, either before or after the action has taken place. *Mr. Simon L. Sachs, Briefcase, Suite 7A, 9/22, 9:51 P.M.* (fig. 133) exemplifies the joys and frustrations of these paintings. Like all of the "Hotel Vide" works, this image presents us with a jumble of clues—in this case, a ransacked briefcase, bullets, a broken champagne glass, and an overturned shoe, all implying that Sachs may have come to a bad end. The torn package, which appears to have contained a portfolio of stolen Rothko drawings, suggests a motive, yet the information does not quite add up. Hess claims that the paintings of "Hotel Vide," taken together, constitute a cohesive story—"a mystery novel in ten paintings"—but it is a narrative that the artist has been unwilling to divulge.[103] In the meantime, we are left

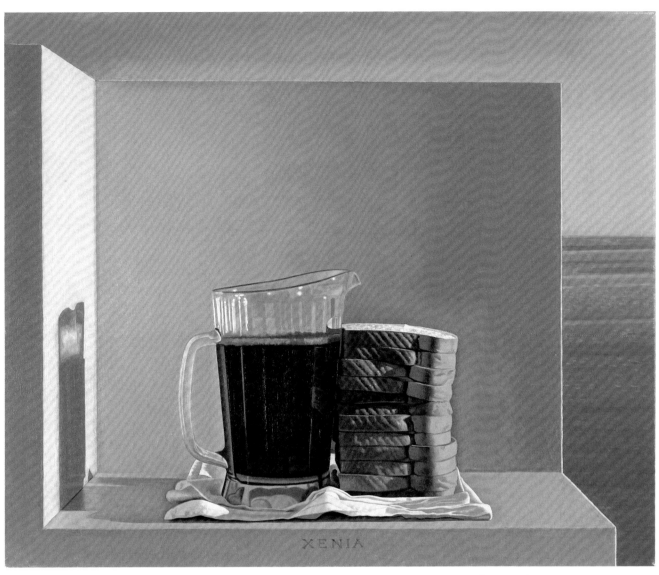

132 DAVID LIGARE
 Still Life with Grape Juice
 and Sandwiches (Xenia)

1994, oil on linen, 20 × 24 in. Fine Arts Museums of San Francisco.
Gift of Barbara and William G. Hyland, 1998.39.

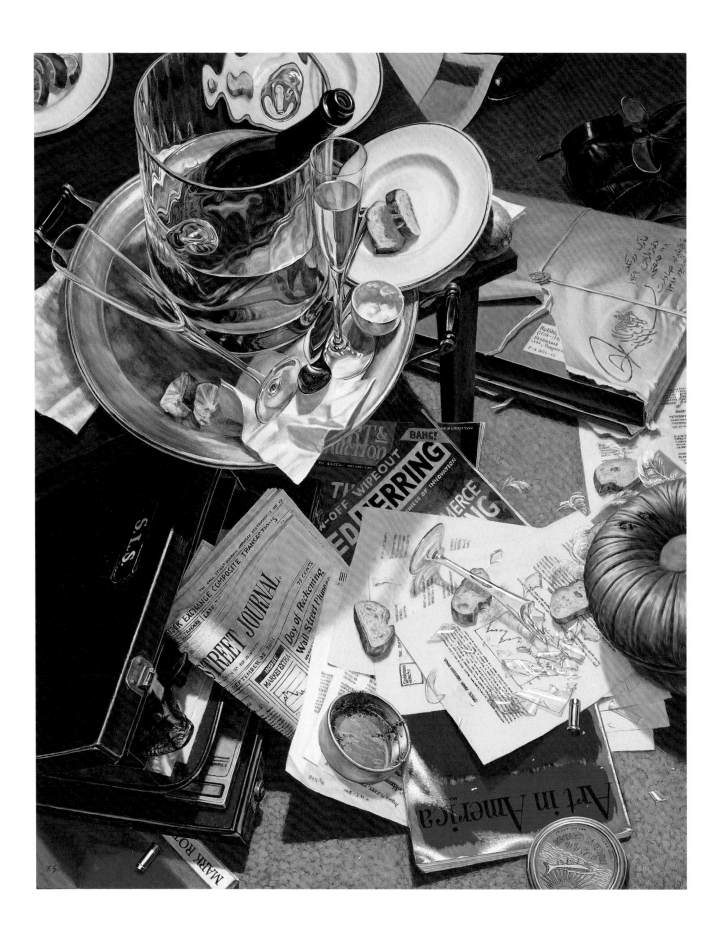

in a state of suspense; indeed, the *Red Herring* magazine spilling out of Sachs's briefcase may be the most important clue of all.

One might expect still lifes with complex layers of allegory and symbolism to be the special province of realist painting, yet since the late 1980s the most multivalent versions have been produced by artists working in other modes. The semiabstract, semifigurative paintings of Christopher Brown exemplify this turn. Brown, whose work has also tended to concentrate on the human figure, has nonetheless produced some innovative examples of the still life genre. Brown partakes of the postmodernist habit of borrowing from the past, quoting artists from Velázquez to Eakins. The dreamy *Decker's Memory* of 1992 (fig. 134) was inspired by an *Antiques* magazine advertisement for a still life of pears by the late-nineteenth-century American painter Joseph Decker. The diminutive original is hardly recognizable in Brown's rendition, which at 88 inches square seems to soar, engulfing the viewer with its pear-laden boughs. This must have been Brown's intention, for he has acknowledged that Decker's painting brought forth boyhood memories of Ohio, lying on his back in a country orchard looking skyward through branches and golden fruit.[104] The quality of reverie is intensified by Brown's distinctive paint handling, "sensual yet elusive, tactile yet pensive, fluid—all movement and flow—yet frozen," in the words of art critic Michael Brenson.[105] There is a sense of intimacy in Brown's painting, if not of the immediate sort George Sterling described in his classic study of still life; but rather than presenting objects in graspable terms, Brown's pears seem forever out of reach.[106]

133 F. SCOTT HESS
Mr. Simon L. Sachs, Briefcase, Suite 7A, 9/22, 9:51 P.M.

2001, oil on aluminum, 30 × 24 in. Courtesy of the artist and Hackett-Freedman Gallery, San Francisco. Photographer: PHOCASSO/ J. W. White.

Childhood and memory are also persistent themes for Raymond Saunders, whose assemblage-paintings are metaphorically dense examples of the contemporary still life. Saunders's works present a rich tapestry of associations, evoking the human comedy in all its complexity while commenting on the ambiguity and transience of our lives. His interpretations of the *vanitas* theme draw from his personal experience as a black man in America, yet always manage to strike at resonant universal truths. *Not Real But Wanting to Be* of 1999 (fig. 135) poignantly addresses the unfulfilled hopes and dreams of life and its all-too-soon passing. Saunders's delicate renderings of fruit and flowers in erasable chalk allude to the ephemeral nature of beauty. The *Shazam* comic book with torn pages, the blackboard, the spinning tops—all suggest the preciousness and fragility of childhood. Yet despite its poignancy, the work conveys a sense of humor. As its title suggests, this piece plays with the real versus the illusory by creating a removable painting within the painting, attached to the canvas with Velcro and sitting on an easel that is part real (the wooden ledge) and part trompe l'oeil (the painted stand). Our lives, he seems to be saying, represent a complex mix of fact and fiction—depending on how we perceive our surroundings and ourselves.

Another powerful recasting of the *vanitas* theme can be found in the equally nontraditional canvases of Los Angeles–based Lari Pittman. Like many Americans who have lost friends to AIDS and as someone who nearly died himself as the victim of a violent crime, Pittman has a sense of mortality that is profound and deeply personal.[107] Like Saunders, he reminds us of life's fragility, but leaves out the admonishment of excess common to traditional *vanitas*. Instead, Pittman would like us to savor our pleasures to the fullest while we can, as the declarative title of *Mix Vigorously and Ingest #4* (1997; fig. 136) suggests. The painting presents a row of bottles containing the basic human pleasures and virtues. In Pittman's universe, the gilt of sexuality comes first (semen); kindness is also prominent (represented by milk, as in the "milk of human kindness"); and the sweet (sugar) can be appreciated only in concert with its antithesis (dirt).[108] All of this is depicted in Pittman's characteristically exultant style of "joyful noise," as art curator Howard Fox has described it, a dazzling, sprawling array of "runaway decoration."[109]

At first glance Peter Saul's rambunctious, high-spirited still lifes might seem to express a similar life-affirming vision, but further examination reveals them to be far from benign. Despite the goofy, cartoony

134 CHRISTOPHER BROWN
Decker's Memory

1992, oil on canvas, 88 × 88 in.
Santiago Collection, Atherton, Calif.
Douglas Sandberg Photography.

135 RAYMOND SAUNDERS
Not Real But Wanting to Be

1999, mixed media on slate,
72 × 48 in. Collection of the
San Jose Museum of Art,
museum purchase with funds
from the Board of Trustees
and Friends of Josi Callan in
honor of former director Josi
Callan (1992–99).

136　LARI PITTMAN
Mix Vigorously and Ingest #4

1997, acrylic, alkyd, aerosol enamel, 47 × 57½ in. Collection of Shaun Caley Regen, Los Angeles. © Lari Pittman. Photograph courtesy of Regen Projects, Los Angeles.

images and Day-Glo colors, his message is grim indeed. Saul belongs to the rebellious, antimainstream generation that came of age at the California School of Fine Arts in the late 1950s, yet his work has gained currency only in recent years, finding admirers among younger artists such as Elizabeth Murray and Mike Kelley.[110] A self-avowed antimodernist, Saul developed his sensibility as a conscious rebuttal to Clement Greenberg's purist dogma. As art curator Robert Storr tells it, "Peter simply went in the opposite direction, putting as much storytelling and many images and as much bulbous weight into his pictures as they could contain—and then some."[111] Tellingly, Saul's most important sources of artistic inspiration have been the bêtes

noires of high modernism: Thomas Hart Benton and Salvador Dalí. To this list Saul adds the rubbery *Zap* comic book styles of underground Bay Area porn cartoonists like R. Crumb and especially Victor Moscoso, who anatomically distorted his figures to repellent effect.

Much of Saul's work until the late 1990s consisted of critiques lambasting American politics and culture, from the Vietnam War to the hypocrisies of the art world. His approach is never without humor, but, like his friend and colleague Robert Colescott (see fig. 99), Saul uses wit to expose painful truths. As one might expect, his first still lifes, begun in 1996, are parodies of the genre. Indeed, at first glance they epitomize the "not-so-still life." But

137　PETER SAUL
Still Life #1

1996, acrylic and oil on canvas, 78 × 108 in. Fine Arts Museums
of San Francisco, Partial Gift of Rena G. Bransten, 1994.14.

Saul's work always cuts deeper. *Still Life #1* of 1996 (fig. 137) is a ferocious exploration of *vanitas* aimed at contemporary society at large and the art world in particular. The tone of the work might be described as violent slapstick: Saul presents a table in an interior with many of the conventional domestic objects of still life, but the whole ensemble looks as if a bomb has exploded, sending everything flying in every direction. Saul seems to be saying that the material objects that we gather around ourselves are but temporary follies vulnerable to the hazards of life, providing only false security. To make his point, Saul has rallied conventional *vanitas* iconography: clocks, symbolizing the obliterating effects of time, and dice, representing the arbitrariness of chance. But instead of the usual memento mori skull, he has invented his own imaginative allegories for death,

the ultimate annihilator. Healthy foods show false promise of longevity: an anthropomorphic strawberry shatters a teacup with gunfire; several teeth are lost in the fleshy pulp of a watermelon; and a glass of V-8 juice rests in a cozy easy chair alongside two eight balls, symbols of the "end game." Saul shows us the cruel vicissitudes of the art world with flies that feed with equal gusto on paint brushes and excrement lodged between two cigarettes; with a diamond ring that undermines the phrase "diamonds are forever" by serving as a hoop through which a gavel hammers its judgment on a hapless tube of paint. And finally, we see Dalí's melting clocks being sawed in half by a maniacal alarm clock. It appears that Saul would like us to know that the Latin saying that has given artists courage for so many centuries—*ars longa, vita brevis*—is only

a futile illusion. But then again, that may just be Saul's two cents' worth.

It is not surprising that some of the most intriguing contemporary articulations of the memento mori still life since the 1980s have involved assemblage. Like the contemporary painters in this tradition, these artists are not concerned with didactic messages, but rather with meditations on death, destruction, and the passage of time. In the Bay Area, Mildred Howard, who describes herself as "part Panther and part flower child," comes perhaps closest to her Beat predecessors, expressing both the fire and the poetry of that movement.[112] The latest in a long series of valentine candy boxes dating back to the late 1970s, *Post-Traumatic Slave Syndrome: Don't Get It Twisted, This Is Not My Real Life* from 2001 (figs. 138 and 139), takes its title from a rap song by the late singer Tupak Shakur.[113] The power of the work derives from its jolting juxtaposition: Shakur's fate is not so sweet as the chocolates in the heart-shaped sampler; the singer died in a drive-by shooting in Las Vegas in 1996. Each of the candies is topped with photo-transferred images of bullets or Shakur's face. The rapper is thus now in wrappers—a grim play on words that the singer might have appreciated. With its gilt-edged black satin lining, the box is reminiscent of a casket, but Shakur's slaying is far more than a private tragedy, and Howard has transformed the incident into a collective commemoration. To emphasize this point, Howard has lined the bottom of the box with American flags "because," as she explains, "all of us are products of this American experience."[114]

Collective and personal memory are also at the heart of the work of Kim Turos, whose former career as a landscape architect and marriage to the physicist John Gilleland have led her to focus on the increasingly delicate symbiosis of nature and society. Many of her works deal with the mutual forces of natural and man-made environments. With *Kitchen-aid* of 1991–92 (figs. 140 and 141) Turos has worked magic out of a natural disaster of immense proportions—the East Bay firestorm of 1991 that destroyed 2,475 houses and apartment buildings in less than twelve hours. Turos's own house on Grand View Drive was close to the epicenter of the blaze. When she returned to the site she found that the fire had incinerated her home, leaving only a charred wasteland almost devoid of recognizable forms. One of the few relics that she pulled from the ashes was her dishwasher, which, along with its contents, had partly melted, turning an ordinary appliance into a biomorphic "blobject."[115] Most remarkable was nature's fanciful

"refiring" of Turos's ceramic dishes—teacups from Prague, Austrian cups and pitchers, and Lenox china—and the mutation of her wedding crystal into grotesque blackened shapes that sparkle like cryolite.[116] In *Kitchen-aid,* as in much of her work, Turos preserves the wonder of nature's creation while seamlessly augmenting it with her own hand. She made silver-coated dishes that reflected the melted crockery, distorting them further like a fun-house mirror, and she fashioned plexi bubble-shaped portals to suggest that the dishwasher still contained suds. The final result is a work that is both whimsical and disturbing. The word "save," which Turos scrawled in red lipstick on the appliance's side when she recovered it from a mound of soot, expresses poignantly the calamity of the event and the resilience of the human spirit.

Turos's desire to transform the destructive forces of nature is taken a step further by Bay Area artists Lucy Puls and Kathryn Spence, both of whom address the effects of time, not so much to enhance the nostalgic patina of age as to stop the decay—in short, to suspend nature. Puls's strategy is to trap discarded plastic dishes, toasters, stuffed animals, and CD-ROMS in blocks of polyester resin—often to extraordinary effect, as light refracts and reflects their humble surfaces. By giving these ephemeral objects Latin titles such as *Cumulus ab XXVI, Green* (1999; fig. 142), *Densa Discus* (1999), and *Materia Impervia Saepo* (2000), Puls would seem to aspire to eternity, if not a kind of taxidermy of the mundane (Latin being the universal language of science).[117] Freezing these objects like insects in amber, Puls invites us to study and contemplate her inventory. But this preservationist urge is tempered by the artist's very means of preservation. As the critic Jeff Kelley has noted, the tinted resin both protects and conceals the objects, much the way the mind obscures memory through a filter of shifting experience.[118] Ultimately, Puls's artifacts of the familiar partake of postmodernist skepticism, saying as much about the inaccessibility of the past as about collective culture.

Spence, in contrast, sincerely seeks to redeem garbage—"to find where wholeness resides in the imperfect, where permanent exists in the temporary."[119] Her materials are often downright seedy, sometimes debris plucked from the street, though looking at Spence's *Money Pile* of 1998 (fig. 143), the casual viewer would never suspect this. As art critic David Bonetti observes, the piece "is a play on the alchemical nature of art making. Here, by making a work of art that comes with an exalted value, she has turned the dross of heavily handled and

138　MILDRED HOWARD
Post-Traumatic Slave Syndrome:
Don't Get It Twisted, This Is Not
My Real Life

2001, hand-sewn silk with photo
transfers in handmade box, 8 ×
9 × 2 in. Collection of Amaru
Entertainment, Inc. Photogra-
pher: schoppleinstudio.com.

139　MILDRED HOWARD
Post-Traumatic Slave
Syndrome: Don't Get It
Twisted, This Is Not
My Real Life (detail)

140 KIM TUROS
Kitchen-aid

1991–92, mixed media,
70 × 24 × 48 in.
Courtesy of the artist.
Photographer: M. Lee
Fatherree.

141 KIM TUROS
Kitchen-aid
(detail)

142 LUCY PULS
Cumulus ab XXVI, Green

1999, plastic dishes in resin, 12¾ × 9 × 4¼ and 8 × 5⅝ × 5⅝ in. Courtesy of the artist and Stephen Wirtz Gallery, San Francisco. Photographer: Daniel Babior.

143 KATHRYN SPENCE
Money Pile

1998, mixed media, newspaper, and string, 17 × 18 × 21 in. Oakland Museum of California, purchased with funds from the Wallace Alexander Gerbode Foundation. Photographer: M. Lee Fatherree.

used papers into gold."[120] This sounds very much like what George Herms attempted to do forty years before when he rescued castoffs from the Larkspur marsh, but Spence is more concerned with issues of signification and perception than with the artistic value of refuse. Spence has fooled viewers into believing that they are viewing a great quantity of dollar bills when in fact they are seeing mostly something else: old bed sheets, newspapers, magazines, coupons, receipts, photocopied money, play money, tissues, string, rubber bands, and tape. In fact, Spence has not only turned garbage into simulated money; she has transformed simulated money into real money, the exchange value of her art.

Simulacra are the primary theme of Mike Kelley, who also uses discarded objects as the raw material for assemblages that occasionally spoof the conventions of still life. Kelley's work represents an important strain of postmodernism that engages in a broadly cynical but often playful deconstruction of cultural assumptions, using simu-

lation to "re-present" commonly held ideas and in so doing belie their falsehood. Along with his East Coast contemporaries Sherrie Levine, Cindy Sherman, and Jeff Koons, Kelley has appropriated images and objects and recontextualized them to raise issues of authorship, originality, signification, and commodification. Where Kelley stands apart is in the sheer multiplicity of interpretations he generates, combined with his self-described "adolescent stall-kicking" mentality.[121] The latter often manifests itself in taboo-breaking themes that can be understood in mutually exclusive terms—as both fantasy and critique. Kelley is the mischievous dissembler of contemporary California art, reveling in tricking and confounding his critics.

Mooner of 1990 (fig. 144) exemplifies Kelley's disruption of the viewer's expectations with the raunchy verbal and visual puns that have become his trademark.[122] Initially the crocheted blanket on the floor spread with cat dishes and toys, with its familiar traces of a meal eaten and recreation enjoyed, might appear to be a feline version of a still

144 MIKE KELLEY
Mooner (component of a
three-part installation)

1990, cat blanket, pillow,
double cat-food dish,
four cat toys, 39 × 36 ×
4½ in. The Museum of
Contemporary Art, Los
Angeles. Gift of the artist.
Photographer: Paula
Goldman.

life repast. In fact, the assemblage is composed of the former property of a friend's diseased cat named Mooner, and the work can thus be understood as a kind of memento mori to the pet.[123] But, as with much of Kelley's work, the relationship between visual and verbal language is complex, and all carriers of meaning must be taken into account. As Kelley says, "I want the initial perception of it to elicit comfort, which then starts to break down. You come to recognize that it's not what you thought it was. . . . I want the viewer to spend enough time with the work to discover all the jokes and perversities at play."[124]

Following Kelley's advice yields a multiplicity of associations, some intended by the artist, others not. In addition to commemorating the passing of a cat, *Mooner* pays playful homage to what Kelley calls the "death of modernism." Aside from its obvious allusion to Pollock's practice of painting on the floor, we have also the title, which calls to mind to Gene Davis's *Moon Dog* (1966), an icon of formalist painting.[125] Kelley, who found the "regime of minimalist cultural interference" at Cal Arts stifling, appears to parody Davis's signature vertical stripes by mimicking them in the cat's pillow.[126] Of course, "mooning"

is also slang for exposing one's buttocks—a common adolescent prank. This association, which Kelley denies,[127] is visually reinforced by the double circles of the cat's dish, which suggest the literal "impression" of such an act. But finally, the dictionary definition of "mooner"—"One who wanders or gazes idly or moodily about, as if moonstruck"—is most illuminating. This is the way most Americans view contemporary artists. Ultimately, this piece has the sting of satire, as Kelley pokes fun at both himself and the questionable value of his antics.

Absurdity and bravura are the hallmarks of the still lifes of two artists who might otherwise make an unlikely pairing: Nancy Rubins of Los Angeles and Chester Arnold of Marin County, both of whom astonish their viewers with monumental heaps of garbage. Rubins's gravity-defying towers, which can reach as high as sixty-five feet, are constructed from household appliances—pots, pans, toasters, fans, radios, and hair dryers—occasionally interspersed with airplane parts and foodstuffs (fig. 145). *Mattresses and Cakes* (1993), Rubins's installation for the Whitney Biennial, consisted of ten thousand pounds of mattresses and one thousand pounds of Entemann's cakes (the latter quite possibly a reference to

145 NANCY RUBINS 1982, steel and electric appliances, 45 × 40 × 40 ft.
 Worlds Apart Courtesy of the artist. Photographer: Irv Tepper.

Wayne Thiebaud, a dominant presence at the University of California, Davis, where Rubins studied in the late 1970s. As the weeks went by, the sugar in the cakes began to give off an odor that art critic Michael Duncan described as "accentuating the works' sweetly sexy associations and indulging in an upbeat, sensual fantasy."[128]

Arnold's "monuments to impermanence" are no less excessive and improbable, consisting of enormous piles of discarded objects, including refrigerators, mattresses, boats, ping-pong tables, and pianos.[129] Unlike Rubins's assemblages, however, Arnold's are made of painted memories rather than real objects. His "Accumulation" series (fig. 146) originated as a classroom assignment in which Arnold asked his students to draw every possession they could remember having thrown away. After years of disappointment, Arnold decided to try the exercise himself; the result was a group of paintings that represented a tour of his life, reaching as far back as memories of forgotten childhood toys to yesterday's discarded canvases. "A visual autobiography" is how one commentator described these motley heaps, which for all their whimsy are also meditations on a culture addicted to excess and waste.[130]

146 CHESTER ARNOLD 1998, oil on linen, 66 × 80 in. Collection of Katie and
 Accumulation Drew Gibson. Photographer: PHOCASSO/J. W. White.

Even if his "Accumulations" are highly autobio-graphical, Arnold, like most artists in recent years, does not display special affection for the objects he paints, instead maintaining a critical distance through humor and irony. It seems that the age-old impetus of still life—to communicate the desirabil-ity of possessions—has virtually disappeared. A notable exception to this rule can be found in Frank Romero, who initially achieved renown as a member of Los Four, the artist collective that "stormed" the Los Angeles County Museum of Art, breaking the institution's history of discrimination, with the first exhibition of Chicano art in 1974.[131]

While Romero often addresses issues of Latino strife and struggle, he also enjoys painting the pleasures of life.[132] Since the early 1980s, a large portion of his work has consisted of still lifes that take as their inspiration Mexican *bodegones* (shelf pictures), depicting his most cherished belongings: gifts from family and friends, childhood memorabilia, and things he has collected over the years. *Scamp with Hat and Gun* of 1992 (see p. viii) takes its title from Romero's beloved fifteen-year-old studio cat, while also depicting a humorous toy Romero made him-self: a cart holding two large breasts that jiggle as the wheels turn. *Baby Shoes and Thunderbird* of

1997 (fig. 147) is a compendium of Romero's collecting interests, including a handwoven rug from the Steppes of Central Asia, a tin wind-up toy of a bucking bronco, and an antique Cuban cigar box.[133] Most important, the painting depicts objects relating to the artist's childhood: a miniature Ford Thunderbird, the same model that his rich uncle owned in the 1950s, as well as Romero's own baby shoes recovered from his father's attic. As with all of Romero's still lifes, the objects are painted in an exuberant style that reflects his affection not only for his subjects but for the tradition of easel painting and the sensuous possibilities of oil on canvas.

A similar philosophy—albeit filtered through a very different temperament—informs the still lifes of Guy Diehl, whose straightforward tributes to personal possessions show his abiding reverence for art-historical tradition. Diehl trained as a photo-

realist in the mid-1970s at San Francisco State with two of California's preeminent practitioners of the movement, Robert Bechtle and Richard McClean. After spending several years painting sunny pool pictures, Diehl turned to the still life as the theme that has occupied him to the present day. Nearly all of his subsequent canvases treat the same subject. With smooth precision aided by the use of photographs, Diehl delineates arrangements of books, usually art books, along with greeting cards, postcards, and occasionally other objects such as fruit or flowers, on a table under raking studio light. The books and reproductions serve as homages to artists Diehl admires and sometimes make observations about art history. *Birth of the Cool* of 1998 (fig. 148), for example, brings together a picture of a Jasper Johns target with books on jazz, including a biography of Miles Davis named after his bebop album. In this manner, Diehl suggests that the cool jazz of

148 GUY DIEHL
Birth of the Cool

1998, acrylic on canvas,
27 × 34 in. Private collec-
tion. Photograph courtesy
Hackett-Freedman Gallery,
San Francisco.

147 FRANK ROMERO
Baby Shoes and Thunderbird

1997, oil on canvas, 36 × 48 in.
Collection of James and Selina Casso.
Photograph © Douglas M. Parker Studio.

Davis was part of a late 1950s zeitgeist that produced hip Neo-Dadaists like Johns.[134] Diehl's own sleek, velvety style partakes of their sensibility as well. His cool detachment and elimination of superfluous detail also allies him with formalist-realist predecessors such as Gordon Cook, whose pared-down still lifes were an early stimulus for Diehl.

If Diehl's paintings represent a revival of the formalist-realist still life, the leader of that trend is undoubtedly Bruce Cohen. Like Diehl, Cohen began by painting landscapes—in his case, fanciful Surrealist landscapes—making a decisive shift to the still life in the early 1980s. Cohen has drawn from diverse sources to create an approach that is singularly and unmistakably his own. One of his most important mentors was Paul Wonner, a visiting artist at the University of California at Santa Barbara, where Cohen studied in the 1970s. Although Cohen never took courses with Wonner, he credits the older artist with encouraging him to pursue still life and with strengthening his interest in seventeenth-century Dutch painting. From the beginning, Cohen's still lifes displayed the crystalline clarity and immaculate surfaces of the Dutch masters, combined with a classical sense of structure. A typical Cohen still life, while describing physical objects in the world, is nonetheless a tour de force of abstraction, a complex rhythm of balance and counterbalance that could vie with the most rigorous geometric painters. One of Cohen's acknowledged sources for this mathematical precision is the Indian miniature, which taught him "order, compartmentalization, and love of surface decoration and spatial ambiguities, without the normal restrictions of Western art."[135] *Blue Table with Many Tulips* (1989; fig. 149) and *Interior with Flemish Tile Floor* (1999; fig. 150) show how he relieves the unrelenting flatness of his interiors with surprising disjunctures of space that open vistas to the outside. Cohen borrowed this technique in part from Magritte, and indeed, despite the insistent formality of his paintings, they evoke a mysterious pregnant absence that reflects Cohen's early infatuation with Surrealism and the paintings of de Chirico.

No such narrative intimation appears in the still lifes of Steven Criqui, who has taken the process of formal reduction as far it can possibly go. His arrangements of bottles, fruit, and flowers are as precise and anonymous as an architect's blueprint—an effect he achieves with the aid of a computer. Computer-generated imagery can, however, be quite complex. In the case of Criqui, it is clear that he has taken great pains to simplify and streamline his forms, eliminating anything variable or accidental.

Criqui has in essence produced a compelling refashioning of Purism, the French movement of the late teens and twenties that celebrated the machine age. Paintings such as *Untitled (#4)* (from the series "Contemplative Still Lifes") of 1999 (fig. 151), with their reductive shapes and razor-sharp contours, are hard to conceive without the precedent of Amédée Ozenfant or Le Corbusier. Yet Criqui's preoccupations are thoroughly contemporary, having to do with the nature of communication and perception rather than Purism's goal of creating a utopian aesthetic program. He has described his still lifes as explorations of cognitive perception, based on recent clinical research showing that, regardless of the detailed complexity of an image, the brain stores information in abstract forms.[136] Nonetheless, even if Criqui intends his paintings as intellectual musings, they are above all sensually gratifying. We return to them because of their graceful forms and delicate color harmonies, and because their clarity and simplicity convey a sense of calm and order, soothing and restful to the eye.

In recent years most artists have responded to the increasing chaos and confusion of the contemporary world not by providing soothing antidotes, but by expressing their own ambivalent and sometimes anguished experience of it. Still life has become an important vehicle for a number of artists, particularly women, to communicate disharmony in the domestic sphere—endemic in the ambiguous expectations of old and new in the modern two-career household. With its historic association with domestic comfort and order, the still life genre plays perfectly to the postmodernist love of irony—a fact not lost on Patssi Valdez, Ann Hamilton, Maria Porges, Sandra Mendelsohn Rubin, and Deborah Oropallo—all of whom deal in diverse ways with the theme of domesticity gone awry.

Of these artists, Valdez has made this subject most central to her art. Raised in East Los Angeles, Valdez joined the artists Gronk, Harry Gamboa, and Willie Herron to form the Chicano performance artist coalition Asco (Spanish for nausea) in 1972, a group dedicated to shattering Latino stereotypes. Since then, Valdez's versatile work in performance art, photography, and painting has focused on the anxiety surrounding the split personality of the modern Chicana—expected to uphold the Catholic virtues of docility while having the strength and courage to survive the dangers of the barrio. Speaking for the Chicana experience generally, Valdez's work is also deeply autobiographical, examining her own childhood, which she describes as "dysfunctional."[137]

149 BRUCE COHEN 1989, oil on canvas, 48 × 48 in. Collection of Lorrie
 Blue Table with Many Tulips and Richard Greene. Douglas Sandberg Photography.

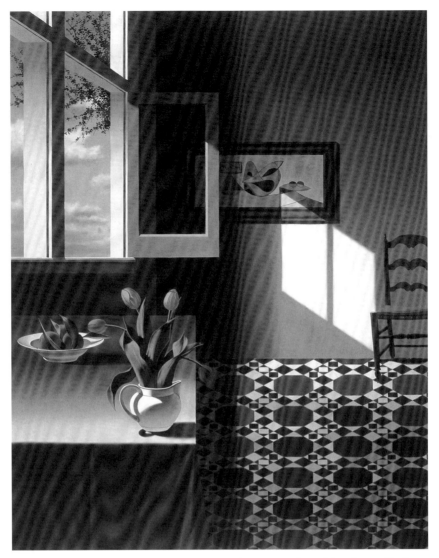

150　　BRUCE COHEN　　　　　　　　　　　1999, oil on canvas, 60 × 48 in. Private collection.
　　　　Interior with Flemish Tile Floor　　　　Photographer: Susan Einstein, Los Angeles.

Valdez's paintings of the late 1980s and 1990s—mostly still lifes—confront these realities head-on. Her first major canvas, *The Kitchen* of 1988 (fig. 152), presents the domestic chamber as both refuge and prison. As in much of her subsequent work, the painting shows a kitchen table, emblem of community, possessed by demonic forces. Everything is skewed and off-balance. In a room with lurid red walls that look like flayed skin, an army of forks fly in every direction, their sharp prongs stabbing at fruit and other objects. Later works continue along these lines, presenting topsy-turvy rooms in which even the most familiar objects

have become menacing. Some of Valdez's paintings in the 1990s, however, strike a more optimistic note. Although *Daisy Queen* of 1992 (fig. 153), for example, depicts a kitchen table and chairs in customary agitation, with objects on the tilted tabletop—flowers, pieces of *pan dulce* (Mexican sweet bread), and two glasses of water—on the verge of tumbling to the floor, the room nevertheless has a stabilizing force: a framed picture of a dark-skinned Madonna. She is not the sorrowful Virgin of Guadalupe, but a dignified and assertive "queen." Carrying a daisy in place of the Christ Child, she is both self-projection and hopeful

151 STEVEN CRIQUI 1999, oil on canvas with silver leaf frame,
 Untitled (#4) 47 × 56¼ in. Collection of Creative Artists
 (from the series Agency, Beverly Hills, Calif. Photograph
 "Contemplative Still Lifes") © Douglas M. Parker Studio.

152 PATSSI VALDEZ
The Kitchen

1988, acrylic on canvas,
48 × 36 in. Collection of
Curtis Hill. Photographer:
Gene Ogami.

153 PATSSI VALDEZ
Daisy Queen

1992, acrylic on canvas,
48 × 36 in. LAM/OCMA,
Art Collection Trust, gift
of Victor Hugo Zayas.
Christopher Bliss
Photography.

image of the liberated Chicana, free from the binds of cultural expectation.

Ann Hamilton's domestic rooms are no less powerful in conveying a feeling of discord, perhaps all the more so since on initial viewing they appear so calm and orderly. For the site-specific *still life* of 1988 (fig. 154), a temporary installation that she created for the group exhibition "Home Show: 10 Artists' Installations in 10 Santa Barbara Homes," Hamilton neatly piled 800 ironed, folded, and starched white men's shirts on a table. The credit for this enormous labor presumably went to a woman (the artist) stationed in one of the table's chairs for the duration of the installation. Yet something was clearly askew: not only were the shirts singed, but the room smelled like a hospital, the effect of vaporizers filled with water and Vick's vapor rub. Visitors recalled that it was difficult to breathe, and the sterile odor gave the impression that the "attendant" presiding over the table was in fact "a guardian keeping the company of the deceased in a funeral parlor."[138] These were clearly some of the associations Hamilton hoped to convey. As she explained, "The home is often a sanctuary, a refuge, a place where one is tended, but tending can get claustrophobic. It can strangle and destroy the very thing it's trying to create. [The shirts] . . . were so tended that they were rendered dysfunctional."[139]

Expectation and disappointment are recurring themes for Maria Porges, whose elegant sculptures since the mid-1990s consist of shelves holding cast wax bottles of myriad shapes, sizes, and colors— some based on found vessels, others invented, and each carrying words or phrases that form a suggestive chain of associations. These rows of text-bearing bottles invite comparison to Lari Pittman's painted tableaux, but where Pittman is jubilant and idealistic, Porges is cautionary. Porges uses the familiar domestic shapes and seductive textures of her vessels to lure her viewers into a state of mental languor. The text, too, on first viewing, seems commonplace and innocuous. But after spending time with the work, the meanings of the words begin to reverberate and collide. One of Porges's primary

154 **ANN HAMILTON** 1988, installation. Photograph courtesy Sean Kelly
 still life Gallery, New York. Photographer: Wayne McCall.

concerns is the poststructuralist insistence on questioning presuppositions.

Why Are We Like Our Parents? of 1996 (fig. 155) takes its name from one of twenty "Wonder Questions" listed in *The Book of Knowledge*, the children's encyclopedia that became a mainstay of American homes after its publication in the 1910s. With their silken, opaque surfaces and forms suggestive of human bodies, the vessels of this piece take on the appearance of family members lined up for a portrait. "It is important, too, that they are hollow," Porges explains, providing a clue to the question the piece poses.[140] All children, of course, are metaphorical vessels, receptacles for what their parents teach them. But with Porges, nothing is quite that simple. Taken together, the words on the bottles read like a collective warning label: "Fear, need, admiration, heredity, fate, accident, habit, imitation, instinct, spite, inertia, solace, forgetfulness, flattery." For Porges, these make up the complex and intricate shoal that all children and parents must navigate. In her estimate, Tolstoy was right when he observed that no two unhappy families are alike.[141]

Like Porges, Sandra Mendelsohn Rubin makes an enigma of the familiar, creating a sense of dislocation and estrangement by arranging her domestic objects into unfamiliar conjunctions. Beginning primarily as a landscape and figure painter of the realist persuasion, Rubin turned to still life in the mid-1990s, working in a crisp literal style that often utilizes contrasts of light and shadow to create ominous moods. Contributing to the strangeness of her work is a Magritte-like scale dissociation that is inherent rather than fictive. Some of the things she uses in her studio compositions are in fact miniature objects. Rubin's reliance on unexpected juxtapositions gives her still life paintings a whiff of Surrealism, but it is never more than a faint perfume; she is too concerned with formal matters and too restrained to merit more than a vague association with that movement. Nonetheless, there is a presentiment of danger in Rubin's work. On the face of it, *Shadow* (1996; fig. 156) suggests nothing ominous: a miniature swing set and a carved bear sit in the shadow of a music stand and headphones. Yet the music equipment's scale and corresponding shadow seem monstrously large and distorted, even while convincingly true to life. A more direct allusion to violence is conveyed in *Sledgehammer with Light Bulbs* of 2000–2001 (fig. 157), in which a sledgehammer lies amid the shards and splinters of two lightbulbs, suggesting the delicate remains of crushed eggs.

Deborah Oropallo's painting took a decisive turn after the birth of her first child, Leo, in 1995. Within a short time she was incorporating the objects that began to clutter her domestic environment, such as toy train tracks, bicycle inner tubes, jump ropes, coat hangers, and tin cans (fig. 158). Although the paintings of Oropallo emit cool detachment—a quality she cultivates by way of updated Warholian silkscreen techniques and, most recently, through the use of digital prints—her subjects nonetheless spark metaphoric associations that can be psychologically charged. Oropallo knows how to take the most mundane object and give it that jolt of defamiliarization that breathes life into its mask of emotional vacancy. As critic Jeff Kelley has written about Oropallo's work since the mid-1990s, there is "an undercurrent of danger lurking in these subjects—a real train track runs near the studio, a child can be hurt riding a bike, burner coils may sear tiny hands, jump ropes are sometimes traps for entanglement."[142] As the artist has acknowledged, almost all of her imagery is "about vulnerability in some way."[143]

In 2000, Oropallo's premonitions of danger came terrifyingly real. Returning to her home one day in the industrial neighborhood of West Berkeley, she encountered a fire that had erupted across the street next to a chemical storage yard. Although the flames were put out before they reached the chemicals, the colorful canisters, sacks, and drums behind the cyclone fence now took on a sinister aura. Perhaps as a way of gaining emotional control over living near such a hazardous environment, Oropallo began a series of digital canvases based on these containers. In some cases she domesticated them with attributes antithetical to their toxic contents. Works such as *Solution* (2000), *Low-Level* (2001), and *Air Gas* (2001) are dressed in feminine lace or overlaid with snowflakes, doilies, and other references to her own childhood growing up in New Jersey. The punning title of *Flour Bed* (2000; fig. 159), a heap of bags filled with powdered chemicals, both parodies the genre of still life and disarms the lethal subject with nostalgia. As the artist explains, the painting pays homage to her father, who worked nights at the family's bakery and sometimes napped on a pile of flour sacks.[144]

While Valdez, Hamilton, Porges, Rubin, and Oropallo were reformulating still life as a genre that could address contemporary issues of domesticity, a group of mostly male artists in Southern California were taking the tradition in a very different direction. "L.A. Baroque" is the term critic Marlena Donohue coined to describe the large-scale sculpture of Southern California artists such as Robert Therrien, Charles Ray, and Peter Shelton, noting their "intense

155 MARIA PORGES
Why Are We Like Our Parents?

1996, wax, wood, and gold leaf, 24 × 18½ × 10 in. Collection of
Vicki and Kent Logan, fractional and promised gift to San Francisco
Museum of Modern Art. Photographer: Ben Blackwell.

156 SANDRA MENDELSOHN RUBIN
Shadow

1996, oil on linen, 11 × 20 in. Private collection. Courtesy of
L.A. Louver Gallery, Venice, Calif. © Sandra Mendelsohn Rubin.
Photographer: Robert Wedemeyer.

157 SANDRA MENDELSOHN RUBIN
Sledgehammer with Light Bulbs

2000–2001, oil on linen, 36 × 78 in. Courtesy of L.A. Louver Gallery, Venice,
Calif. © Sandra Mendelsohn Rubin. Photographer: Robert Wedemeyer.

159 DEBORAH OROPALLO
Flour Bed

2000, iris print, oil on
canvas, 92½ × 68½ in.
Courtesy of the artist and
Stephen Wirtz Gallery,
San Francisco. Photographer: Ben Blackwell.

158 DEBORAH OROPALLO
Tubes

1999, oil on canvas,
72 × 52 in. Paige
Family Collection.
Photographer: Ben
Blackwell.

and odd sort of theatricality." As she observed, "there has always been a certain suspicion in L.A. of any art found too refined, too academic, too art-for-its-own-sake-ish. L.A. avoids the academic pedestal like a bad rash." [145] It is hardly surprising that Therrien, Ray, and Shelton would gravitate to still life, the tamest and most tradition-bound of subjects. Each has taken on the ultimate challenge of transporting the quiet idiom into the realm of theater.

Influenced by his love of cartoons and fairy tales, Robert Therrien's towering stacks of plates perfectly exemplify this trend. As art historian Norman Bryson has observed, in Therrien's "animated universe, the distinction between objects and the living figure becomes blurred: a tea set may sing a song, flatware and plates can dance." [146] Valdez and others had done this in painting, but the sheer size of Therrien's work gives it a theatricality rarely achieved in earlier still life. The projection into the viewer's space insists on a participatory experience in real time that is the essence of drama.

Since the mid-1980s, Therrien had been exploring ways of animating his sculptural still lifes. In 1988 he hit on an ingenious idea by applying the principles of *contrapposto*—the technique classical Greek and Italian Renaissance sculptors used to activate the human figure by setting parts of the body in opposition to each other around a central axis. It took Therrien more than ten years of fits and starts to obtain his goal in the series of five stacked dishes begun in 1993 (fig. 160). To create the sense of *contrapposto*, he skewed the plates and bowls, creating the dizzying sensation that they might topple over at any minute as one walks around them. Their gargantuan size—an ostrich could easily nest in one of the bowls—and the height of the stacks, approximately eight feet, intensify the feeling of vertigo that one critic described as "evocative of the dishes in the Mad Hatter's tea party." [147]

Charles Ray is perhaps best known for his eerie mannequinlike giants, especially his female titans dressed in business suits. His still lifes, while not monumental in scale, also demonstrate Ray's flair for showmanship. Beginning in the late 1980s, Ray began pressing the limits of the sculptural still life. He created at least four life-size tables with objects, each tweaking and teasing the tradition in a new way. *How a Table Works* (1986) defies gravity by removing the surface that would ordinarily support the objects, holding them in place with a tubular framework. *Table* (1990), made entirely of Plexiglas, simply renders the piece of furniture dysfunctional with bottomless vessels. *Viral Research* (1986; fig. 161) is startling in its perversion of still life's associ-

ations with conviviality and bounty. Instead of providing a delectable repast, Ray offers an array of glass bottles, jars, and cups filled with jet-black ink. The poisonous-looking fluid connotes death and disease, perhaps a reference to AIDS and to Ray's preoccupation with mortality. [148] But the most theatrical of all is his *Tabletop* of 1989. For this work Ray chose the most unassuming objects, things hardly worth a passing glance: a ceramic plate and canister, an aluminum salt and pepper shaker, a plastic cup and bowl, and a pot of plastic flowers. One would never guess that these ordinary objects sitting on a plain wooden table do not form a still life at all, but actually move in slow rotations by means of a hidden motor. According to curator Paul Schimmel, the work was inspired by Uri Geller, the psychic who purported to move objects with his mind. [149] Because of the objects' subtle motion, Ray's sculpture has the unsettling capacity to make viewers second-guess their perceptions.

If Ray and Therrien have turned the sleepy genre of still life into spectacle, Shelton functions like a playwright, casting his objects in parts for a living theater of sculpture. Animating the inanimate is the leitmotif of Shelton, who brings to his work training in drama and set design, premed studies in anatomy, and an avid interest in psychology and literature. All of this has come to fruition in his freestanding sculpture and installations, which partake of some of the theatricality of the immersive environments of James Turrell and Bruce Nauman, important influences for Shelton while a student at Pomona College in Southern California during the 1970s.

160 ROBERT THERRIEN
No title (white plates)

1993, ceramic epoxy on fiberglass, 94 × 60 × 60 in. The Broad Art Foundation, © 2003 Robert Therrien/ Artists Rights Society (ARS), New York. Photograph © Zindman/Fremont.

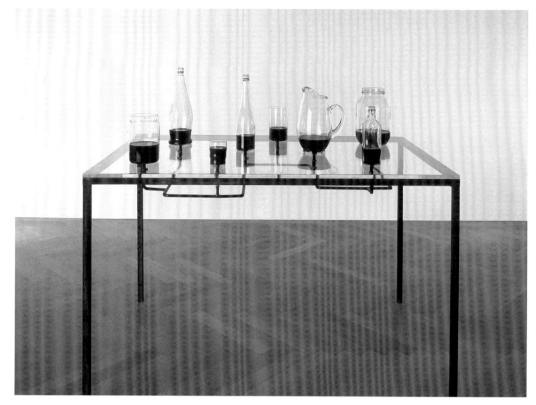

161 CHARLES RAY 1986, plexiglass, steel, ink, 32 × 53 × 36 in. Photograph
 Viral Research courtesy of Regen Projects, Los Angeles. © Charles Ray.

Although he had experimented with still life before, Shelton's first serious efforts began in the late 1980s with a series he called "thingsgetwet" (figs. 162 and 163), a group of cast-bronze objects initially commissioned for Dartmouth College and later exhibited together at the Los Angeles County Museum of Art in 1994. This series represented the culmination of concerns dating back to his earliest ruminations on sculpture as "a Pygmalion enterprise in which you are constantly trying to bring the dead to life."[150] Shelton sketchbooks and dream diaries from his students days in the 1970s indicate he was searching for analogies between the forms of his sculptures and the human organism, plastic equivalents for "layers of the body and layers of consciousness."[151] As curator Carol Eliel explains, for Shelton, "art had to encompass imagery, memory, ideas, and responses (i.e., form, concept, and narrative) in order to be complete and to fulfill his—and by extension, the viewer's—needs."[152]

In "thingsgetwet" he brilliantly achieved his ambition to humanize his sculpture—not by resorting to the figure, but by mining the rich lode of object associations that the ancient tradition of still life could provide. For the series, Shelton was able to utilize his remarkable technical facility as a certified industrial welder. Most of the objects are cast in bronze from life, ranging from a stack of books to a cluster of bones (canine and human) to a pair of boots, each bathed in water that slowly drips through a network of copper pipes. The complex metaphoric strata of these works is represented by *breadwaterwall* of 1993 (fig. 163), which consists of ninety-nine life-size loaves of brown bread neatly stacked in rows. As with all of the works in this series, the sculpture has a "capillary network" that carries what Shelton calls its "life juice."[153] Water, of course, has long-standing symbolic meanings of purity, fertility, and birth, in addition to more recent Jungian associations with creativity and the unconscious. In connection with bread, it cannot help but allude to the Christian symbolism of the Eucharist, with its suggestions of sacrifice and mystical communion. Shelton himself provides no answers, knowing that to keep the meaning of his art indeterminate is to keep it alive. If he intends his work as a form of sculptural "theater," its denouement is of the most open-ended kind.

Shelton's "Pygmalion enterprise" finds its logical extension in the nascent field of "interactive media," an umbrella term that includes Internet art as well as computerized sculpture. Interactive electronic art enables viewers to take an active role in physically manipulating the objects of an artwork, which may be real, imaginary, or a mind-bending amalgam. The evolving technologies of interactive media are inspiring some of the most radically challenging interpretations of the age-old tradition of still life, particularly in the Bay Area, where Silicon Valley's computer industry and San Francisco's "multimedia gulch" have been providing a hyperfocus on electronic media.

Two of the Bay Area's leading practitioners of interactive electronic media are Ken Goldberg and Alan Rath, each of whom have exploded the conventions of still life in unique ways. Goldberg, a professor of engineering at the University of California at Berkeley, led the team that developed the first robot on the Internet and has been a pioneer of net installations that involve user interaction with remote environments. One of his best-known projects, a collaboration with Joe Santarromana and others entitled *The Telegarden* (1995–present; fig. 164), allowed individuals to tend an arrangement of live plants over the Internet.[154] Participants could seed and water telerobotically, but their experience and knowledge of the garden remained cybernetic. The scent of its flowers, the ripening of its tomatoes, could exist only in the imagination.

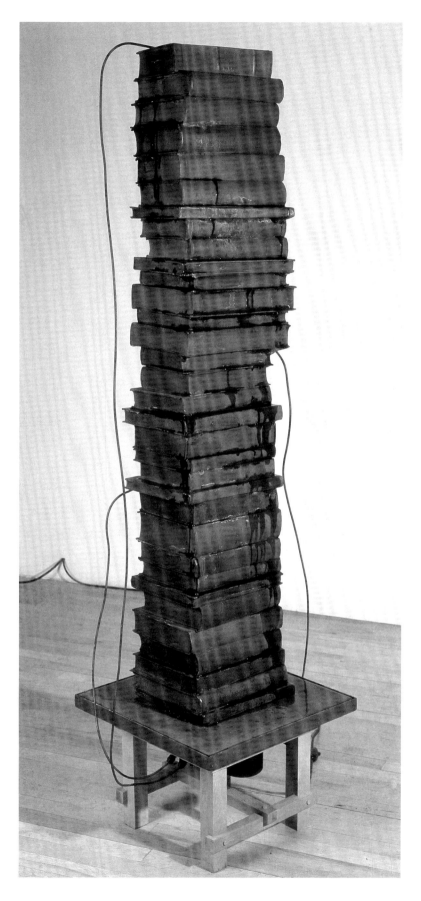

162 PETER SHELTON
books

1993, cast bronze and water,
65 × 18 × 18 in. Collection
of Robert and Mary Looker.
Photographer: Bill Orcutt.

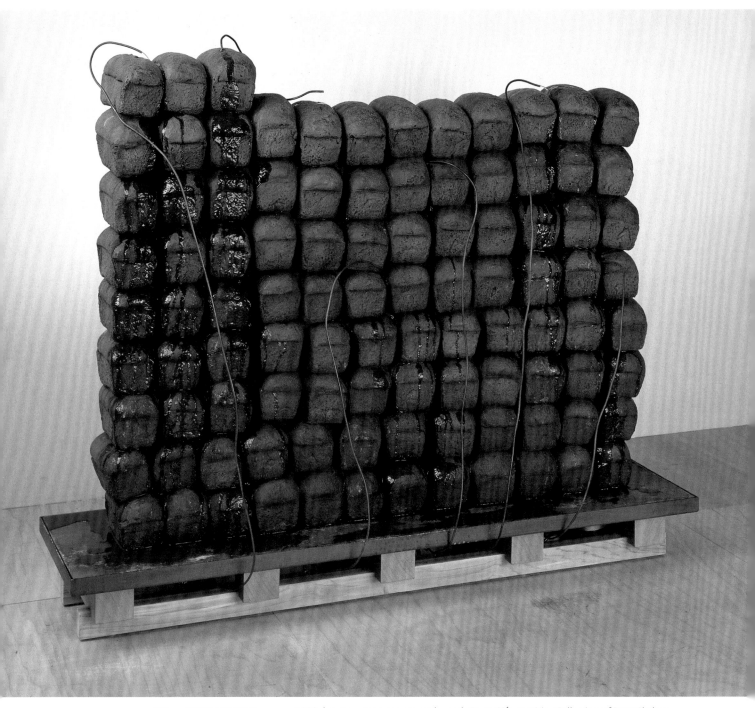

163 PETER SHELTON
breadwaterwall

1993, bronze, water, copper, and wood, 51 × 62½ × 18 in. Collection of Peter Shelton.
Courtesy L.A. Louver Gallery, Venice, Calif. Photographer: Orcutt and Van Der Putten.
© Peter Shelton.

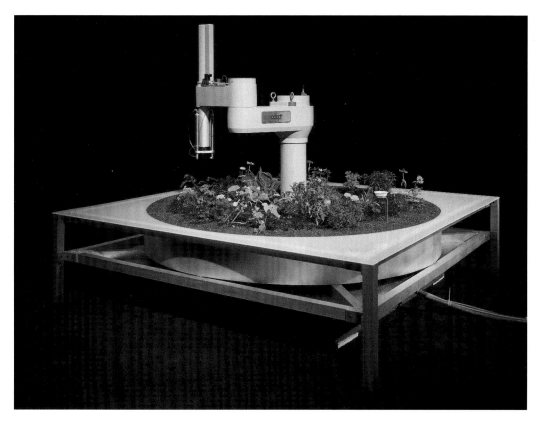

164 KEN GOLDBERG
The Telegarden

1995–present, 120 ×
120 × 72 in. Collec-
tion of Ken Goldberg
and collaborators.
Exhibited at Ars Elec-
tronica Center, Linz,
Austria. Photographer:
Robert Wedemeyer.

Another of Goldberg's net-based installations, *Dislocation of Intimacy* of 1998 (figs. 165 and 166), allows users to manipulate the lighting of a collection of objects with clicks of the mouse. Again like *The Telegarden*, the piece invites active participation, yet the experience remains remote. The objects, which can be viewed on a computer screen, are in fact hermetically sealed in a black box, suggestive of the impersonal cubes of the Minimalist Robert Morris and the conceptual artist Sol Lewitt.[155] They are also difficult to identify (some appear to be dried leaves and flowers) because of the dim light and soft-focus digital photography. Both *Telegarden* and *Dislocation of Intimacy* explore what Goldberg and others have called "telepistemology"—a new phase of epistemology for the digital age.[156] Goldberg's art begs the question that has been asked since Plato: Do we know what we are seeing? Digital imagery represents another step in the history of visual illusion by giving us potentially false evidence of remote physical activity, what Catherine Wilson has called "telefictivity."[157] In still life terms, this is yet another form of trompe l'oeil deception, one that leaves the viewer suspended in a perpetual state of doubt.

While Goldberg's interactive art addresses the impersonal and distancing effects of mediated communication in the electronic age, Alan Rath wants to warm things up. Despite their cold-looking wires, coils, and monitors—the artificial components of what are undeniably lifeless machines—his robotic sculptures are inherently likable, sometimes even friendly. As one commentator noted, they cannot help but strike an "emotional rapport" with their viewers.[158] Rath's intention is to humanize technology. As he said in a recent interview, "machinery is not unnatural. It's a reflection of the people who make it."[159]

A former computer hardware specialist with a degree in electrical engineering from MIT, Rath was inspired to become an artist in part by an exhibition of the Neo-Dada kinetic sculptor Jean Tinguely that he saw at the Tate Gallery in London in 1982. Tinguely's comical self-destructing machines, which questioned the goals of the Machine Age, struck a note of empathy for Rath, who often exhibits an irreverent sense of humor. From the beginning, his electronic sculptures sought to present objects that are "active, alive, not passive."[160] Still lifes were among the first subjects he tackled, and while he has

165 KEN GOLDBERG
Dislocation of Intimacy

1998, mixed media,
38 × 48 × 58 in.
Collection of the San
Jose Museum of Art.
Gift of the artist and
Catharine Clark
Gallery. Photogra-
pher: Ken Goldberg.

166 KEN GOLDBERG
Dislocation of Intimacy
(detail)

continued to produce sculptures that are more "creaturely" in appearance, still life has remained among Rath's important subjects. He began in the late 1980s with a group of works that have come to be known as his "speaker sculptures" (fig. 167) because of his use of vintage woofers—which, in the case of the still lifes, he transformed into pulsating mushrooms and blossoms. (One of these, *Jimi's Guitar,* pays homage to Jimi Hendrix.) Rath's *Wallflowers,* so called both for its position on the wall and temperament (one curator described it as having a "shy, retiring disposition"), has tentacles and vines that loop across the wall like calligraphy.[161]

Rath's most recent work has become technically more sophisticated and elegant without losing its humanity. After several years of using video monitors he has shifted to flat LCD (liquid crystal display) screens, which provide a smooth and refined resolution to the images of roving human eyes that blink and stare at the viewer. These screens give the pun to one of his latest still lifes, *Eyeris* (2001; see fig. 1), a three-stalked floral piece with eyes that change color seasonally. Through a remarkable feat of digital programming, this piece senses the human presence through movement and temperature. When no one is in the room it closes its eyes and goes to sleep.

Fifty years ago, Rath's electronic still lifes might have heralded the genre's logical conclusion. The animated still life had been achieved before, but in Rath's sculpture, the subversion is complete: the gaze is now reversed so that *we* are the objects of contemplation. Fortunately for the fate of still life, artists no longer believe in art as an evolutionary phenomenon, having discarded that notion as a relic of modernist ideology. As long as artists feel compelled to test their mettle by tackling great art of the past, the genre will continue to flourish.

California artists since midcentury have been skeptical about Greenbergian linearity—a fact that has had profound consequences for still life. To follow the course of still life on the West Coast is to track the feints and jabs of a boxing match with New York's powerful critical ideologues. Still life's greatest enemy in the 1950s and 1960s was the formalist orthodoxy of tastemakers like Clement Greenberg and Michael Fried, and it is no coincidence that the Bay Area Figuratives—champions of the genre—were among the first in the nation to resist compulsory reductive abstraction. They were joined by the Beat assemblage artists, the Davis ceramicists, and a host of individualists who have not only rejected formalism but have ignored and in some cases even flouted subsequent imperatives of New York's avant-garde.

Most significantly for the fortunes of still life, California artists have disregarded or significantly modified the postmodernist ideology of neutrality—the genre's other major impediment. Curator Margit Rowell's summation of contemporary still life in her survey for the Museum of Modern Art does not ring true for West Coast artists. In Rowell's estimate, "Concepts of individual style, vision, emotion, labor, and even uniqueness are circumvented in this art. In all cases [contemporary still lifes] are drained of their acquired or inherent cultural emotional associations."[162] Putting aside the accuracy of Rowell's observation even for many New York artists, this makes for very dull art indeed. In fact, the genre is compelling precisely because of its infinitely rich associational capacity. The poet Robert Duncan described it well when he noted the extraordinary mutability of still life as a "changing reality whose laws are remade at each instant by everything living."[163]

To invest with life, to succeed in realizing the livingness of things, is the thread that runs through still life of the twentieth century. Rath's winking "eyerises" represent an extreme manifestation to be sure, but they exemplify an impulse that can be traced through the decades, an impulse to push the boundaries of the genre. This has occurred in a variety of ways: through the disruption of related objects (in Surrealism); the transformation into three dimensions (an innovation of Cubism); the animation of the inanimate (beginning with the Futurists); and the hybridization of genres and art forms—notably the object-as-portrait and object-as-theater. The most significant impetus behind the animation of still life is not, as many postmodern commentators have assumed, a subversive urge to transgress. The animation of still life is a recognition of the associative life of things—and, on a deeper level, a recognition that art, despite its inherent materiality and inertness, is alive. It is an acknowledgment that although art may have no control over its destiny, that it may hang on hooks or languish in storage, it has infinite capacity to live through its active engagement with its viewers.

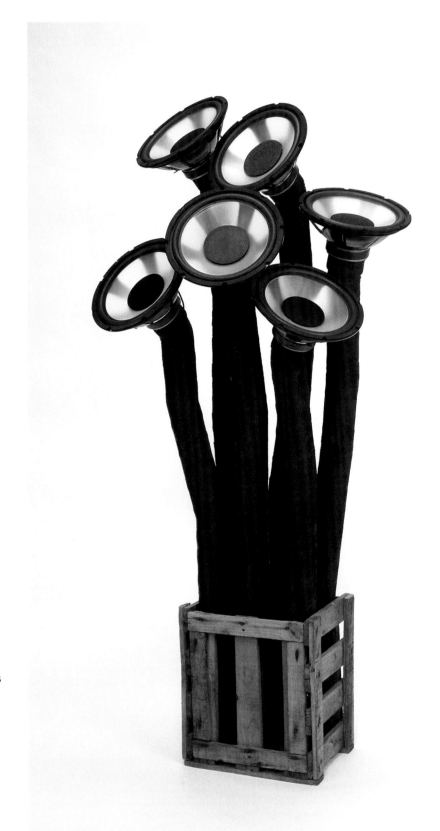

167 ALAN RATH
Magic Mushrooms

1990, wood, plastic, aluminum,
electronics, six speakers, 73 × 33
× 22 in. Collection of Lisille and
Henry Matheson. Photographer:
George Tillman.

artists' biographies

Cities listed are in California unless otherwise specified.

MARTHA ALF

Born 1930, Berkeley
Lives in Venice

Moved with her parents to Winterset, Iowa, in 1932 to live with her father's family during the Depression. Moved to San Diego in 1938 and then to nearby La Mesa in 1941. Studied clinical psychology and art at San Diego State University (SDSU). Married Edward Franklin Alf in 1951 and lived briefly in Monterey before moving to Seattle in 1953. Returned to San Diego in 1957 and two years later began graduate studies in clinical psychology at SDSU. Later studied fine arts at the University of California, Los Angeles, with artists Sam Amato, Richard Diebenkorn, William Brice, Lee Mullican, and James Weeks. Purchased a studio in Venice, California, in 1976. Known for her still life paintings of household objects.

Lit.: *Martha Alf: Retrospective,* exh. cat. (Los Angeles: Los Angeles Municipal Art Gallery, 1984); *Martha Alf: Paintings, Drawings, and Photographs,* exh. cat. (Redlands: Peppers Art Gallery, University of Redlands, 1980); D. C. Hines, "Martha Alf Explores Simple Forms," *American Artist* 40 (Dec. 1976): 56–61.

MABEL ALVAREZ

Born 1891, Oahu, Hawaii
Died 1985, Los Angeles

Moved with her family to California in 1906. Studied art in Los Angeles under William Cahill and John Hubbard Rich beginning in 1915. A devoted student of artists Stanton Macdonald-Wright and Morgan Russell, she was also influenced by writer and philosopher Will Levington Comfort. Traveled and painted in Mexico and the Caribbean Islands in the 1950s. Known for her modern paintings of religious and symbolic dreamscapes, landscapes, and still lifes.

Lit.: Glenn Bassett, "Mabel Alvarez: A Personal Memory," *American Art Review* 11 (Mar./Apr. 1999): 184–89; Will South, *Mabel Alvarez: A Retrospective,* exh. cat. (Los Angeles: Laband Art Gallery, Loyola Marymount University, 1999); Nancy Dustin Wall Moure, "A Quest for Excellence: Chronicling the Life of Mabel Alvarez," *Antiques and Fine Art* 7 (May/June 1990): 94–100.

ROBERT ARNESON

Born 1930, Benicia
Died 1992, Benicia

Began cartooning during high school and contributed sports cartoons to the *Benicia Herald* from 1949 to 1952. Attended the College of Marin, Kentfield, and graduated from the California College of Arts and Crafts (CCAC), Oakland, in 1954. Taught at Menlo-Atherton High School, Menlo Park, from 1954 to 1957. Attended summer school classes at San Jose State College with Herbert Saunders in 1956, then continued his studies at CCAC with Edith Heath and at Mills College, Oakland, with Antonio Prieto, receiving his M.F.A. from Mills in 1958. Established the ceramics program at the University of California, Davis, where he taught from 1962 to 1991. Diagnosed with cancer in 1972. Known for his series of witty ceramic self-portraits exploring his own mor-

tality and for his ceramic sculptures and drawings on political themes.

Lit.: Gary Garrels, *Robert Arneson: Self-Reflections,* exh. cat. (San Francisco: San Francisco Museum of Modern Art, 1997); Steven A. Nash, *Arneson and Politics: A Commemorative Exhibition,* exh. cat. (San Francisco: Fine Arts Museums of San Francisco, 1993); Neal Benezra, *Robert Arneson: A Retrospective,* exh. cat. (Des Moines: Des Moines Art Center, 1985).

CHESTER ARNOLD

Born 1952, Santa Monica
Lives in Sonoma

Lived in Munich, Germany, from 1957 to 1969, studying art with private teachers there between 1966 and 1969. Attended the College of Marin, Kentfield, and earned an M.F.A. from the San Francisco Art Institute in 1987. Received a Western States Arts Federation/National Endowment for the Arts Foundation Grant in 1996 and was an artist-in-residence at the Tamarind Institute Lithography Center, Albuquerque, in 1997. Taught at San Francisco Art Institute; Sonoma State University, Rohnert Park; San Francisco State University. Has taught at the College of Marin since 1988. Known for his sociopolitically charged landscapes and cityscapes.

Lit.: *Urban Invasion: Chester Arnold/James Doolin,* exh. cat. (San Jose: San Jose Museum of Art, 2001); *Chester Arnold: Accumulation, Reflections of a Material Life,* exh. cat. (Mill Valley, Calif.: Susan Cummins Gallery, 1998); Kenneth Baker, *Chester Arnold: Paintings, 1988–1994,* exh. cat. (Santa Clara, Calif.: de Saisset Museum, 1995).

BELLE GOLDSCHLAGER BARANCEANU

Born 1902, Chicago, Illinois
Died 1988, La Jolla

Raised by her maternal grandparents on a North Dakota farm. Studied at the Minneapolis School of Art in 1924 with Anthony Angarola; enrolled at the School of the Art Institute of Chicago in 1925, following Angarola there. Sent to Los Angeles by her father in 1927 in an attempt to slow the romance developing between Belle and her teacher. Exhibited in Los Angeles between 1927 and 1928, and relocated permanently to San Diego in 1933. Employed by the Works Progress Administration Federal Art Projects. Taught at the San Diego School of Arts and Crafts from 1946 to 1951 and the Francis Parker School, San Diego, from 1946 to 1969. Known for her figure studies, landscapes, still lifes, murals, and later experiments with modern abstraction.

Lit.: Bruce Kamerling, "Belle Goldschlager Baranceanu," in *100 Years of Art in San Diego* (San Diego: San Diego Historical Society, 1991); Suzanne Blair Brown, "The Prime of Belle Baranceanu," *San Diego Magazine* 37, no. 9 (July 1985); Bram Dijkstra, *Belle Baranceanu: A Retrospective*, exh. cat. (San Diego: Mandeville Gallery, University of California, San Diego, 1985).

DANA BARTLETT

Born 1882, Ionia, Michigan
Died 1957, Los Angeles

Studied at the Art Students League, New York, with William M. Chase and Charles Warren Eaton. Lived briefly in Boston and then Portland, Oregon, where he worked as a commercial artist for the Foster-Kleiser Company. Maintained a studio in San Francisco in 1915 before relocating to Los Angeles. Traveled to Paris in 1924 and later taught at the Chouinard Art Institute, Los Angeles. Opened an art gallery in Los Angeles in 1928. Founder and president of the California Watercolor Society and president of the California Art Club. Known for his plein air landscape paintings.

Lit.: *Mission Motifs: A Collection of Decorative Details From Old Spanish Missions of California—Drawings by Dana Bartlett and Hal Blakeley* (Los Angeles: Works Projects Administration, 1940).

JANE CLARA HOWARD BERLANDINA

Born 1898, Nice, France
Died 1970, San Francisco

Studied at the Ecole Nationale des Art Décoratifs, Paris, and privately under Raoul Dufy. Taught at a private girls school in Tarrytown, New York. Married architect Henry Howard in 1931 and moved to California. Worked on the murals at Coit Tower in San Francisco in 1934. Designed stage sets and costumes at the San Francisco Opera House. A member of the San Francisco Art Association and the Society of Women Artists. Known for her semiabstract Coit Tower murals.

Lit.: Stacey Moss, "Jane Berlandina (1898–1970)," in *The Howards: First Family of Bay Area Modernism,* exh. cat. (Oakland: Oakland Museum, 1988); Muriel Rukeyser, *Berlandina,* exh. cat. (New York: Hugo Gallery, 1953); "Jane Berlandina," *California Art Research Monographs* 17 (1936–37): 110–48.

ELMER BISCHOFF

Born 1916, Berkeley
Died 1991, Berkeley

Studied at the University of California, Berkeley, under John Haley, Erle Loran, Margaret Peterson, and Worth Ryder from 1934 to 1938. Served during World War II in U.S. Air Force Intelligence in England; resigned from the military in 1945. Began teaching at the California School of Fine Arts, San Francisco, with Richard Diebenkorn, David Park, and Clyfford Still in 1946. Moved to Marysville in 1953 and taught at Yuba College. Returned to Berkeley in 1956 and taught at the San Francisco Art Institute in 1957. Appointed tenured professor at University of California, Berkeley, in 1963, where he taught until retiring in 1985. Known for his modern figurative paintings and his association with the Bay Area Figurative group.

Lit.: Susan Landauer, *Elmer Bischoff: The Ethics of Paint* (Berkeley and Los Angeles: University of California Press, 2001); Christopher Brown and David Simpson, *On Painting: The Works of Elmer Bischoff and Joan Brown*, exh. cat. (Berkeley: University Art Museum and Pacific Film Archive, University of California, 1992); Robert M. Frash, *Elmer Bischoff, 1947–1985*, exh. cat. (Laguna Beach: Laguna Art Museum, 1985).

FRANZ ARTHUR BISCHOFF

Born 1864, Stein Schönau, Austria
Died 1929, Pasadena

Studied design, watercolor painting, and ceramics in Vienna, immigrating to the United States in 1885. Worked as a china decorator in a New York City factory. Moved to Pittsburgh, Pennsylvania, in 1887, and lived briefly in Fostoria, Ohio, in 1888. Relocated to Detroit in 1888, where he opened the Franz A. Bischoff Art Studio. Served as president of the Detroit Keramic Club. Moved with his family to Dearborn, Michigan, in 1895. Visited Los Angeles in 1900. Built a home and studio in South Pasadena in 1908. Known for his landscapes, coastal scenes, floral still lifes, and porcelain designs.

Lit.: Jean Stern, "Franz Bischoff: From Ceramist to Painter," in Patricia Trenton and William H. Gerdts, eds., *California Light*, exh. cat. (Laguna Beach: Laguna Art Museum, 1990), 157–70; Jean Stern, "California Impressionist: Franz Bischoff," *Art and Antiques* 4 (May/June 1981): 82–89; Jean Stern, *The Paintings of Franz A. Bischoff (1864–1929): A Retrospective Exhibition*, exh. cat. (Beverly Hills: Petersen Galleries, 1980).

DORR HODGSON BOTHWELL

Born 1902, San Francisco
Died 2000, Mendocino

Studied with Gottardo Piazzoni at the California School of Fine Arts, San Francisco, and with Rudolf Schaeffer at the Rudolf Schaeffer School of Design, San Francisco, from 1920 to 1924. Established a San Francisco studio from 1924 to 1927. Traveled abroad from 1928 to 1931. Moved to Los Angeles and worked for pottery manufacturer Gladding McBean from 1935 to 1936. Spent the next three years working on murals for the Works Progress Administration Federal Art Projects. In 1940 moved to San Francisco, where she taught at the California School of Fine Arts from 1944 to 1948. Also taught at the Parsons School of Design, New York; San Francisco Art Institute; and Mendocino Art Center, Mendocino. Known for her symbolic surrealist paintings.

Lit.: Patricia Trenton, ed., *Independent Spirits: Women Painters of the American West, 1890–1945* (Los Angeles: Autry Museum of Western Heritage, in association with University of California Press, Berkeley, 1995); Nancy Dustin Wall Moure, "Dorr Bothwell," in *Pacific Dreams: Currents of Surrealism and Fantasy in California Art, 1934–57*, exh. cat. (Los Angeles: University of California, Los Angeles, 1995); Dorr Bothwell, *Notan* (New York: Dover, 1991).

GEORGE KENNEDY BRANDRIFF

Born 1890, Millville, New Jersey
Died 1936, Laguna Beach

Moved to Orange, California, in 1913 and worked as a piano salesman. Studied dentistry at the University of Southern California, Los Angeles, in 1918, then established a dental office in Hemet. Studied art informally with Anna Hills, Carl Oscar Borg, and Jack Wilkinson Smith. Built a studio in Laguna Beach in 1927, abandoning dentistry the next year to pursue painting full time. Traveled to Europe in 1929. Taught painting in Laguna Beach and served as president of the Laguna Beach Art Association. Died by suicide. Known for his landscapes, seascapes, still lifes, figure studies, and harbor scenes.

Lit.: Susan Anderson, "George Brandriff," *Art of California* 3, no. 1 (Jan. 1990): 16–22; Susan M. Anderson and Bolton Colburn, *The Allegorical Still Lifes of George Kennedy Brandriff*, exh. cat. (Laguna Beach: Laguna Art Museum, 1989); Elaine Smith Baker, "George Brandriff: Portait [*sic*] of a Painter," *Orange Countiana: A Journal of Local History* 2 (1980): 46–51.

MAURICE BRAUN

Born 1877, Nagy Bittse, Hungary
Died 1941, San Diego

Immigrated to New York in 1881, and at age fourteen worked as a jeweler's apprentice. Began his studies at the National Academy of Design, New York, in 1897. Studied under William M. Chase for one year. Became a well-known portraitist and figure painter. Traveled to Europe in 1902. In 1909 established a studio in San Diego. Founded the San Diego Academy of Art in 1912 and became affiliated with the Theosophical Society. Was also active in the Laguna Beach art colony. Lived in Silvermine, Connecticut, from 1921 to 1923, and for the next five years divided his time between California and the East. Known for his Impressionist landscape paintings of California.

Lit.: Martin E. Petersen, "Maurice Braun," in *Second Nature: Four Early San Diego Landscape Painters*, exh. cat. (San Diego: San Diego Museum of Art, 1991); Martin E. Petersen, "Maurice Braun, Painter of the California Landscape," *Art of California* 2 (Aug./Sept. 1989): 44–53; *Maurice Braun: Retrospective Exhibition of Paintings*, exh. cat. (San Francisco: M. H. de Young Memorial Museum, 1954).

ANNE MILLAY BREMER

Born 1868, San Francisco
Died 1923, San Francisco

Began her studies with Arthur Matthews at the Mark Hopkins Institute of Art, San Francisco, continuing with Emil Carlsen at the San Francisco Art Students League. In 1910 traveled to New York and then Paris. Studied with André L'Hôte at the Académie Moderne and La Palette in Paris in 1911. Returned to San Francisco and served as president of the San Francisco Sketch Club from 1905 to 1907 and as a member of the board of directors of the San Francisco Art Association. Known for her modern still lifes, landscapes, and stylized figures.

Lit.: "Anne Bremer," in *California Art Research*, ed. Gene Hailey (San Francisco: California Art Research Project, Works Progress Administration, 1936–37), 7:88–128; Helen Dare et al., *Tributes to Anne Bremer* (San Francisco: J. H. Nash, 1927); Raymond L. Wilson, "Anne M. Bremer," in *Plein Air Painters of California: The North*, ed. Ruth Lilly Westphal (Irvine: Westphal Publishing, 1986).

NICHOLAS BRIGANTE

Born 1895, Padua, Italy
Died 1989, Los Angeles

Moved to Los Angeles with his family in 1897. Worked as a sign painter for the Thomas Cusack Company before studying painting with Hanson Putuff, Rex Slinkard, and Val Costello. Served in the U.S. Army during World War I. Became close friends with Stanton Macdonald-Wright. Lived in New York in 1923–24, then returned to Los Angeles in 1925. Known for his modern landscape paintings and abstract automatic drawings.

Lit.: Geri DePaoli, "Spirit Resonance in the Art of Nicholas Brigante," *Art of California* 5 (Sept. 1992): 33–35; *Nicholas Brigante (to Honor, Celebrate and Mark Nick Brigante's Eightieth Birthday, June 29, 1975)* (Los Angeles: American Art Review Press, 1975); J. E. Young, "Nicholas Brigante: An Elegant Timelessness," *Art News* 74 (Jan. 1975): 44–46.

CHRISTOPHER BROWN

Born 1951, Camp Lejeune, North Carolina
Lives in Berkeley

Moved with his family to Warren, Ohio, at age three and to Illinois at age thirteen. Earned a B.A. at the University of Illinois, Urbana-Champaign, in 1973. Lived in Spain and Germany in 1974–75 and 1978–79. Received an M.F.A. from the University of California, Davis, in 1976, where he studied with Wayne Thiebaud, William T. Wiley, Roy De Forest, and Robert Arneson. Lived in Woodland and San Francisco. Began writing and publishing articles on art. Professor and departmental chair at the University of California, Berkeley, from 1981 to 1994. Known for his figurative paintings.

Lit.: Michael Brenson, *History and Memory: Paintings by Christopher Brown*, exh. cat. (Fort Worth: Modern Art Museum of Fort Worth, 1995); *Christopher Brown: Recent Paintings*, exh. cat. (San Francisco: Campbell-Thiebaud Gallery, 1993); John Yau, *Christopher Brown, 1989–90*, exh. cat. (San Francisco: Gallery Paul Anglim, 1990).

JOAN BROWN

Born 1938, San Francisco
Died 1990, Puttaparthi, India

Enrolled at the California School of Fine Arts (CSFA), San Francisco, in 1955 and began exhibiting regularly in San Francisco in 1957 and New York in 1959. Received an M.F.A. from CSFA in 1960. Traveled to Europe, then joined the faculty of CSFA in 1961. Appointed assistant professor at the University of California, Berkeley, in 1974. In 1986 received an honorary Ph.D. from the San Francisco Art

Institute. Died in a construction accident in India while installing an obelisk for Sathya Sai Baba. Known for her autobiographical paintings, which often featured her son, Noel, her pets, her travels, and her adventures in and around San Francisco.

Lit.: Karen Tsujimoto and Jacquelynn Baas, *The Art of Joan Brown*, exh. cat. (Berkeley and Los Angeles: University of California Press, 1998); Christopher Brown and David Simpson, *On Painting: The Works of Elmer Bischoff and Joan Brown*, exh. cat. (Berkeley: University Art Museum and Pacific Film Archive, 1992); Mark Levy, *Joan Brown: The Golden Age*, exh. cat. (San Diego: University Art Gallery, San Diego State University, 1986).

HANS GUSTAV BURKHARDT

Born 1904, Basel, Switzerland
Died 1994, Los Angeles

Apprenticed to a gardener from 1919 to 1922. Immigrated to New York in 1923 and two years later began work as a furniture decorator at Schmieg and Co. Studied in New York at Cooper Union School in 1925 and, in 1927, at the Grand Central School of Art with Willem de Kooning and Arshile Gorky. Collaborated and shared a studio with Gorky before moving to Los Angeles in 1934. Took classes at Otis Art Institute from 1938 to 1939. First taught at Long Beach State College in 1959, then began a ten-year professorship at San Fernando Valley State College (now California State University, Northridge) in 1963. Traveled abroad frequently during the 1970s. Known for his political, abstract, and figurative paintings.

Lit.: *Hans Burkhardt Drawings, 1932–1989*, exh. cat. (Little Rock: Arkansas Art Center, 1996); Peter Selz, "Hans Burkhardt," in *Pacific Dreams: Currents of Surrealism and Fantasy in California Art, 1934–57*, exh. cat. (Los Angeles: University of California, Los Angeles, 1995); *Hans Burkhardt, 1950–60*, exh. cat. (Los Angeles: Jack Rutberg Fine Arts, 1987).

EDUARDO CARRILLO

Born 1937, Los Angeles
Died 1997, Tijuana, Mexico

Received a B.A. in 1962 and an M.A. in 1964 from the University of California, Los Angeles, where he studied with Stanton Macdonald-Wright and William Brice. Studied privately with Antonio Valles and Daniel Zenteno. Traveled to Spain and then moved to La Paz, Mexico, and founded El Centro de Arte Regional in 1966. Taught at University of California Extension, San Diego, 1964–66; El Centro de Arte, 1966–69; California State, Northridge, 1969–70; California State, Sacramento, 1970–72; and University of California, Santa Cruz, 1972–97. Traveled frequently

to Baja California in the 1980s. Known for his self-portraits, still lifes, and public murals.

Lit.: John Fitz Gibbon, *The Pilot Hill Collection of Contemporary Art,* exh. cat. (Sacramento: Crocker Art Museum, 2002); John Fitz Gibbon, *California A–Z and Return,* exh. cat. (Youngstown, Ohio: Butler Institute of American Art, 1990); Jacinto Quirarte, *Mexican American Artists* (Austin: University of Texas Press, 1973).

VIJA CELMINS

Born 1939, Riga, Latvia
Lives in New York City

Fled Latvia with her family during World War II, immigrating to the United States via Berlin. Arrived in Indianapolis in 1949. Attended the John Herron Art Institute, Indianapolis, in 1962. That same year moved to Venice, California, where she lived until 1980. Received an M.F.A. from the University of California, Los Angeles, in 1965. Taught at the University of California, Irvine, from 1967 to 1972 and at the California Institute of the Arts, Valencia, in 1976–77. Moved to New York in 1980. Known for her graphite drawings based on photographs of ocean, lunar, and desert surfaces.

Lit.: *Vija Celmins,* exh. cat. (Madrid: Museo Nacional Centro de Arte Reina Sofía, 1996); *Vija Celmins,* exh. cat. (London: Institute of Contemporary Arts, 1996); Judith Tannenbaum, *Vija Celmins,* exh. cat. (Philadelphia: Institute of Contemporary Art, University of Pennsylvania, 1992).

ALICE BROWN CHITTENDEN

Born 1859, Brockport, New York
Died 1944, San Francisco

Raised in San Francisco, Chittenden began studies at the California School of Design, San Francisco, under Virgil Williams in 1877. Married Charles P. Overton in 1886, and taught briefly at the California School of Fine Arts (CSFA) in 1897. In 1908 she traveled and painted in Wales, France, and Italy, and spent a leave of absence in New York in 1915. A resident of Pacific Heights in San Francisco, she taught at CSFA until 1940. Known for her portraits, landscapes, floral still lifes, and paintings of California wildflowers.

Lit.: Patricia Trenton, ed. *Independent Spirits: Women Painters of the American West, 1890–1945* (Los Angeles: Autry Museum of Western Heritage, in association with University of California Press, Berkeley, 1995); Alice B. Chittenden Papers, Smithsonian Archives of American Art, reel 919.

ALSON SKINNER CLARK

Born 1876, Chicago, Illinois
Died 1949, Pasadena

Raised in Chicago, Clark spent childhood summers on Comfort Island in New York. Enrolled in Saturday classes at the Art Institute of Chicago in 1887. Traveled with his family to Europe from 1889 to 1891. Studied at the School of the Art Institute of Chicago from 1895 to 1896, then at the Art Students League, New York, with William M. Chase until 1898. The next year he traveled to Europe to study with James McNeill Whistler. Returned to New York in 1909, then, in 1919, moved to California, painting in La Jolla, Mission Beach, and Laguna Beach. Moved to Pasadena in 1920. Taught at the Stickney Memorial School of Art, Pasadena, and served as its director in 1921. Known for his Impressionist figural works and landscapes.

Lit.: Jean Stern, "Alson Clark: An American at Home and Abroad," in Patricia Trenton and William Gerdts, eds., *California Light,* exh. cat. (Laguna Beach: Laguna Art Museum, 1990); Jean Stern, *Alson S. Clark* (Los Angeles: Petersen Publishing Co., 1983).

BRUCE COHEN

Born 1953, Santa Monica
Lives in Santa Monica

Began drawing fanciful landscapes at a young age, and was attracted to Dutch still life painting. Earned a summer scholarship in high school to study life drawing at the Otis Art Institute, Los Angeles. Attended the College of Creative Studies at the University of California, Santa Barbara, where he met artist Paul Wonner; earned a B.F.A. in 1975. Moved to Berkeley for two years and attended the University of California, where he was influenced by a course in Indian miniature painting. Periodically returned to Los Angeles, where he earned money painting houses. Settled in Los Angeles permanently in 1977. Known for his realistic still life paintings.

Lit.: *Bruce Cohen: Recent Paintings* (San Francisco: John Berggruen Gallery, 1999); Thomas H. Garver, *Flora: Contemporary Artists and the World of Flowers* (Wausau, Wis.: Leigh Yawkey Art Museum, 1995); *Bruce Cohen: Paintings* (San Francisco: John Berggruen Gallery, 1990).

ROBERT COLESCOTT

Born 1925, Oakland
Lives near Tucson, Arizona

Although he had little exposure to art growing up, as a child Colescott met well-known African American sculptor Sargent Johnson, who was his father's friend and fellow Pullman

porter. He also admired the work of muralist Diego Rivera, whom he encountered at the 1939 World's Fair. Earned a B.A. in 1949 and M.A. in 1951, both in art, from the University of California, Berkeley. Studied in Paris in Fernand Léger's atelier in 1949–50. Returned to the Pacific Northwest in 1952, teaching at Portland State University, Oregon. Received a fellowship at the American Research Center in Cairo, Egypt, in 1964–65. Returned to California in 1970 and taught at UC Berkeley from 1974 to 1979. Moved to Tucson, Arizona, in 1985 and taught at the University of Arizona until 1995. Known for his satirical figurative paintings.

Lit.: *The Eye of the Beholder: Recent Work by Robert Colescott,* exh. cat. (Richmond: University of Richmond, Virginia, 1988); *Robert Colescott: A Retrospective, 1975–1986,* exh. cat. (San Jose: San Jose Museum of Art, 1987); *Robert Colescott: Another Judgment,* exh. cat. (Charlotte, N.C.: Knight Gallery, 1985).

BRUCE CONNER

Born 1933, McPherson, Kansas
Lives in San Francisco

Studied at the University of Wichita in 1951–52 and received a B.F.A. from the University of Nebraska in 1956. Studied further at the Brooklyn, New York, Museum Art School and the University of Colorado, moving to San Francisco in 1957. Began making assemblages and films in the early 1950s. Lived in Mexico from 1961 to 1962. Founded the Ratbastard Protective Association in 1960. Affiliated with the Beat movement in Northern California, although he never referred to himself as a "Beat." Known for his drawings, collages, assemblages, and films.

Lit.: *2000 BC: The Bruce Conner Story, Part II,* exh. cat. (Minneapolis: Walker Art Center, 1999); *Bruce Conner: Assemblages, Paintings, Drawings, Engravings, Collages, 1960–1990* (Santa Monica: Michael Kohn Gallery, 1990); *Bruce Conner: Sculpture, Assemblages, Drawings, Films,* exh. cat. (Waltham, Mass.: Poses Institute of Fine Arts, Brandeis University, 1965).

GORDON COOK

Born 1927, Chicago, Illinois
Died 1985, San Francisco

Enrolled at Illinois Wesleyan University, Bloomington, in 1945 and earned his B.F.A. in 1950. Took courses at the American Academy of Art, Chicago, in 1948–49, the School of the Art Institute of Chicago in 1949, and the State University of Iowa in 1950–51. Moved to San Francisco in 1951 and worked as a printer's apprentice at the International Typographical

Union. Taught printmaking at the California School of Fine Arts, San Francisco, from 1962 to 1969. Married artist Joan Brown in 1969. Taught throughout the Bay Area in the 1970s, returning to San Francisco in 1977. Known for his realistic prints and paintings of landscapes, figures, and still lifes.

Lit.: *Gordon Cook: A Retrospective* (Santa Monica: Bryce Mannatyne Gallery, 1990); Christina Orr-Cahill, *Gordon Cook: A Retrospective,* exh. cat. (Oakland: Oakland Museum, 1987); *Gordon Cook,* exh. cat. (Santa Cruz: Art Museum of Santa Cruz County, 1985).

META GEHRING CRESSEY

Born 1882, Cleveland, Ohio
Died 1964, Los Angeles

Studied at the Cleveland School of Art and in New York with William M. Chase and Frank Vincent Dumond. Enrolled at the National Academy School in New York in 1911, and studied with Robert Henri in Spain. Married Bert Cressey, a fellow art student from the Los Angeles area, in Cleveland in 1913. Moved to California the next year, first to the Cressey ranch in Compton and then to the Hollywood Hills. Exhibited with the Los Angeles Modern Art Society in 1917 and served as its director. Known for her Impressionist paintings and her ceramic and porcelain decoration.

Lit.: *All Things Bright and Beautiful: California Impressionist Paintings from the Irvine Museum,* exh. cat. (Irvine: Irvine Museum, 1998); Tim Mason, "Bert and Meta Cressey" (typescript based on interviews with Robert Cressey, c. 1985); Antony Anderson, "Art and Artists," *Los Angeles Times,* July 6, 1914, pt. 3, 11.

STEVEN CRIQUI

Born 1964, Olean, New York
Lives in Glendale

Raised near Buffalo, moved with his family to San Diego in the mid-1970s. Earned a B.A. in art history and studio arts from the University of California, San Diego, in 1988, where he studied with Manny Farber. Taught part-time at the University of California, Los Angeles; University of Nevada, Las Vegas; Otis College of Art and Design, Los Angeles; and Art Center College of Design, Pasadena. Currently teaches at the University of California, Irvine. Known for his reductive still life paintings.

Lit.: Christopher Knight, "The Case for Painting: New Painters Who Matter," *Los Angeles Times,* Apr. 4, 1999, "Calendar" sec., 4–6, 80; Susan Kandel, "Disarming Works from Steve Criqui," *Los Angeles Times,* Mar. 8, 1997, sec. F, 19.

RINALDO CUNEO

Born 1877, San Francisco
Died 1939, Monterey Peninsula

Born into a family of painters and musicians who were founders of the San Francisco Tivoli Opera Company. Following service in the navy during the Spanish-American War, he attended the Mark Hopkins Institute of Art, San Francisco, where he studied with Gottardo Piazzoni and Arthur Mathews. Later he attended the Académie Colarossi, Paris, from 1911 to 1913. Lived in San Anselmo and, in 1916–17, worked in the Bay Area as an overseer for a tugboat service while establishing himself as a painter. Taught at the California School of Fine Arts, San Francisco, in 1920, 1925, and 1935–36. Painted portraits and still lifes, but best known for landscapes and waterfront scenes.

Lit.: Monica E. Garcia-Thow, *Rinaldo Cuneo: An Evolution of Style* (Carmel: William A. Karges Fine Art, 1991); *Painters of the California Landscape: Cadenasso, Cuneo, Piazzoni,* exh. cat. (San Francisco: Museo Italo Americano, 1990); "Rinaldo Cuneo," in *Monterey: The Artist's View,* exh. cat. (Monterey: Monterey Peninsula Museum of Art, 1982).

EDWIN DEAKIN

Born 1838, Sheffield, England
Died 1923, Berkeley

Immigrated to the United States in 1856 and settled in Chicago, where he painted Civil War portraits. Moved to San Francisco in 1870, sharing a studio with still life painter Samuel Marsden Brooks. Traveled to Denver and Salt Lake City in 1882. Visited Europe throughout the period 1879–90. Moved to Berkeley in 1891 and built a Mission-style studio on a large tract of land. Known for his paintings of California missions, architectural subjects, and roses.

Lit.: *The Art of California: Selected Works from the Collection of the Oakland Museum* (Oakland: Oakland, Museum, 1984); Ruth I. Mahood, ed., *A Gallery of California Mission Paintings by Edwin Deakin* (Los Angeles: Ward Ritchie Press, 1966); Edwin Deakin, *The Twenty-one Missions of California* (San Francisco: Murdock Press, 1899).

PAUL DE LONGPRÉ

Born 1855, Lyons, France
Died 1911, Hollywood

Began drawing flowers and birds as a young boy and decorated fans from age twelve to eighteen. Moved to Paris in 1876. Contributed floral illustrations to the periodical *Revue horticole* from 1888 to 1890. Sailed for New York in

1890, where he produced floral illustrations for D. M. Ferry and Co., King Flower Seeds, *Scribner's, Century,* and the *Cosmopolitan.* Moved to Los Angeles in 1899 and built a home in Hollywood. Many of his floral paintings were of plants growing in his garden. Known for his floral still lifes, which earned him the nickname "Le Roi des Fleurs."

Lit.: Nancy C. Hall, *The Life and Art of Paul de Longpré* (Irvine: Irvine Museum, 2001); *Splendide Californie: French Artists' Impressions of the Golden State, 1786–1900,* exh. brochure (San Francisco: California Historical Society, 2001); Nancy Dustin Wall Moure, *Loners, Mavericks, and Dreamers,* exh. cat. (Laguna Beach: Laguna Art Museum, 1993).

RICHARD DIEBENKORN

Born 1922, Portland, Oregon
Died 1993, Berkeley

Arrived in the San Francisco Bay Area with his family in 1924. Studied at the University of California, Berkeley, with Worth Ryder and Erle Loran in 1943. Earned a B.A. from Stanford University, and studied under Russian émigré professor Victor Anrautoff and painter Daniel Mendelowitz. Taught at the California College of Arts and Crafts from 1955 to 1959 and San Francisco Art Institute from 1959 to 1963. Lived in Santa Monica, teaching at the University of California, Los Angeles, from 1966 to 1973. Spent the final years of his life in Berkeley. Known for his "Berkeley" abstractions, his association with the Bay Area Figurative group, and his "Ocean Park" series.

Lit.: Jane Livingston, *The Art of Richard Diebenkorn,* exh. cat. (New York: Whitney Museum of American Art, in association with the University of California Press, Berkeley, 1997); Catherine Lampert and John Elderfield, *Richard Diebenkorn,* exh. cat. (London: Whitechapel Art Gallery, 1991); Gerald Nordland, *Richard Diebenkorn* (New York: Rizzoli International, 1987).

GUY DIEHL

Born 1949, Pittsburgh, Pennsylvania
Lives in Marin County

Moved with his family to the San Francisco Bay Area in 1960. Began drawing at a young age and enrolled at Diablo Valley College, Pleasant Hill, in 1970. Earned a B.A. from California State University, Hayward, in 1973, where he studied with Mel Ramos, and an M.A. from San Francisco State University in 1976, where he studied with Robert Bechtle and Richard McLean. Taught at Diablo Valley College from 1977 to 1982 and 1989 to 1991 and Las Positas College, Livermore, from

1980 to 1990. Known for his formalist-realist still life paintings.

Lit.: *Guy Diehl: New Work* (San Francisco: Hackett-Freedman Gallery, 2001); Keelin Devincenzi, "Diehl's Entitlement," *Northern California Home and Design,* May/June 1998, 38–42; Steven Nash, *Guy Diehl: Recent Paintings,* exh. cat. (San Francisco: Hackett-Freedman Gallery, 1998).

JULES ENGEL

Born 1918, Budapest, Hungary
Lives in Los Angeles

Immigrated to the United States with his family in 1931, where he excelled in art classes at Evanston High School in Illinois. Moved to Hollywood in 1937 to work as an animator for the Walt Disney film *Fantasia.* During World War II enlisted in the Motion Picture Unit of the U.S. Air Force, then, in 1947, helped establish the United Productions of America (UPA) studio. Founded the Department of Animation and Experimental Film at the California Institute of the Arts in Valencia. Known for his animated and live-action films.

Lit.: *Jules Engel: Anything But Still* (Los Angeles: Tobey C. Moss Gallery, 2001); Paul J. Karlstrom and Susan Ehrlich, "Jules Engel," in *Turning the Tide: Early Los Angeles Modernists, 1920–1956* (Santa Barbara: Santa Barbara Museum of Art, 1990); "Jules Engel, George Barrows," *Arts and Architecture* 62, no. 9 (Sept. 1945): 40.

CHARLES GRIFFIN FARR

Born 1908, Birmingham, Alabama
Died 1997, San Francisco

Raised in Knoxville, Tennessee, Farr studied at the Art Students League, New York, with George Bridgman and privately with George Luks in 1927–28. Traveled to Paris in 1928 and studied at the Académie Américaine in 1928–29. Taught at the New York Art Students League from 1931 to 1933, and in 1939 at the Art Center in Key West, Florida. Served as an artist-correspondent in the U.S. Army during World War II. Taught art classes in New York and restored ancient pottery at the Metropolitan Museum of Art from 1945 to 1947. Moved to San Francisco in 1948. Attended the California School of Fine Arts, San Francisco, from 1948 to 1950. Taught at the San Francisco Art Institute from 1959 to 1967. Known for his realistic still life and figurative paintings.

Lit.: Harvey Jones, *Charles Griffin Farr,* exh. cat. (San Francisco: Contemporary Realist Gallery, 1996); George Neubert, *Classical Observations: Still Lifes and Portraits by Charles Griffin Farr,* exh. cat. (Santa Cruz: Mary Porter Sesnon Art Gallery, University of California, Santa Cruz, 1990); Christina Orr-Cahall, *Charles Griffin Farr: A Retrospective,* exh. cat. (Oakland: Oakland Museum of California, 1984).

LORSER FEITELSON

Born 1898, Savannah, Georgia
Died 1978, Los Angeles

Raised in New York City, Feitelson trained briefly at the Art Students League there with Karl Tefft and George Bridgman. Studied at the Académie Colarossi, Paris, in 1919. Moved to California in 1927 and taught at the Chouinard Art Institute, Los Angeles, and the Stickney Memorial School of Art, Pasadena, in 1929. Met art student Helen Lundeberg at the Stickney School and founded Subjective Classicism/Postsurrealism with her in 1934. Served as the supervisor of the Southern California division of the Works Progress Administration Federal Art Projects from 1937 to 1943. Known for his Postsurrealist and hard-edge abstract paintings.

Lit.: Ilene Susan Fort, "Post-Surrealism: The Art of Lorser Feitelson and Helen Lundeberg," *Arts* 57 (Dec. 1992): 124–28; Diane Degasis Moran, *Lorser Feitelson and Helen Lundeberg: A Retrospective Exhibition,* exh. cat. (San Francisco: San Francisco Museum of Modern Art; Los Angeles: UCLA Art Council, 1980); *Lorser Feitelson: A Retrospective Exhibition,* exh. cat. (Los Angeles; Municipal Art Gallery, 1972).

CHARLES ARTHUR FRIES

Born 1854, Hillsboro, Ohio
Died 1940, San Diego

Apprenticed to a Cincinnati lithographer from 1869 to 1874. Attended the McMicken Art Academy in Cincinnati from 1874 to 1876 and studied portraiture privately under Charles T. Weber. Traveled in Europe in 1876 and throughout the Southwestern United States sketching lithographs that appeared in *Harper's, Leslie's,* and *Century* magazines during the 1870s and 1880s. Moved to New York in 1887; established a reputation as a portraitist and illustrator while living on a farm in Vermont. Relocated to San Diego in 1896 and painted the area's landscape until his death. Known for his published illustrations and his scenic paintings, especially of atmospheric landscapes.

Lit.: Martin E. Petersen, "Charles Fries," *Second Nature: Four Early San Diego Landscape Painters,* exh. cat. (San Diego: San Diego Museum of Art, 1991); Martin E. Petersen, "Charles Arthur Fries (1854–1940)," in *Plein Air Painters of California: The Southland,* ed. Ruth Lilly Westphal (Irvine: Westphal Publishing, 1982); Ben F. Dixon, ed., *"Too Late": The Picture and the Artist—A Tribute to the Dean* (San Diego: D. Diego's Libreria, Associated Historians of San Diego Bicentennial, 1969).

FRANK J. GAVENCKY

Born 1888, Chicago, Illinois
Died 1966, Ramona

Attended the School of the Art Institute of Chicago in 1913–14 and studied privately with Antonin Sterba. Continued his studies at the Chicago Academy of Fine Arts with Charles W. Dahlgreen. Member of the Palette and Chisel Club in Chicago. Visited California often during the 1930s. Moved to Ramona in 1949, frequently visiting nearby Mexico for new artistic subjects. Known for his realistic landscapes, seascapes, and desert scenes.

Lit.: Frank J. Gavencky Archival Papers, Michael Johnson Fine Arts, Fallbrook, Calif.

WILLIAM ALEXANDER GAW

Born 1891, San Francisco
Died 1973, Berkeley

Studied as a youth under landscape painter James Martin Griffin at the San Francisco Art Institute, encouraged by his artist father, Hugh Gaw. Moved to Berkeley in 1923. Taught at the California School of Fine Arts, San Francisco, in the 1930s and served as chairman of the art department at Mills College, Oakland, California, from 1942 to 1957. Known for his modern landscapes, drawings, and still lifes.

Lit.: Nancy Dustin Wall Moure, "William Gaw: The Science of Color," *Art of California* 5, no. 5 (Nov. 1992): 19–21; *William A. Gaw: Oil Paintings, Watercolors, and Lithographs,* exh. cat. (San Francisco: Maxwell Galleries, 1969); "William Gaw," *California Art Research* 18 (1936–37): 40–70.

YUN GEE

Born 1906, Wing-On-Li, near Canton, China
Died 1963, New York, New York

Arrived in San Francisco in 1921 and enrolled at the San Francisco Art Institute. Studied at the California School of Fine Art, San Francisco, under Gottardo Piazzoni and Otis Oldfield. Founded the Chinese Revolutionary Artists' Club in 1926. Traveled to Paris, where he studied with André L'Hôte. Returned to New York in the 1930s. Stopped painting due to personal depression; diagnosed with schizophrenia in the 1940s. Known for his modern urban landscapes.

Lit.: *The Art of Yun Gee,* exh. cat. (Taipei: Taipei Fine Arts Museum, 1992); *Yun Gee: Early Modernist Paintings, 1926–1932,* exh. cat. (New York: Vanderwonde Tannenbaum Gallery, 1983); Joyce Brodsky, *The Paintings of Yun Gee,* exh. cat. (Storrs: William Benton Museum of Art, University of Connecticut, 1979).

SELDEN CONNOR GILE

Born 1877, Stow, Maine
Died 1947, Lucas Valley

Attended Shaw's Business College in Portland, Maine, from 1894 to 1899. Moved to California in 1901, where he worked in Lincoln as a bookkeeper; moved to Oakland in 1905, where he worked as a salesman. Primarily a self-taught artist, he occasionally attended classes at the California College of Arts and Crafts, Oakland, and was considered the leader of the group of Oakland painters known as the "Society of Six." Moved to Tiburon in 1927, then to Belvedere. Worked as librarian and treasurer for the City of Belvedere from 1934 to 1946. Known for his colorful modernist paintings of the California landscape.

Lit.: Nancy Boas, *Society of Six: California Colorists* (San Francisco: Bedford Art Publishers, 1988); *A Feast for the Eyes: The Paintings of Selden Connor Gile*, exh. cat. (Walnut Creek: Civic Arts Gallery, 1983); *Paintings by Selden Connor Gile, 1877–1947 . . . from the Collection of James L. Coran and Walter Nelson-Rees*, exh. cat. (Oakland: Soloman Art Gallery, 1982).

DAVID GILHOOLY

Born 1943, Auburn
Lives in Newport, Oregon

Moved with his family to Davis in 1947. Traveled and lived with his family in St. Croix, Virgin Islands; Puerto Rico; and, in California, Los Altos, Santa Maria, and Solvang. Enrolled at the University of California, Davis, in 1962, where he studied with Robert Arneson and Wayne Thiebaud; received his B.A. in 1965 and M.F.A. in 1967. Taught at San Jose State University, 1967–69; University of Saskatchewan, 1969–71; York University, Toronto, 1971–77; and University of California, Davis, 1975–76. Moved to Yamhill County, Oregon, in 1989. Known for his ceramic frog sculptures, prints, and Plexiglas artworks.

Lit.: Susan Landauer, *The Lighter Side of Bay Area Figuration* (Kansas City, Mo.: Kemper Museum of Contemporary Art; San Jose: San Jose Museum of Art, 2000); *David Gilhooly* (Davis: John Natsoulas Press, 1992); Richard Marshall and Suzanne Foley, *Ceramic Sculpture: Six Artists*, exh. cat. (New York: Whitney Museum of American Art; Seattle: University of Washington Press, 1981).

RALPH GOINGS

Born 1928, Corning
Lives in Charlotteville, New York, and Santa Cruz

Raised in the Sacramento Valley, he received a B.F.A. in 1953 from the California College of Arts and Crafts, Oakland, where he studied with Leon Golden. Earned an M.F.A. in painting from Sacramento State College (SSC) in 1966. Taught briefly at SSC and University of California, Davis, but spent most of his career teaching high school art. Established a second home in upstate New York in 1974. Known for his Photo-realist paintings.

Lit.: *Ralph Goings: Photorealism* (Sacramento: Solomon Dubnick Gallery, 1997); John Parks, "The Watercolors of Ralph Goings," *Watercolor*, fall 1996, 68–73; Gerald Silk, *Ralph Goings, A Retrospective View of Watercolors: 1972–1994*, exh. cat. (New York: McCoy Gallery, 1994).

KEN GOLDBERG

Born 1961, Ibadan, Nigeria
Lives in San Francisco

Raised in Bethlehem, Pennsylvania, he received B.S.E. degrees in electrical engineering and R&D management from the University of Pennsylvania, Philadelphia, in 1984. Studied at Edinburgh University, Scotland, in 1982; visiting researcher at the Israel Institute of Technology, Haifa, in 1986. Completed his Ph.D. in computer science at Carnegie Mellon University, Pittsburgh, in 1990. Taught computer science at the University of Southern California, Los Angeles, from 1991 to 1995. Began teaching at the University of California, Berkeley, in 1995, where he founded the Art, Technology, and Culture Colloquium. Known for his new-media art projects and net installations.

Lit.: Steve Wilson, *Information Arts: Intersections of Art, Science, and Technology* (Cambridge, Mass.: MIT Press, 2002); Ken Goldberg, ed., *The Robot in the Garden: Telerobotics and Telepistemology in the Age of the Internet* (Cambridge, Mass.: MIT Press, 2000); Lawrence Biemiller, "Ken Goldberg's Research Is about Facts, but His Online Works Challenge Viewers' Reality," *Chronicle of Higher Education,* 17 Mar. 2000.

JOE GOODE

Born 1937, Oklahoma City, Oklahoma
Lives in Los Angeles

Began drawing at a young age with instruction from his artist father. Attended high school with Ed Ruscha. Moved to Los Angeles in 1959, where he attended the Chouinard Art Institute. Married to Judy Winans from 1960 to 1962. Moved to Springville, a small town in the Sierra Nevada foothills in 1975. Married artist Natalie Biezer in 1979. Began visiting Los Angeles again in the mid 1980s and rented a second studio in Venice, California. Moved permanently to Los Angeles in 1987. Known for his Pop Art paintings of common objects and recent abstract work related to nature.

Lit.: *Joe Goode* (Los Angeles: L.A. Louver, 2000); *Joe Goode*, exh. cat. (Newport Beach: Orange County Museum of Art, 1997); *L.A. Pop in the Sixties*, exh. cat. (Newport Beach: Newport Harbor Art Museum, 1989).

PAUL GRIMM

Born 1892, King Williams Town, South Africa
Died 1974, Palm Springs

Moved to the United States in 1899 where he earned a scholarship at age eighteen to study art at the Düsseldorf Royal Academy in Stuttgart, Germany. Moved to Hollywood in 1919 and painted backdrops for movie sets. Settled in Palm Springs in 1932, where he maintained a small studio and gallery. Frequently painted the High Sierra, California missions, and Native American portraits, but best known for his paintings of the Southern California desert.

Lit.: Katharine M. McClinton, "Paul Grimm, Painter of the California Desert," *Antique Trader Weekly* 30 (Feb. 19, 1986): 72–74; Rush Hughes, interview with Paul Grimm, Palm Springs Historical Society, Apr. 1969; "Paul Grimm: Foremost Desert Artist," *Palm Springs Pictorial* 19 (1949): cover, 46.

ANN HAMILTON

Born 1956, Lima, Ohio
Lives in Columbus, Ohio

Raised in Columbus; attended St. Lawrence University, Canton, New York, then transferred to the University of Kansas, Lawrence, where she received a B.F.A. in textile design in 1979. Completed an M.F.A. in sculpture at Yale University. Taught at the University of California, Santa Barbara, from 1985 to 1991. Moved to Ohio in 1991. Represented the United States at the 1999 Venice Biennale. Known for her mixed-media installations.

Lit.: Joan Simon, *Ann Hamilton* (New York: Harry N. Abrams, 2002); *Ann Hamilton: Present-Past, 1984–1997*, exh. cat. (Lyon, Fr.: Musée d'Art Contemporain, in association with Skira, Milan, 1998); *The Body and the Object: Ann Hamilton, 1984–1996*, exh. cat. (Columbus: Wexner Center for the Visual Arts, Ohio State University, 1996).

ARMIN CARL HANSEN

Born 1886, San Francisco
Died 1957, Monterey

First studied art with his father, Hermann Wendelborg Hansen, and later at the California School of Design, San Francisco, from 1903 to 1906 under Arthur Mathews. Traveled to Stuttgart, Germany, in 1906 and studied for two years at the Royal Academy under Carlos Gerthe; visited Paris, Munich, Holland, and Belgium before returning to San Francisco in 1912. Settled in Monterey in

1913; taught private art classes, served as first president of the Carmel Art Association, and was a founding member of the Monterey History and Art Association. Known for his paintings of harbor and coastal scenes and of the fishing industry of the Monterey Peninsula.

Lit.: *Armin Hansen: The Jane and Justin Dart Collection* (Monterey: Monterey Peninsula Museum of Art, 1993); Anthony R. White, *The Graphic Art of Armin C. Hansen: A Catalogue Raisonné* (Los Angeles: Hennessey and Ingalls, 1986); Kent L. Seavey, "Armin Hansen," *Monterey Life*, 3, no. 3 (Mar. 1982): 65–69.

EJNAR HANSEN

Born 1884, Copenhagen, Denmark
Died 1965, Pasadena

Raised on a dairy farm, he was apprenticed as an interior designer at age fourteen to Denmark's foremost painting contractor, Christian Molmand and Co. Attended the Royal Academy of Art, joining Denmark's Secessionist group De Tretten (The Thirteen), which endorsed revolutionary modern art. Moved to Chicago in 1914; lived in Minnesota and Wisconsin before settling in Wheaton, Illinois, where he lived from 1916 to 1925. Moved to Pasadena in 1925. Taught art at various Southern California schools for twenty-five years. Took painting trips to Denmark, Utah, and Taos, New Mexico. Known for his landscapes and portraits.

Lit.: Nancy Dustin Wall Moure, "Ejnar Hansen," *Art of California* 3 (Jan. 1990): 29–34; *Ejnar Hansen, 1884–1965: A Retrospective Exhibition,* exh. cat. (Santa Barbara: James M. Hansen, 1984); Arthur Millier, "Ejnar Hansen," *American Artist,* Oct. 14, 1950, 28–33, 62.

MIKI HAYAKAWA

Born 1904, Hokkaido, Japan
Died 1953, Santa Fe, New Mexico

Immigrated with her family to Alameda in 1911. Defying her father, she left the family home in Oakland and enrolled at the College of Arts and Crafts, Oakland, and the California School of Fine Arts, San Francisco, where, self-financed, she studied with Matsusaburo Hibi. Moved to the Monterey Peninsula in the 1930s, then to Stockton in 1942. Sent to Santa Fe War Relocation Center in New Mexico during World War II. Married artist Preston McCrossen in 1947. Known for her portraits and landscapes of Northern California and the American Southwest.

Lit.: Michael D. Brown, *Views from Asian California, 1920–1965* (San Francisco: Michael Brown, 1992); *Miki Hayakawa: A Retrospective,* exh. cat. (Santa Fe: Santa Fe East Galleries,

1988); Louise Turner, "A Japanese-American of the Cézanne School," in *Southwest Profile,* Sept./Oct. 1985, 19–24.

GEORGE HERMS

Born 1935, Woodland
Lives in Los Angeles

Self-trained artist. First met Southern California artists Wallace Berman and Bob Alexander in 1955 in Topanga Canyon. Lived in Hermosa Beach in 1956–57. While living in an abandoned shack in Larkspur in 1960, he created the sculpture *Poet,* which was included in the 1961 "Art of Assemblage" exhibition at the Museum of Modern Art, New York. Affiliated with the Beat movement, he created numerous films and designed sets. Returned to Topanga Canyon in 1962 and then to the mountains near Malibu, where he exhibited and sold his work. Taught at California State University, Fullerton, from 1977 to 1979; University of California, Los Angeles, in 1980–81 and 1987–90; Otis Art Institute, Los Angeles, in 1987; and Santa Monica College of Design and Art from 1991 to 1998. Known for his sculptures and assemblages made from found objects.

Lit.: *George Herms: The Secret Archives,* exh. cat. (Los Angeles: Los Angeles Municipal Art Gallery, 1992); *Rome Poem,* exh. cat. (Fullerton: Fullerton Art Gallery, California State University, Fullerton, 1984); *The Prometheus Archives: A Retrospective Exhibition of the Works of George Herms,* exh. cat. (Newport Beach: Newport Harbor Art Museum, 1979).

F. SCOTT HESS

Born 1955, Baltimore, Maryland
Lives in Los Angeles

Began drawing at age seven; received a B.S.A. from the University of Wisconsin, Madison, in 1977, then studied at the Academy of Fine Arts, Vienna, with Rudolf Hausner from 1979 to 1983. Moved to Los Angeles in 1984. Received a fellowship to live and work in Iran the following year. Taught at the Art Center College of Design, Pasadena, in 1995 and the University of Southern California, Los Angeles, in 1995–96. Belongs to a group of figurative artists called "The Bastards." Known for his narrative, figurative paintings.

Lit.: Peter Frank, *F. Scott Hess, The Hotel Vide: Ten Narrative Still Lifes,* exh. cat. (San Francisco: Hackett-Freedman Gallery, 2002); Richard Vine, *F. Scott Hess: The Hours of the Day,* exh. cat. (Newport Beach: Orange County Museum of Art, 2001); Michael Duncan, *F. Scott Hess: The Passing Hours,* exh. cat. (San Francisco: Hackett-Freedman Gallery, 1999).

CLARENCE KEISER HINKLE

Born 1880, Auburn
Died 1960, Santa Barbara

Raised on a ranch outside Sacramento; studied with William F. Jackson at the Crocker Art Gallery, Sacramento. Moved to San Francisco and enrolled at the Mark Hopkins Institute of Art. Attended the Art Students League, New York, and the Pennsylvania Academy of Fine Arts, Philadelphia. Trained at the Académie Julian and the Ecole des Beaux-Arts, Paris. Returned to San Francisco in 1912. Moved to Los Angeles in 1917 and taught at the Los Angeles School of Art and Design and the Chouinard School of Art. Resided in Laguna Beach from 1931 to 1935; moved to Santa Barbara in 1935. Known for his portraits, figures, and coastal views.

Lit.: Ruth Lilly Westphal, "Clarence Hinkle," in *Plein Air Painters of California: The Southland,* ed. Westphal (Irvine: Westphal Publishing, 1982); *Clarence Keiser Hinkle (1880–1960): A Selection of His Paintings,* exh. cat. (Stockton: Raymond-Callison Gallery, University of the Pacific, 1978); *Clarence Hinkle, 1880–1960,* exh. cat. (Santa Barbara: Santa Barbara Museum of Art, 1960).

DAVID HOCKNEY

Born 1937, Bradford, West Yorkshire, England
Lives in Los Angeles

Earned a national diploma of design at Bradford School of Art at age seventeen. Began studies at the Royal College of Art, London, in 1959. Traveled to Southern California in 1964. Taught at the University of Iowa, University of Colorado, and University of California, Los Angeles. Returned to London in 1968. Lived briefly in Malibu in 1973 and Paris until 1975. Returned to Southern California in 1976, where he currently lives. Known for his paintings, drawings, prints, photography, and opera designs.

Lit.: Marco Livingstone, *David Hockney* (New York: Thames and Hudson, 1996); Peter Clothier, *Hockney* (New York: Abbeville Press, 1995); Maurice Tuchman and Stephanie Barron, eds., *David Hockney: A Retrospective,* exh. cat. (Los Angeles: Los Angeles County Museum of Art; New York: Harry N. Abrams, 1988).

MILDRED HOWARD

Born 1945, San Francisco
Lives in Berkeley

Raised in San Francisco by Texas-born parents who were antique dealers and political activists. Began making art as a young child at the South Berkeley Congregational Church. Studied Afro-Caribbean dance with Ruth

Beckford in the 1960s. Studied fashion arts at the College of Alameda, and earned an M.F.A. in fiberworks from John F. Kennedy University, Orinda, in 1985. Traveled to Surinam in 1984 and Brazil in 1987–88. Known for her assemblages, collages, and installations that refer to personal and collective African American memory.

Lit.: *Mildred Howard: In the Line of Fire*, exh. cat. (Leicester, Eng.: City Gallery, University of Bradford, 1999); Robbin Henderson, *Crossings: The Installation Art of Mildred Howard*, exh. cat. (Berkeley: Berkeley Art Center Association, 1997); *Ten Little Children Standing in a Line (one got shot and then there were nine)*, exh. cat. (San Francisco: San Francisco Art Institute Adaline Kent Award Exhibition, 1991).

WILLIAM HUBACEK

Born 1866, Chicago, Illinois
Died 1958, San Bruno

Moved with his family to San Francisco at age five and began painting at age twelve. Studied at the Mark Hopkins Institute of Art, San Francisco, with Virgil Williams, Arthur Mathews, and Amadee Joullin. Traveled and trained in France, Germany, and Italy before returning to teach at the Mark Hopkins Institute. The 1906 fire and earthquake destroyed his studio and many of his works. In 1938 he moved permanently to San Bruno, where he lived and painted until his death. Nicknamed "The Old Master" by his students. Known for his still life paintings.

Lit.: Roberta Solomon, *Burlingame Advance Star,* Feb. 9, 1958.

JESS

Born 1923, Long Beach
Lives in San Francisco

Studied chemistry at the California Institute of Technology, Pasadena, in 1942 before induction into the U.S. Army the next year; assigned to the Special Engineer Corps at the Manhattan Project in Oak Ridge, Tennessee. Returned to California in 1946 and finished his degree in 1948. Worked for the General Electric Laboratories on the Hanford Atomic Energy Project in Washington State. Moved to San Francisco in 1949 and enrolled at the California School of Fine Arts. Met his companion, the poet Robert Duncan, in 1951. Affiliated with the Beat movement in the 1950s. Known for his collages, "paste-ups," and assemblies.

Lit.: Michael Auping et al., *Jess: A Grand Collage, 1951–93*, exh. cat. (Buffalo, N.Y.: Albright Knox Gallery, 1993); *Jess: Emblems for Robert Duncan*, exh. cat. (San Jose: San Jose Museum of Art, 1990); *Jess*, exh. cat. (New York: Odyssia Gallery, 1989).

MIKE KELLEY

Born 1954, Detroit, Michigan
Lives in Los Angeles

Received a B.F.A. from the University of Michigan, Ann Arbor, in 1976. Earned an M.F.A. at the California Institute of the Arts, Valencia, in 1978. Taught at the Minneapolis College of Art and Design; University of California, Los Angeles; Otis Art Institute, Los Angeles; California Institute of the Arts, Valencia; and Art Center College of Design, Pasadena. Lived in Hollywood for many years before moving to Highland Park, Los Angeles, in 1989. Known for his sculptures, installations, and performances.

Lit.: John C. Welchman et al., *Mike Kelley* (London: Phaidon Press, 1999); *Mike Kelley*, exh. cat. (Barcelona: Museu d'Art Contemporani, 1997); Elizabeth Sussman, ed., *Mike Kelley: Catholic Tastes*, exh. cat. (New York: Whitney Museum of American Art, 1993).

EDWARD KIENHOLZ

Born 1927, Fairfield, Washington
Died 1994, Hope, Idaho

Raised on his family's wheat farm, he studied at the Eastern Washington College of Education and Whitworth College, Spokane, in the late 1940s. Moved to Los Angeles in 1953. Founded the NOW Gallery in 1956 and cofounded the Ferus Gallery in 1957. His *Back Seat Dodge* installation ignited public controversy at the Los Angeles County Museum of Art in 1966. Moved to Berlin in the 1970s. Built a home and studio in Hope, Idaho, and opened the Faith and Charity in Hope Gallery in 1977. Traveled frequently between Germany and Idaho. Affiliated with the Beat movement in Southern California. Known for his life-size assemblages and installations.

Lit.: Rosetta Brooks, *Kienholz: A Retrospective*, exh. cat. (New York: Whitney Museum of American Art, in association with Distributed Art Publishers, 1996); Robert L. Pincus, *On a Scale That Competes with the World: The Art of Edward and Nancy Reddin Kienholz* (Berkeley and Los Angeles: University of California Press, 1990).

JOSEPH KLEITSCH

Born 1882, Nemet Szent Mihaly, Hungary (now Romania)
Died 1931, Santa Ana

Apprenticed to a sign painter and worked as a freelance portraitist as a teenager. Immigrated to the United States after 1901, settling in Denver in 1905. Lived briefly in Hutchinson, Kansas, and then in Mexico City from 1907 to 1909 before moving to Chicago in 1909. Returned to Mexico in 1911. Studied briefly at the School of the Art Institute of Chicago in 1912. Moved to Laguna Beach in 1920 and

established the Kleitsch Academy in 1929. Worked in Laguna Beach until his death. Known for his vigorously painted Impressionist portraits, figures, landscapes, and still lifes.

Lit.: *All Things Bright and Beautiful: California Impressionist Paintings from the Irvine Museum*, exh. cat. (Irvine: Irvine Museum, 1998); Patricia Trenton, "Joseph Kleitsch: A Kaleidoscope of Color," in Patricia Trenton and William Gerdts, eds., *California Light, 1900–1930*, exh. cat. (Laguna Beach: Laguna Art Museum, 1991).

LUCIEN ADOLPHE LABAUDT

Born 1880, Paris, France
Died 1942, en route from India to China

Trained as a couturier, he traveled to London and through the United States before settling in San Francisco in 1911, where he designed stage sets and costumes. Became acquainted with Lorser Feitelson and the Postsurrealists in 1929. Painted frescoes at the San Francisco Beach Chalet in 1937. Worked as an artist-correspondent for *Life* magazine and died in the field during World War II. Known for his Postsurrealist landscape and still life paintings.

Lit.: Katherine Holland, "Lucien Labaudt," in *Pacific Dreams: Currents of Surrealism and Fantasy in California Art, 1934–57*, exh. cat. (Los Angeles: University of California, Los Angeles, 1995); *Lucien Labaudt, 1880–1943: Memorial Exhibition*, exh. cat. (San Francisco: San Francisco Museum of Modern Art, 1944); "Lucien Labaudt," *California Art Research Monographs* 19 (1936–37): 1–28.

DAVID LIGARE

Born 1945, Oak Park, Illinois
Lives in Monterey County

Moved to Los Angeles with his family in 1951. Began drawing at a young age and attended the Art Center College of Design, Los Angeles. Traveled to Europe, including Greece, in 1963. Drafted into the U.S. Army in the 1960s and stationed in New Jersey, he painted landscapes there and exhibited in New York. Moved to Big Sur, California, in 1968. Taught at the University of California, Santa Barbara, and in the University of Notre Dame Rome Studies Program. Known for his classical paintings of figures, landscapes, and still lifes.

Lit.: *David Ligare: Objects of Intention—Still Life Paintings*, exh. cat. (San Francisco: Hackett-Freedman Gallery, 2002); *David Ligare: The Classical Impulse*, exh. cat. (Seattle: Frye Art Museum, 1998); *Landscape and Language: Paintings of David Ligare*, exh. cat. (Monterey: Monterey Museum of Art, 1997).

HELEN LUNDEBERG

Born 1908, Chicago, Illinois
Died 1999, Los Angeles

Moved with her family to Pasadena at a young age. Attended Pasadena City College, majoring in English. Took drawing classes from Lorser Feitelson at the Stickney Memorial School of Art, Pasadena, in 1930. Later married Feitelson and with him founded the New Classicism (Postsurrealist) movement in 1934. Painted numerous murals in California under the Works Progress Administration Federal Art Projects. Known for her Postsurrealist paintings.

Lit.: Ilene Susan Fort, *An 80th Birthday Salute to Helen Lundeberg,* exh. cat. (Los Angeles: American Art Council of the Los Angeles County Museum of Art, 1988); Diane Degasis Moran, *Lorser Feitelson and Helen Lundeberg: A Retrospective Exhibition,* exh. cat. (San Francisco: San Francisco Museum of Modern Art; Los Angeles: UCLA Art Council, 1980); *Helen Lundeberg: A Retrospective Exhibition,* exh. cat. (La Jolla: La Jolla Museum of Contemporary Art, 1971).

STANTON MACDONALD-WRIGHT

Born 1890, Charlottesville, Virginia
Died 1973, Los Angeles

Moved with his family to Santa Monica in 1900. Studied at the Art Students League, Los Angeles, with Warren Hedges and Joseph Greenbaum in 1906. Moved to Paris in 1909 and attended classes at the Sorbonne and Académies Julian, Colorossi, and Casteluccho. Moved to Los Angeles in 1918 and taught at the Chouinard Art Institute in 1922–23. Served as director of the Art Students League, Los Angeles, beginning in 1923 and led the Southern California division of the Works Progress Administration Federal Art Projects from 1935 to 1943. Taught at the University of California, Los Angeles, from 1942 to 1954. Known for his modern abstract paintings and Synchromist color theories.

Lit.: Will South, *Color, Myth, and Music: Stanton Macdonald-Wright and Synchromism,* exh. cat. (Raleigh: North Carolina Museum of Art, 2001); *Stanton Macdonald-Wright: A Retrospective Exhibition, 1911–1970,* exh. cat. (Los Angeles: The UCLA Art Galleries and Grunwald Graphic Arts Foundation, 1970); David Scott, *The Art of Stanton Macdonald-Wright,* exh. cat. (Washington, D.C.: National Collection of Fine Arts, Smithsonian Institution, 1967).

ALFREDO RAMOS MARTÍNEZ

Born 1871, Monterrey, Mexico
Died 1946, Los Angeles

Attended the Academy of Fine Arts in Mexico City. Phoebe A. Hearst discovered his paintings while visiting Mexico and sponsored his studies in Europe. Remained in Europe for fourteen years, returning to Mexico City in 1910. In 1912 he served as director of the Academy of Fine Arts, Mexico City. Founder of the Outdoor School of Painting in Mexico. Moved to the United States in 1928, settling in Los Angeles in 1929. Painted many murals in Southern California, and completed two murals in Mexico in 1942. Known for his indigenous, native pastoral murals and still lifes.

Lit.: *Alfredo Ramos Martínez (1871–1946): Una visión retrospectiva,* exh. cat. (Mexico City: Museo Nacional de Arte, Consejo Nacional para la Cultura y las Artes, Instituto Nacional de Bellas Artes, 1992); Bruce Kamerling, "Alfredo Ramos Martinez," in *100 Years of Art in San Diego* (San Diego: San Diego Historical Society, 1991); *Alfredo Ramos Martinez,* exh. cat. (Beverly Hills: Louis Stern Galleries, 1991).

ALBERTA BINFORD MCCLOSKEY

Born c. 1855, Missouri
Died 1911, Jamaica, British West Indies

Moved to Denver, Colorado, c. 1882, where she met and married artist William J. McCloskey in 1883. The next year the couple established a portrait studio in Los Angeles. Lived in New York c. 1885–92; traveled and painted in London and Paris in the 1890s. Returned to Los Angeles in 1893, where she remained for two years before traveling again to Europe and New York. After separating from William in 1898, she returned to San Francisco and remained there until 1908, when she was taken to Jamaica for health reasons. Known for her portraits and realistic still lifes.

Lit.: Nancy Dustin Wall Moure, *Partners in Illusion: Alberta Binford and William J. McCloskey,* exh. cat. (Santa Ana: Bowers Museum of Cultural Art, 1996).

WILLIAM JOSEPH MCCLOSKEY

Born 1858, Philadelphia, Pennsylvania
Died 1924, Orange

Studied at the Pennsylvania Academy of Fine Arts, Philadelphia, under history painter Christian Schussele and portraitist Thomas Eakins beginning in 1877. Moved to Denver, Colorado, in 1882. Established a portrait studio with his wife, Alberta Binford McCloskey, in Los Angeles in 1884. Traveled and painted in England and Paris in the 1890s and later in Nevada and San Francisco before separating from Alberta in

1898. Lived in Philadelphia from 1901 to 1904. Served as official portrait painter for the Southern Division of the American Legion in 1923. Moved to Oregon in 1924. Known for his realistic still life paintings of citrus fruits wrapped in tissue paper and for his portraits.

Lit.: Nancy Dustin Wall Moure, *Partners in Illusion: Alberta Binford and William J. McCloskey,* exh. cat. (Santa Ana: Bowers Museum of Cultural Art, 1996); John Fuller McGuigan, Jr., "Wrapped Oranges, Still Life Paintings: William J. McCloskey" (master's thesis, University of Denver, 1995).

HENRY LEE MCFEE

Born 1886, St. Louis, Missouri
Died 1953, Los Angeles

Attended Kemper Military Academy from 1902 to 1905 before enrolling at the School of Fine Arts, St. Louis. Later attended the Stevenson Art School in Pittsburgh, Pennsylvania, and, in 1909, the Art Students League, New York, under Birge Harrison. Traveled to France in 1921. Moved to Savannah, Georgia, and then to San Antonio, Texas, where he served as director of the Museum School of Art at the Witte Museum. Moved to Los Angeles and taught at the Chouinard Art Institute in the 1920s and at Scripps College, Claremont, from 1939 until his death. Known for his Formalist Realist still lifes.

Lit.: John Baker, *Henry Lee McFee and Formalist Realism in American Still Life, 1923–1936,* exh. cat. (Lewisburg, Pa.: Bucknell University Press, 1987); Virgil Barker, *Henry Lee McFee,* exh. cat. (New York: Museum of American Art, 1931); *Henry Lee McFee: Twenty-eight Reproductions of Paintings,* exh. cat. (Claremont: Fine Arts Foundation of Scripps College, 1950).

JOHN MCLAUGHLIN

Born 1898, Sharon, Massachusetts
Died 1976, Dana Point

Raised by parents who collected Asian art, McLaughlin studied at the Phillips Academy, Andover, Massachusetts, in 1915. Served in the U.S. Navy, then worked as a realtor in Boston after World War I. Traveled to Japan and China in 1935, where he lived for two years. Returned to Boston and opened Tokaido, Inc., in 1937, a gallery featuring Asian art and Japanese prints. Worked as a military translator during World War II. Settled in Dana Point, California, in 1946. Known for his hard-edge, geometric abstract paintings.

Lit.: *John McLaughlin, Western Modernism/Eastern Thought,* exh. cat. (Laguna Beach: Laguna Art Museum, 1996); *John McLaughlin: Retro-*

spective Exhibition, 1946–67, exh. cat. (Washington, D.C.: Corcoran Gallery of Art, 1968); *John McLaughlin: A Retrospective Exhibition*, exh. cat. (Pasadena: Pasadena Art Museum, 1963).

JACK MENDENHALL

Born 1937, Ventura
Lives in Oakland

Moved with his family to Yuba City at age seven. Began painting at a young age and took art classes at Yuba City High School. Received a B.F.A. in 1968 and an M.F.A. in 1970 from the California College of Arts and Crafts, Oakland. Painted abstractly in the early 1960s, influenced by the work of Richard Diebenkorn. Began painting realistically in 1963. Worked for the California Highway Department in Marysville from 1956 to 1966 and part-time in San Francisco from 1966 to 1970. In 1970 he oversaw the painting of the rainbows over the Caldecott Tunnel in Berkeley. Known for his Photo-realist paintings.

Lit.: *Third Annual Realism Invitational*, exh. cat. (San Francisco: Jenkins Johnson Gallery, 2001); *A Survey of Contemporary American Realism*, exh. cat. (Seoul: Posco Gallery, 1996); Louis K. Meisel, *Photorealism since 1980* (New York: Harry N. Abrams, 1993).

KNUD MERRILD

Born 1894, Odum, Denmark
Died 1954, Copenhagen, Denmark

Apprenticed to a housepainter as a teen, Merrild studied at Copenhagen's Art and Technical School from 1909 to 1912 and the Arts and Crafts School until 1917. Converted to modernism after viewing a Cubist exhibition in 1913. Studied at the Royal Academy of Fine Arts, Copenhagen, from 1917 to 1918. Organized Anvendt Kunst (Applied Art) in 1917, an alliance that advocated the union of progressive aesthetics and crafts. Immigrated to New York in the early 1920s and moved to Los Angeles in 1923. Supported himself as a housepainter and decorator in the 1940s. After suffering a heart attack in 1952 he returned to Denmark. Known for his Postsurrealist paintings and his automatist, drip painting method called "flux."

Lit.: *Knud Merrild: Works from the 1930s and 1940s*, exh. cat. (Los Angeles: Steve Turner Gallery, 1991); *Knud Merrild, 1894–1954*, exh. cat. (Los Angeles: Los Angeles County Museum of Art, 1965); *Knud Merrild: Twenty-five Year Retrospective*, exh. cat. (Beverly Hills: Modern Institute of Art, 1948).

HELEN CLARK OLDFIELD

Born 1902, Santa Rosa
Died 1981, San Francisco

Spent childhood summers at Jenner-by-the-Sea and graduated from DeWitt Montgomery High School, Santa Rosa. Took classes in industrial design and became an expert tailor. Moved with her family to Oakland in 1921. Enrolled at the California School of Arts and Crafts and worked as a designer at the Novelty Electric Sign Company. Studied with Otis Oldfield at the California School of Fine Arts, San Francisco, in 1925; they married in 1926. Moved to San Francisco and taught for over twenty-five years at Sarah Dix Hamlin School, retiring in 1971. Known for her realistic figurative paintings and still lifes.

Lit.: "Helen Oldfield (1902–1981): Otis Oldfield and the San Fancisco Art Community, 1920–1960s," interview conducted by Micaela Du Casse and Ruth Cravath in 1981 (transcript University of California, Berkeley, Bancroft Library, Regional Oral History Office, 1982); "Oral History: Helen Oldfield," Anne T. Kent California History Program, San Rafael, 1975.

DEBORAH OROPALLO

Born 1954, Hackensack, New Jersey
Lives in Berkeley

Raised in New Jersey, Oropallo earned her B.F.A. from Alfred University, Alfred, New York, in 1979. Attended the University of California, Berkeley, where she received an M.A. and M.F.A. in 1983. Influenced by artists Bruce Nauman, Chris Burden, David Ireland, Bob Irwin, Paul Kos, and her instructor Elmer Bischoff. Known for her paintings that incorporate mundane objects.

Lit.: *How To: The Art of Deborah Oropallo*, exh. cat. (San Jose: San Jose Museum of Art, 2002); *Material Handling*, exh. cat. (San Francisco: Stephen Wirtz Gallery, 2001); *Celebrating Modern Art: Works from the Anderson Collection*, exh. cat. (San Francisco: San Francisco Museum of Modern Art, 2000).

JOHN O'SHEA

Born 1876, Ballintaylor, Ireland
Died 1956, Carmel

Immigrated as a teenager to New York, where he studied at Adelphi Academy and the Art Students League. Worked briefly as an artisan-engraver at Tiffany and Co. in Brooklyn, New York. Moved to Pasadena in 1913, establishing a studio in Laguna Beach in 1914. Visited the Monterey Peninsula in 1916 and in 1923 moved to Carmel Highlands. Founded and directed the Carmel Art Association. Traveled

and painted widely throughout Tahiti, the South Pacific, Arizona, Hawaii, and Mexico. Known for his landscape paintings and figure studies.

Lit.: *All Things Bright and Beautiful: California Impressionist Paintings from the Irvine Museum*, exh. cat. (Irvine: Irvine Museum, 1998); *John O'Shea and Friends: John O'Shea, Burton Shepard Boundry, Theodore Morrow Criley*, exh. cat. (Carmel: Carmel Art Association, 1993); Walter A. Nelson-Rees, *John O'Shea, 1876–1956: The Artist's Life as I Know It—With a Complete Catalogue of the Artist's Known Works* (Oakland: WIM, 1985).

JULES EUGÈNE PAGÈS

Born 1867, San Francisco
Died 1946, San Francisco

Learned the principles of drawing from his father, Jules François Pagès, and artist Jules Tavernier. Worked as an apprentice in his father's engraving shop at age fifteen. Studied at the California School of Design, San Francisco. Worked as an illustrator for the *San Francisco Call* in the 1880s. Enrolled at the Académie Julian, Paris, in 1888, where he studied under Benjamin Constant and Jules Lefebvre. Traveled frequently between Paris, New York, San Francisco, and throughout Europe in the 1890s. Taught at the Académie Julian and was appointed first American professor in 1902. Returned permanently to San Francisco in 1941. Known for his landscapes, cityscapes, and harbor scenes.

Lit.: *Splendide Californie: French Artists' Impressions of the Golden State, 1786–1900*, exh. brochure (San Francisco: California Historical Society, 2001); Monica E. Garcia, "Jules Pagès," *Art of California* 3 (Mar. 1990): 17–22; Janet B. Dominik, "Jules Eugene Pagès (1867–1946)," in *Plein Air Painters of California: The North*, ed. Ruth Lilly Westphal (Irvine: Westphal Publishing, 1986).

DAVID PARK

Born 1911, Boston, Massachusetts
Died 1960, Berkeley

Moved to Los Angeles in 1928 and studied at the Otis Art Institute. Moved to Berkeley in 1929. Returned to Boston in 1936 and taught at the Winsor School for Girls. Returned to California in 1941 and began teaching at the California School of Fine Arts (CSFA), San Francisco, in 1943. Discarded his abstract paintings in 1949. Served as interim director of CSFA in 1950, resigning in protest in 1952. Appointed to the faculty of the University of California, Berkeley, in 1955. Moved to a new studio in the Berkeley Hills in 1957 and began

painting constantly. Designed sets for theatrical productions in 1958. Diagnosed with cancer in 1960. Known for his association with the Bay Area Figurative movement.

Lit.: Richard Armstrong, *David Park: Paintings and Drawings of the 1950s*, exh. cat. (New York: Whitney Museum of American Art, 1988); *David Park, 1911–1960*, exh. cat. (Newport Beach: Newport Harbor Art Museum, 1977); *David Park: His World*, exh. cat. (Santa Barbara: Santa Barbara Museum of Art, 1968).

EDGAR ALWIN PAYNE

Born 1882, Washburn, Missouri
Died 1947, Hollywood

Left home at a young age to paint houses, stage sets, and signs. Primarily self-taught as an artist, he studied for a short time at the School of the Art Institute of Chicago. Visited California in 1909 and 1911. Married Elsie Palmer in 1912; they resided in Chicago until 1918, when they purchased a home in Laguna Beach. Traveled abroad from 1922 to 1925, then lived on the East Coast until 1931. Moved to Los Angeles in 1932 and separated from Elsie. Organized and served as the first president of the Laguna Beach Art Association. Traveled widely and painted throughout the American Southwest, Canada, and Europe. Known for his paintings of the Sierra Nevada and Southwest desert scenery.

Lit.: Rena Neumann Coen, *The Paynes, Edgar and Elsie: American Artists*, exh. cat. (Minneapolis: Payne Studios, 1988); *Edgar Payne, 1882–1947*, exh. cat. (Los Angeles: Goldfield Galleries, 1987); Antony Anderson and Fred S. Hogue, *Edgar Alwin Payne and His Work* (Los Angeles: Stendhal Art Galleries, 1926).

ELSIE PALMER PAYNE

Born 1884, San Antonio, Texas
Died 1971, Minneapolis, Minnesota

Moved with her family to San Francisco in 1899, where she studied at Best Art School from 1903 to 1905. Worked for the Rimes Illustrating Company and Barney and J. Charles Green Advertising Co. in 1907. Moved to Chicago in 1910; two years later married artist Edgar Alwin Payne. Resided in Chicago until 1918, when they purchased a home in Laguna Beach. Traveled abroad from 1922 to 1925; lived on the East Coast until 1931. Moved to Los Angeles in 1932 and separated from Edgar. Founded the Elsie Palmer Payne Art School and Gallery in Beverly Hills in 1936. Caregiver for Edgar from 1946 until his death in 1947. Founded Payne Studios, Inc., in 1969 to conserve their works and records. Known for her floral studies, portraits, and landscape paintings of California and the American Southwest.

Lit.: Jean Stern and Evelyn Payne Hatcher, *Elsie Palmer Payne (1884–1971)*, exh. cat. (Beverly Hills: Petersen Galleries, 1990); Rena Neumann Coen, *The Paynes, Edgar and Elsie: American Artists*, exh. cat. (Minneapolis: Payne Studios, 1988); Rena Neumann Coen, *Elsie Palmer Payne: Out of the Shadow—A Retrospective Exhibition*, exh. cat. (Minneapolis: Edward Dean Museum of Decorative Arts, 1988).

AGNES PELTON

Born 1881, Stuttgart, Germany
Died 1961, Cathedral City

Immigrated to the United States in 1888 with her mother, who operated the Pelton School of Music in Brooklyn, New York. Studied at the Pratt Institute, Brooklyn, from 1895 to 1900 with Arthur W. Dow. Studied privately with William L. Lathrop in 1907 and Hamilton Easter Field in 1910–11. Taught at her mother's music school and established an art studio in New York in 1918. In 1917 she became interested in mysticism and the occult, which lasted throughout her life. Traveled frequently in the 1920s. Moved to California in 1928, and settled in Cathedral City in 1932. Known for her portraits, floral still lifes, desert landscapes, and abstract paintings.

Lit.: Michael Zakian, *Agnes Pelton: Poet of Nature*, exh. cat. (Palm Springs: Palm Springs Desert Museum, 1995); Penny L. Perlmutter, "Toward the Light: Agnes Pelton's Transcendental Paintings," *Antiques and Fine Art* 7, no. 3 (Mar./Apr. 1990): 92–99; Margaret Steiner, *Agnes Pelton*, exh. cat. (Fremont: Ohlone College Art Gallery, 1989).

LARI PITTMAN

Born 1952, Glendale
Lives in Los Angeles

Spent most of his early childhood in Cali and Tumaco, Colombia, where his father worked in the lumber industry. Returned to the Los Angeles area in 1963. Attended University of California, Los Angeles (UCLA), from 1970 to 1973. Received his B.F.A. from California Institute of the Arts, Valencia, in 1974, and his M.F.A. in 1976. Began teaching at UCLA in 1993, where he is now a tenured professor. Known for his semiabstract paintings and drawings that incorporate text.

Lit.: *Lari Pittman: Paintings, 1992–1998* (Exeter, Eng.: Spacex Gallery, 1998); Howard N. Fox, *Lari Pittman*, exh. cat. (Los Angeles: Los Angeles County Museum of Art, 1996); Elizabeth A. Brown, *Lari Pittman; Drawings*, exh. cat. (Santa Barbara: University Art Museum, University of California, Santa Barbara, 1996).

MARIA PORGES

Born 1954, Oakland
Lives in Oakland

Daughter of a research physicist who nurtured her interest in art. Received a B.A. from Yale University in 1975 and an M.F.A. from the University of Chicago in 1979. Also attended Grinnell College, Iowa, and the San Francisco Art Institute. Influenced by the work of Claes Oldenburg. Began writing reviews, columns, and exhibition catalogue essays in 1986. Visiting faculty instructor at numerous institutions from the 1990s to the present, including Stanford University, Palo Alto; California College of Arts and Crafts, Oakland; and Pilchuck Glass School, Stanwood, Washington. Known for her sculptures of bottles and vessels.

Lit.: *Acts of Deception*, exh. cat. (San Francisco: John Berggruen Gallery, 2000); *Hand Signals*, exh. cat. (Chicago: Gallery A, 1999); *Looking at Ourselves: Works by Women Artists from the Logan Collection*, exh. cat. (San Francisco: San Francisco Museum of Modern Art, 1999).

LUCY PULS

Born 1955, Milwaukee, Wisconsin
Lives in Berkeley

Received a B.S. in art from the University of Wisconsin, Madison, in 1977. Attended the Tyler School of Art, Temple University, Philadelphia, in 1977–78, and in 1980 earned an M.F.A. in sculpture from the Rhode Island School of Design (RISD), Providence. Taught at RISD from 1981 to 1983 and at Western Carolina University, Cullowhee, North Carolina, from 1982 to 1985. Began teaching at the University of California, Davis, in 1985. Known for her mixed media sculpture.

Lit.: Mark Johnstone et al., *Epicenter: San Francisco Bay Area Art Now* (San Francisco: Chronicle Books, 2003); *Childhood Imagery from the Logan Collection: The Darker Side of Playland*, exh. cat. (San Francisco: San Francisco Museum of Modern Art, 2000); *Lucy Puls*, exh. cat. (San Francisco: Stephen Wirtz Gallery, 1995).

JOSEPH MORRIS RAPHAEL

Born 1869, Jackson
Died 1950, San Francisco

Studied at the California School of Design, San Francisco, under Arthur Mathews and Douglas Tilden. Continued his training at the Ecole des Beaux-Arts and Académie Julian in Paris in 1903. Joined the artists' colony in Laren, the Netherlands. Spent eight months in San Francisco in 1907, then moved to Belgium, while his agent exhibited his paintings in San Francisco. In 1939, with the advent of World War II, he returned to San Francisco, where he

maintained a studio until his death. Known for his Impressionist and Postimpressionist landscapes, still life, and genre paintings.

Lit.: *All Things Bright and Beautiful: California Impressionist Paintings from the Irvine Museum*, exh. cat. (Irvine: Irvine Museum, 1998); T. H. Garver, "Joseph Raphael: A Decade in California," *Southwest Art* 9 (May 1980): 88–95; *Joseph Raphael: The California Years, 1969–1978*, exh. cat. (San Francisco: San Francisco Museum of Modern Art, 1978).

ALAN RATH

Born 1959, Cincinnati, Ohio
Lives in Oakland

Self-trained new-media artist. Earned a B.S. in electrical engineering from the Massachusetts Institute of Technology, Cambridge, in 1982, and worked with technology artists at the Center for Advanced Visual Studies, Architecture Machine Group, and Visible Language Workshop during his last year there. Was inspired by a museum exhibition of work by Jean Tinguely on a trip to Europe in 1982. Quit his job as a hardware engineer and moved to Oakland in 1984. Known for his electronic sculptures.

Lit.: *Alan Rath: Robotics*, exh. cat. (Santa Fe: SITE Santa Fe; Santa Monica: Smart Art Press, 1999); *Alan Rath: Plants, Animals, Humans, Machines* (Santa Monica: Smart Art Press, 1995); Dana Friis-Hansen, *Alan Rath: Bio-Mechanics*, exh. cat. (Houston: Contemporary Arts Museum, 1995).

CHARLES RAY

Born 1953, Chicago, Illinois
Lives in Los Angeles

Raised by a family that owned and operated a commercial art school. Attended Catholic high school at Marmion Military Academy in Aurora, Illinois. Studied at the University of Iowa, Iowa City, with Roland Brener and lived briefly in Vancouver, British Columbia. Returned to Chicago and then studied at the University of Kentucky, Lexington. Completed an M.F.A. at the Mason Gross School of Art, Rutgers University, New Brunswick, New Jersey, in 1979. Began teaching at the University of California, Los Angeles, in 1981. Known for his oversized, mannequinlike figure sculptures.

Lit.: Paul Schimmel, *Charles Ray*, exh. cat. (Los Angeles: Museum of Contemporary Art, 1998); Bruce W. Ferguson, *Charles Ray*, exh. cat. (Malmö, Swe.: Rooseum—Center for Contemporary Art, 1994); Lucinda Barnes, ed., *Charles Ray*, exh. cat. (Newport Beach: Newport Harbor Art Museum, 1990).

GRANVILLE REDMOND

Born 1871, Philadelphia, Pennsylvania
Died 1935, Los Angeles

Diagnosed with scarlet fever as a young child, he was deaf by age three. Moved with his family to San Jose in 1874. Attended the Berkeley Institution for the Deaf, Blind, and Dumb from 1879 to 1890, where he studied drawing and painting with Theophilus Hope D'Estrella. Studied at the California School of Design and the Académie Julian, Paris, in 1893. Returned to Los Angeles in 1898; moved to the Monterey Peninsula in 1908. Worked as a silent-movie actor in Hollywood and became friends with Charlie Chaplin. Known for his landscape paintings of poppy and wildflower fields.

Lit.: Jean Stern, *Selections from the Irvine Museum* (Irvine: Irvine Museum, 1993); *Granville Redmond*, exh. cat. (Oakland: Oakland Museum, 1988).

EDNA REINDEL

Born 1900, Detroit, Michigan
Died 1990, Santa Monica

Graduated from the Pratt Institute, Brooklyn, New York, in 1923 and spent five years doing book illustration and freelance commercial art work. Received Tiffany Foundation Fellowships in 1926 and 1932. Moved to Hollywood in 1939, where she painted murals for the Works Progress Administration Federal Art Projects. Known for her meticulous realist paintings of floral still lifes, portraits, landscapes, and genre scenes.

Lit.: Robert Henkes, *American Women Painters of the 1930s and 1940s: The Lives and Work of Ten Artists* (Jefferson, N.C.: McFarland, 1991); Edna Reindel Papers, National Museum of Women in the Art, Washington, D.C.

JOHN HUBBARD RICH

Born 1876, Boston, Massachusetts
Died 1954, Los Angeles

Moved to Minneapolis with his family at a young age. Took night-school art classes and worked as an illustrator for the *Minneapolis Times*. Enrolled at the Art Students League, New York, and the School of the Museum of Fine Arts, Boston. Earned a scholarship to study in Europe in 1905. Taught at the Groton School, Boston, in 1912. Cofounded the School for Illustration and Painting in Los Angeles in 1914. Taught at the University of Southern California, Los Angeles, and the Otis Art Institute, Los Angeles. Known for his portraits, figure studies, and still lifes.

Lit.: Nancy Dustin Wall Moure, *Publications in Southern California Art 1, 2, and 3* (Los Angeles:

Dustin Publications, 1984); Sonia Wolfson, "Art and Artists," *California Graphic*, Mar. 20, 1926, 6; Everett C. Maxwell, "Art," *The Graphic*, July 16, 1910.

FRANK ROMERO

Born 1941, Los Angeles
Lives in Los Angeles

Raised in the Boyle Heights district of East Los Angeles. Studied at the Otis Art Institute, Los Angeles, and California State College, Los Angeles, from 1956 to 1958. Formed an art collective known as "Los Four" with Carlos Almaraz, Gilbert Lujan, and Alberto de la Rocha. Lived in New York in 1968–69 and first visited Mexico in 1969. Worked as a designer for the Charles Eames Studio, A&M Records, and Los Angeles Community Redevelopment Agency. Commissioned for numerous murals and public art projects since 1974. Known for his colorful figurative paintings.

Lit.: *Frank Romero: Urban Iconography/ Iconografia urbana*, exh. cat. (Los Angeles: Harriet and Charles Luckman Fine Arts Complex, California State University, Los Angeles, 1998); Margarita Nieto, "Conversation with Artist Frank Romero," *Latin American Art* 3, no. 1 (winter 1991): 23–24; Heather Sealy Lineberry, "Frank Romero," *Art of California* 3, no. 5 (Sept. 1990): 21–25.

GUY ROSE

Born 1867, San Gabriel
Died 1925, Pasadena

Graduated from high school in Los Angeles and then moved to San Francisco, where he studied at the California School of Design with Virgil Williams and Emil Carlsen. Studied at the Académie Julian, Paris, from 1888 to 1890. Returned to New York in 1891, working as an illustrator for *Harper's Bazaar, Scribner's*, and *Century*. Taught at the Pratt Institute, Brooklyn, New York. Moved to Giverny, France, in 1904. Returned to New York in 1912; relocated to Pasadena in 1914, where he taught at and directed the Stickney Memorial School of Art. Known for his Impressionist paintings of California missions, landscapes, and coastal scenes.

Lit.: Will South, *Guy Rose: American Impressionist*, exh. cat. (Oakland: Oakland Museum; Irvine: Irvine Museum, 1995); Ilene Susan Fort, "The Cosmopolitan Guy Rose," in *California Light*, ed. Patricia Trenton and William H. Gerdts, exh. cat. (Laguna Beach: Laguna Art Museum, 1990); Earl L. Stendahl, *Guy Rose*, exh. cat. (Los Angeles: Stendahl Gallery, 1922).

SANDRA MENDELSOHN RUBIN

Born 1947, Santa Monica
Lives in Boonville

Raised in Venice, California. Earned a B.A. from the University of California, Los Angeles, in 1976 and an M.F.A. in 1979. Taught at the Art Center College of Design, Pasadena, and University of California, Los Angeles. Moved to Boonville in 1990. Known for her realistic still life, landscape, and figure paintings.

Lit.: Wendy Becket, *Sandra Mendelsohn Rubin: Paintings and Drawings*, exh. cat. (New York: Claude Bernard Gallery, 1987); *Sandra Mendelsohn Rubin*, exh. brochure (Los Angeles: Los Angeles County Museum of Art, 1985).

NANCY RUBINS

Born 1952, Naples, Texas
Lives in Topanga Canyon, Los Angeles County

Raised in Tullahoma, Tennessee. Attended high school on the East Coast and returned to Tennessee to start college. Served with a mobile medical unit in the Appalachian backwoods. Received a B.F.A. in 1974 from the Maryland Institute College of Art, Baltimore, and an M.F.A. in 1976 from the University of California, Davis, where she studied with William T. Wiley, Roy De Forest, and Robert Arneson. Moved to San Francisco and started scavenging thrift shops for art materials. Began teaching at the University of California, Los Angeles, in 1988. Known for her sculptures and installations made from discarded objects.

Lit.: Elizabeth Hayt, "Monuments of Junk Artfully Compacted," *New York Times*, May 2, 1999; Michael Duncan, "Transient Monuments," *Art in America* 83 (Apr. 1995); *Nancy Rubins*, exh. cat. (San Diego: Museum of Contemporary Art, 1995).

EDWARD RUSCHA

Born 1937, Omaha, Nebraska
Lives in Los Angeles

Raised in Oklahoma City; began drawing comics as a young boy. Visited California with his family in 1949 and traveled to Mexico City in 1955. Moved with his high school friend Joe Goode to Los Angeles in 1956, where he attended the Chouinard Art Institute, from 1956 to 1960. Worked for an advertising agency 1960–61. Served in the U.S. Navy and traveled to Europe in 1961. Began showing his work at the progressive Ferus Gallery in Los Angeles in 1963. Built a home in the remote California desert in 1976. Known for his paintings and prints that appropriate advertising imagery.

Lit.: Neal Benezra and Kerry Brougher, *Ed Ruscha*, exh. cat. (Washington D.C.: Hirshhorn Museum and Sculpture Garden, Smithsonian Institution, 2000); Dave Hickey, *Ed Ruscha*, exh. cat. (Los Angeles: Gagosian Gallery, 1998); *The Works of Edward Ruscha*, exh. cat. (New York: Hudson Hills Press, in association with the San Francisco Museum of Modern Art, 1982).

MATTEO SANDONA

Born 1881, Schio, Italy
Died 1964, San Francisco

Raised in the Italian Alps; began drawing and modeling as a young child. Immigrated with his family to Hoboken, New Jersey, in 1894 and studied at the Sacred Heart Academy. Returned to Europe for two years to study art in Verona and Paris, then continued his studies at the National Academy of Design, New York. Settled in San Francisco in 1901, where he became known for his figure and portrait paintings. Cofounded the California Society of Artists as a reaction to the conservative attitudes of the San Francisco Art Association. Known for his portraits, still lifes, and figure studies.

Lit.: *All Things Bright and Beautiful: California Impressionist Paintings from the Irvine Museum*, exh. cat. (Irvine: Irvine Museum, 1998); "Matteo Sandona," in *California Art Research Monographs* 13 (1936–37): 1–50.

PETER SAUL

Born 1934, San Francisco
Lives in Upstate New York

Worked as a merchant seaman and courier as a young man. Briefly attended Stanford University, Palo Alto, and the California School of Fine Arts, San Francisco, 1950–52. Studied at the Art School at Washington University, St. Louis, Missouri, where he encountered the work of Max Beckmann and Francis Bacon. Lived in Holland, Paris, and Rome between 1956 and 1964. Returned to the United States, living in Mill Valley 1964–74; and Chappaqua, New York, 1975–81. Moved to Austin, Texas, in 1981, where he taught at the University of Texas until 2000. Known for his early expressionistic paintings and his politically charged paintings of Vietnam and of public figures such as Martin Luther King, Jr., Angela Davis, and Ronald Reagan.

Lit.: *Peter Saul: Heads, 1986–2000*, exh. cat. (New York: Nolan/Eckman Gallery, 2000); *Peter Saul*, exh. cat. (Somogy and Les Sables d'Olonne, Fr.: Musée de l'Abbaye Sainte-Croix, 1999); *Peter Saul: Political Paintings, 1965–1971*, exh. cat. (New York: Frumkin/Adams Gallery, 1990).

RAYMOND SAUNDERS

Born 1934, Pittsburgh, Pennsylvania
Lives in Oakland

Studied at Schenley High School, Pittsburgh, with Joseph Fitzpatrick. Attended the Pennsylvania Academy of the Fine Arts, Philadelphia, the University of Pennsylvania, and the Barnes Foundation, Merion, Pennsylvania. Served in the U.S. Army at Fort Ord, near the Monterey Peninsula, from 1957 to 1959. Returned to Pittsburgh, where he received a B.F.A. at Carnegie Institute of Technology in 1960, followed a year later by an M.F.A. from the California College of Arts and Crafts (CCAC), Oakland. Taught at the Rhode Island School of Design before joining the faculty at California State College, Hayward, in 1969. Currently teaches at CCAC. Known for his semiabstract paintings and mixed media assemblages.

Lit.: *Raymond Saunders Forum*, exh. cat. (Pittsburgh: Carnegie Museum of Art, 1996); Steven Nash, *Raymond Saunders: Black Paintings*, exh. brochure (San Francisco: M. H. de Young Memorial Museum, 1995); Gay Morris, "Raymond Saunders: Improvising with High and Low," *Art in America* 83 (Feb. 1995): 86–94.

ROBERT BENTLEY SCHAAD

Born 1925, Los Angeles
Died 1999, Los Angeles

Studied at the Claremont Colleges, Claremont, under Henry Lee McFee. Taught at the Otis Art Institute, Los Angeles. Wrote and illustrated an instructional book entitled *The Realm of Contemporary Still Life Painting*. Known for his formal-realist still life paintings.

Lit.: Bentley Schaad, *The Realm of Contemporary Still Life Painting* (New York: Reinhold Publishing Corp., 1962); *Artists of Los Angeles and Vicinity: 1954 Annual Exhibition*, exh. cat. (Los Angeles: Los Angeles County Museum of Art, 1954).

DONNA SCHUSTER

Born 1883, Milwaukee, Wisconsin
Died 1953, Los Angeles

Daughter of a well-established cigar manufacturer. Studied at the School of the Art Institute of Chicago and the Museum School of Fine Arts, Boston, under Edmund C. Tarbell. Toured Belgium with William M. Chase in 1912 and moved to Los Angeles in 1913. Took summer school class with Chase in Carmel in 1914. Inspired by Stanton Macdonald-Wright and taught at the Otis Art Institute. Cofounded the Women Painters of the West group and served as president of the Watercolor Society. Known for her Impressionist and Postimpressionist harbor scenes, landscapes, floral still lifes, and figures.

Lit.: Patricia Trenton and Roberta Gittens, "Donna Norine Schuster: Afloat on Currents of Change," *Southwest Art*, Feb. 1993, 68–74; Roberta Gittens, "Donna Schuster," *Art of California* 4, no. 3 (May 1991): 16–20; *Retrospective Exhibit of the Oil Paintings and Water Colors by Donna Norine Schuster, 1883–1953*, exh. cat. (Downey: Downey Museum of Art, 1977).

SUEO SERISAWA

Born 1910, Yokohama, Japan
Lives in Hemet

Immigrated to the United States in 1918 to join his father in Seattle; the family then moved to Long Beach. Influenced by his artist father, Yoichi Serisawa, and portrait and landscape painter George Barker. Relocated to Colorado during World War II and then to Chicago, where he studied at the Art Institute before moving to New York in 1943. Influenced by Yasuo Kuniyoshi. Returned to Southern California in 1947 and taught at Kann Institute of Art, 1948–50, and Scripps College, Claremont, 1950–51. Traveled to Japan in 1955. Known for his early still lifes and portraits and his later abstract expressionist paintings.

Lit.: *Sueo Serisawa: Retrospective*, exh. cat. (Los Angeles: Doizaki Gallery, 2000); Michael D. Brown, *Views from Asian California, 1920–1965* (San Francisco: Michael Brown, 1992); *Artists of Los Angeles and Vicinity: 1954 Annual Exhibition*, exh. cat. (Los Angeles: Los Angeles County Museum of Art, 1954).

JOSEPH HENRY SHARP

Born 1859, Bridgeport, Ohio
Died 1953, Pasadena

Began his studies at the McMicken School of Design in Cincinnati, followed by a year in Antwerp, where he studied art with Charles Verlat in 1882. Visited Taos, New Mexico, in 1893 and Pasadena in 1898. Returned to Europe with Frank Duveneck, where he continued his studies with Charles Marr and Jean Paul Laurens in Paris. Taught at the Cincinnati Art Academy for ten years before retiring to travel and paint in the American West. Maintained studios in Montana, New Mexico, and Pasadena. Well known for his illustrations and paintings of Native Americans.

Lit.: *Joseph Henry Sharp (1859–1953): A Symphony in Silence*, exh. cat. (Orange, Tex.: Stark Museum of Art, 1994); Forrest Fenn, *The Beat of the Drum and the Whoop of the Dance: A Study of the Life and Work of Joseph Henry Sharp* (Santa Fe, N.M.: Fenn Publishing Co., 1983); Joseph Henry Sharp, *Indian Paintings*, exh. cat. (New York: Kennedy Galleries, 1976).

RICHARD SHAW

Born 1941, Hollywood
Lives in Fairfax

Moved with his artist parents to Newport Beach in 1950. Studied at Orange Coast College, Costa Mesa, from 1961 to 1963. Earned a B.F.A. from the San Francisco Art Institute in 1965, where he studied with Ron Nagle, Robert Hudson, and Manuel Neri. Attended the State University of New York, Alfred, in 1965, and earned an M.F.A. from the University of California, Davis, in 1968, where he studied with William T. Wiley, Robert Arneson, and Roy De Forest. Taught at the San Francisco Art Institute from 1966 to 1987. Joined the faculty of the University of California, Berkeley, in 1987, where he currently teaches. Known for his trompe l'oeil ceramic sculptures.

Lit.: Jock Reynolds, *Robert Hudson and Richard Shaw: New Ceramic Sculpture*, exh. cat. (Andover, Mass.: Addison Gallery of American Art, Phillips Academy, 1998); Bill Berkson, "Shaw Business," *American Craft*, Oct./Nov. 1966, 79–81; Richard Shaw, *Illusionism in Clay, 1971–85*, exh. cat. (San Francisco: Braunstein Gallery, 1985).

PETER SHELTON

Born 1951, Troy, Ohio
Lives in Los Angeles

Moved with his family to Tempe, Arizona, as a young child. Received a B.A. from Pomona College, Claremont, in 1973. Returned to Troy, Ohio, and attended the Hobart Brothers School of Welding Technology. Worked as a welder in Ohio and Michigan. Returned to Los Angles in late 1974. Enrolled in graduate school at the University of California, Los Angeles, in 1977. Taught at Otis Art Institute, Los Angeles, from 1980 to 1984; Claremont Graduate School, Claremont, from 1981 to 1985; University of Southern California, Los Angeles, in 1985; and University of California, Santa Barbara, in 1989. Known for his mixed media sculptures and installations.

Lit.: *Peter Shelton: sixtyslippers*, exh. cat. (Berkeley: University of California, Berkeley, Art Museum, 1998); Carol S. Eliel, *Peter Shelton: bottlesbonesandthingsgetwet*, exh. cat. (Los Angeles: Los Angeles County Museum of Art, 1994); *Peter Shelton: Waxworks*, exh. cat. (Des Moines: Des Moines Art Center, 1988).

HENRIETTA SHORE

Born 1863, Toronto, Canada
Died 1963, San Jose

Studied with Laura Muntz Lyall at St. Margaret's College, Toronto, in 1893, then at the New York School of Art under William M. Chase, Frank V. DuMond, and Robert Henri.

Attended the Heatherly Art School, London, in 1905. Taught art in Toronto before moving to Los Angeles in 1913, where she helped establish the Los Angeles Modern Art Society the same year. Moved to New York in 1920, and then again to California in 1928, where she became a close companion to photographer Edward Weston, who was inspired by her work. Established a permanent home in Carmel and spent her final years in San Jose. Known for her portraits, murals, landscapes, and still lifes depicting flowers, cacti, animals, and seashells.

Lit.: Ann Hitchcock, *Visions of Their Own: Four Monterey Bay Artists of the Depression Era— Corde Gauere, Leonora Naylor Penniman, Margaret Rogers, Henrietta Shore*, exh. cat. (Santa Cruz: Octagon Museum, Santa Cruz Historical Trust, 1990); Roger Aikin, "Henrietta Shore and Edward Weston," *American Art* 6, no. 1 (winter 1992): 42–61; Roger Aikin, *Henrietta Shore: A Retrospective Exhibition, 1900–1963*, exh. cat. (Monterey: Monterey Peninsula Museum of Art, 1986).

KATHRYN SPENCE

Born 1963, Stuttgart, Germany
Lives in San Francisco

Received a B.F.A. from the University of Colorado, Boulder, in 1986 and an M.F.A. from Mills College, Oakland, in 1993, where she studied with Anna Murch and Ron Nagle. Completed an artist-in-residency at the Headlands Center for the Arts, Sausalito, in 1998, and in 2002 received a San Francisco Art Council Grant. Known for her mixed media sculptures made from discarded materials.

Lit.: *Kathryn Spence: Wild* (Kansas City, Mo.: Kemper Museum of Contemporary Art, 1999); *Present Tense: Nine Artists in the Nineties* (San Francisco: San Francisco Museum of Modern Art, 1997); *n2n: Agelio Batle, Vincent Fecteau, Brian Goggin, Lisa Hein, Siobhan Liddell, Manuel Lucero, Ulrike Palmbach, Kathryn Spence, Ella Tideman* (San Francisco: Center for the Arts at Yerba Buena Gardens, 1994).

RAIMONDS STAPRANS

Born 1926, Riga, Latvia
Lives in San Francisco

Began drawing at age six. Fled to Germany with his family upon the Soviet invasion of Latvia in 1944. Attended the School of Art, Esslingen, Germany, in 1946. Moved to Salem, Oregon, in 1947. Earned a B.A. from the University of Washington, Seattle, in 1952, where he was influenced by Georges LeBrun and Alexander Archipenko. Studied at the University of California, Berkeley, with Karl Kasten and Erle Loran in the 1950s. Moved to Oregon

in 1953, then settled permanently in San Francisco in 1955. Began writing stage plays in 1967. Known for his vibrantly colored, semi-abstract paintings of figures and objects.

Lit.: *Raimonds Staprans, Recent Paintings,* exh. cat. (San Francisco: Hackett Freedman Gallery, 2001); *Raimonds Staprans,* exh. cat. (Pasadena: Mendenhall Gallery, 1997); *Raimonds Staprans: A One Man Exhibition of Recent Oil Paintings,* exh. cat. (San Francisco: Maxwell Galleries, 1969).

ROBERT THERRIEN

Born 1947, Chicago, Illinois
Lives in Los Angeles

Moved with his family to Palo Alto in 1954; following high school enrolled at the California College of Arts and Crafts, Oakland. Transferred to the Brooks Institute, Santa Barbara, to study photography, completing a B.F.A. in 1970. Earned an M.F.A. from University of Southern California, Los Angeles, in 1973. Known for his sculptures and two-dimensional works that reinterpret the scale and psychology of objects from popular culture.

Lit.: Lynn Zelevansky, *Robert Therrien,* exh. cat. (Los Angeles: Los Angeles County Museum of Art, 2000); *Robert Therrien,* exh. cat. (Madrid: Museo Nacional Centro de Arte Reina Sofía, 1991); *Robert Therrien,* exh. cat. (Los Angeles: Museum of Contemporary Art, 1984).

WAYNE THIEBAUD

Born 1920, Mesa, Arizona
Lives in Sacramento

Worked in the animation department of Walt Disney Studios, Los Angeles, as a teenager in 1936, and the following year studied commercial art at Frank Wiggins Trade School. Attended Long Beach Junior College in 1940–41 and served in the U.S. Air Force between 1942 and 1945. Worked for Rexall Drug Company in Los Angeles as a layout designer and cartoonist from 1946 to 1949. Studied at San Jose State College in 1949–50, and earned a B.A. in 1951 and M.A. in 1953 from California State College, Sacramento. Taught and served as chair of the art department at Sacramento Junior College from 1951 to 1960. Joined the faculty at the University of California, Davis, in 1960, retiring in 1990. Known for his colorful paintings of popular culture objects and food.

Lit.: Steven A. Nash and Adam Gopnik, *Wayne Thiebaud: A Paintings Retrospective,* exh. cat. (New York: Thames and Hudson; San Francisco: Fine Arts Museums of San Francisco, 2000); Stephen McGough, *Thiebaud Selects Thiebaud: A Forty-Year Survey from Private Collections,* exh. cat. (Sacramento: Crocker Art

Museum, 1996); Kathleen Whitney Behet, *Wayne Thiebaud: Still Lifes and Landscapes* (New York: Associated American Artists, 1993).

KIM TUROS

Born 1955, San Antonio, Texas
Lives in San Diego

Took classes at the McNay Art Institute, San Antonio, as a child. Received a B.S. in landscape architecture from Texas A&M University, College Station, in 1978. Moved to San Diego in 1985 and to San Francisco in 1987. From 1988 to 1991 she resided in both Berkeley and Germany, where she held a residency in Munich. Studied at the San Francisco Art Institute in 1988–89 and Skowhegan School of Painting and Sculpture, New York, in summer 1989. Held a residency at the Headlands Center for the Arts, Sausalito, in 2001, and earned an Andy Warhol Foundation for the Visual Arts grant the same year. Married to physicist John Gilleland. Artist and landscape architect known for her sculpture and site-specific installations.

Lit.: Kyle MacMillan, "Contemporary's Archipelago Does Its Job Brilliantly," *Denver Post,* July 21, 2002; Henry Urbach, "A Delicate Balance," *Interior Design* 8 (June 1997): 104.

PATSSI VALDEZ

Born 1953, Los Angeles
Lives in Los Angeles

Raised by a family of artists in East Los Angeles, she attended East Los Angeles College. Cofounded ASCO, a multimedia art and performance collaborative group, with Willie Herron, Gronk, and Harry Gamboa in 1972. Graduated from the Otis Parsons School of Design, Los Angeles, in 1985, and studied at the Parsons School of Design, New York, in 1993. Began painting in 1988. Worked as art consultant and designer for various films and television programs. Known for her installations, paper fashions, and vibrantly colored paintings.

Lit.: Cheech Marin, *Chicano Visions: American Painters on the Verge* (Boston: Bulfinch Press, 2002); *Patssi Valdez: A Precarious Comfort/Una comodidad precaria,* exh. cat. (San Francisco: Mexican Museum, 1999); Margarita Nieto, "Patssi Valdez," *Latin American Art* 2, no. 3 (summer 1990): 9.

ALBERT R. VALENTIEN

Born 1862, Cincinnati, Ohio
Died 1925, San Diego

Trained with Frank Duveneck at the Cincinnati Art Academy and also studied in Europe. By age nineteen he was employed at Rookwood

Pottery in Cincinnati; eventually served as head director for over twenty-four years, leaving in 1905. Visited San Diego in 1903 and moved there permanently in 1908; three years later he and his wife, Anna, established the Valentien Pottery Company there. Commissioned by Helen Browning Scripps to paint 1,200 watercolors of California wildflowers between 1908 and 1918. Well known for his landscapes, floral still lifes, and pottery designs.

Lit.: *Albert R. Valentien: The California Years, 1908–1925,* exh. cat. (Cincinnati: Cincinnati Art Galleries, 2000); Bruce Kamerling, "Anna and Albert Valentien: The Arts and Crafts Movement in San Diego," *Arts and Crafts Quarterly* 3 (July 1, 1987): 1, 12–20; Bruce Kamerling, "Anna and Albert Valentien: The Arts and Crafts Movement in San Diego," *Journal of San Diego History* 24 (summer 1978): 343–65.

PETER VANDENBERGE

Born 1935, The Hague, Netherlands
Lives in Sacramento

Moved with his family to the Dutch East Indies (now Indonesia), where they were interned in Japanese prison camps from 1942 to 1945 during World War II. Moved to Bakersfield in 1954, attending Bakersfield Junior College from 1954 to 1957. Spent a year in Europe, then enrolled at California State College, Sacramento, where he earned a B.F.A. in 1959. Received his M.A. from the University of California, Davis, in 1963. Taught at San Francisco State University from 1966 to 1973; currently teaches at California State University, Sacramento. Known for his humorous ceramic vegetable sculptures and large ceramic busts.

Lit.: Susan Landauer, *The Lighter Side of Bay Area Figuration,* exh. cat. (Kansas City, Mo.: Kemper Museum of Contemporary Art; San Jose: San Jose Museum of Art, 2000); *VandenBerge,* exh. cat. (Davis: Natsoulas/Novelozo Gallery, 1991); Mark Van Proyen, "A Sardonic Wit," *Artweek* 14 (Jan. 22, 1983): 5.

LUVENA BUCHANAN VYSEKAL

Born 1873, LeMars, Iowa
Died 1954, Los Angeles

Educated in Pittsburgh, Kansas, and began her artistic training at the School of the Art Institute of Chicago. Moved to Los Angeles in 1914; completed a mural in El Centro. Studied with J. H. Vanderpoel, Stanton Macdonald-Wright, and Harry M. Walcott. Upon the death of her husband, artist Edouard Vysekal, in 1939, she became director of the Vysekal Studio Gallery in Hollywood, California. Organized the Los Angeles Group of Eight. Known for her modernist figure and still life paintings.

Lit.: Arthur Millier, "Our Artists in Person, No. 8—The Vysekals," *Los Angeles Times,* July 20, 1930, 3, 12; Sonia Wolfson, "Two Ironic Romanticists," *Argus* 4 (Oct. 1928): 3–4.

NELL WALKER WARNER

Born 1891, Richardson County, Nebraska
Died 1970, Carmel

Studied in Colorado Springs and graduated from Lexington College, Missouri, in 1910. Moved to California, graduating from the Los Angeles School of Art and Design in 1916. Traveled in Europe and spent three summers in Cape Ann, Massachusetts, where she painted harbor scenes. Served as art curator of the Tuesday Afternoon Club, Los Angeles, and president of the Women Painters of the West. Continued her studies in Los Angeles with Nicolai Fechin and Paul Lauritz. Moved to Carmel in 1950. Known for her floral still life paintings.

Lit.: Patricia Trenton, ed., *Independent Spirits: Women Painters of the American West, 1890–1945* (Los Angeles: Autry Museum of Western Heritage, in association with University of California Press, Berkeley, 1995); *How Nell Walker Warner Paints in Oils* (Laguna Beach: Walter T. Foster, [c. 1950]); *Nell Walker Warner,* exh. cat. (Hollywood: Hollywood Gallery of Modern Art in the Knickerbocker Hotel, 1937).

EDITH WHITE

Born 1855, Decorah, Iowa
Died 1946, Berkeley

Settled with her family in French Corral, Nevada County, California, in 1859. Graduated from Mills Seminary, Oakland, in 1874. Taught primary school for two years, continuing her studies at the California School of Design, San Francisco, under Virgil Williams. Moved to Los Angeles in 1882. Studied at the Art Students League, New York, in 1892. Returned to California; helped establish the Pasadena Art Association. Moved to Point Loma in 1902 and taught art at the Theosophical Society. Returned to Oakland and then Berkeley in 1938 to teach privately. Known for her paintings of California missions, landscapes, portraits, and floral still lifes.

Lit.: Patricia Trenton, ed., *Independent Spirits: Women Painters of the American West, 1890–1945* (Los Angeles: Autry Museum of Western Heritage, in association with University of California Press, Berkeley, 1995); Bruce Kamerling, *100 Years of Art in San Diego* (San Diego: San Diego Historical Society, 1991); *Memories of Pioneer Childhood and Youth in French Corral and North San Juan Nevada County, California, with a Brief Narrative of Later Life, Told by Edith White, Emigrant of 1859, to Linnie Marsh Wolfe* (San Francisco: Library of the California Historical Society, 1936).

WILLIAM T. WILEY

Born 1937, Bedford, Indiana
Lives in Woodacre

Attended Columbia High School in Richland, Washington, where he met longtime friends Robert Hudson and William Allan in art classes. Attended the California School of Fine Arts, San Francisco, earning a B.F.A. in 1960 and M.F.A. in 1962. Began combining images and text after visiting a René Magritte retrospective exhibition in the mid-1960s. Participated in the development of the Funk Art movement. Taught at the University of California, Davis, from 1962 to 1973 and the San Francisco Art Institute in 1963 and from 1966 to 1967. Known for his watercolors, constructions, and large-scale linear paintings that incorporate puns and ambiguous phrasing.

Lit.: *Nothing Lost from the Original: William T. Wiley Looks at Art History,* exh. cat. (San Francisco: M. H. de Young Memorial Museum, Fine Arts Museums of San Francisco, 1996); Constance Lewallen, *William T. Wiley: Watching the World,* exh. cat. (Philadelphia: Locks Gallery, 1995); Terrie Sultan, *William T. Wiley: Struck! Sure? Sound/Unsound,* exh. cat. (Washington, D.C.: Corcoran Gallery of Art, 1991).

EVELYN ALMOND WITHROW

Born 1858, Santa Clara
Died 1928, San Diego

Educated in San Francisco public schools and graduated from College of the Pacific, Stockton. Traveled to Munich in 1881, where she studied under J. Frank Currier. Visited Italy, Paris, and then settled with her sister in London and established a studio. Returned to San Francisco in 1887; served as first president of the San Francisco Society of Women Artists in 1925. Relocated to San Diego in 1926. Known for her portraits, still lifes, and symbolist paintings.

Lit.: Lowell Darling, "Evelyn Almond Withrow" (ms., 1995); George Wharton James, "Evelyn Almond Withrow: Painter of the Spirit," *National Magazine* 44 (Aug. 1916): 763–75; Pierre N. Boeringer, "Original Sketches by San Francisco Painters. I. Miss Eva Withrow," *Overland Monthly* 27 (Feb. 1896): 161–65.

PAUL WONNER

Born 1920, Tucson, Arizona
Lives in San Francisco

Attended the California College of Arts and Crafts, Oakland, from 1937 to 1941; served in the U.S. Army from 1942 to 1946. Moved to New York and worked as a package designer at the House of Harley from 1946 to 1950. Received a B.A. in 1952 and M.A. in 1953 from the University of California, Berkeley. Worked as a librarian at the University of California, Davis, 1956–59. Taught at Otis Art Institute, Los Angeles, in 1965–66; University of California, Santa Barbara, 1968–71; and University of California, Davis, 1975–76. Moved to San Francisco in 1976. Known for his association with the Bay Area Figurative group and his realistic still life compositions.

Lit.: *Paul Wonner,* exh. cat. (New York: D. C. Moore Gallery, 1999); *Paul Wonner,* exh. cat. (New York: Coe Kerr Gallery, 1992); *Paul Wonner: Abstract Realist,* exh. cat. (San Francisco: San Francisco Museum of Modern Art, 1981).

KARL JULIUS YENS

Born 1868, Altona, Germany
Died 1945, Laguna Beach

Studied in Berlin with Max Koch and in Paris with Benjamin Constant and Jean Paul Laurens. Painted murals in Germany and Scotland. Moved to the United States in 1901, painting murals in New York and Washington, D.C. Moved to Southern California in 1910, settling in Laguna Beach in 1918. Cofounded the Modern Art Society and the Laguna Beach Artists' Association. Known for his bold, colorful landscapes and figural work.

Lit.: *All Things Bright and Beautiful: California Impressionist Paintings from the Irvine Museum* (Irvine: Irvine Museum, 1998); Jean Stern, *Selections from the Irvine Museum* (Irvine: Irvine Museum, 1993); H. K. Peabody, "Karl Yens," *Western Arts,* Mar. 1926, 9–12.

WAYNE THIEBAUD
Four Sandwiches

1965, oil on panel, 13 × 21¼ in. Collection of Hackett-Freedman Gallery, San Francisco. © Wayne Thiebaud/Licensed by VAGA, New York, N.Y.

notes

DIRECTOR'S FOREWORD

1. Janice T. Driesbach, *Bountiful Harvest: 19th-Century California Still-Life Painting* (Sacramento: Crocker Art Museum, 1991).

INTRODUCTION

1. Gertrude Stein, "Sacred Emily," in *Geography and Plays* (1922; repr. Lincoln: University of Nebraska Press, 1993), 178.

2. George Herms, telephone interview with the author, Mar. 31, 2002.

3. The idea is similar to the jazz concept of the "melodic nugget," by which Charlie Parker, Dizzy Gillespie, and Miles Davis transformed popular tunes such as "Over the Rainbow" and "Jingle Bells" into virtuoso performances of improvisational jazz. I would like to thank San Francisco artist Marco Aidala for this insight.

4. According to Picasso's biographer, John Richardson, this statement was originally T. S. Eliot's and has been misattributed to Picasso. Lindsey Wylie, conversation with John Richardson, April 17, 2003.

5. William Gerdts, with Russell Burke, *American Still life Painting* (New York: Praeger, 1971); Norman Bryson, *Looking at the Overlooked: Four Essays on Still Life Painting* (Cambridge, Mass.: Harvard University Press, 1990); Anne W. Lowenthal, ed., *The Object as Subject: Studies in the Interpretation of Still Life* (Princeton: Princeton University Press, 1996); Margit Rowell, *Objects of Desire: The Modern Still Life* (New York: Museum of Modern Art, in association with Harry N. Abrams, 1997). Publications focusing on still life began to appear with increasing frequency in the 1980s and proliferated in the 1990s. See, for example, Linda L.

Cathcart, *American Still Life, 1945–1983* (Houston: Contemporary Arts Museum, 1983); Lowery Stokes Sims and Sabine Rewald, *Still Life: The Object in American Art, 1915–1995* (New York: Metropolitan Museum of Art, in association with the American Federation of the Arts, 1996); and *Silent Things, Secret Things: Still Life from Rembrandt to the Millennium* (Albuquerque: Albuquerque Museum, 1999). For a brilliant analysis of pictorial and literary still life and their interrelationship, see Guy Davenport, *Objects on a Table: Harmonious Disarray in Art and Literature* (Washington, D.C.: Counterpoint, 1998).

6. Bryson, *Looking at the Overlooked*, 11.

7. Although Bryson cites as evidence of still life's variety "Pompeii, Cubism, Dutch still life, Spanish still life, *trompe l'oeil* [and] collage," his conception is clearly the archetypal repast when he argues that "still life exists as a coherent category" by virtue of its "low-plane" subject matter: the "conditions of creaturality" and "culture of the table." He contends that still life's subject matter "pitches itself at a level of material existence where nothing exceptional occurs" and therefore, "while history painting is constructed around narrative, still life is the world minus its narrative, or better, the world minus its capacity for generating narrative interest." Ibid., 7, 13, 14, 60, 61.

8. E. H. Gombrich, "Tradition and Expression in Western Still Life," in *Meditations on a Hobby Horse, and Other Essays on the Theory of Art*, 3d ed. (London: Phaidon Press, [1963] 1978), 95.

9. Wayne Thiebaud, telephone interview with Lindsey Wylie, July 26, 2002.

MAKING ARRANGEMENTS

1. William H. Gerdts and Russell Burke, *American Still-Life Painting* (New York: Praeger, 1971).

2. See Janice T. Driesbach's superb catalogue *Bountiful Harvest*. See also the section on nineteenth-century still life in Nancy Dustin Wall Moure, *California Art: 450 Years of Painting and Other Media* (Los Angeles: Dustin Publications, 1998), 69–75.

3. For the phenomenon of California light, see especially the essays by Michael P. McManus, "A Focus on Light," and Iris H. W. Engstrand, "In Search of the Sun," in Patricia Trenton and William H. Gerdts, eds., *California Light, 1900–1930* (Laguna Beach, Calif.: Laguna Art Museum, 1990), 13–18, 53–60.

4. See Harvey L. Jones, *Twilight and Reverie: California Tonalist Painting, 1890–1930* (Oakland: Oakland Museum, 1995), which contains no reference to still lifes.

5. One of the best surveys of American gardens during this period is Louise Shelton, *Beautiful Gardens in America* (New York: Charles Scribner's Sons, 1928); California gardens are discussed on pages 493–548. For a discussion of California gardening, see John McLaren, *Gardening in California: Landscape and Flower* (San Francisco: A. M. Robertson, 1909).

6. William H. Gerdts, *Down Garden Paths: The Floral Environment in American Art* (Madison, N.J.: Fairleigh Dickinson University Press; London and Toronto: Associated University Presses, 1983). For California garden paintings, see Nancy Moure, "California Garden Scenes," *Art of California* 4, Sept. 1991, 52–57.

7. Driesbach, *Bountiful Harvest*, 12–38. The principal earlier study was Joseph Armstrong Baird, Jr., ed., *Samuel Marsden Brooks, 1816–1892* (San Francisco: California Historical Society, 1963).

8. See Ulrich W. Hiesinger, *Quiet Magic: The Still-Life Paintings of Emil Carlsen* (New York: Vance Jordan Fine Art, 1999), esp. 18–20.

9. Despite the extensive citrus groves in Southern California and the exuberant Orange Crate advertising art, California painters made little use of this subject in their still lifes. I have been unable to find any citrus pictures by the McCloskeys securely dated to their years in Southern California, though surely some of the undated ones must have been painted while they were living in Los Angeles. See John Salkin and Laurie Gordon, *Orange Crate Art* (New York: Warner Books, 1976).

10. The definitive published study here is Nancy Dustin Wall Moure, *Partners in Illusion: Alberta Binford and William J. McCloskey* (Santa Ana, Calif.: Bowers Museum of Cultural Art, 1996). See also John Fuller McGuigan, Jr., "Wrapped Oranges, Still Life Paintings by William J. McCloskey" (master's thesis, University of Denver, 1995).

11. See the extensive clippings in the Alice B. Chittenden Papers, Archives of American Art (hereafter cited as AAA), Smithsonian Institution, Washington, D.C., reel 919.

12. *Chrysanthemums* was exhibited in the 1892 spring annual of the San Francisco Art Association and held the place of honor on the south wall. In "The Art Association's Exhibition," *San Francisco Newsletter and California Advertiser*, Apr. 9, 1892, 18, the basket was identified as Chinese, a clear reference to a segment of San Francisco's population. A similar painting by Chittenden won a silver medal at the 1893 World's Columbian Exposition in Chicago.

13. Judging by her exhibition records in San Francisco and at the Del Monte Hotel Art Gallery, chrysanthemums and roses were the two flowers Chittenden repeatedly painted. Within the rose family she often carefully distinguished the specific variety: La France roses figure most often in her oeuvre, but are often joined by Maréchal Niel, Lamarque, Duchesse de Brabant, Meteor, Perle des Jardins, Jacqueminot, and American Beauty roses.

14. "Chittenden Oil Paintings to Be Exhibited Here," Chittenden Papers, AAA, reel 919, frames 370–71.

15. Edwin Deakin, *The Twenty-one Missions of California* (San Francisco: Murdock Press, 1899); Ruth I. Mahood, *A Gallery of California Mission Paintings by Edwin Deakin* (Los Angeles: Ward Ritchie Press, 1966).

16. Moure, *California Art*, 73, mistakenly states that "Deakin developed his own still-life talents only after Brookes died in 1892."

17. My thanks to Marjorie Arkelian for sharing with me a great deal of material and discussion on the life and art of Edwin Deakin.

18. Reviewing an exhibition at the San Bruno Public Library, Roberta Solomon wrote: "Even more remarkable are Hubacek's still lifes. He has captured the full feeling of copper, brass, and various textiles. One can feel the nub of a Navajo rug of one painting and the feathers of a goose in another" (*Burlingame Advance Star*, Feb. 9, 1958). My thanks to Judy Steele of the San Bruno Public Library for her assistance.

19. The primary study of Redmond is Mary Jean Haley, "Granville Redmond: A Triumph of Talent and Temperament," in *Granville Redmond* (Oakland: Oakland Museum, 1988). Most of the other published discussions of Redmond's art and career center on his landscape paintings and his association with Charlie Chaplin. Redmond appeared in a series of Chaplin's films of the 1920s.

20. After his return from Paris in 1898, Redmond took up residence in East Los Angeles, but his closest artistic contacts remained in San Francisco—he was close to colleagues such as Douglas Tilden (also a deaf-mute) and Gottardo Piazzoni—and he exhibited paintings of this period there.

21. [Theophilus] d'Estrella, "The Itemizer," *California News*, May 5, 1900. My thanks to James Delman for this citation, sent to him by Mildred Albronda in 1986. The reference here is to James M. Barrie, *My Lady Nicotine: A Study in Smoke* (Boston: Joseph Knight, 1895), illustrated by Maurice Prendergast.

22. There has been no modern study of Sandona. See "Matteo Sandona," in *California Art Research*, 20 vols., ed. Gene Hailey (San Francisco: California Art Research Project, Works Progress Administration, 1936–37), 13:1–50. Sandona showed a painting titled *Chrysanthemums* in the annual spring exhibition of the San Francisco Art Association in 1911.

23. Albert Bender Papers, undated clipping, AAA.

24. Phyllis Ackerman, "A Woman Painter with a Man's Touch," *Arts and Decoration* 18 (Apr. 1923): 20, 73; Helen Dare et al., *Tributes to Anne Bremer* (San Francisco: J. Nash, 1927); Hailey, ed., *California Art Research*, 7:88–128 (102–9 for Bremer's still lifes). Bremer's career awaits modern investigation, the exception being Raymond L. Wilson, "Anne M. Bremer (1868–1923)," in *Plein Art Painters of California: The North*, ed. Ruth Lilly Westphal (Irvine: Westphal Publishing, 1986), 38–41.

25. The Sketch Club was formed in the late nineteenth century and revitalized in 1906 under Bremer's presidency. For its reorganization and 1906 exhibition, see Laura Bride Powers, "Women's Art Show Proves That Personality, Not Sex, Dominates Art," *San Francisco Call*, Feb. 18, 1906, 23; and Will Sparks, "Sketch Club Women Set Pace for Progress among the Artist Folk of San Francisco," *San Francisco Call*, Oct. 8, 1906, 9. My thanks to Alfred Harrison, Jr., for sharing his voluminous files on California artists who painted still lifes (henceforth cited as Harrison files). For an earlier consideration of the club, see N. L. Murtha, "The Sketch Club 'Art for Art's Sake,'" *Overland Monthly* 29 (June 1897): 577–78.

26. *The Lacquer Screen* was a gift to the Oakland Museum from Bremer's cousin, Albert M. Bender, one of San Francisco's greatest art patrons of the day. Bender established the Anne Bremer Memorial Library at the San Francisco Art Institute and sponsored two 1927 publications, *Tributes to Anne Bremer* by Helen Dare et al. and a volume of Bremer's poems titled *The Unspoken and Other Poems*, published by John Henry Nash.

27. Sylvia Mardfin ("Anne Bremer: An Appreciation," in Dare et al., *Tributes*, 14) recalled "Oriental potteries and drapes, Chinese screens, and California flowers glowing onto her canvases." I would like to express tremendous appreciation to Amy Postar, curator of Asian Art at the Brooklyn Museum, for her identification of the vessel in *The Lacquer Screen*.

28. Bremer, *Unspoken*, 8.

29. For Withrow, see Pierre N. Boeringer, "Original Sketches by San Francisco Painters. 1. Miss Eva Withrow," *Overland Monthly* 27 (Feb. 1896): 161–65; L. D. Ventura, "A Notable Exhibition of Paintings," *Sunset* 17 (Sept. 1906): 292–93; George Wharton James, "Evelyn Almond Withrow: Painter of the Spirit," *National Magazine* 44 (Aug. 1916): 763–75; Hailey, ed., *California Art Research*, 5:1–18. A significant study by Lowell Darling, "Evelyn Almond Withrow" from 1995, remains unpublished. Many thanks to Darling for sharing his work with me, and to Birgitta Hjalmarson for putting me in touch with Darling.

30. See the long, laudatory review of her work by "G," "Art Notes," *Argonaut*, Dec. 10, 1887, 11. Withrow returned to Europe a num-

ber of times; traveling with her sister to England and the Low Countries in 1897–98, she wrote a series of letters published in the *Evening Post* in 1897, on May 25, 11; October 30, 13; November 6, 13; November 13, 13; November 20, 11; November 27, 11; and on January 6, 1898, 11. See also "What Two Californians Have Accomplished in London," *San Francisco Chronicle*, Sept. 15, 1901, 23. Harrison files.

31. The interpretation of bubbles as a symbol of transience has also been associated with *vanitas*. Although *vanitas* was initially (in seventeenth-century Dutch still lifes) represented by emblems of wealth and prosperity, items that refer to the ephemerality of life may also be included in *vanitas* works. See Helene E. Roberts, "Vanity/Vanitas," in *Encyclopedia of Comparative Iconography* (Chicago: Fitzroy Dearborn, 1998), 883.

32. Harrison has several references to bubble paintings by Withrow in his files: Katharine Clark Prosser, "Withrow Oil Display Will Be March Event," *San Francisco Call*, Feb. 12, 1912, 38; "The Art Gallery," *Sacramento Daily Record-Union*, Sept. 11, 1894, 3 (a mention of *Withrow's Life*, shown at the State Agricultural Society, depicting a graceful female rising toward a bubble that floated above her); Lucy B. Jerome, "In the World of Art," *San Francisco Call*, Jan. 10, 1909, 27 (in which the writer noted in Withrow's studio a red crayon sketch of a woman gazing at a bubble in her hand); and Anna Cora Winchell, "Artists and Their Work," *San Francisco Chronicle*, Oct. 19, 1919, 105 (mention of a pastel titled *The Birth of the Bubble*).

33. Withrow previously, in October 1912, exhibited several still lifes with the Cap and Bells Club. See "Women Artists Are Exhibiting," *San Francisco Call*, Oct. 24, 1912, 6. Harrison files.

34. A. de Talmours, "M. J. Pagès," *L'Académie Julian* 5 (March 1903), 2–3.

35. "Jules Pages [*sic*], Painter," *Los Angeles Times*, Apr. 14, 1907, pt. 6, 2; "Jules Pages [*sic*]," *Los Angeles Times*, Feb. 18, 1912, pt. 3, 15; Antony Anderson, "Art and Artists," *Los Angeles Times*, Aug. 24, 1913, pt. 3, 2; Louise E. Taber, "Jules Pagès—An American Artist," *Fine Arts Journal* 31 (July 1914): 511–12; Louise E. Taber, "Jules Pagès," *Art and Progress* 5 (Sept. 1914): 385–87. The only modern treatments of the artist are Janet B. Dominik, "Jules Eugene Pages [*sic*] (1867–1946)," in Westphal, ed., *Plein Air Painters: North*, 143–47; Monica E. Garcia, "Jules Pages [*sic*]," *Art of California* 3 (Mar. 1990): 17–22. See also Pagès's short essay "Definition of Art," *Western Art* 1 (Apr. 1914): 23.

36. There is no satisfactory study of Raphael's life and art. See Hailey, ed., *California Art Research*, 5:32–94; *Joseph Raphael, 1869–1950* (Laren, Neth.: Singer Museum, 1981); Raymond Wilson, "Joseph Raphael (1869–1950)," in Westphal, ed., *Plein Air Painters: North*, 160–65.

37. See the several autobiographies of Dame Laura Knight, a colleague of Raphael's in the Laren art colony, especially *Oil Paint and Grease Paint* (New York: MacMillan, 1936), 154–57.

38. Bender-Raphael Correspondence, 1911–1938, Special Collections, Mills College Library, Oakland.

39. All of Raphael's still lifes are undated, but a painting similar to *Apples* was donated to Mills College by Albert Bender in 1925. Thus it is likely that these pictures were painted in the early 1920s. Raphael to Bender, Mar. 29, 1922: "This month I am digging and preparing my garden and as there is much rain, I paint still lifes, in sometimes one corner of our big room, or when I am fired out of that particular nook, I change my apparatus over into another angle" (Bender-Raphael Correspondence, 1911–1938).

40. "John O'Shea's Exhibit," *Carmelite*, Mar. 26, 1931, 3 (review of O'Shea's exhibition at the Dennis-Watrous Gallery).

41. The definitive study of O'Shea is Walter A. Nelson-Rees, *John O'Shea, 1876–1956: The Artist's Life As I Know It* (Oakland: WIM, 1985); *Bird of Paradise* is discussed on page 80 and illustrated on page 81. See also John Douglas Short, "John O'Shea," *Controversy* 1 (Nov. 2, 1934): 9; "John O'Shea," *Western Woman* 13, nos. 2–3 (1951): 64–65; Virginia McGrath, "John O'Shea," *Game and Gossip* 5 (May 2, 1952): 15, 37; Janet B. Dominik, "John O'Shea (1876–1956)," in Westphal, ed., *Plein Air Painters: North*, 136–141; *John O'Shea and Friends* (Carmel: Carmel Art Association, 1993).

42. De Longpré is the only California still life painter of the period for whom there is a substantial bibliography. Indeed, he was the subject of almost annual discussions in periodicals from shortly after his arrival in this country until his death in 1911. See "Paul de Longpré," *Art Interchange* 30 (Feb. 1893): 38; "America's Foremost Flower Painter," *Art Interchange* 35 (Nov. 1895): 118; "M. de F.," "Paul de Longpré," *New York Times Illustrated Magazine* (Dec. 26, 1897), 10–11; "Paul de Longpré, the Flower Painter," *Truth* 18 (Apr. 1899): 87–91; Pierre N. Beringer, "Le Roi des Fleurs: A Citizen of the Republic," *Overland Monthly* 36 (Mar. 1900): 234–36; "The King

of Flowers: Paul de Longpré," *Western Graphic* (Mar. 10, 1900): 8; Marian A. White, "Paul de Longpré—King of Flower Painters," *Fine Arts Journal* 12 (Aug. 1901): 448–54; Louis N. Richards, "The King of the Flower Painters in His California Home," *Overland Monthly* 43 (May 1904): 395–402; "Paul de Longpré: The 'King of Flower Painters,'" *Woman's Home Companion* 23 (May 1905): 20–21; "Paul de Longpré, Flower Painter," *Craftsman* 8 (July 1905): 498–510; John S. McGroarty, "'Le Roi Des Fleurs,'" *West Coast Magazine* 5 (Mar. 1909): 708–19; Addison Edward Avery, "Paul de Longpré, Painter of Roses," *American Rose Annual* 33 (1948): 72–76. The lack of contemporary discussions of de Longpré, with the exception of *Paul de Longpré* (Laguna Beach: Redfern Gallery, 1996), is addressed in Nancy C. Hall, *The Life and Art of Paul de Longpré* (Irvine: Irvine Museum, 2001).

43. De Longpré book illustrations are not well known; see William R. Bradshaw, *The Goddess of Atvatabar, Being the History of the Discovery of the Interior World and Conquest of Atvatabar* (New York: J. F. Douthitt, 1892); William Cullen Bryant, *Poems of Nature* (New York: D. Appleton, 1893); Mrs. Alfred Gatty, *Parables of Nature* (New York: G. P. Putnam, 1893); and Henry Wadsworth Longfellow, *Nature Poems* (London: Ward, Lock, and Bowden, [c. 1893]). See also de Longpré's illustrations in W. A. Stiles, "Orchids," *Scribner's Magazine* 15 (Feb. 1894): 190–203; and "Buzz," *Cosmopolitan* 17 (Mar. 1894): 570–78. Three sets of facsimile watercolors of de Longpré's floral works were published about 1896–98 in London and New York by F. A. Stokes Co.

44. Katharine Morrison McClinton, *The Chromolithographs of Louis Prang* (New York: Clarkson N. Potter, 1973), 95

45. Moses King, *A California Paradise: Home, Gardens, and Studio of Paul de Longpré* (New York: King's Booklets, 1904). William Wurtz, "Hollywood's First Tourist Attraction: Paul de Longpre [*sic*], Hollywood's Eccentric 'Flower Artist,'" *California Historical Courier* 35 (June 1983): 4; Merry Ovnick, *Los Angeles: The End of the Rainbow* (Los Angeles: Balcony Press, 1994), 107.

46. Six days after de Longpré arrived in Los Angeles, a reviewer referred to him as the "Roi des Fleurs"; see "Music and Art," *Western Graphic,* Mar. 25, 1899, 14. The artist continued to show his paintings of California flowers in the East at Knoedler and Co. in New York and Williams & Everett in Boston. He had first shown at Williams & Everett in 1896, again in March 1899, just as he settled in California,

and again in January 1901 and January 1903; the third show was titled a "Special Exhibition of Water Color Roses from California," although pictures of many other flowers were featured as well, including a variety of California poppies.

47. "Flowers by de Longpré," *Los Angeles Times,* Apr. 8, 1906, pt. 6, 2. The writer found that his "water colors are botanical studies rather than pictures. He is too perfect, too precise, too much concerned with the little things at the expense of the big ones."

48. He was memorialized by Margaret Hobson in a poem, "In De Longpré's Garden," *Out West* 4 (Feb. 1912): 132.

49. Ren T. de Quelin, "Art and Artists," *Graphic,* Dec. 12, 1908, 17; Antony E. Anderson, "Art and Artists," *Los Angeles Times,* Dec. 13, 1908, pt. 3, 2.

50. The Scripps collection of Valentien watercolors was donated in 1933 to the San Diego Natural History Museum, which is now publishing them in book form. The standard studies of Valentien are both by Bruce Kamerling and both called "Anna and Albert Valentien: The Arts and Crafts Movement in San Diego": *Journal of San Diego History* 24 (summer 1978): 343–65 and *Arts and Crafts Quarterly III* 1 (July 1987): 1, 12–20. Kamerling, however, concentrates on the ceramic work of this husband-and-wife team. For the still lifes, see *Albert R. Valentien, The California Years, 1908–1925* (Cincinnati: Cincinnati Art Galleries, 2000).

51. Emma Homan Thayer, *Wild Flowers of the Pacific Coast* (New York: Cassell, 1887); Volney Rattan, *A Popular California Flora* (San Francisco: A. L. Bancroft, 1883); Mary Elizabeth Parsons, *The Wild Flowers of California* (San Francisco: California Academy of Sciences, 1897); Elisabeth Hallowell Saunders, *California Wild Flowers: 12 Reproductions in Natural Colors from Watercolor Drawings* (n.p., [c. 1905]). Parsons's book was especially notable, with illustrations by Margaret Warriner Buck of San Francisco, a specialist in depicting California wildflowers and an illustrator for *Sunset* magazine. See also Bertha F. Herrick, "California Wild Flowers," *Californian* 3 (Dec. 1892): 3–15; and Charles F. Lummis, "The Carpet of God's Country," *Out West* 22 (May 1905): 307–17. Given Lummis's prominent role in extolling California's beauty and distinctive attributes, and his advocacy of historic preservation, this article may well have provided inspiration for Valentien's commission from Scripps.

52. Bibliography on White is extremely fragmentary except for *Memories of Pioneer Childhood and Youth in French Corral and North San Juan Nevada County, California, with a Brief Narrative of Later Life, Told by Edith White, Emigrant of 1859, to Linnie Marsh Wolfe* (San Francisco: Library of the California Historical Society, 1936). For the artists at Lomaland, see Bruce Kamerling, "Theosophy and Symbolist Art: The Point Loma Art School," *Journal of San Diego History* 26 (fall 1980): 233–55; for White, see 248–49.

53. White utilized the same vase in her monumental *Untitled (Yellow, White, and Pink Roses with Sweet Peas)* of about 1892 (Theosophical Society, International Headquarters). White was also a landscape painter. Several of her depictions of California missions are owned by the Atchison, Topeka, and Santa Fe Railroad; her painting of the Point Loma Theosophical Temple is at the California Historical Society in San Francisco; and the *Raja-Yoga School* is at the Theosophical Society, International Headquarters.

54. Fries painted occasional still lifes. Several fruit paintings were included in his one-man show at the Hoover Gallery in Hollywood in 1914; several others, including the early *Vegetables,* were exhibited in "Charles Arthur Fries: A Memorial Exhibition of His Painting" at the Fine Arts Gallery in San Diego in December 1941. See Antony Anderson, "Art and Artists," *Los Angeles Times,* Jan. 18, 1914, 6. In addition to *Still Life with Lobster*, there are three fruit pictures by Fries at the San Diego Historical Society.

55. See Ben F. Dixon, ed., *"Too Late": The Picture and the Artist—A Tribute to the Dean* (San Diego: D. Diego's Libreria, Associated Historians of San Diego Bicentennial, 1969); Robert Kesler, "Charles Arthur Fries: Writer, Artist, Philosopher," *Westerners the Wrangler San Diego Corral* 10 (June 1977): 2–6; Martin E. Petersen, "Charles Arthur Fries (1854–1940)," in *Plein Air Painters of California: The Southland,* ed. Ruth Lilly Westphal (Irvine: Westphal Publishing, 1982), 192–97; and the essay on Fries in Martin E. Petersen, *Second Nature: Four Early San Diego Landscape Painters* (San Diego: San Diego Museum of Art; Munich: Prestel, 1991), 12–23. Among earlier treatments of Fries are Everett C. Maxwell, "Art," *Graphic* (Jan. 10, 1914), 9; Esther Mugan Bush, "California's Beauty and Charm as Told on Canvas," *Santa Fe Magazine* (Nov. 11, 1917), 51–54; and Reginald Poland, "Charles Arthur Fries," *Modern Clubwoman,* Nov. 1929, 4–5.

56. There is more bibliography on Braun than on many of the California painters of the period, some of it by or about him in the magazine *Theosophical Path.* The standard modern treatment is Petersen, *Second Nature,* 24–35, which appeared also as "Maurice Braun: Master Painter of the California Landscape," *Journal of San Diego History* 23 (summer 1977): 20–40, with a "Selected List of Known Works by Maurice Braun." Petersen also published a shorter version as "Maurice Braun, Painter of the California Landscape," *Art of California* 2 (Aug./Sept. 1989): 44–53. About sixteen of the hundreds of paintings listed in the "Selected List," including *Anemones and Daffodils,* seem to have been still lifes. See also Martin E. Petersen, "Maurice Braun (1877–1941)," in Westphal, ed., *Plein Air Painters: Southland,* 186–91. For other treatments, see Esther Mugan Bush, "A Master Brush Which Breathes Its Inspiration from Point Loma," *Santa Fe* 11 (Aug. 1917): 13–21; Hazel Boyer, "A Notable San Diego Painter," *California Southland* 6 (Apr. 1924): 12; Helen Comstock, "Painter of East and West," *International Studio* 80 (Mar. 1925): 485–88; and "Maurice Braun, Painter," *San Diego* 4 (Dec./Jan. 1951–52): 13–16, 43–44.

57. Petersen, *Second Nature,* 33; Julia Gethman Andrews, *San Diego Union,* May 31, 1936.

58. John Fabian Kienitz, introduction to *Maurice Braun: Retrospective Exhibition of Paintings* (San Francisco: M. H. de Young Memorial Museum, 1954), n.p.

59. For a discussion of "plein air" versus "Impressionist" painting, see, for example, Westphal, ed., *Plein Air Painters: Southland and North;* Susan Landauer, "Impressionism's Indian Summer: The Culture and Consumption of California 'Plein-Air' Painting," in *California Impressionists* (Irvine: Irvine Museum; Athens: Georgia Museum of Art, 1996), 11–49.

60. Rena Neumann Coen's *The Paynes, Edgar and Elsie: American Artists* (Minneapolis: Payne Studios, 1988) is the standard study of Payne; Coen discusses the two still lifes on page 76 and includes a reproduction of *Sunflowers.* See also Martin E. Petersen, "Edgar Payne," *Artists of the Rockies and the Golden West* 6 (summer 1979): 52–57; "Edgar Alwin Payne (1882–1947)," in Westphal, ed., *Plein Air Painters: Southland,* 158–63; Charlotte Berney, "Edgar Alwin Payne and the Grandeur of California," *Antiques and Fine Art* 3 (Oct. 1986): 18–20; and *Edgar Payne, 1882–1947* (Los Angeles: Goldfield Galleries, 1987). The major monograph is Antony Anderson and Fred S. Hogue, *Edgar Alwin Payne and His Work* (Los Angeles: Stendahl Art Galleries, 1926); the authors were columnists for the *Los Angeles Times* and both wrote about Payne in that newspaper on numerous occasions.

61. Neither still life is illustrated in Anderson and Hogue, *Payne and His Work,* suggesting that they were not yet painted in 1926.

62. For Clark, see Elizabeth Whiting, "Painting in the Far West: Alson Clark, Artist," *California Southland* 2 (Feb. 1922): 8–9; M[abel] U[rmy] S[eares], "Alson Skinner Clark, Artist," *California Southland* 9 (Mar. 1927): 28–29; John Palmer Leeper, "Alson S. Clark (1876–1949)," *Pasadena Art Institute Bulletin* 1 (Apr. 1957): 15–19; Terry DeLapp, "Alson Skinner Clark (1876–1949)," in Westphal, ed., *Plein Air Painters: Southland*, 52–57; Jean Stern, *Alson S. Clark* (Los Angeles: Petersen, 1983); Jean Stern, "Alson Clark: An American at Home and Abroad," in Trenton and Gerdts, eds., *California Light*, 113–36.

63. Information on Yens is fragmentary and can be gathered primarily from newspaper reviews of his work. See especially Everett C. Maxwell, "Art," *Graphic* (July 27, 1912): 9; Maxwell, "Art," *Graphic* (Sept. 27, 1913): 9; Antony Anderson, "Of Art and Artists," *Los Angeles Times*, Nov. 8, 1925, pt. 3, 30; and numerous articles both by and about Yens in *South Coast News* (Laguna Beach), such as Roger Quayle Denny, "With the Artists: Karl Yens of Laguna Beach," Oct. 21, 1932. See also H. K. Peabody, "Karl Yens," *Western Arts,* Mar. 1926, 9, 12.

64. Anderson, "Of Art and Artists," *Los Angeles Times*, Oct. 1, 1916, pt. 3, 2.

65. Mabel Urmy Seares, "The Color Plates and the Work of Dana Bartlett," *California Southland* 19 (June 1921): 9; Dana Bartlett, "Dana Bartlett Writes European Letter," *For Arts Sake* 2 (Oct. 1, 1924): 1; "Dana Bartlett (1882–1957)," in Westphal, ed., *Plein Air Painters: Southland*, 37 (*The Green Jar* is reproduced here). Bartlett also illustrated the book by the Reverend Dana W. Bartlett (his father?) *The Bush Aflame* (Los Angeles: Grafton, 1923).

66. I am indebted to Amy Postar for the identification of this vessel.

67. Homer W. Evans, "Dana Bartlett," typescript, July 20, 1938, Southern California Index of American Design, Federal Art Project, Los Angeles; copy in the Ferdinand Perret Papers, AAA. Perret was a teacher at the Dana Bartlett Art Gallery and Art School at 3283 Wilshire Boulevard in Los Angeles in the early 1940s. Bartlett's *Ming Dynasty* was owned by Judge David R. Richardson of Boston in 1933. See Dana Bartlett, *Jewels in Color* (Los Angeles: Studio of Dana Bartlett, [1933?]).

68. Jean Stern, *The Paintings of Franz A. Bischoff (1864–1929): A Retrospective Exhibition* (Beverly Hills: Petersen Galleries, 1980); "Franz Arthur Bischoff (1864–1929)," in Westphal, ed., *Plein Air Painters: Southland*, 38–43; Jean Stern, "California Impressionist: Franz A. Bischoff," *Art and Antiques* 4 (May/June 1981):

82–89; Janet B. Dominik, "Franz Bischoff," *Art of California* 2 (Apr./May 1989): 12–17; Jean Stern, "Franz Bischoff: From Ceramist to Painter," in Trenton and Gerdts, eds., *California Light*, 157–70.

69. Bischoff taught watercolor painting in Detroit. The *Detroit Journal* reported on May 7, 1894: "He is fairly beset with people who wish to study the art of making roses in water colors, or on china." On January 12, 1895, when he was moving to Dearborn, the *Journal* announced that "he will come to the city several weeks each season to teach his classes. The remainder of his time he will devote to study and painting." I want to thank Justin Clark of the Detroit Institute of Arts for locating and photocopying newspaper references to Bischoff's Michigan years.

70. Bischoff, quoted in Everett C. Maxwell, "Art," *Graphic* (Mar. 23, 1912): 9.

71. Stern, *Paintings of Bischoff,* n.p.

72. Dando was quite highly regarded for her watercolor florals in the early years of the century. Antony Anderson heaped great praise on her art (misspelling her name "Bando") in his "Art and Artists" column in the *Los Angeles Times*, Nov. 11, 1909, pt. 3, 15; and Jan 29, 1911, pt. 3, 14.

73. Will South, "California Impressionists at Home and Afield," in William H. Gerdts and Will South, *California Impressionism* (New York: Abbeville Press, 1998), 158.

74. See Stern, "Bischoff: From Ceramist to Painter," 159; and "The Painting of China," *Detroit Journal*, May 17, 1893. Because of his involvement in this craft, Bischoff was also known as the "king of china painters" and "king in Keramic flower painting"; see "More Artists," *Graphic,* Dec. 1, 1906, 29; and May 9, 1908, 19. Bischoff's ceramic work was later featured in the Pasadena publication *China Decorator*: see his obituary by Lettie B. Benbow, "Franz A. Bischoff," Mar. 1959, 44; Gladys Burbank, "Franz A. Bischoff," Jan. 1963, 2–5; Gladys Burbank, "Life of Franz A. Bischoff," Jan. 1963, 20, which states incorrectly that he abandoned ceramics on moving to California; and especially "A Visit to Pat Bischoff's," Oct. 1966, 16–20.

75. Bischoff's floral-designed ceramics were preceded in California by the Stockton Art Pottery's Rekston ware. This firm was incorporated in Stockton in October 1896 and managed first by Thomas W. Blakey, a Scottish-trained potter and then by his son John. Rekston ware was based on florals rendered naturalistically in colored slips under a high-gloss glaze. These ceramics were sold in New York and San Francisco. In 1898, a similar

decorative line was marketed as Mariposa Pottery, to maintain the appeal of their California identity; in 1902 a fire led to the firm's demise. See Kenneth Trapp, "The Arts and Crafts Movement in the San Francisco Bay Area," in Kenneth Trapp et al., *The Arts and Crafts Movement in California: Living the Good Life* (New York: Abbeville Press, 1993), 130–32, 289.

76. Stern, "Bischoff: From Ceramist to Painter," 185n.30.

77. "Bischoff's Out-of-Doors," *Los Angeles Times,* Oct. 4, 1914, pt. 3, 4. On Bischoff's early identification with roses, see "Among the Local Artists," *Detroit Tribune*, Dec. 18, 1892; and "Art in Detroit," *Detroit Journal*, Nov. 17, 1893.

78. The standard monograph on Sharp is Forrest Fenn, *The Beat of the Drum and the Whoop of the Dance: A Study of the Life and Work of Joseph Henry Sharp* (Santa Fe: Fenn Publishing, 1983). This and almost all other books, articles, and exhibition catalogues emphasize Sharp's images of Native Americans almost exclusively, making little more than passing reference to his still lifes and usually ignoring his presence in Pasadena. Sharp himself stated that he wanted to be known as a Taos painter and not identified with California: "I have never painted in California to amount to anything—never liked it and never cared to" (ibid., 268).

79. The Stark Museum of Art in Orange, Texas, has a large group of Sharp's paintings, including a good many still lifes. One is titled *California Mums;* his *Sweet William* is inscribed, in part: "my best flower painting / Flowers from Mrs. Phoebe Hearst, Calif." My thanks to David C. Hunt, director of the Stark Museum of Art. For Sharp's relationship to Hearst, his major patron, see Marie A. Watkins, "Painting the American Indian at the Turn of the Century: Joseph Henry Sharp and his Patrons, William H. Holmes, Phoebe A. Hearst, and Joseph G. Butler" (Ph.D. diss., Florida State University, 2000), 244–317.

80. Information on Warner's life and career is scarce. See Patricia Trenton, "'Islands on the Land': Women Traditionalists of Southern California," in *Independent Spirits: Painters of the American West, 1890–1945,* ed. Patricia Trenton (Los Angeles: Autry Museum of Western Heritage, in association with University of California Press, Berkeley, 1995), 64, 66, 67.

81. Quoted in the catalogue of the show, *Nell Walker Warner* (Hollywood: Hollywood Gallery of Modern Art in the Knickerbocker Hotel, 1937).

82. *How Nell Walker Warner Paints in Oils* (Laguna Beach: Walter T. Foster, [c. 1950]).

83. Much has been published on Rose, but the definitive study is Will South, *Guy Rose: American Impressionist* (Oakland: Oakland Museum; Irvine: Irvine Museum, 1995), with a full bibliography. See also Ilene Susan Fort, "The Cosmopolitan Guy Rose," in Trenton and Gerdts, eds., *California Light*, 93–112. In *Catalogue of the Guy Rose Memorial* (Los Angeles: Stendahl Art Galleries, 1926), 14, seven flower paintings and one titled *Fish and Brass Dish* were listed (but not illustrated), but none of these have come to light. In a letter to the author of April 17, 2001, Roy C. Rose, a descendant of the artist who is compiling the catalogue raisonné on Guy Rose, states that these all date from the 1880s and 1890s.

84. This painting is described in the *Catalogue of the Guy Rose Memorial* (60) as "a cool, shadowy interior whose dusk is broken by the blaze of cactus bloom, and the limpid clarity of table china. The window affords a note of contrast with the full light of outdoors."

85. Little has been written about Rich. See Everett C. Maxwell, "Art," *Graphic,* July 16, 1910, 9; and Antony Anderson, "Of Art and Artists," *Los Angeles Times,* Nov. 23, 1919, pt. 3, 2.

86. Sonia Wolfson, "Art and Artists," *California Graphic,* Mar. 20, 1926, 6, suggests that Rich's pure still lifes were of recent origin.

87. Kleitsch is said to have painted and titled *Highlights* "after hearing a disciple of Cézanne in a Paris cafe inveigh against high lights as a form of visual superficiality which should never be reported by an artist" (Arthur Millier, "Kleitsch Memorial, Sacred Art of South America, Seen," *Los Angeles Times,* June 18, 1933, pt. 2, 4).

88. The standard study of Kleitsch is Patricia Trenton: "Joseph Kleitsch: A Kaleidoscope of Color," in Trenton and Gerdts, eds., *California Light,* 137–56. See also "Joseph Kleitsch," in Westphal, ed., *Plein Air Painters: Southland,* 152–57. *Los Angeles Times* reviews of Kleitsch's exhibitions were exceptionally informative; in addition, see Fred Hogue, "A Hungarian Artist," *Los Angeles Times,* June 25, 1928, pt. 2, 4.

89. South, "California Impressionists at Home and Afield," in Gerdts and South, *California Impressionists,* 217. For Kleitsch as a Chicago painter, see "Editor" [James William Pattison], "The Art of Joseph Kleitsch," *Fine Arts Journal* 37 (June 1919): 46–52.

90. Antony Anderson, "The Technique of Joseph Kleitsch," *Los Angeles Times,* Feb. 1, 1925, pt. 3, 13.

91. In a second review of the Kleitsch show, Antony Anderson wrote: "It is only that the still-lives [sic] are a new departure for Kleitsch

and that he is so amazingly brilliant in the doing of them" ("More Comment on Kleitsch Pictures," *Los Angeles Times,* Feb. 3, 1925, pt. 3, 30). Kleitsch's exhibition held at the Stendahl Art Galleries in Los Angeles in June 1926 included a number of still lifes and studio interiors.

92. The button accordion in the background is a fairly deluxe version with three bellows. My thanks here to J. Kenneth Moore, Frederick P. Rose Curator in Charge, Department of Musical Instruments, Metropolitan Museum of Art, New York.

93. Trenton, "Kleitsch: Kaleidoscope of Color," 152.

94. The standard monograph on Hansen is *Armin Hansen: The Jane and Justin Dart Collection* (Monterey: Monterey Museum of Art, 1973). See also Hailey, ed., *California Art Research,* 9:105–37; "Dean of Western Painters," *Western Woman* 11 (Oct.–Dec. 1944): 3–4; "The Sea and the Men Who Sail: A Story of Armin Hansen," *Spectator* (Carmel) 11 (Feb. 18, 1954): 3, 8; Kent L. Seavey, "Armin Hansen," *Monterey Life,* Mar. 1982, 65–68, a particularly insightful study of the artist within the economic and cultural life of the Monterey Peninsula; Raymond L. Wilson, "Armin C. Hansen (1886–1957)," in Westphal, ed., *Plein Air Painters: North,* 86–89; *Armin Hansen: A Centennial Salute* (Monterey: Monterey Peninsula Museum of Art, 1986); and *Our First Five National Academicians* (Carmel: Carmel Art Association, 1989). For Hansen's graphic work, see especially Anthony R. White, *Graphic Art of Armin C. Hansen: A Catalogue Raisonné* (Los Angeles: Hennessey and Ingalls, 1986); none of Hansen's etchings are still lifes. For the start of Hansen's involvement with the art community in Monterey, although 1913 and 1916 are variously cited, the earlier date is substantiated in "Attractive Indian Pictures Are Exhibited: Canvases of Interest Shown in Galleries," *San Francisco Chronicle,* May 11, 1913, 27.

95. On Brandriff, see Arthur Millier, "Our Artists in Person: No. 26—George K. Brandriff," *Los Angeles Times,* Apr. 19, 1931, pt. 3, 10; Everett Carroll Maxwell, "Painters of the West—George K. Brandriff," *Progressive Arizona* 11 (Oct. 1931): 16–17, 20; Elaine Smith Baker, "George Brandriff: Port[r]ait of a Painter," *Orange Countiana* 2 (1980): 46–51; "George Kennedy Brandriff (1890–1936)," in Westphal, ed., *Plein Air Painters: Southland,* 128–133; and Susan Anderson, "George Brandriff," *Art of California* 3 (Jan. 1990): 16–22.

96. Susan M. Anderson and Bolton Colburn, *The Allegorical Still Lifes of George Kennedy Brandriff* (Laguna Beach: Laguna Art

Museum, 1989). This show included nineteen still lifes recently donated to the museum—apparently, with one exception, the entire body of allegorical still lifes that Brandriff painted. *Ebb-Flow* had previously been dated 1934, but the picture appeared with the Laguna Beach Art Association in March 1933 and was included in "Exhibition of Paintings by George K. Brandriff," held at the Biltmore Salon in Los Angeles in May of that year. Some of these works were shown again in April 1934 at the Pasadena Art Institute.

97. The New Haven, Connecticut, still life painter John Haberle painted a trompe l'oeil *Japanese Doll* (private collection) in 1889, and Frank Sauerwein, a specialist in western subjects, painted a *Still Life* (Panhandle-Plains Historical Museum, Canyon, Texas) in 1901, featuring a Kachina doll.

98. Anderson, "George Brandriff," 20. The author notes that while these still lifes are usually quite dark and pessimistic in tone, *Ebb-Flow* is not, suggesting the influence of still lifes by Armin Hansen and Hovsep Pushman.

99. In his otherwise perceptive analysis of this work, Bolton Colburn ("George Kennedy Brandriff," in *75 Works, 75 Years: Collecting the Art of California* [Laguna Beach: Laguna Art Museum, 1993], 49) misreads the book's title as "Europe since 1850," interpreting it as a reference to the suppression of liberal and national revolutionary movements that swept Europe in 1848. No book of that title seems to exist; rather, this book is almost surely Charles Downer Hazen's monumental *Europe since 1815,* published in 1910.

100. Sonia Wolfson, "Art Show Called Propaganda," *South Coast News,* Mar. 17, 1933, 12.

101. Arthur Millier, "'Every Story's a Picture,' Artist Opines," *Los Angeles Times,* May 9, 1933, pt. 2, 8; Wolfson, "Art Show Called Propaganda."

102. Examples include Laguna Beach artist John H. Hinchman's *Dolls* and the Southern California miniaturist Martha Wheeler Baxter's *Doll with Doll Bonnet.*

103. "Paul Grimm: Foremost Desert Artist," *Palm Springs Pictorial* 19 (1949): cover, 46; Katharine M. McClinton, "Paul Grimm, Painter of the California Desert," *Antique Trader Weekly* 30 (Feb. 19, 1986): 72–74. See also interview with Paul Grimm by Rush Hughes, April 1969, transcript, Palm Springs Historical Society, courtesy of Patricia Trenton.

104. Arthur Millier, "Art and Artists," *Los Angeles Times,* Nov. 13, 1927, pt. 3, 28.

105. For Meta Cressey, see Anthony [sic] Anderson, "Art and Artists," *Los Angeles Times,* July 6, 1914, pt. 3, 11; Tim Mason, "Bert and

Meta Cressey," typescript, c. 1985, based on interviews with Robert Cressey. My thanks to Mike Kelley for providing me with this essay and other information on Meta and Bert Cressey.

106. *Toys Resting* was illustrated in Arthur G. Vernon, "Modern Art in California," *Graphic,* Mar. 20, 1918, 13.

107. For the more modern painters of the era, see Susan M. Anderson, *California Progressives, 1910–1930* (Newport Beach: Orange County Museum of Art, 1996). Reviewing the society's second exhibition, Antony Anderson wrote: "Decidedly the Los Angeles Modern Art Society is not composed of nature's imitators" ("Of Art and Artists," *Los Angeles Times,* Mar. 17, 1918, pt. 3, 14).

108. Sarah Vure, "Building Artistic Independence" and "Modern Art Comes to Los Angeles," in Vure, *Circles of Influence: Impressionism to Modernism in Southern California Art, 1910–1930* (Newport Beach: Orange County Museum of Art, 2000), 58–66, 84–92.

109. Antony Anderson, "Of Art and Artists," *Los Angeles Times,* Dec. 3, 1916, pt. 3, 2.

110. Information on the Vysekals is scarce, especially on Luvena, although the AAA has a portion of a scrapbook she assembled. See Sonia Wolfson, "Two Ironic Romanticists," *Argus* 4 (Oct. 1928): 3–4; Arthur Millier, "Our Artists in Person: No. 8—The Vysekals," *Los Angeles Times,* July 20, 1930, pt. 3, 12. Luvena wrote about her husband under her maiden name: see Luvena Buchanan, "Edouard A. Vysekal, Painter," *Czechoslovak Review* 8 (June 1924): 157–59.

111. In addition to Susan M. Anderson, *California Progressives,* the most perceptive study of early California Modernism is in the essays by Sarah Vure in *Circles of Influence.* The California Impressionists and the Progressives were not mutually exclusive. Karl Yens, for instance, often worked in an Impressionist manner and was a member of the Modern Art Society, and John Hubbard Rich was one of the Group of Eight.

112. Barbara Johnson, "Modern Art Workers," *Dark and Light* 4, Oct. 1925, 5.

113. Nancy Dustin Wall Moure, "A Quest for Excellence: Chronicling the Life of Mabel Alvarez," *Antiques and Fine Art* 7 (May 1990): 94–100; Glenn Bassett, "Mabel Alvarez: A Personal Memory," *American Art Review* 11 (Mar./Apr. 1999): 184–89; Will South, "Mabel Alvarez," in *Mabel Alvarez: A Retrospective* (Los Angeles: Laband Art Gallery, Loyola Marymount University, 1999); Mabel Alvarez Papers, AAA.

114. Antony Anderson, "Of Art and Artists," *Los Angeles Times,* Nov. 28, 1920, pt. 3, 2.

115. The flowers in *Narcissus and Ranunculus* bear close similarities to those in *Marigolds and Apples,* exhibited at the Kanst Gallery in January 1918, in a show of work by students at John Hubbard Rich and William V. Cahill's School for Illustration and Painting. *Marigolds and Apples* is reproduced in Arthur G. Vernon, "Modern California," *Graphic,* Feb. 1, 1918, 11. This softer style also informs *Still Life* (William Shallert Collection), painted before 1920.

116. "Transcription of Mabel Alvarez' Notes on Art (1920–1927)," typescript courtesy of Glenn Bassett, who has been immeasurably helpful to me on Alvarez's life and art; he also supplied me with excerpts from Alvarez's diary and with photographs of more than two dozen of her still lifes.

117. Arthur Millier, review of Alvarez's show at the Chouinard School, *Los Angeles Times,* Sept. 29, 1935, pt. 2, 4.

118. *Retrospective Exhibit of the Oil Paintings and Water Colors by Donna Norine Schuster (1883–1953)* (Downey: Downey Museum of Art, 1977); "Donna Norine Schuster (1883–1953)," in Westphal, ed., *Plein Air Painters: Southland,* 100–105; Roberta Gittens, "Donna Schuster," *Art of California* 4 (May 1991): 16–20; Patricia Trenton and Roberta Gittens, "Donna Norine Schuster: Afloat on Currents of Change," *Southwest Art* 22 (Feb. 1993): 68–74, 132. See the perceptive if somewhat contrary discussions of Schuster by Susan Landauer and Ilene Fort in Trenton, ed., *Independent Spirits,* 68–73, and 82, 84, respectively.

119. Leonard R. de Grassi, "Donna Norine Schuster," in *Donna Norine Schuster, 1883–1953* (Downey: Downey Museum of Art, 1977), n.p.

120. In the 1921 annual exhibition of the Painters and Sculptors of Southern California Schuster showed the stylistically similar *Flowers, Fruit, Sunlight,* and in their 1924 annual she showed *A Boy with Parrot and Fan.* In 1924 she also showed *Macaw and Still Life* in a show of Impressionistic Paintings by Western Artists in September at the Oakland Art Gallery.

121. At the time of the group's second exhibition, Antony Anderson considered Hinkle the most experimental of the Group of Eight; see "Art and Artists: 'The Group of Eight,'" *Los Angeles Times,* Jan. 29, 1922, pt. 3, 23.

122. On Hinkle generally, see Antony Anderson, "Of Art and Artists," *Los Angeles Times,* June 3, 1917, pt. 3, 24; Arthur Millier, "Our Artists in Person: No. 38—Clarence K. Hinkle," *Los Angeles Times,* June 4, 1932, pt. 2, 4, 7; *Clarence Keiser Hinkle (1880–1960): A Selection of his Paintings* (Stockton: Raymond-Callison Gallery, University of the Pacific, 1978); "Clarence Hinkle (1880–1960)," in Westphal, ed., *Plein Air Painters: Southland,* 70–75. A hundred paintings by Hinkle were bequeathed to the University of the Pacific, which in 1986 sold them to Gary Brietwieser of Santa Barbara. In 1978 the university held a small exhibition (see catalogue cited above), about a third of which were still lifes.

123. This painting was titled *Still Life—Blue Jar* when it was reproduced in the catalogue titled *45th Anniversary Exhibit: Clarence Hinkle, 1880–1960* (Laguna Beach: Laguna Beach Art Association, 1965).

124. A similar but more elaborate still life of fruit on a corner table set for three won an honorable mention in a 1930 show in Pasadena; see Clarence Hinkle, Ferdinand Perret Papers, AAA.

125. "Clarence Keiser Hinkle, Outdoor Still Life," illustrated and discussed in Nancy Dustin Wall Moure, "Catalogue Entries," in *A Time and a Place: From the Ries Collection of California Painting* (Oakland: The Oakland Museum, 1990), 96-97. On *Pomegranates,* see Gerdts and South, *California Impressionism,* 246.

BEFORE THE WORLD MOVED IN

1. Lorser Feitelson, interview by Fidel Danieli, Los Angeles Art Community, Group Portrait, Oral History Program, University of California at Los Angeles, Special Collections, 1982.

2. Bernard Barryte, "The Question of Meaning," in *Silent Things, Secret Things: Still Life from Rembrandt to the Millennium* (New Mexico: Albuquerque Museum, 1999), 4.

3. Information about "Oldfield's Teaching Philosophy" and "Color Zones" theory comes from Oldfield Papers, typescript, Archives of American Art (hereafter cited as AAA), Smithsonian Institution, Washington, D.C.

4. Oldfield used to carry his color blocks to and from his classes, according to Oldfield's daughter Jayne Blatchly. The blocks are presently in the Oldfield Estate.

5. A summary of Oldfield's remarks on his painting method; see Oldfield Papers, typescript, AAA.

6. Information on Oldfield's skull provided by Jayne Blatchly, letter to author, Feb. 25, 2001. Gee's use of the skull as a still life motif does not have the potency or symbolism usually assigned to the *vanitas* still life, in which the human skull symbolizes death and often serves as a moralizing reminder of the transience of life and the eternity of death, a tradition since the Middle Ages. Oldfield may have been aware of Cézanne's use of the skull as a still life motif.

7. See Will South, "Synchromism: Theoretical Beginnings," in *Color, Myth, and Music:*

Stanton Macdonald-Wright and Synchromism (Raleigh: North Carolina Museum of Art, 2001), 34.

8. Joyce Brodsky, *The Paintings of Yun Gee* (Storrs: William Benton Museum of Art, University of Connecticut, Storrs, 1979), 20.

9. "The group used to call themselves the Chinese Revolutionary Art Club, but they dropped the word 'revolutionary' when their brilliant young founder and leader, Yun Gee, left for Paris some three years ago" (Esther S. Johnson, *San Francisco Daily News,* 1931; newspaper clipping, Oldfield Estate, courtesy of Jayne Blatchly).

10. Gee, quoted in Anthony W. Lee, *Painting on the Left* (Berkeley: University of California Press, 1999), 196.

11. Unidentified newspaper clipping, Oldfield Estate. Dorr Bothwell, one of the four women artist members of the Modern Gallery, painted a portrait of Yun Gee in 1926 (location unknown).

12. Information on the Six and Bay Area modern art is from Nancy Boas, *The Society of California Six Colorists* (San Francisco: Bedford Arts, 1988).

13. Arthur Bloomfield, *San Francisco Examiner,* June 10, 1977.

14. Information on Macdonald-Wright comes from South, *Color, Myth, and Music.*

15. *American Mercury* 25, no. 100 (Apr. 1932): 385–90.

16. Roger Aikin, *Henrietta Shore: A Retrospective Exhibition, 1900-1963* (Monterey: Monterey Peninsula Museum of Art, 1986), 17.

17. Unidentified New York newspaper review by Henry Tyrell, quoted ibid.

18. Roger Aikin, "Henrietta Shore and Edward Weston," *American Art* 6, no. 1 (winter 1992): 47.

19. "Every time I see that cactus, I have renewed emotion: it is a great painting" (Weston's daybooks, quoted ibid., 50). Shore finally gave Weston one of her semiabstractions; but it was *Cactus* that he really wanted.

20. The spelling of the word "floripondios" has been corrupted in various exhibition records. According to *Webster's Third,* it is a member of "the genus *Datura* that have narcotic seeds from which an intoxicant is prepared and that are sometimes cultivated in warm regions esp. for their very large commonly (trumpet-shaped) white flowers." It is unknown whether Shore knew of the flower's properties and its use as a hallucinogen over the centuries. The plant was also used for medicinal purposes.

21. Weston's daybooks, quoted in Aikin, "Shore and Weston," 43.

22. This question is posed also by Ilene Susan Fort in *Independent Spirits,* 96. A second version of this painting shows three full blooms in sunlight in place of the three buds, suggesting that the former may be an earlier version. The drooping leaves and three buds versus the upright position and full blooms may suggest a metaphorical exploration of the cycle of life and death—a possible concern of the artist at this stage in her life (she was about fifty when she painted *Gloxinia*). I am indebted to my colleague Penny Perlmutter for bringing to my attention the second version and its possible relationship to the first.

23. Bram Dijkstra, *Belle Baranceanu—A Retrospective* (La Jolla: Mandeville Gallery, University of California, La Jolla, 1985), 16.

24. Taber, quoted in Monica E. Garcia-Thow, *Rinaldo Cuneo: An Evolution of Style* (Carmel: William A. Karges Fine Art, 1991), 35, 37.

25. Frankenstein, quoted ibid., 100.

26. Stacey Moss, "Jane Berlandina (1898–1970)," in *The Howards: First Family of Bay Area Modernism* (Oakland: Oakland Museum), 67.

27. Wessel, quoted in Gene Hailey, ed., "Jane Berlandina," abstract from California Art Research WPA Project 2874, OP 65-3-3632, 129.

28. From 1926 to 1928 it seems that Hayakawa was also involved with Oldfield's Cubist/Synchromist-inspired style, as her painting *Sleeping Man* attests. It is not known whether she was a student of Oldfield's at the California School of Fine Arts. For an illustration of the picture, see Nancy Dustin Wall Moure, *California Art: 450 Years of Painting and Other Media* (Los Angeles: Dustin Publications, 1998), 305.

29. The major source on Feitelson and Postsurrealism is Diane Degasis Moran, "The Painting of Lorser Feitelson" (Ph.D. diss., University of Virginia, 1979). Moran interviewed Feitelson between 1974 and 1978, and Feitelson spoke of his and Lundeberg's ideas on their Postsurrealist work. Only recently—not until after finishing this essay—did I get access to the Feitelson/Lundeberg Art Foundation Archives.

30. See Susan Ehrlich, ed., *Pacific Dreams: Currents of Surrealism and Fantasy in California Art, 1934–1957* (Los Angeles: UCLA at the Armand Hammer Museum of Art and Cultural Center, 1995), 16.

31. "[Feitelson and Lundeberg] added the subtitle Post-surrealism to acknowledge an interest they held in common with the . . . [European Surrealists], namely the exploitation of the power of subjective association. Critics

who first discussed the movement in the mid-Thirties persisted in referring to it as Post-surrealism, and the label stuck" (Diane Moran, "Post-Surrealism: The Art of Lorser Feitelson and Helen Lundeberg," *Arts* 57, no. 4 [Dec. 1982]: 124).

32. Mitchell Douglas Kahan, "Subjective Currents in American Painting of the 1930s" (Ph.D. diss., City University of New York, 1983), 161.

33. Feitelson, interview with Danieli.

34. Feitelson served as a mural supervisor for the Los Angeles Works Progress Administration Federal Art Projects (WPA/FAP) and as a supervisor for the FAP easel painting section; he also worked as a muralist. The WPA murals were done in an acceptable 1930s style but harked back to the artist's neoclassic figurative style of the 1920s. See Kahan, "Subjective Currents," 158.

35. Guston's comments are in Moran, "Painting of Feitelson," 111. In the late 1920s and early 1930s a limited number of collectors and dealers exhibited modern art in Southern California. Feitelson, Earl Stendahl, Jake Zeitlin, and several other dealers held shows mostly of modern European art, and particularly of the Surrealists.

36. See Moran, "Painting of Feitelson," 121, 252–53.

37. Moran, "Post-Surrealism," 126.

38. See Patricia Trenton, ed., *Independent Spirits: Women Painters of the American West, 1890–1945* (Los Angeles: Autry Museum of Western Heritage, in association with University of California Press, Berkeley, 1995), 92, pl. 86.

39. Moran, "Post-Surrealism," 127.

40. Ehrlich, ed., *Pacific Dreams,* 18.

41. Kahan, "Subjective Currents," 38.

42. Jeffrey Wechsler, *Surrealism and American Art, 1931–1947* (New Brunswick, N.J.: Rutgers University Art Gallery), 48.

43. The biography and works of "Lucien Labaudt" from 1880 to 1937 are in Gene Hailey, ed., "Abstract from California Art Research, W.P.A. Project #2874, O.P. 65-3-3632," vol. 19 [1937], 10–11; Hailey notes that the painting was exhibited at the Carnegie Institute in 1935.

44. Wechsler, *Surrealism and American Art,* 48.

45. Kahan, "Subjective Currents," 39, cites Masson as a source for Labaudt's images of mutation.

46. Michael Zakian, *Agnes Pelton: Poet of Nature* (Palm Springs: Palm Springs Desert Museum, 1995), 79. The painting's title refers to an evening prayer—a form of spoken worship or song in the Anglican Church.

47. Agnes Pelton Papers, AAA. Pelton was a founding member of the influential but short-lived New Mexico Transcendentalist Painting Group (1938–41). The group disbanded in 1941 on the U.S. declaration of war.

48. Agnes Pelton Papers, AAA.

49. Bothwell destroyed the painting in 1956. According to her friend Marlys Mayfield, Bothwell later embraced a philosophy that stressed positive rather than negative thoughts, which may explain the painting's destruction.

50. Quoted from a transcription of Marlys Mayfield's taped interview with Dorr Bothwell. I am indebted to Ms. Mayfield for all the shared information on Bothwell.

51. Letter from Mayfield to Trenton, Apr. 25, 2001.

52. Nancy Moure, in *California Art*, dates the painting to 1941 (after the bombing of Pearl Harbor). However, the painting is listed in the 1940 American Art Annual of the Art Institute of Chicago and appeared in a 1941 exhibition of Serisawa's work at the Los Angeles County Museum of Art, indicating that it was executed by the artist before both dates. In addition, "1939" appears in the artist's hand on the back of the canvas.

53. Susan Landauer, *Elmer Bischoff: The Ethics of Paint* (Berkeley: University of California Press, 2001), 27.

54. See Lewis Ferbrache, "Taped Interview with Mr. William Gaw, Berkeley, CA, March 6, 1964," 20–21; and [Curator C. L. Wysuph], *Maxwell Galleries Ltd. Is Pleased to Present a Retrospective Exhibition of the Works of William A. Gaw: Oil Paintings, Watercolors, and Lithographs, June 6 thru 28, 1969*, 6. I am indebted to Gaw's late daughter Patricia G. Shields for providing archival material on her father.

55. I am indebted to Paul Karlstrom, former director of Archives of American Art on the West Coast, for the introduction to Jayne Blatchly, Jayne Blatchly Trust, Estate of Otis Oldfield. Ms. Blatchly's devotion to this project has been overwhelming, and without her support this essay would not have been accomplished. I extend my warm gratitude to a new friend.

56. For a discussion of Formalist Realism, see John Baker, *Henry Lee McFee and Formalist Realism in American Still Life, 1923–1936* (Lewisburg, Pa.: Buckwell University Press, 1987).

57. Howard Devree, "Diverse Modernism: Works by Picasso, McFee, Hartley in New Shows," *New York Times,* Jan. 15, 1950, 10.

58. For another illustration of her 1930s work, see John Baker, *Henry Lee McFee and Formalist Realism in American Still Life, 1923–1936,* 102.

59. Bentley Schaad, *The Realm of Contemporary Still Life Painting* (New York: Reinhold, 1962), 35.

60. Peter Selz, "Hans Burkhardt, 1904–1994," in Ehrlich, ed., *Pacific Dreams,* 92. Burkhardt admitted a large debt to Feitelson, who became a friend in Los Angeles, saying that he "did more for me than any other artist. He loved my work" (quoted in Jack V. Rutberg, *Hans Burkhardt: The War Paintings—A Catalogue Raisonné* [Northridge: California State University Northridge, 1984], 16).

61. Engel, interview by Lawrence Wechsler and Milton Zolotow, in "The Los Angeles Art Community: Group Portrait on Jules Engel," Oral History Program, University of California, Los Angeles, 1985. In what follows, information on his life and career and quotations are from this source unless otherwise noted.

62. Engel, quoted in *Jules Engel: Anything But Still* (Los Angeles: Tobey C. Moss Gallery), [1].

63. Engel, interview with Wechsler and Zolotow, 58.

64. John McLaughlin, interview by Fidel Danieli, "Los Angeles Art Community Group Portrait," Oral History Program, University of California, Los Angeles, 1974, 8, 15, and 16.

65. Susan Ehrlich, "John McLaughlin," in Paul J. Karlstrom and Susan Ehrlich, *Turning the Tide: Early Los Angeles Modernists, 1920–1956* (Santa Barbara: Santa Barbara Museum of Art, 1990), 93.

66. McLaughlin, quoted in Fidel Danieli, "John McLaughlin: Retrospective, 1946–1975," *Artweek,* Sept. 21, 1975, 2.

67. Ibid., 3.

68. McLaughlin first arranged this abstract design by manipulating shapes cut from colored paper; see John McLaughlin Papers, AAA.

THE NOT-SO-STILL LIFE

1. Hilton Kramer, "Pure and Impure Diebenkorn," *Arts* 38 (Dec. 1963): 51.

2. For a discussion of the "criminalization" of realism in the critical discourse after the war, with Clement Greenberg as its primary critical adversary, see Linda Nochlin, "The Realist Criminal and the Abstract Law," *Art in America* 5 (Sept.–Oct. 1973): 54–61. For a discussion of the modern art controversy, see Taylor D. Littlejohn and Maltby Sykes, *Advancing American Art: Painting, Politics, and Cultural Confrontation at Mid-Century* (Tuscaloosa: University of Alabama Press, 1989); Margaret Lynne Ausfeld and Virginia M. Mecklenburg, *Advancing American Art* (Montgomery, Ala.: Montgomery Museum of Art of Fine Arts, 1984); and Serge Guilbaut, "The Frightening Freedom of the Brush," *Dissent: The Issue of Modern Art in Boston* (Boston:

Institute of Contemporary Art, 1985). These accounts date the height of the controversy to 1948, but in San Francisco it was already at a fever pitch by 1947. See Grace McCann Morley, "Tour of Some Paintings Is Stopped and a Controversy Seems to Be On," *San Francisco Chronicle,* May 25, 1947; and for an account of the continuing debates in the early 1950s, see Alfred Frankenstein, "A Discussion of the Charges That Communists Influence Modern Art," *San Francisco Chronicle,* Mar. 23, 1952.

3. Richard Diebenkorn, quoted in Caroline A. Jones, *Bay Area Figurative Art, 1950–65* (San Francisco: San Francisco Museum of Modern Art; Berkeley: University of California Press, 1990), 82.

4. Bischoff, Park, and Diebenkorn seemed to have been specifically troubled with the pronouncements of Clyfford Still, who taught with them at the California School of Fine Arts (now the San Francisco Art Institute) in the late 1940s.

5. David Park, quoted in Paul Mills, *Contemporary Bay Area Figurative Painting* (Oakland: Oakland Art Museum, 1957), 7.

6. Elmer Bischoff, interview by Maurice Tuchman, May 12, 1976, transcript in Archives of American Art (hereafter cited as AAA), Smithsonian Institution, Washington, D.C.

7. Bischoff, quoted in Paul Mills, *The New Figurative Art of David Park* (Santa Barbara: Capra Press, 1988), 74.

8. Bischoff, interview by Paul J. Karlstrom, Aug. 10, 24 and Sept. 1, 1977, AAA, 46.

9. Theophilus Brown, conversation with the author, Apr. 24, 1998.

10. Joan Bossart, "Bay Area Figurative Painting," in *Directions in Bay Area Painting: A Survey of Three Decades, 1940s–1960s,* ed. Joseph Armstrong Baird, Jr. (Davis: Richard L. Nelson Gallery and the Fine Arts Collection, Department of Art, University of California, Davis, 1983), 14.

11. The term "funk art" came into common usage after Peter Selz's landmark exhibition "Funk" in 1967. See Peter Selz, *Funk* (Berkeley: Regents of the University of California, 1967).

12. It is important to recognize that the term "Beat" was never accepted by the artists I am discussing here. The term was initially used as an insult for people who were not necessarily creative artists, and later as a commercial packaging device. The "Beats," moreover, did not form a discrete coterie but what I would describe as a series of pods composed of like and unlike individuals who clashed as well as mingled. The assemblage artists, as a subset, shared a closer sensibility, although they, too, constituted a loose fraternity rather

than a discrete group. For example, Bruce Conner and Edward Kienholz were mere acquaintances.

13. Norman Mailer, "The White Negro," in *The Beat Generation and the Angry Young Men*, ed. Gene Feldman and Max Gartenberg (New York: Dell, 1958), 373, quoted in Jack Foley, *"O Her Blackness Sparkles!": The Life and Times of the Batman Art Gallery, San Francisco, 1960–1965* (San Francisco: 3300 Press, 1995), 1.

14. By some accounts, Picasso inaugurated assemblage with his *Still Life* of 1914, composed of painted wood and upholstery fringe; neither painting nor sculpture, it hangs from the wall and projects several inches out into space. See William C. Seitz, *The Art of Assemblage* (New York: Museum of Modern Art, 1961), 21. Picasso had sculpted still life previously, however, in a work of 1909 that makes a bow to Cézanne: an apple carved to suggest Cézanne's trademark faceted fruit. Later, he definitively opened the door to still life sculpture with his well-known *Absinthe Glass* of 1914.

15. Robert Motherwell, "Introduction," in Pierre Cabanne, *Dialogues with Marcel Duchamp* (London: Thames and Hudson, 1971), 12, quoted in Verni Greenfield, "Ed Kienholz: The Artist and the Man," in Henry Hopkins et al., *Forty Years of California Assemblage* (Los Angeles: Wight Art Gallery, University of California, Los Angeles, 1989), 89.

16. Joan Brown, quoted in Rebecca Solnit, *Secret Exhibition: Six California Artists of the Cold War Era* (San Francisco: City Lights Books, 1990), 68.

17. George Herms, telephone interview with the author, Mar. 31, 2002. The phrase "artistic alchemy" may have first been used as the title of an article by Hunter Drohojowska in the *Los Angeles Times*, Sept. 6, 1992. Drohojowska describes Herms's "obsession with the process of alchemy" and quotes the artist as saying one of his primary aims was to "take something really gross and make something fine out of it."

18. George Herms, quoting William Seitz, in Drohojowska, "Artistic Alchemy."

19. Bruce Conner, letter to Susan Landauer and Lindsey Wylie, Nov. 23, 2002.

20. Interestingly, Bruce Conner does not acknowledge the accomplishments of the Dadaists and Surrealists as direct sources for his own assemblage sculpture but points, rather, to the still lifes of William Harnett. (Conner, telephone interview with author, January 2003.)

21. Short probably became known as "Black Dahlia" after the murder; the name came from a popular Veronica Lake film, "Blue Dahlia," combined with the fact that Short had black hair and often wore black. The flower connotation reinforced her vulnerability in the popular imagination.

22. James Ellroy, *The Black Dahlia* (New York: Mysterious Press, 1987); John Gilmore, *Severed: The True Story of the Black Dahlia Murder,* 3d ed. (Los Angeles: Amok Books, 1998); Janice Knowlton, *Daddy Was the Black Dahlia Killer* (New York: Pocket Books, 1998); Mary Pacios, *Childhood Shadows: The Hidden Story of the Black Dahlia Murder* (Bloomington, Ind.: 1st Books, 1999); *Black Dahlia Avenger: The True Story* (New York: Arcade Books, 2003); http://www.bethshort.com.

23. Solnit, *Secret Exhibition,* 65. Much of Conner's work bears unmistakable allusions to African Congo and Plains Indian fetishes, which were intended as vehicles of supernatural power. The word "fetish" originates from the Portuguese *feitico.* Its Latin source, *factitus,* means "made with the hands." They could be both "natural" (i.e., "found") and "impregnated" (made). The two most common fetishes are the "nail fetishes" of certain African tribes (especially of the Congo) and the Plains Indians' medicine bundles, which contained a collection of various powerful objects. The more aged the fetish, cracked and blackened with use, the more powerful. For an excellent study of the fetish that remains a classic, see Wolfgang Born, "The Fetish," *Ciba Symposia,* Oct. 1945, 102–32.

24. Edward Kienholz, quoted in Hopkins et al., *Forty Years of California Assemblage,* 176.

25. Maurice Tuchman, ed., *Art in Los Angeles: Seventeen Artists in the Sixties* (Los Angeles: Los Angeles County Museum of Art, 1981), 15.

26. See, for example, the tawdry boudoir of Miss Cherry Delight, the most popular prostitute at *Roxys.*

27. Hopkins et al., *Forty Years of California Assemblage,* 176.

28. This work has also been interpreted as a warning against the dangers of war, its shape echoing that of a mushroom cloud from an atomic explosion. See Walter Hopps et al., *Kienholz: A Retrospective* (New York: Whitney Museum of American Art, 1996), 103.

29. George Herms, quoted in Hopkins et al., *Forty Years of California Assemblage,* 156.

30. Foley, *"O Her Blackness Sparkles!"* 20; Michael McClure, "Sixty-six Things about the California Assemblage Movement," *Artweek* 12 (Mar. 12, 1992), quoted in ibid.

31. Information on the history of *The Librarian* comes from a telephone interview with George Herms by the author, Mar. 31, 2002.

32. Among the object portraits Herms has created are works dedicated to Cameron, Diane di Prima, Edward Kienholz, Philip Lamantia, Michael McClure, Kenneth Patchen, and Robert Rauschenberg.

33. Thomas Albright, "Herms, Master of the Visual Metaphor," *San Francisco Chronicle*, Aug. 17, 1979.

34. George Herms, interview with the author, Apr. 5, 2002.

35. Herms originally operated his Love Press in Topanga Canyon; he then briefly relocated to the redwoods of Healdsburg to form a partnership with Paul Beattie, publishing under the imprint M-C Press. The initials allude variously to "master of ceremonies"; the Mill Creek address; Midi Coelum, Latin for mid-heaven; and (according to Los Angeles poet Tony Scibella in a conversation with the author) Mu Chu, as in Mu Chu pork.

36. Edmund Wilson, *Axel's Castle: A Study in the Imaginative Literature of 1870–1930* (New York: W. W. Norton, [1931] 1984), 21.

37. Stephane Mallarmé, quoted ibid., 20.

38. Information on *Secret Archives* derives from George Herms, interview with the author, Apr. 5, 2000.

39. Hilton Kramer, "Dude Ranch Dada," *New York Times*, May 16, 1971.

40. Little has been written on Pop Art in Northern California specifically, since its forms are so hybrid and personal. The Bay Area artist who most closely approximated Pop was Mel Ramos, whose "consumer Odalisques" consist of pin-up girls in beckoning poses astride name-brand foods—Chiquita bananas and Baby Ruth bars. An argument could conceivably be made that these figures function as "objects," but in the author's view, their figurative content precludes membership in the still life genre. See Julia Armstrong, "Pop Art: Wayne Thiebaud and Mel Ramos," in *Directions in Bay Area Painting: A Survey of Three Decades, 1940s–1960s,* ed. Joseph Armstrong Baird (Davis: Richard L. Nelson Gallery and the Fine Arts Collection, Department of Art, University of California, Davis, 1983), 20–23.

41. Thomas Albright, *Art in the San Francisco Bay Area, 1945–1980: An Illustrated History* (Berkeley: University of California Press, 1985), 124.

42. Ibid., 117.

43. Wayne Thiebaud, quoted ibid., 124.

44. Ibid., 126.

45. According to art historian John Fitz Gibbon (conversation with the author, Oct. 2000), Robert Colescott denies that Wayne Thiebaud is the subject of this painting. However, Fitz Gibbon believes that the place-card with the name "Wayne" and the cake make the

connection hard to dispute. "Wayne has a sartorial predilection for bow ties," he further points out. "The pun is on Thie-baud." In addition, the boot appears in many of Colescott's paintings and may be taken as an autobiographical reference.

46. Staprans studied with Karl Kasten, Erle Loran, and Worth Ryder, all of whom took workshops with Hans Hofmann.

47. Thiebaud, quoted in Albright, *Art in the San Francisco Bay Area*, 123.

48. For more on humor in Bay Area art, especially the Davis School, see Susan Landauer, *The Lighter Side of Bay Area Figuration* (Kansas City: Kemper Museum of Contemporary Art; San Jose: San Jose Museum of Art, 2000).

49. Richard Shaw, quoted in Landauer, *Lighter Side of Bay Area Figuration*, 16.

50. Albright, *Art in the San Francisco Bay Area*, 250.

51. Mark Stevens, "Robert Arneson," *Newsweek* 107 (May 26, 1986): 73.

52. Arneson's *Typewriter* might be compared with Claes Oldenburg's *Soft Typewriter* (1963), reproduced in Sam Hunter and John Jacobus, *American Art of the 20th Century* (Englewood Cliffs, N.J.: Prentice-Hall; New York: Harry N. Abrams, 1973), 347.

53. Neal Benezra, *Robert Arneson: A Retrospective* (Des Moines: Des Moines Art Center, 1986), 31.

54. Robert Arneson, quoted ibid.

55. Thomas Albright, *Art in the San Francisco Bay Area*, 248.

56. David Gilhooly also set up several "Frog Fred's donut carts," and in 1975 staged two major bake sales at the Candy Store gallery in Folsom, California, and at the Hansen-Fuller Gallery in San Francisco.

57. David Gilhooly, quoted in Kenneth Baker et al., *David Gilhooly* (Davis: John Natsoulas Press, 1992), 57.

58. For examples of environmental still lifes by Aertsen and Beuckelaer, see Norman Bryson, *Looking at the Overlooked: Four Essays on Still Life Painting* (Cambridge, Mass.: Harvard University Press, 1990), 146–150.

59. Baker et al., *David Gilhooly*, 55.

60. Ibid., 57.

61. John Fitz Gibbon, *VandenBerge* (Davis: Natsoulas/Novelozo Gallery, 1991), n.p.

62. VandeBerge, quoted ibid.

63. Ibid.

64. Charles Johnson, "A Ceramic Sculptor Immortalizes Carrot," *Sacramento Bee*, June 26, 1974.

65. I would like to thank *San Jose Mercury* art critic Jack Fischer for this insight in a conversation with the author, Sept. 2000.

66. Peter VandenBerge, conversation with the author, Apr. 2001.

67. Richard Shaw, letter to Mara Holt Skov, ca. June 2001, archives of the San Jose Museum of Art.

68. Landauer, *Lighter Side of Bay Area Figuration*, 24.

69. For more on Pop Art in Los Angeles, see Nancy Marmer, "Pop Art in California," in Lucy Lippard, *Pop Art* (London: Thames and Hudson, 1966); and Anne Ayres, "Impure Pop: L.A. Painting in the 1960s," in Anne Ayres et al., *L.A. Pop in the Sixties* (Newport Beach: Newport Harbor Art Musuem, 1989).

70. This exhibition was followed the next year by another influential Pop Art show at the Los Angeles County Museum of Art, "Six Painters and the Object," which included the Northern Californians Wayne Thiebaud and Mel Ramos. The Bay Area's first and only significant early Pop Art exhibition was the Oakland Art Museum's "Pop Art U.S.A." in 1963.

71. Ayres, "Impure Pop."

72. Dave Hickey and Peter Plagens, *The Works of Edward Ruscha* (New York: Hudson Hills Press, in association with the San Francisco Museum of Modern Art, 1982), 27.

73. Ayres, "Impure Pop," 20.

74. Morris Louis died in 1962, but his open-field abstractions, the *Unfurleds* (1961–62), which were never shown publicly in his lifetime, received enormous subsequent attention from formalist critics such as Michael Fried and Clement Greenberg. Ruscha has acknowledged a familiarity with the "edge paintings" of Edward Corbett, Sam Francis, and Clyfford Still, which preceded Louis's paintings by more than a decade and which Walter Hopps showed at the Ferus Gallery, then representing Ruscha, in the mid-1950s. Telephone interview by Lindsey Wylie with Ed Hamilton, Ruscha's partner at Hamilton Press, Los Angeles, Aug. 8, 2002. See Susan Landauer, *The San Francisco School of Abstract Expressionism* (Berkeley: University of California Press, in association with the Laguna Art Museum, Laguna Beach, 1996), 87, 95–96.

75. See, for example, Jonathan Fineberg, *Art Since 1940: Strategies of Being* (Englewood Cliffs, N.J.: Prentice-Hall, 1995), 284, in which he characterizes the "Milk Bottle" series as engaging in the perceptual queries that were being advanced by Jasper Johns at the time, while presaging related concerns of conceptual artists in the late 1960s. Fineberg isolates Goode's primary issue in the "Milk Bottles" as "a comparison between the reality of things and the reality of signs of things." For the comparison with Harnett, see Philip Leider, "Joe

Goode and the Common Art Object," *Artforum* 4 (Mar. 1966): 24.

76. In 1973 Goode said, "I don't mean to restrict my definition of 'art,' whatever that is, to objects, but I do believe that when I talk about art I'm talking about work which emphasizes the primacy of the visual experience" (quoted in Graham W. J. Beal, *Joe Goode: Recent Work* [St. Louis, Mo.: Washington University Gallery of Art, 1976], n.p.).

77. Ibid.

78. According to Anne Ayres, Celmins has said the allusion was to Magritte, not to the large-scale sculptures of Oldenburg, but she concedes that Oldenburg's work "'gave permission' to a whole generation of object-makers" (Ayres, "Impure Pop," 83–84).

79. Martha Alf, quoted in Suzanne Muchnic, "Martha Alf," in *Martha Alf: Retrospective* (Los Angeles: Los Angeles Municipal Art Gallery, in association with the Fellows of Contemporary Art, 1984), 19.

80. Martha Alf, quoted ibid., 24.

81. William Wilson, quoted ibid., 24.

82. *David Hockney by David Hockney*, ed. Nikos Stangos (London: Thames and Hudson, 1977), 101.

83. David Hockney, quoted in Marco Livingstone, *David Hockney*, enlarged ed. (London: Thames and Hudson, 1996), 76–78.

84. Ibid., 74–75.

85. See Peter Clothier, *David Hockney* (New York: Abbeville Press, 1995), 91.

86. See Corinne Robins, *The Pluralist Era: American Art, 1968–1981* (New York: Harper and Row, 1984).

87. Arguments for the postmodernism of the 1970s can be found in ibid., 1–2; and Edward Lucie-Smith, *Art in the Seventies* (Ithaca, N.Y.: Cornell University Press, 1980).

88. According to Aron Goldberg, who exhibited at Ceeje in the 1960s, the "art was romantic and visionary—with a vengeance. It was probably the only gallery where *narration* became a consistent artistic principle like push-pull, the hard edge, and the big empty space" (Goldberg, "Ed Carrillo—Ceeje Alumnus," *Artweek*, Apr. 12, 1975, 3).

89. Robert Bechtle has stated that he considers his paintings of cars to be "still lifes," in that he isolates them as objects and paints their countenance with fidelity—the traditional approach to the still life. Telephone message for the author, December 4, 2002.

90. For a more thorough overview of the Photo-Realist movement, see the following books by Louis K. Meisel: *Photo-Realism* (New York: Harry N. Abrams, 1980), *Photo-Realism Since 1980* (New York: Harry N. Abrams,

1993), and *Photo-Realism at the Millennium* (New York: Harry N. Abrams, 2002).

91. In a telephone interview with the author on July 26, 2002, Ralph Goings pointed out a misconception in the literature that he painted pickup trucks in California and began to paint still lifes only after moving to New York in 1974. In fact, the shift was from fast-food-chain still lifes to diner still lifes—"the difference primarily being in the ketchup containers, from plastic squirters to glass bottles." Goings also characterized himself emphatically as "a Californian"—born there, trained there, and still spending half the year there, in Santa Cruz, his second home.

92. "Ralph Goings: Artist Profiles," O.K. Gallery, http://www.okharris.com/previous/prev1/pressa.htm (Aug. 5, 2002).

93. Christina Orr-Cahall, *Charles Griffin Farr: A Retrospective* (Oakland: Oakland Museum, 1984), 12.

94. Charles Griffin Farr, interview with Christina Orr-Cahall, Terrie Sultan, and Ann Lee, Nov. 3, 1983, transcript, Archives of California Art, Oakland Museum, 12.

95. Kirk Varnedoe, quoted in Jeffrey Kastner, "A Pragmatic Modernist Prepares for Post-Modern Life," *New York Times*, Jan. 6, 2002.

96. The exhibition consisted of large-scale paintings by Al Leslie, James McGarrell, Theodore Manolides, James Valerio, Paul Wiesenfeld, and others. In the catalogue essay, Allan Frumkin wrote that the exhibition was a way of "testing the climate for still life painting"; see Allan Frumkin, *The Big Still Life* (New York: Allan Frumkin Gallery, 1979). For critical response, see, for example, Hilton Kramer, "The Return of Still Life," *New York Times*, Mar. 4, 1979.

97. See Linda L. Cathcart, *American Still Life, 1945–1983* (Houston: Contemporary Arts Museum, 1983) (despite the exhibit's title, the bulk of the art featured was produced in the 1980s); Dahlia Morgan, *American Art Today: Still Life* (Miami: Florida International University, 1985); and Zoltan Buki, *Contemporary American Still Life* (Trenton, N.J.: New Jersey State Museum, 1986).

98. Janice C. Oresman, "Still Life Today," *Arts* 57 (Dec. 1982): 111.

99. See Kramer, "Return of Still Life."

100. David Ligare, "Involving Architecture, Painting, and Architectural Principles," *Dialogo* (University of Notre Dame, School of Architecture), 1991–92, 9.

101. See David Ligare's description of the iconography of this painting in Patricia Junker, *David Ligare: Paintings* (Monterey: Monterey Museum of Art, 1997), 38.

102. "The Bastards" formed around 1997 as a demonstration of solidarity in the face of museums' lack of recognition of their work; the group still meets informally to discuss issues of common interest. Besides F. Scott Hess, the group includes Steve Galloway, John Frame, Jon Swihart, and Peter Zokosky. Michael C. McMillen is a former member.

103. According to F. Scott Hess, "The challenge of 'The Hotel Vide' was to tell an intricate, complex narrative, maintain a sense of the deep human content, and deliver believable characters, without relying on my visual props . . . people. It is a mystery novel in ten paintings, and it is 'readable,' though you are correct in that I won't divulge the answer." Letter to the author, Dec. 10, 2002.

104. Telephone interview with G. B. Carson, June 27, 2002. It was Carson who sent the clipping of the Decker reproduction to Christopher Brown. I would like to thank Carson for bringing this painting to my attention.

105. Michael Brenson, *History and Memory: Paintings by Christopher Brown* (Fort Worth, Tex.: Modern Art Museum of Fort Worth, 1995), 9.

106. George Sterling ends his *Still Life Painting from Antiquity to the Present Time* (New York: University Books, 1959) with the observation that the genre has persisted perhaps above all because of the satisfaction it affords in reinforcing our ability to manipulate the material world. It is an impulse, he suggests, that begins in infancy when objects "afforded each of us—when we were babies in the cradle, toying with objects for hours—our first contact with the world, and by way of these things the artist revives our maiden sense of wonder and our first dreams" (134).

107. According to Howard Fox, after Lari Pittman's near-death experience the central theme of his work became the celebration of life. In Fox's estimate, Pittman's art "is a conjuring forth, an idealistic pining for things so fragile and evanescent in the world as beauty, virtue, and harmony with life and with death that it is sometimes only through art that they can be expressed with unabashed and noisy sentimentality" (Howard N. Fox, with contributions by Dave Hickey and Paul Schimmel, *Lari Pittman* [Los Angeles: Los Angeles County Museum of Art, 1996], 22).

108. Pittman has spoken of the importance of experiencing the bitter along with the sweet. See ibid., 21.

109. Ibid., 22, 9.

110. In the case of Mike Kelley, the admiration is mutual; Peter Saul expressed his desire to share in Kelley's self-described "juvenile stall-kicking," saying that "to stop doing it is to invite diseases of old age, cancer, etc." (quoted in Robert Storr, "The Peter Principle," in Benoit Decron, Robert Storr, and Anne Tronche, *Peter Saul* [Paris: Somology Editions, in association with Musée de l'Abbaye Sainte-Croix, Les Sables d'Olonne, 1999], 17).

111. Ibid., 13.

112. Mildred Howard, quoted in Judith Bettelheim, "A Beautiful Tree Has Deep Roots: Mildred Howard," in Judith Bettelheim and Amalia Mesa-Bains, *Ten Little Children Standing in a Line (one got shot, and then there were nine): Mildred Howard* (San Francisco: Walter/McBean Gallery, San Francisco Art Institute, 1991), 12.

113. Mildred Howard, telephone interview with Hillary Helm, Nov. 7, 2001, archives of the San Jose Museum of Art.

114. Howard, quoted in Jesse Hamlin, "Meaning and Memory in Ephemera," *San Francisco Chronicle*, June 6, 2001.

115. The term "blobject" was coined by design historian Steven Skov Holt in 1989 to describe the curvaceous objects that began appearing in the 1980s. See his forthcoming exhibition and catalogue, with Mara Holt Skov, *Blobjects and Beyond*, San Jose Museum of Art.

116. This and the following information about the piece comes from a letter (n.d.) to and conversation with the author, spring 2001, and a telephone interview by Hillary Helm with Kim Turos, Jan. 3, 2002, archives of the San Jose Museum of Art.

117. In telephone interviews with Lucy Puls, Dec. 18, 2002, and Jan. 21, 2003, the artist acknowledged that her Latin titles suggest the language of science. She has been aware of the connection between science and Latin since childhood. Her father was a physician and her mother a medical technician, and Puls remembers her fascination with hearing them use Latin words at home.

118. Jeff Kelley, "Memory Improper," in *Lucy Puls: Recent Work* (San Francisco: Stephen Wirtz Gallery, 1995), 15–21.

119. Kathryn Spence, statement, n.d., Archives of California Art, Oakland Museum.

120. David Bonetti, "Charting 35 Years of California Art," *San Francisco Examiner*, Jan. 6, 2000.

121. Mike Kelley, quoted in Decron, Storr, and Tronche, *Peter Saul*, 17.

122. *Mooner* is one portion of a three-part installation by Mike Kelley in the collection of the Museum of Contemporary Art, Los Angeles; the two other pieces, also from 1990, are entitled *Storehouse* and *Ougi*. Collectively, the subjects of these works are two pet cats, Mooner and Ougi, who died within a close period of time.

123. Mike Kelley, e-mail to Lindsey Wylie, San Jose Museum of Art, Nov. 29, 2002.

124. Mike Kelley, quoted in John C. Welchman, Isabelle Graw, and Anthony Vidler, *Mike Kelley* (London: Phaidon Press, 1999), 25.

125. Kelley, e-mail to Wylie, Nov. 29, 2002. Kelley says in this communication that he did not initially refer to Gene Davis's *Moon Dog*; however, the work is so widely reproduced that he may have unconsciously alluded to it.

126. Quoted in Welchman, Graw, and Vidler, *Mike Kelley*, 47.

127. Kelley, e-mail to Wylie, Nov. 29, 2002.

128. Michael Duncan, "Transient Monuments," *Art in America* 4 (Apr. 1995): 79.

129. "Monuments to impermanence" is Gary Garrels's description (ibid., 81) of Nancy Rubins's work, but the phrase applies equally to the work of Chester Arnold.

130. Karen Kienzle, "Chester Arnold," in Patricia Hickson and Karen Kienzle, *Urban Invasion: Chester Arnold and James Doolin* (San Jose: San Jose Museum of Art, 2001), 20.

131. The other members of Los Four were Gilbert Lujan, Roberto de la Rocha, and Carlos Almaraz.

132. Frank Romero said, "I look at my work and I think it says something very clearly. It says that I have a right to wake up every morning and be happy. . . . A lot of it is about the joy and the pleasant experiences that I've been lucky enough to have" (quoted in Todd Gold, "Painting the Streets of L.A.," *Southwest Profile,* Nov. 1992–Jan. 1993, 17).

133. Information here on the iconography of Romero's still lifes come from a telephone interview with Romero by the author, June 18–19, 2002.

134. Guy Diehl described this work in correspondence with Hillary Helm, Dec. 20, 2001, archives of the San Jose Museum of Art.

135. Bruce Cohen, quoted in Thomas Garver, *Flora: Contemporary Artists and the World of Flowers* (Wausau, Wis.: Leigh Yawkey Woodson Art Museum, 1995), 33.

136. "Steven Criqui: Artist's Statement," typescript, Oct. 24, 2000, archives of the San Jose Museum of Art.

137. Patssi Valdez, e-mail to Lindsey Wylie, San Jose Museum of Art, Dec. 10, 2002. See also Tere Romo, *Patssi Valdez: A Precarious Comfort* (San Francisco: Mexican Museum, 1999), 20.

138. Joan Simon, *Ann Hamilton* (New York: Harry N. Abrams, 2002), 63.

139. Ann Hamilton, quoted in Pamela Lee, "Construction Sites: Women Artists in California and the Production of Space-Time," in *Art/Women/California: Parallels and Intersections, 1950–2000,* ed. Diana Burgess Fuller and Daniella Salvioni (Berkeley: University of California Press, in association with San Jose Museum of Art, 2002), 280.

140. Maria Porges, telephone interview with the author, June 20, 2002. Porges described the bottles as "stand-ins for figures."

141. Ibid. According to Porges, *Why Are We Like Our Parents?* is about the "perversity of the 1950s myth of the happy family," and she referred to Tolstoy's observation in *Anna Karenina* (1875) that "happy families are all alike; every unhappy family is unhappy in its own way."

142. Jeff Kelley, "Deborah Oropallo: Making Contact," in *How To: The Art of Deborah Oropallo* (San Jose: San Jose Museum of Art, 2002), 32–33.

143. Deborah Oropallo, e-mail to Lindsey Wylie, San Jose Museum of Art, Nov. 25, 2002.

144. Deborah Oropallo, conversation with the author, fall 2000.

145. In "Robert Therrien: L.A.'s Baroque Exemplar" (2000; http://artscenecal.com/ ArticlesFile/Archive/Articles2000/Articles0400/ MDonohue0400.html) Marlena Donohue describes the state of sculpture in Los Angeles generally as "Baroque." Although she mentions only Therrien in this context, the work of Ray and Shelton equally apply.

146. Norman Bryson, "Coda: Animating Sculpture," in Lynn Zelevansky, *Robert Therrien* (Los Angeles: Los Angeles County Museum of Art, 2000), 96.

147. Kristine McKenna, "Spinning Beds, Giant Table, Brancusi's Beard: Robert Therrien's Big Art," *L.A. Weekly,* Feb. 25–Mar. 2, 2000.

148. According to Paul Schimmel, the black fluid in *Viral Research* is a metaphor for death, probably a reference to AIDS but also to "the artist's much deeper and darker fascination with mortality in general, especially his own. This fascination was no doubt intensified by the death of his brother" (Schimmel, "Beside One's Self," in Paul Schimmel, *Charles Ray* [Los Angeles: Museum of Contemporary Art, 1998], 78).

149. Ibid., 79.

150. Carol S. Eliel, "An Armature for Our Desires," in Carol S. Eliel, *bottlesbonesandthingsgetwet* (Los Angeles: Los Angeles County Museum of Art, 1994), 10–11.

151. Peter Shelton, quoted ibid., 19.

152. Eliel, ibid.

153. Shelton, quoted ibid., 12; Eliel, paraphrasing Shelton, ibid. Eliel (19) notes that this concept can be traced to Shelton's notebooks of the 1970s, in which "some of the earliest drawings were of tubes, pipes, simple vessel forms, and conduits—forms that Shelton early on perceived as 'some kind of metabody, often thinking of the work as if it were an organism or an organ system.'"

154. *http://telegarden.aec.at*. This garden was located at the Ars Electronica Center in Austria from 1996 to 1999.

155. *Dislocation* was in part inspired by Sol Lewitt's book *Incomplete Open Cubes* (1974), consisting of 511 photographs of a cube lit by nine light sources. It also has an affinity with Robert Morris's "Unitary Objects" (1965–68), particularly the hollow cubes, which despite their impersonal exteriors, create a sense of mystery about their contents.

156. See Ken Goldberg, ed., *The Robot in the Garden: Telerobotics and Telepistemology in the Age of the Internet* (Cambridge, Mass.: MIT Press, 2000).

157. See Catherine Wilson, "Vicariousness and Authenticity," ibid., 65–88.

158. Louis Grachos, "A Human Dimension," in Louis Grachos et al., *Alan Rath: Plants, Animals, People, Machines* (Santa Monica: Smart Art Press), 17.

159. Alan Rath, quoted in Merideth Tromble, "Interview: Alan Rath," *E-Guide: Entertainment on the Gate* (http://www.sfgate .com/eguide/profile).

160. Alan Rath, quoted in Dana Friis-Hansen, *Alan Rath's Bio-Mechanics* (Houston: Contemporary Arts Museum, 1999), 4.

161. Donna Harkavy, "Plants," ibid., 3.

162. Margit Rowell, *Objects of Desire: The Modern Still Life* (New York: Museum of Modern Art, 1997), 195–96.

163. Robert Duncan, quoted in Foley, "*O Her Blackness Sparkles!*": 169. Duncan was specifically referring to Bruce Conner's assemblage sculpture *BLACK DAHLIA* (1959).

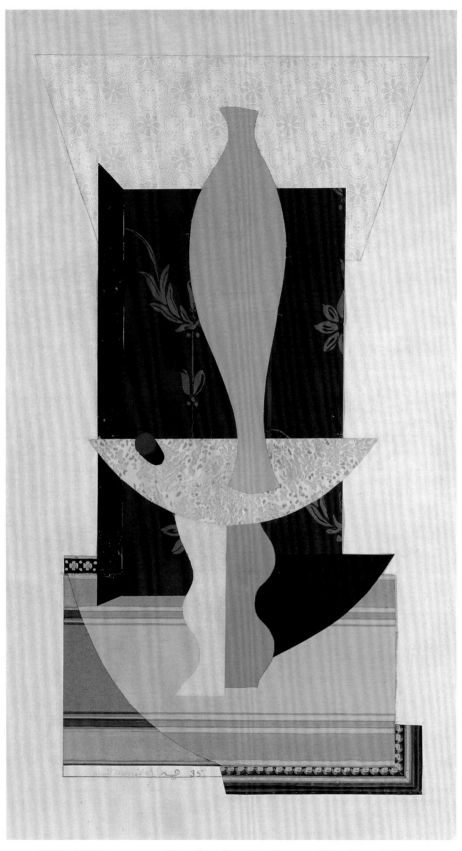

KNUD MERRILD
Green Vase

1935, collage, 26 × 15 in. Courtesy of Steve Turner Gallery, Beverly Hills.

bibliography

American Nineteenth and Early Twentieth-Century Paintings, Watercolors, and Sculpture: The Collection of Kathryn and Robert Steinberg. New York: James Graham & Sons, 1993.

American Still-Life Painting, 1913–1967. New York: American Federation of Arts, 1967.

American Still Life Tradition, 1855–1985. San Francisco: The Gallery, 1985.

Auger, Julia. *Private Worlds: 200 Years of American Still Life Painting.* Aspen, Colo.: Aspen Art Museum, 1996.

Bartyte, Bernard. *In Medusa's Gaze: Still Life Painting from Upstate New York Museums.* Introductory essay by Norman Bryson. Rochester, N.Y.: Memorial Art Gallery, University of Rochester, 1991.

Bohrod, Aaron. *A Decade of Still Life.* Madison: University of Wisconsin Press, 1966.

Born, Wolfgang. "Notes on Still-Life Painting in America." *Magazine Antiques* 50 (Sept. 1946): 158–160.

———. *Still-Life Painting in America.* New York: Oxford University Press, 1947.

Breckenridge, Bruce. "The Object: Still Life." *Craft Horizons* 25 (Sept./Oct. 1965): 33–35.

Bryson, Norman. *Looking at the Overlooked: Four Essays on Still Life Painting.* Cambridge, Mass.: Harvard University Press, 1990.

Cathcart, Linda L. *American Still Life, 1945–1983.* Houston: Contemporary Arts Museum, 1983.

Cloudman, Ruth H. *The Chosen Object: European and American Still Life.* Omaha, Neb.: Joslyn Art Museum, 1977.

Contemporary American Still Life. Trenton: New Jersey State Museum, 1986.

Contemporary New England Still Life. Lincoln, Mass.: De Cordova Museum, 1984.

Contemporary Still Life. Chicago: Renaissance Society at the University of Chicago, 1974.

Cotter, Holland. "Quiet but Very Much Alive." *New York Times,* Nov. 30, 2001.

Danly, Susan, et al. *For Beauty and for Truth: The William and Abigail Gerdts Collection of American Still Life.* Amherst, Mass.: Mead Art Museum, 1998.

Davenport, Guy. *Objects on a Table: Harmonious Disarray in Art and Literature.* Washington, D.C.: Counterpoint Press, 1998.

Dreisbach, Janice T. *Bountiful Harvest: 19th Century California Still Life Painting.* Sacramento: Crocker Art Museum, 1991.

Ebert-Schifferer, Sybille. *Still Life: A History.* Translated by Russell Stockman. New York: Harry N. Abrams, 1999.

Ensemble Moderne: Das Moderne Stilleben/The Still Life in Modern Art. Salzburg, Austria: Galerie Thaddaeus Ropac, 1998.

Esielonis, Karen. *Still Life Painting in the Museum of Fine Arts, Boston.* Introduction by Theodore Stebbins and Eric Zafran. Boston: Museum of Fine Arts, 1994.

Garver, Thomas H. *Flora: Contemporary Artists and the World of Flowers.* Wausau, Wis.: Leigh Yawkey Art Museum, 1995.

Gerdts, William H. *Painters of the Humble Truth: Masterpieces of American Still Life, 1801–1939.* Tulsa, Okla.: Philbrooke Art Center, 1981.

———, ed. *Century of American Still-Life Painting, 1813–1913.* New York: American Federation of Arts, 1966.

Gerdts, William H., and Russell Burke. *American Still-Life Painting.* New York: Praeger, 1971.

Gibson, Eric. "American Still Life." *New Criterion* 3 (Oct. 1984): 70–73.

Gombrich, E. H. "Tradition and Expression in Western Still Life." In *Meditations on a Hobby Horse, and Other Essays on the Theory of Art,* 95–105. London and New York: Phaidon, 1963.

Goodyear, Frank H., Jr. "Objects That Delight the Eye." In *Contemporary American Realism Since 1960,* 151–202. Boston: New York Graphic Society, in association with Pennsylvania Academy of Fine Arts, 1981.

Gordon, Allan. "Bountiful Harvest." *Artweek* 22 (Dec. 19, 1991): 19.

Hegarty, Laurence. "Is There Still Life?" *New Art Examiner* 25 (Nov. 1997): 57.

Hixson, Kathryn. "New Still Life." *Arts* 64 (Dec. 1989): 105–106.

Hohl, Reinhold. *The Silent Dialogue: The Still Life in the Twentieth Century.* Basel, Switz.: Galerie Boyeler, 1979.

It's a Still Life: Sculpture, Paintings, Drawings, and Photographs from the Arts Council Collection. London: South Bank Centre, 1989.

Johnson, Ellen H. "Modern Art and the Object from Nineteenth-Century Nature Painting to Conceptual Art." In *Modern Art and the Object: A Century of Changing Attitudes,* 10–64. New York: Harper & Row, 1996.

Jones, Jonathan R. "Still Life: The Remix." *Art Review* 53 (May 2001): 41–43.

Kohlitz, Karen. "A Not-so Still life." *Ceramics Monthly* 35 (May 1987): 40–3.

Kramer, Hilton. "The Return of the Still Life." *New York Times,* Mar. 4, 1979.

Lauf, Cornelia, ed. *Natura Narturata (An Argument for Still Life).* New York: Josh Baer Gallery, 1989.

Lowenthal, Anne W., ed. *The Object as Subject: Studies in the Interpretation of Still Life.* Princeton, N.J.: Princeton University Press, 1996.

Marquardt-Cherry, Janet. *Nothing Overlooked: Women Painting Still Life.* San Francisco: Contemporary Realist Gallery, 1995.

Pennington, Estell Curtis. *Gracious Plenty: American Still-Life Art from Southern Collections.* Augusta, Ga.: Morris Museum of Art, 1996.

Phillips, Stephen Bennett. *Twentieth-Century Still-Life Paintings from the Phillips Collection.* Washington, D.C.: Phillips Collection, 1997.

Radcliff, Carter. *American Art Today: Still Life.* Miami: Art Museum at Florida International University, 1985.

Rathbone, Eliza E., and George M. Shackelford. *Impressionist Still Life.* New York: Henry N. Abrams, 2001.

Rosenblum, Robert. "Modernist Still Lifes— American Experiments with Radical European Ideas." *Architectural Digest* 47 (Nov. 1990): 244–249, 308.

Rowell, Margit. *Objects of Desire: The Modern Still Life.* New York: Harry N. Abrams, 1997.

Schapiro, Meyer. "The Apples of Cézanne: An Essay on the Meaning of Still Life." In *Modern Art: 19th and 20th Centuries.* New York: George Braziller, 1978.

Schneider, Norbert. *Still Life: Still Life Painting in the Early Modern Period.* Cologne, Ger.: Taschen, 1999.

Schwabsky, Barry. "Is There Still Life in Still Life?" *Arts* 59 (Nov. 1984): 130–133.

Sheets, Hilarie M. "The Oranges Are Alive." *Artnews* 99 (Mar. 2000): 118–120.

Silent Things, Secret Things: Still Life from Rembrandt to the Millennium. Albuquerque: Albuquerque Museum, 1999.

Sims, Lowery Stokes, and Sabine Rewald, with a contribution by William S. Lieberman. *Still Life: The Object in American Art, 1915–1995—Selections from the Metropolitan Museum of Art.* New York: Rizzoli, 1996.

Skira, Pierre. *Still Life: A History.* New York: Rizzoli, 1989.

Sterling, Charles. *Still Life Painting: From Antiquity to the Twentieth Century.* Rev. ed. New York: Harper & Row, [1959] 1981.

Stewart, Susan. *On Longing: Narratives of the Miniature, the Gigantic, the Souvenir, the Collection.* Durham, N.C.: Duke University Press, 1993.

Walter, Start. *Still Life Painting.* New York: Reinhold, 1960.

index

Page numbers in italics refer to illustrations.

East Coast art: vs. California art, 2–3, 5, 45, 93, 106, 114, 183

Ebb-Flow (Brandriff), 38, 40, *44,* 208nn96, 98, 99

Eggs (Celmins), 128, *130*

Eisenhower, Dwight D., 103

El Greco, 138

Eliel, Carol, 178

Eliot, T. S., 203n4

Engel, Jules, 85, 87, 190; *The Vase,* 87, *88*

Environmental still lifes, 8, 34–35, 49, *50,* 66, 68

Eraser (Celmins), 128, *132*

Ernst, Max, 71

Estes, Richard, 81, 138

Eucharist symbolism: in Ligare, 146, *147;* in Shelton, 178, *180*

Evans, Homer W., 26

Even Song (Pelton), 74, *75*

Eyeris (Rath), *xiii,* 2, 183

"Fantastic Art, Dada, Surrealism" (Museum of Modern Art), 69

Fantin-Latour, Henri, 14

Farr, Charles Griffin, 140–41, 190; *Watermelon and Knife,* 140–41, *142*

Fauvism, 45, 53, 56

Feitelson, Lorser, 69–71, 190, 210nn31, 34, 35, 211n60; *Genesis, First Version, 3, 5,* 71; *Genesis #2,* 71, *72;* Peasant Series, 71

Ferus Gallery (Los Angeles), 138, 213n74

Fineberg, Jonathan, 213n75

Fitz Gibbon, John, 212–13n45

Floripondios (Shore), 61, *63,* 210n20

Flour Bed (Oropallo), 171, *175*

Flower Music (Alvarez), 48

Flower paintings, 2, 10–12, 18, 20, 22–23; by Alvarez, 48–49, *48;* by Bischoff (Franz), 31, 33–34; by Braun, 26, *27;* by Chittenden, 2, *3,* 11, 204nn12, 13; by Clark, 26, *29;* by Cohen, 164, *165–66;* by Dando, 207n72; by Hockney, 135, *137;* by Macdonald-Wright, 57, *58;* by Martínez, 66, *69;* by McFee, 81, *83;* by Mendenhall, 140, *141;* by O'Shea, 20, *21;* by Pagès, 18, *19;* by Payne (Edgar), 26, *28;* by Raphael, 18; by Schuster, 49, *50;* by Sharp, 31, *35;* by Shore, 61, 63, *63–64,* 210nn20, 22; by Warner, 31, 34, *36;* wildflowers in, 10, 11, 22–23, 26; by Wonner, 142, *144–45,* 146; by Yens, 26, *29*

Flowers (Ranunculus) (Edgar Payne), 26, *28*

Flower Worship (Alvarez), 48

Foley, Jack, 105

Formalist Realism, 81, 133, 135

Four Sandwiches (Thiebaud), *202*

Fox, Howard, 149, 214n107

Frame, John, 214n102

Francis, Sam, 213n74

Frankenstein, Alfred, 66

French influence, 2, 9, 45, 56; from Giverny, 10, 26, 34; on individual artists, 12, 14, 16, 18, 22, 40, 49, 53, 54, 57, 66, 93; *see also specific French artists*

Fried, Michael, 126, 183, 213n74

Fries, Charles Arthur, 24, 190, 206n54; *Still Life with Lobster,* 24, *25*

From the Dining Room Window (Rose), *8,* 34–35, 38, 208n84

Frumkin, Allan, 214n96

Funk art, 100, 106, 211n11

The Future as an Afterthought (Kienholz), 103, *104,* 212n28

Futurism, 3, 45, 53, 54, 183

Galloway, Steve, 214n102

Gamble, John, 22

Gamboa, Harry, 164

Garabedian, Charles, 138

Garden Table with Flowers and French Books (Wonner), 142, *144*

Gauguin, Paul, 45

Gavencky, Frank J., 81, 85, 190; *Hat Market,* 81, *86*

Gaw, William Alexander, 76, 78, 190; *Arrangement,* 78, *79*

Gay, August, 56

Gee, Yun, 3, 54–55, *56,* 190, 210n9; *Skull,* 3, 54, 55, 209n6

Geller, Uri, 176

Genesis, First Version (Feitelson), *3, 5,* 71

Genesis #2 (Feitelson), 71, *72*

Geometric Abstraction, 53, 85

Gerdts, William H., 2, 3; on still life, 9–49

Gile, Selden Connor, 56, *56,* 191; *The Red Tablecloth,* 56, *57*

Gilhooly, David, 5, 119–20, *119,* 191, 213n56; "FrogFry" series, 120, *122;* frogs, 119, 120; *The Leaning Tower of Dagwood,* 120, *121; Mini-Fry (with eggs and ham),* 120, *122; Never on a Sundae,* 120

Gilleland, John, 154

Gillespie, Dizzy, 203n3

Giverny, France, 10, 26, 34

Gloxinia by the Sea (Shore), 63, *64,* 210n22

Goings, Ralph, 138, 191, 214n91; *Café de Palma Still Life, xi,* 138; *River Valley Still Life,* 138, *140*

Goldberg, Aron, 213n88

Goldberg, Ken, 7, 179, 181, 191; *Dislocation of Intimacy,* 181, *182,* 215n155; *The Telegarden,* 179, 181, *181*

Gombrich, E. H., 2

Goode, Joe, 126, 128, 191, 213n76; *Happy Birthday,* 128, *129;* "Milk Bottle" series, 126, 128, 213n75; *One for Monk,* 128; *One Year Old,* 128

Gorky, Arshile, 85

Greenberg, Clement, 126, 152, 183, 211n2, 213n74

Green Coca-Cola Bottles (Warhol), 114, *117*

The Green Jar (Bartlett), 26, *30*

Green Vase (Merrild), *220*

Grimm, Paul, 40, 45, 191; *Protection,* 40, *44,* 45

Gris, Juan, 78

Gronk, 164

Group of Eight, 45, 48

Group of Independents, 59

Growth in Silence (Bothwell), *52,* 76

Guitar (Picasso), 100

Guston, Philip, 69, 70

Hamilton, Ann, 161, 164, 170, 191; *still life,* 170, *170*

Hansen, Armin Carl, 38, 191–92, 208nn94, 98; *After Lunch,* 38, *42; My Worktable,* 38, *41*

Hansen, Ejnar, 69, 192; *Artist Table,* 69, *70*

Happy Birthday (Goode), 128, *129*

Harnett, William Michael, 14, 24, 102, 123, 212n20

Hartley, Marsden, 57; *Doll, Glass, and Fruit,* 40

Harvest (Schaad), 81, *85*

Hassam, Childe, 10

Hat Market (Gavencky), 81, *86*

Hausner, Rudolf, 146

Hayakawa, Miki, 66, 192, 210n28; *Open Window,* 66, *68*

Hazen, Charles Downer, 208n99

Hearst, Phoebe, 31

Heater (Celmins), 128, *131*

Helgesen Gallery (San Francisco), 20

Henri, Robert, 45, 59

Herms, George, 1, 100, 103, 105–6, 119, 158, 192, 212nn17, 32, 35; "Celebration" series, 105; *The Librarian,* 105, *105; Secret Archives,* 106, *107*

Herron, Willie, 164

Hess, F. Scott, 146, 149, 192, 214n102; "Hotel Vide" cycle, 146, *148,* 149, 214n103; "Hours of the Day" cycle, 146; *Mr. Simon L. Sachs, Briefcase, Suite 7A,* 146, *148,* 149

Highlights (Kleitsch), 35, 38, *39,* 208nn87, 92

Hill, Thomas, 10

Hinchman, John H., 208n102

Hinkle, Clarence Keiser, 49, 192, 209nn121–24; *Outdoor Still Life,* 49; *Pomegranates,* 49; *Still Life,* 49, *51; Still Life from Chinatown,* 49

Hockney, David, 133, 135, 138, 192; *Blue Interior and Two Still Lifes,* 133, *136; Breakfast at Malibu, Wednesday,* 135, *137; Bridlington Violets,* 135, *137;* "Hollywood Collection" series, 135; *A Less Realistic Still Life,* 133, *135; A More Realistic Still Life,* 133; *Portrait Surrounded by Artistic Devices,* 135; *A Realistic Still Life,* 133

Hofmann, Hans, 112, 114

Holiday (Brandriff), 40

"Hollywood Collection" series (Hockney), 135

Hollywood filmmaking, influence on still life, 45, 85, 86

Holt, Steven Skov, 214n115

DESIGN & COMPOSITION BY SEVENTEENTH STREET STUDIOS

TEXT: BERKELEY OLD STYLE

DISPLAY: ITC LEGACY SANS

PRINTED & BOUND BY FRIESENS